PHOTOGRAPHY OF THE NUDE

PHOTOGRAPHY OF THE NUDE:

AN ANNOTATED BIBLIOGRAPHY

Frank H. Wallis

SOURCE PUBLICATIONS

MONROE, CT

1993

Photography of the Nude: An Annotated Bibliography.

Copyright © 1993 Frank H. Wallis. All rights reserved.

Library of Congress Catalog Card Number 93-86015

First Edition

ISBN 0-9638332-9-4

Published by Source Publications, 3 Cross Hill RD, Monroe, CT 06468

Printed and bound in the United States of America.

Acid free paper throughout.

TABLE of CONTENTS

PREFACE

Until now, anyone interested in researching photography of the nude was forced to spend a considerable amount of time trying to find sources. With this volume the task of locating citations will be much easier. I thought an annotated bibliography was the best form, because a simple list of books and individual works would say little or nothing about their content and purpose. As can be judged from the works included here, there is a tremendous variety of approaches and styles in photography of the nude.

Anyone working in the field of visual arts, especially photography, should find this volume useful. The primary emphasis in selecting works for inclusion was visual. The focus is on photography of the nude, and not commentary on the nude. Thus, book reviews are not listed. Scholarly essays on photography of the nude are not included unless they contain visuals. Most importantly, the major criteria for inclusion was publication. If a photographic work was published, then it was a legitimate candidate for citation. Nudes from public or private collections (e.g., libraries, galleries, and museums) are thus not included.

Photographers have been working for 150 years on this most challenging of subjects, and I thought their work deserved better organization. Four sections comprise the bibliography, with the addition of a glossary and indexes. The first is the largest, and consists of an alphabetical arrangement of annotated citations. The second concerns photographer's models, because there is at least some literature on these vital characters. Third, related articles. Fourth, a list of reference works and sources used in compiling this bibliography. The glossary defines technical terms found in the annotations, e.g., camera types, print types. The four indexes are arranged by photographer, by model, by special techniques, and by subject areas.

I want to thank the following persons and institutions for their help in completing this project: Tom Clarie, Southern Connecticut State University; Lucia Siskind, International Center of Photography (New York); Melvin Dennis, for information on *ARTnudes* and *Puchong Folios*; Museum of Modern Art (New York); New York Public Library; Art and Architecture Library, and Sterling Memorial Library, Yale University.

ORGANIZATION AND TERMINOLOGY

Included in this annotated bibliography are photographic nudes in the following categories: art, glamour, *photographie de charme*, nudist. Art nudes tend to focus on beauty of form, on experimental imaging techniques, on eroticism, and most recently, on socio-political issues. Glamour (I follow the English spelling in deference to most photographers who title their books this way) tends to highlight and glorify those physical characteristics which differentiate women from men: breasts, hips, buttocks. Thus, glamour tends to be directed to a male heterosexual audience. *Photographie de charme* is a French sub-genre of glamour, distinguished by less emphasis on large breasts, heavy makeup, and the quaint (if not shopworn) poses evident in most American glamour. Homoerotic photographs are the male homosexual equivalent of glamour. Nudist nudes are a difficult category, because they are often no more than snapshots of the nudist lifestyle. And yet, some photographers who take nudism as a subject make images that portray it in a unique way, going beyond simple visual recording. Some of the German photographers of the 1930s are exemplars of this, with their images of the *freikörperkultur* (free body culture) movement. It must be noted at the outset that many photographers create nudes which cross categories.

Generally, images of people having sex are not included. A nude is a photograph of a person without clothes, but when persons are shown stimulating each other's sex organs it is usually thought to be pornography. While it is true that some art nudes have been quite explicit in depicting sexual behavior, the intent behind the image is to make a statement about society and the human condition. Pornography is intended to show people having sex, because watching people this way is thought by many to be a form of entertainment. Of course, any nude can be interpreted in an erotic sense, but a nude does not usually involve explicit sexual behavior.

The words female and male are usually not employed as descriptive terms in this volume, because they are too vague. The gender descriptors in this work are woman and man. The word girl means girl, and not a young woman. Boy means boy, and not a young man. The somewhat arbitrary age of 18 is the dividing line between girl and woman, boy and man.

Descriptions of individual works involve the use of the following terminology: standing, seated, kneeling, supine, prone, reclining, torso, fragment. *Standing:* the person is standing, rear to camera, front to camera, or profile; a figure may fill only a portion of the frame, e.g., 3/4 standing means only 3/4 of the body is visible, usually from the knees to the head. *Seated:* the figure is seated, on the studio floor, in a chair, on a bed, on a rock, etc. *Kneeling:* the subject is kneeling. *Supine:* the person is lying down face up. *Prone:* the figure is lying face down. *Reclining:* avoiding this vague term has been one of the goals of this work, but it seemed

suitable when a nude was neither prone nor supine, but somewhere in between. *Torso:* that portion of the human body from the neck to the upper thigh. *Fragment:* a part of the human body, e.g. hip, shoulder, buttocks, breasts, hands; but not the face. Technical terms about specific images can be found in the glossary.

Arrangement of entries follows the *Chicago Manual of Style* (13th edn., 1982): author, title, place of publication, date of publication. In addition, country of citizenship and date of birth/death (if known) are included in citation. If one author/photographer has published more than one citation, then the list begins with the oldest work and ends with the latest. Page numbers for periodical articles appear after the semicolon, e.g., *Camera* 23 (Jan 1954):22. Page references for books are usually found in parentheses, e.g., Genthe, Arnold. (ed.) *Highlights and Shadows.* New York: Greenberg, 1937:(217). The exception is in cases where an abbreviation is used (see table of title abbreviations below), e.g., AVK:122.

TITLE ABBREVIATIONS

A M. Köhler (ed.), *Das Aktfoto*

AA J. Řezáč (ed.), *Akty a Akty*

AAP American Annual of Photography

AIS S. Paternite (ed.), *American Infrared Survey*

APBPC American Photographic Book Publishing Co.

AVK M. Köhler (ed.), *Ansichten vom Körper*

BB H. Campbell (ed.), *The Body Beautiful* Vol. II

BL G. Braus (ed.), *BilderLust*

BTM A. Foster (ed.), *Behold the Man*

BWC M. White (ed.), *Be-ing Without Clothes*

C *Corps Photographies*

CAEP *Contemporary American Erotic Photography*

CP *Contemporary Photographers*. 2nd edn. (1988)

CS C. Sullivan (ed.), *Nude Photographs*

DH D. Hayes (ed.), *Women Photograph Men*

DP D. Palazzoli (ed.), *Il Corpo Scoperto*

FT C. Di Grappa (ed.), *Fashion Theory*

HP A. Ellenzweig (ed.), *The Homoerotic Photograph*

HS A. Genthe (ed.), *Highlights and Shadows*

KS K. Scheid (ed.), *Hind Sight*

IPM *Imaginary Photo Museum*

JL Jacques Laurent (ed.), *Le Nu Française*

JS J. Šmok (ed.), *Akt vo Fotografii*

LN Centre Nationale de la Photographie. *Le Nu*. Paris, 1986.

MEP *Masterpieces of Erotic Photography*

N *Nude*. Tokyo [1970?].

NEW *New Nude: From Naked to Nude*

NIP A. Goldsmith (ed.), *The Nude in Photography*

NN J. Lewinski (ed.), *The Naked and the Nude*

PK *Planket Katalog 1986*

PL P. Lacey (ed.), *History of the Nude in Photography*

RK R. Krauss (ed.), *L'Amour Fou: Photography and Surrealism*

RPSGB Royal Photographic Society of Great Britain

S *Selections 1*

SII *Selections 2*

SEM R.M. Mayou (ed.), *Splendeurs et misères du corps...*

USI U. Scheid (ed.), *Das Erotische Imago*

USII U. Scheid (ed.), *Das Erotische Imago II*

WE W. Ewing (ed.), *Dance and Photography*

WP C. Sullivan (ed.), *Women Photographers*

YK Y. Kalmus (ed.), *Women See Men*

TEXT ABBREVIATIONS

b.g.	background
butt.	buttocks
esp.	especially
ex. cat.	exhibition catalog
exp.	exposure
f.g.	foreground
FKK	*freikörperkultur*
Ger.	Germany
HK	high key
incl.	includes
LK	low key
w	with

I. MONOGRAPHS, ANTHOLOGIES

AND INDIVIDUAL WORKS

All photographs are B&W, unless defined otherwise. If a work has no title, then one is not given, although brief descriptions are included for individual works. If no date is given for a photograph, then it was not included in the original source. If a book has no publication date, then it was not provided in the book itself. If there is no page number for a photograph, then it is from a page without numeration. In all of the described works the human subjects are nude unless otherwise stated.

ANONYMOUS:

28 Études de Nus. Paris: Arts et Métiers Graphiques, 1936.

28 Men & a Woman. Austin, TX: Austin Projects, 1984.

40 Plus. Sydney, Australia: Presurn, 1989.

Akademia: Le Nu Academique Francais. Paris: Herman Puig, 1981.

Akt. Special edition of *International Photo-Technik.* Munich: Großbildtechnik, 1974. Incl. Eric Bach, P. Basch, Rainer Burghardt, Jürgen Dommnich, Paul Genest, S. Haskins, J. Nemeth, Gilbert Petit, Wolfgang Speckmann, Rolf Schlosser, Walter Stuller.

Akt Art. Dokumentation Moderner Aktfotokunst. Ger., 1968-72.

Akt. Der Männlich Akt. Egestorf, Ger.: Laurer, 1927.

Der Akt: Zwanzig Photographische Aufnahmen Weiblicher Korper nach der Natur. Dachau, Ger.: Einhorn Verlag, 1918.

Akt 61. Kiel, Ger.: Fravex, 1961. Incl. P. Basch, Richard Conrad, Zoltan Glass, Serge Jaques, Vincent Lussa, Fritz Schulz-Ferré, Gerhard Vetter.

Akt 62. Kiel, Ger.: Fravex, 1962. Incl. A. de Diénes, Willi Gasché, Libo Gwosdz, Martha Hoepffner, Werner Schmölcke.

Akt 63. Kiel, Ger.: Fravex, 1963. Incl. Gasché, Gwosdz, Scmölcke, Vetter, Johannes Zachs.

Akt 64. Kiel, Ger.: Fravex, 1964. Incl. Gwosdz, H. Kröbl, Schmölcke, Zachs, Hans Zeidler.

Akt 65. Kiel, Ger.: Fravex, 1965. Incl. S. Jaques, Werner Loges, Fritz Meisnitzer, Schmölcke, Zeidler.

Akt 66. Kiel, Ger.: Fravex, 1966. Incl. A. Baege, Jacques, Lussa, Schmölcke, Reinhard Thomas, Zeidler.

Akt 67. Kiel, Ger.: Fravex, 1967. Incl. de Diénes, Jacques, Lussa, Zeidler.

Akt 68. Flensburg, Ger.: Stephenson, 1968. Incl. Rainer Burghardt, de Diénes, Jacques, Lussa, Ica Vilander, Zeidler.

Akt 69. Flensburg, Ger.: Stephenson, 1969. Incl. de Diénes, Jacques, Judith Rehme.

Akt 70. Flensburg, Ger.: Stephenson, 1970. Incl. de Diénes, Ralph Hampton, Ingeborg & Peter Lenggrüsser, Lussa, George Mechalke.

Akt im Bild. N.P.: Marshal Cavendish, 1983.

Akt in Color. Flensburg, Ger.: Stephenson, 1968.

Akte in Farben. Flensburg, Ger.: Fravex, 1966.

Aktfotosammelwerk. Flensburg, Ger.: Inter-Optik, [ca.1960].

Aktkunstmappen der Körper-Bildungsschule Adolf Koch. Leipzig, Ger.: Oldenburg, [1930].

Aktphoto International. Special edn. of *International Photo-Technik.* Munich: Großbild-Technik, 1983.

Aktphotographie: die Internationale Bibliothek der Photographie. Zurich: Orell Fussli, 1984.

Der Aktsaal. Zürich: Kreutzmann, 1892–94.

Akt International. Munich: Auer, 1954. Incl. Hajek-Halke, F. Henle, H. Flöter, H. List, Adrian, Brassai, Kerff, Klages, Schall, Strache, E. Weston, Winquist.

Akt im Lichtbild. Munich: Wappen, [1964].

Akt und Linie. Egestorf, Ger.: Laurer, 1927. Incl. Lotte Herrlich, M. Weidemann.

American Annual of Photography. Boston: American Photographic Publishing Co., 1887-1953.

"An Anatomy of a Photograph." *Camera* 60 (Sep 1981):3-37. Entire issue devoted to the nude.

Anmut des Liebes. Frankfurt, Ger.: Hoffman, 1966.

L'Année de la Photo. Paris: Love Me Tender, 1983. Incl. *charme* section.

L'Année de la Photo. No. 2. Paris: Love Me Tender, 1984. Incl. *charme* section.

Aphrodite for the 1900s. Edited by Taniguchi Eriya. Tokyo: Shogakkan, 1985.

A Propos du Corps et son Image. [Ex. cat.] Brétigny-sur-Orge, 1983.

"The Arms of Venus." *Camera* 54 (Sep 1975):5-37. Entire issue devoted to the female nude.

ARTnudes. [Ex. cat.] New York: Puchong Gallery, 1991. Incl. Jerry Mallmann photo from "Solitary Moments" series, 1990; Jeri Blake, "Five Faces of Steve" series, 1991 [body fragments]; Charles Gustina, series of three men in women's lingerie, 1989-90; Robert Taylor, "Take," 1990 [man nude fragment]; 3 works by Abigayle Tarsches, "The Music Lesson #1," 1989 [multi-exp. of woman seated on man's lap]; "Blue Laura," 1990 [seated woman on divan, distressed print]; "The Chess Game #1," 1991 [standing woman right profile w chess board & male figure in b.g.]; 2 works by Donna Francis, "Billy," 1986 [woman's reclining torso]; "Karen," 1991 [pregnant woman prone in LK setting].

The Art of Portraits and the Nude. Chicago: Time-Life Books/Kodak, 1983.

L'Art Hard. Paris: Éditions ALPA, 1983. Erotic/glamour.

Asahi Camera Special Issue, July 1986: Nature, Nude, Social Landscape, People. Tokyo: Asahi Shinbunsha, 1986.

Ästhetik und Rythmus. Magdeburg, Ger.: Druck & Verlagsanst., 1947.

Australian Penthouse Girls! Girls! Girls! Cammeray, Australia: Horowitz Grahame, 1984.

Australian Playgirl Parade. Waterloo, Australia: Federal Pub., 1984.

Australian Playgirl Pinups for Men. Waterloo, Australia: Federal Pub., 1984.

La Beauté du Corps. Berlin: Foto-Cabinet Hedler, [ca.1930]. 18 photos.

La beauté de la femme: album du premier salon international du nu photographique. Paris: Masclet, 1933.

La beauté plastique: ouvrage artistique illustré par le nu photographique d'apres nature: orné de 561 études. Paris: Librairie artistique et littéraire.

Beauty Which Inspires. Boston: Bruce Humphries, 1962.

The Best Boobs & Buns. Waterloo, Australia: Tadevan Holdings, 1989.

Best Photography. Los Angeles: Trend [1960-65?].

Bilderbuch der Körperkulturschule Adolf Kocj. Leipzig, Ger.: Oldenburg, 1933.

Bustin' Out. Surry Hills, Australia: Century Pub., 1989.

"Cent ans de photos coquines." *Le Crapouillot* n.s. 79 (1984):2-82. On the popularization of the artistic nude photo in the 19th century.

Les Chefs-D'Œvres de la Photo Érotique. [Paris, 1983?] 132 photos, *charme*/erotic.

Collection Anonyme des Années 60. Paris: JVM Diffusion, 1986. Unpaged.

Color Akt 2000. Flensburg, Ger.: Stephenson, 1969.

Color Akt Modern. Flensburg: Fravex, 1967. Incl. P. Basch, Serge Jacques, Hans Zeidler.

Contemporary American Erotic Photography. Los Angeles: Melrose Publishing, 1984. Incl. Joyce Baronio, Jeff Dunas, Robert Farber, Larry Dale Gordon, Art Kane, Antonin Kratochvil, Stan Malinowski, Robert Mapplethorpe, Ken Marcus, Richard Noble.

Corps Photographies. Saint-Étienne, France: Musée d'art et d'industrie, 1983. Incl. Ghislaine Ligout, Françoise Pacé, Jacqueline Tachon. *See individual entries.*

En Costume d'Eve. Études de Nu Feminine d'apres Nature. Berlin: Eckstein, 1903-1905.

Cover Girls. Paris: Love Me Tender, 1983. Incl. all color photos in the glamour mode from U. Ommer, Joe Gaffney, Jean-Daniel Lorieux, Francis Giacobetti, Michel Moreau, Jacques Bourboulon, Hans Feurer, Denis Jobron.

"Desirs et Fantasmes le Nouvel Érotique." *Photo* 221 (Feb 1986). Issue devoted to erotic nudes incl. H. Ritts, Thomas Glover, S. Lupino, John Steuber, A. Tress.

Das Deutsche Aktwerk. Berlin: Bruno Schultz, 1938. Incl. Hajek-Halke, Perckhammer, Zielke, Grabner, Pecsi, Riebicke, Schultz, and Ewald Hoinkis.

Das Deutsche Aktwerk. Braunschweig, Ger.: Westermann, 1938.

Ecstasy: Exploring the Erotic Imagination. Chicago: Playboy Press, 1976.

"Emancipation of the Nude." *Camera* 51 (Sep 1972):3-42. Entire issue devoted to the theme of "semi-innocence". Women are the subjects in all but one of the photos, but there were several women photographers included. Biographical notes.

Emmanuelle IV. Paris: Love Me Tender, 1984.

Erotic: 48 Female Photographers Reflection on the Theme. (Erotik: 48 kvindelige fotografers reflektioner over temaet) Frederiksberg, Denmark: Forening, 1989. In English.

Erotic Fantasies: 14 Pictorial Love Stories. Los Angeles, CA: Playgirl, 1976.

Die Erotik in der Photographie. 2 vols. Vienna: Verlag für Kulturforschung, 1931-32.

Études d'Art Photographique. Paris: Art et Photographie, 1985[?].

Études de Nus. Paris: Éditions du Chene, 1949.

Eva. Leipzig, Ger.: Eva-Verlag, [1930].

Eva 2. Hamburg: Streifen-Verlag, [1966]. 75 photos.

Eva im Paradies. Berlin: Eckstein, 1905-1906.

"The Family of Woman." *Ms.* 12 (May 1984):95-98.

"La Femme au Paradis des Photographes." Camera International 7 (Ete 1986). Entire issue devoted to "Woman", incl. several works by Fabrizio Ferri, Keiichi Tahara, and J.-L. Sieff. *See individual entries.*

Les Femmes de Vogue Hommes. Paris: A. Michel, 1988.

The Figure from U.S. Camera. New York: U.S. Camera Pub. Corp., 1952.

Figures. Cambridge, England: Cambridge Darkroom, 1987.

Film—Tanz—Exotik. Göttingen, Ger.: Eos-Verlag, 1928.

Die FKK-fotografie International. Frankfurt, Ger.: Danehl, 1961.

Fleur de Peau. Paris: Pink Star, 1984. 96 photos. *Charme*

Formes Nues. Paris: Forme, 1935. 96 photos.

Foto-Digest International. Stuttgart: Ehapa Verlag, 1970.

Fotostrip. Nos. 1-8. Aachen, Ger.: Williams, 1972. Monthly periodical.

Four Masters of Erotic Photography. London, 1972.

Die Frau der 70er Jahre. Bickenbach, Ger.: Schroeder, 1970.

Das Frivolste aus Opas Porno-Album. Flensburg, Ger.: Stephenson, 1979.

Fünfzig Naturistenfotos in Farbe. Hamburg, Ger.: Danehl, 1968.

Die Galerie-Aktmappe. Vienna: Die Galerie, [1940]; 1947.

Garcon. Kirribilli, Australia: Christopher Wilde, 1973.

Gay Baldes. Sydney, Australia: Peer Books, 1972.

Die Gestalt des Menschen und ihre Schönheit. Berlin: Singer, 1907.

Girls, Girls. Berlin: Buchgemeinschaft, [1983].

Girls in Focus. New York: Crescent Books, 1979.

The Girls of Australian Playboy. Darlinghurst, Australia: Mason Stewart, 1989.

The Girls of Las Vegas: ...and Where to Find Them. Las Vegas, NV: VIV Pub., 1974.

The Girls of Playboy. Chicago: Playboy Press, 1973.

The Girls of Playboy 2. Chicago: Playboy Press, 1973.

Glamour Fotografie. Lichtenstein: Int. Management, [ca.1970].

A La Gloire de Corps Humain. Aigremont, France: Éditions de Vivre d'Abord, [1950?].

The Great People Covergirl Hunt: 1987. Waterloo, Australia: Fairfax Magazines, 1987.

Groß und Klein im Sonnenschein. Egestorf, Ger.: Laurer, 1927.

Heavenly Bodies: The Complete Pirelli Calendar Book. New York: Harmony Books, 1975.

Das Hohe Lied der Jungen Liebe. Bickenbach, Ger.: Schroeder, 1969.

The Human Figure. Tokyo: Shueisha, 1983.

Ideale Körperschönheiten. vols. 1-2. Dresden, Ger.: Vitus-Verlag, 1923-24. Incl. M. Weidemann, Lotte Herrlich, Franz Fiedler.

Ideale Nacktheit. 12 vols. Dresden, Ger.: Verlag d. Schönheit, 1914-28.

Ideale Schönheit. Dresden, Ger.: Verlag Geist und Schönheit, 1940. Incl. 16 photos by Alex Binder, G. Riebecke, W. Schmölcke.

In Paradiesischer Schönheit. Berlin: Eckstein, 1905-1906.

Internationale Aktstudien. Wiesbaden, Ger.: Löwit, 1968.

Das International Foto. Hamburg: Prescha, 1957.

Un Jeune Exhibitioniste de 16 Ans. Paris: Éditions de la Mouette, 1990.

Jeunes Filles du Harem. Paris: Éditions Rares, 1990. *Photographie de charme.*

Jeunes Voyons. Paris: Éditions de la Mouette, 1990.

Junge Aphrodite. Bickenbach, Ger.: Schroeder, 1969.

Junger Apoll. 3 vols. Flensburg, Ger.: Stephenson, 1967-69. Incl. Kai Hanson, Reinhard Thomas, Klaus Uhde, Ica Vilander.

Jünglinge. Hamburg: Putziger, [ca.1960].

Kamera und Palette. vols. 1-5. Dresden, Ger.:Verlag Schönheit, 1922-30.

Körperbildung und Kunst. Leipzig, Ger.: Oldenburg, 1932.

Körperschönheit im Lichtbild. Dresden, Ger.: Vitus-Verlag, 1925-25.

Leading Models from Line and Form: Photographic Art Studies. Birkenhead, England: Gannet, 1957.

Lebindige Schönheit in Meisterphotos (Beautiful Nudes by Master Photographers). 2 vols. Wiesbaden, Ger.: Reichelt, 1965-66.

Der Leib. Nos. 1-8. Leipzig, Ger.: Parthenon, 1929-30; 1931.

Love Scenes: Great Moments of Passion and Tenderness. Chicago: Playboy Press, 1976.

Lust: The Body Politic. Los Angeles: The Advocate, 1991.

Mankind. Fairlight, Australia: W.J. Pub., 1972.

Mann und Bild. Hamburg: Putziger, [1960].

Der Mann in der Photographie. Zurich: Der Kreis, 1958. 100 photos, 1955-58.

Das Männliche Foto. Hamburg: Prescha, 1956.

Der Männliche Körper. Zürich: Orell Füssli, 1931.

Masterpieces of Erotic Photography. New York: Greenwich House, 1982. Unpaged. Incl. David Bailey, Harri Peccinotti, Art Kane, Duane Michals, Victor Skrebneski, Kishin Shinoyama, John Thornton, Barry Lategan, Sam Haskins, Oliviero Toscani, C. Vogt, J. Sieff. *See individual entries.*

The Model: A Portrait of Beauty. New York: Ridge Press, 1958.

Model Photography. New York; MACO, 1965.

The Male Nude. [Catalog of exhibition, 13 June–28 July 1978] New York: Marcuse Pfeifer Gallery, 1978.

The Male Nude: Visions of 60 Sensual Photographs. Text by Hiromi Nakamura. Tokyo: Treville, 1991.

Malerische Aktstudien. Berlin: Spielmeyer, 1898.

Mein Modell. Wilhelmshaven, Ger.: Steinkamp-Verlag, 1980. ["How to" manual]

Mio. Tokyo: Orion, 1984.

Der Moderne Akt. Studienmappe für Künstler. Berlin: Verlag d. Schönheit, 1903.

"My October Child." *Camera* 53 (Sep 1974):3-43. Entire issue devoted to the female nude.

My Best Nude Study. London: Routledge, 1937.

The Naked Eye. Sydney, Australia: F.S. Photo Productions, 1972.

Nackte Schönheit. Stuttgart, Ger.: Hermann Schmidt, 1906-1907. Incl. René Le Bègue, E. Schneider, P. von Weber, C.O. Freytag.

Nacktheit als Verbrechen. Egestorf, Ger.: Laurer, 1927.

Nacktsport-Kunstblätter. Berlin: Freisonnland, 1920.

Neue Modellstudien. Basel, Switzerland: Auxilia House, 1953.

New Nude: From Naked to Nude, 1922-1983. Tokyo, 1983. [Unpaged Japanese text edition examined at library of the Museum of Modern Art, New York, call # Photo Dept. 74 P6 N395.] Incl. Mapplethorpe, J. Baronio, M. Leatherdale, O. Perdrix, J. Saudek, G. Pétremand, H. Brehm, M. Newler, R. Monroe, U. Ommer, D. Schmitz, A. David-Tu, Man Ray, Brandt, Newton, Gowin, de Diénes, J.–L. Michel, D. Barreau, I. Ionesco, Blok & Broekmans, J. Pugin, R. Ten Broeke, K. Fonteyne, A. Gelpke, Vogt, G. Krause, A. Tress, M. Lehman, Gibson, J. Silverthorne, B. Saari, C. Younger. *See individual entries.*

Nihon Nude Meidaku Shu. Tokyo: Mainichi Shinbunsha, 1982.

"Nouvelles Tendances." *Photo* 288 (Oct 1991):34. Incl. work by "new" photographers: Joe Maxwell, Fran Collin, Stephan Perry, Marco Binisti, Jean-Luc Michon, Kean Millar, Boris Devic, Klaus Roethlisberger, Wilfred Asencoth, Xavier Raoux.

Le Nu. Paris: Centre National de la Photographie, 1986.

Le Nu International. Paris: Braun & Cie, 1954.

Nus Joyeux: Photographies Américains des Années 30. Paris: Éditions Rares, 1990.

Nude. Tokyo [1970?]. Unpaged. Text in Japanese. [Copy examined in New York Public Library, call # MFW 80-2496.] Incl. works by Daniel Barreau, Peter Basch, Giancarlo Botti, Wynn Bullock, Lucien Clergue, Gordon De'Lisle, André de Diénes, Karl de Haan, Frank Habicht, Sam Haskins, René Maechler, J.–L. Michel, Masaya Nakamura, Siwer Ohlsson, Wingate Paine, Peter Raba, Kishin Shinoyama, Jeanloup Sieff, Karin Székessy, Yoshihiro Tatsuki, Marcel Véronèse, Rolf Winquist.

Nude 1925: French Pin-up Postcards. Dobbs Ferry, NY: Morgan & Morgan, 1978. Anonymous photographers and their allegedly prostitute models.

The Nude in Photography, 1860-1991. Paddington, Australia: Josef Lebovic Gallery, 1991.

Nude Photography. New York: Swank Magazine Corp., 1981.

Nude Photography. Tokyo: Shogakkan, Showa 61, 1986.

Nudes: A Sourcebook for Artists. Philadelphia: National Pub., 1949.

Nudes. Los Angeles: Melrose Publishing Group, 1985.

Nudes of Yesteryear. New York: Eros Books, 1966.

"The Nude and the Window." *Camera* 50 (Sep 1971):13-43. Entire issue devoted to this theme. Biographical notes.

Nues. Paris: Contrejour, 1986. Incl. all women photographers: Brigitte Bordes, Gladys [pseud.], B. Rheims, Florence Chevalier, Mary Ann Parkinson, Marie-Paule Nègre, Kiuston Halle, B. Rix, Marie Brum, Jaschi Klein.

One Eye Open, One Eye Closed. Three Photographers Look at the Nude. [Catalog of exhibition 3-22 Dec 1976] Calgary, Canada: Alberta College of Art, 1976. Unpaged. Works of E.J. Bellocq, Robert Heinecken, Les Krims.

Onna to Otoko. Tokyo: Ado-Angen, 1974.

Paradies-Album. Stuttgart: Paradies-Verlag, 1959.

Paris Revue. Bonn: Verlag EBH, 1960; 1964.

Peeping Tom. Sydney, Australia: Coolibah Pub., 1972.

People's Book of Girls. Sydney, Australia: Magazine Promotions, 1984.

Penthouse Collection. Cammeray, Australia: PH Editorial Services, 1987.

Penthouse Collector's Album. Cammeray, Australia: PH Editorial Services, 1988.

Penthouse Collector's Special. Cammeray, Australia: PH Editorial Services, 1988.

Penthouse Dazzlers. Cammeray, Australia: PH Editorial Services, 1989.

Penthouse Erotic Pets. Cammeray, Australia: PH Editorial Services, 1987.

Penthouse Exclusive. Cammeray, Australia: PH Editorial Services, 1988.

Penthouse Exposé. Cammeray, Australia: PH Editorial Services, 1988.

Penthouse Extras. Cammeray, Australia: PH Editorial Services, 1987.

Penthouse Fabulous Pets. Cammeray, Australia: PH Editorial Services, 1989.

Penthouse Gallery. Cammeray, Australia: PH Editorial Services, 1987.

Penthouse Loving Couples. Cammeray, Australia: Horowitz Grahae, 1984.

Penthouse Portraits. Cammeray, Australia: PH Editorial Services, 1988.

Penthouse Pets. Cammeray, Australia: PH Editorial Services, 1987.

Penthouse Raging Pets. Cammeray, Australia: PH Editorial Services, 1989.

Penthouse Sexational Pets. Cammeray, Australia: PH Editorial Services, 1987.

Penthouse Super Pets. Cammeray, Australia: PH Editorial Services, 1986.

Penthouse Wild Pets. Cammeray, Australia: PH Editorial Services, 1986.

Petit Catalogue des Fétichismes. Paris: Le Club du livre secret, 1982.

La Photo Érotique Contemporaine. Paris: Éditions Filipacchi, 1984. Approx. 150 photos by 35 photographers. *Charme*

Les Photos Interdites des Plus Grands Photographies de Nu. [Paris, 1984?]

Photography of the World, 1960. Tokyo: Heibonsha, 1960. In English. .

Photography Studies. New York: MACO Magazine Corp., 1965.

Pictorial Figure Photography. Minneapolis, MN: American Photography Magazine, 1951.

The Picture: Turn it on! Surry Hills, Australia: Century Magazines, 1989.

Planket Katalog 1986. Stockholm: Fotoutställning, 1986. Unpaged. Incl. P. Meyer, G. Sessler, A. Papaioannou, B. Geijerstam, T. Lindström. *See individual entries.*

The Platypus Portfolio. Van Nuys, CA: Ninja Press, 1987.

The Platypus Portfolio II. Van Nuys, CA: Ninja Press, 1989.

Playboy Bunnies. Chicago: Playboy Press, 1972.

Playboy Bunnies # 2. Chicago: Playboy Press, 1979.

The Playboy Photographer. Chicago: Playboy Press, 1974.

Playboy's Bunnies. Chicago: Playboy Press, 1971.

Playboy's Bunnies 2. Chicago: Playboy Press, 1974.

Playboy's Girls of the World. Chicago: Playboy Press, 1972.

Playboy's Leading Ladies. Chicago: Playboy Press, 1981.

Playboy's Fotos. Hamburg: Nelson, 1979.

Playgirl Junior. Melbourne, Australia: Gordon & Gotch, 1984.

Das Playgirl-Postkartenbuch. Munich: Laterna Magica, 1984.

"Les Premier Nus Autochromes." *Photo* 140 (1979):119. Incl. Georges Balagny (1837-1919), Paul Bergon (1863-1912).

Rio: Les Photos Interdites. Paris: Pink Star, 1983.

Der Schöne Akt. Vienna: Hammer, 1949. 12 plates.

Der Schöne Mensch. Hannover, Ger.: Lehning, 1950. 16 plates.

Schöne Menschen—Schöne Bilder. Hamburg: Danehl, 1957.

Die Schönheit des Menschlichen Körpers. Düsseldorf, Ger.: Ulrich & Steinbecher, 1905. Incl. B. Arthur, H. von Behringer, C.O. Freytag, W. Hartwig, Ewald Hase, Aura Hertwig, Hans Hildenbrand, H.L. von Jan, E. von Kupffer, E. Norbert, Otto Schmidt, Ernst Schneider, A. Schneider, H. Traut, P. von Weber, W. Collins.

Schönheit die Begeistert. 4 vols. Bern, Switzerland: Wissen & Fortschritt, 1955-68.

Schönheit des Leibes. Berlin: Verlag Dt. Leibeszucht, [ca.1930].

Die Schönheit des Liebes. Munich: Una-Verlag, 1965.

Schönheitsspiegel de Weibes. Das Europäische Aktwerk. Stuttgart: Transit Verlag, 1954.

Die Schönsten Playmates des Playboy. Munich: Bauer, 1979. Incl. Erik Klemm, Tassilo Trost, Guido Mangold, Peter Weissbrich.

Schule des Aktfotos. Special edition of *International Photo-Technik.* Munich: Verlag Großbildtechnik, 1968.

Schule der Aktphotographie. Special edition of *International Photo-Technik.* Munich: Verlag Grßbild-Technik, 1979; 1981; 1983.

Sekai no Nudo. Tokyo: Kyodo Tsushinsha Kaihatsukyoku, 1972.

Selections 1. From the Polaroid Collection. Schaffhausen, Switzerland: Verlag Photographie, 1982. Unpaged. Undated work incl. T. Shiraiwa, J. Saudek, D. Auerbacher, D. Blok, D.

Mendelsohn, K. Kuenster, J. Reuter, L. Franchi de Alfaro III, A. Barboza, L. Samaras, C. Vogt, P. de Nooijer. *See individual entries.*

Selections 2. From the Polaroid Collection. Schaffhausen, Switzerland: Verlag Photograpie, 1984. Unpaged. Incl. Franchi de Alfaro III, J. Mézièr, J. Reuter, D. Blok, J. Silverthorne, W. Scheler, A. Barboza, J. Pugin, F. Fontana. *See individual entries.*

Sexe Book. Paris: Éditions Filipacchi, 1984. Incl. 96 color photos, *charme*/erotic.

Sittenspiegel der Nacktheit. Leipzig, Ger.: Parthenon, 1930. 48 nature nudes.

Söhne der Sonne (Sons of the Sun). 2 vols. Flensburg, Ger.: Stephenson, 1968-69. Incl. Reinhard Thomas, Klaus Uhse.

"Special Derrière." *Photo* 272 (May 1990):96. Inc. 9 woman nudes, illustrating story on young would-be starlets posing nude on the beach at Cannes, before flocks of male photographers, during the annual film festival.

The Stars: A Pictorial Tribute. Darlinghurst, Australia: Mason Stewart, 1989.

Les Stars de la Photos... Paris: Condé Nast, 1987.

Successful Glamour Photography. London: Hamlyn, 1981.

Sugar and Spice. Chicago: Playboy Press, 1976.

SX-70 Art. New York: Lustrum, 1979. Incl. H. Newton, Harvey Stein, Detlef Odenhausen, C. von Waggenheim [Wangenheim?], Gene Davis, C. Vogt, Rena Small, John Gintoff, Arne Lewis, Hans Gedda, Don Rodan, Anthony Barboza.

Tendenzen. Munich: Damnitz Verlag, 1982.

Top-Fotografen im Playboy. Munich: Playboy, 1977.

Variationen. Hamburg: Streifen, [ca.1960]. 48 photos.

Veir Meister der Erotischen Fotografie. Munich: Heyne, 1970; 1971. Incl. S. Haskins, Francis Giacobetti, K. Shinoyama.

Venus 68. Stuttgart, Ger.: Ehapa, 1968. Continued as *Venus International,* 1970; 1971; 1972.

Verzeichnis Vorbildlicher Naturaufnahmen Menschlicher Körperschönheiten. Dresden, Ger.: Verlag Schönheit, 1921.

Der Weibliche Akt: Anmut, Schönheit und Grazie des Weiblichen Körpers. Berlin: Hermann Schmidt, 1906.

Weibliche Grazie. Malerische Aktstudien. 5 vols. Stuttgart: Klemm & Beckmann, 1904. Incl. R. Le Bègue, H.L. von Jan, A. Lemoine, G. Plüschow, Graf C. de Clugny, H. Hildenbrand, Otto Schmidt, A. Schneider.

Der Wiener Akt. Vienna, Kunstatelier Viena, 1907.

Woman by 10. Chicago: Playboy Press, 1973.

Wutsukushii Nude. Tokyo: Nippon Camera Sya, 1973.

Zeta. Frankfurt: Hirsch, 1968.

Abbe, James. "At the Folies Bergère," 1924. Two standing women dancers, semi-nude. WE:94.

Abbot, Ashley. *Creative Figure Photography.* Philadelphia: Chilton, 1960.

Abigeo, Raymond. *Erotoscope.* Paris: M. Concorde, 1970.

Adam, Hans Christian. "Three Graces," 1989. Three standing women, rear view, on rock before waterfall. KS:44.

Adams, Edward E. Woman's frontal torso next to classical column. BB:11.

Adams, George. Color works in NIP: supine woman on divan, which is covered w oriental carpet (9); standing man & woman, backlit (16); woman before mirror (201); portrait of two women (202); black woman in "hot pants" (203); oiled woman standing on rocky ledge, glistening in the sun, holding box of Cracker Jacks (204); woman standing behind gauze screen (205); tall woman leaning against tree w watermelon & picnic spread (206); man & woman kneeling & embracing (207); crouching woman holding her toes (208).

Airey, Theresa. Two images: seated woman on windowsill, behind sheer fabric: reclining woman propped up on elbows, HK setting, behind similar fabric. *Viewfinder: Journal of Focal Point Gallery* (1985).

Akin, Gwen. (US 1950-) Two untitled works, 1987. SEM:131.

Akiyama, Shotaro. (Japanese 1920-) *Akiyama Shotaro Sakuhin.* Tokyo: Nihon Kamera Sha, 1974.

Albee, Wayne. "Doris Humphrey in a Hoop Dance," 1924. Standing woman w large diameter hoop. WE:177.

Albin-Guillot, Laure. (French) "Torso," ca.1930s. [from *La Beauté de la Femme* (1933)] NN:121.

————. Herculean male torso, seated, 1939. AVK:100.

————. "The Dream," 1942. Double portrait; woman on left is nude from waist up. *Camera* 53 (Feb 1974):39.

————. "Laure Albin-Guillot." *Photo* 210 (Mar 1985):64-65. Incl. "Nu," 1940, woman in dance pose; "Nu," 1940, supine woman's chest & face; "Nu," 1943, supine woman w another woman's face in b.g.; "Nu étendu tenant un voile," supine woman holding sheet in right hand.

Albright, Richard. "Jodeane #1," 1980. Woman's torso, very grainy infrared. AIS:n.p.

————. "Silent Sleep," 1980. What appears to be a woman's butt. in grainy infrared. AIS:n.p.

Alexander, C. Menges. "Bather." Seated/kneeling woman in head band, arms behind back, HK print. *AAP* 59 (1945):98.

Alexander, Rolf B. *Sex Poster Shop.* Bonn, Ger.: Verlag EBH, 1970.

————. *Leitfaden der Akt-Fotografie.* Munich: Heyne, 1972. ["How to" manual]

Alexandre, Claude. Fat dominatrix lying face down on carpet with whip in hand, 1982. SEM:153.

————. Pregnant belly, 1986. SEM:86.

Alexandroff, S. Woman's torso & head frontal. HS.

Allan, Ray. *Ah Men Nude.* Hollywood, CA: Ah Men Inc., 1976.

Alland, Alexander. Supine woman, LK setting, print rotated so her head is at top of picture frame. BB:81.

————. Frontal view of woman's torso. HS.

Allen, Albert Arthur. *Alo Studies.* Oakland, CA: Allen Art Studios, 1919.

————. Kelemen, Gayle. (ed.) *On a Pedestal: Nudes of the '20s. Photographs of Albert Arthur Allen.* Tempe, AZ: Arizona State Univ., 1991.

Allen, Casey. *New Concepts in Nude Photography.* South Brunswick, NJ: A.S. Barnes, 1966.

————. *The Nude Aesop: Camera Fables for the Modern Man.* South Brunswick, NJ: A.S. Barnes, 1967.

Allen, James. Rear view of standing woman, leaning against wall. HS.

10

Alterio, Dominik. *Childwoman.* Nuremburg, Ger.: Alterio, 1984.

———. *Mädchen, Stilleben, Landschaften (Country Girls).* Nuremburg, Ger.: DMK-Verlag, 1984.

———. *Aphrodite.* Nuremburg, Ger.: DMK-Verlag, 1983. *Charme*

Alvarez Bravo, Manuel. (Mexican 1902-) "La Buena Fama Durmiendo," 1938. Woman supine on blanket, eyes closed, ankles wrapped in gauze, as are her hips. *Camera* 51 (Jan 1972):37.

———. "La Desvendada," 1938. Frontal standing woman partially wrapped in gauze. CS:95.

———. "La Negra," 1959. Seated black woman. CS:97.

———. "Tentaciones en Casa de Antonio," 1970. Woman standing under sheet draped clothesline. CS:96.

———. "Fruta Prohibida," 1977. Woman's breast amid plant life. NE:158.

———. "Catalina," 1978. Woman w abdominal scar, reclining amid plant life. NE:159.

———. Silver, Vivienne. *The Artistic Development...of Manuel Alvarez Bravo.* N.p., 1980. Emphasis on woman nudes.

———. Silver, Vivienne. "A Guide to Viewing Manuel Alvarez Bravo." *Exposure* 19 (1981):42. Special emphasis on woman nudes.

———. *Revelaciones.* San Diego: Museum of Photographic Arts, 1990. A few nudes.

———. "Desnudo Parcial Carismático," 1987. Female breast and belly, with hair and hand at right of frame. SEM:59.

Amar, Pierre-Jean. *Nus.* Paris: Nathan, 1990. 20 plates.

Anderson, Jack. *Nude, Figure, and Glamour Photography.* Text by Burt Murphy. New York: Universal Photo Books, 1961; 2nd edn. 1963.

Andréani, Pierre. Woman's torso frontal, & large black gloves. *Photo* 184 (Jan 1983):61.

Angelicas, Emmanuel. "Angelicas." *Photo* 274 (Jul 1990):117. Incl. 4 woman nudes.

Angelo (Paris/Budapest fl.1930s) Woman dancer w pair of eyes superimposed on b.g., ca.1935. USII:91.

———. Seated/supine woman leaning back on studio backdrop, ca.1935. USII:92.

———. Hand colored print of standing woman in exotic dance costume, ca.1935. USII:147.

Anthony, Gordon. "Adonis," 1951. Studio shot of standing man frontal, in classical gesture, his skin covered w dark oily substance [perhaps in imitation of a bronze statue's patina]. BTM:61.

Aratow, Paul. (comp.) *100 Years of Erotica: A Photographic Portfolio of Mainstream American Subculture from 1845 to 1945.* San Francisco: Straight Arrow, 1973.

Arbeit, Michael. Four intentionally out-of-focus nudes, two standing, one reclining, one sitting; intended to create "a clear new view" of the subject. *Photo/Design* 7 (July 1990):69-71.

Arbus, Diane. (US 1923-71) "Retired Man and Woman," 1963. Aged couple sitting in living room. DP.

———. "Nudist with Sunglasses," 1965. Standing woman, a bit chunky. LN:37.

Archer, Daisy. *Formas Silenciosas.* Mexico: America Comunicacion Editorial, 1983.

Archives of American Art. *Artists and Models...* [ex. cat. of photographs, letters, and other documents from the collections of the Archives of American Art, Smithsonian Institution] Washington, DC: Smithsonian Institution, 1975.

Argov, Michael. *Nus d'Israël.* Paris: Éditions Prisma, 1967.

Arimondi, Victor. *The Look of Men.* N.p., 1980.

———. *Boyfriends.* New York: Arlington House, 1984.

Arlaud, G.L. *Vingt Etudes de Nus en Plein Air.* Paris: Horos, 1900.

Arman, Yves. *Etant donné qu' Eros c'est la vie.* Paris: Marval, 1988.

Arnel, Peter. *Sonia.* 1991?

Arringer, Rudolf M. *Der Weibliche Körper und seine Verunstaltungen durch die Mode.* Berlin: Bermühler, 1909.

Aslan. [pseud.] *Pin Up.* Paris: Éditions Carrere, 1984. 109 photos. *Charme.*

Astore, Henri. Color, standing woman in heather; unusual colors. *Photo* 280 (Jan 1991):53.

Atelier von Behr. Kneeling woman against black b.g.. BB:18.

———. Ditto. BB:66.

———. Seated woman against black b.g.. BB:66.

———. Ditto. BB:79.

———. Slightly contortionist pose of seated/kneeling woman. BB:86.

Atget [Jean-Eugène-Auguste]. (1857-1927) "Femme," 1910. Fat woman reclining on her right side, back to us. CS:50.

———. Plump woman on elbows and knees, on bed. *Camera* 60 (Dec 1981):cover.

Atkinson, R. Valentine. (US 1945-) Grainy image of seated woman, hips to waist only. *Camera* 53 (Sep 1974):7.

Attali, Marc. *Forme de Toi.* Paris: A. Balland, 1968. Unpaged. 390 plates.

———. *Attali.* Paris: A. Balland, 1971.

Atwood, Jane E. *Nächtlicher Alltag. Meine Begegnung mit Prostituierten in Paris.* Munich: Mahnert-Lueg, 1980.

Audras, Eric. Color, magnificent shot of supine woman w blue shadow in pool of water beneath her. *Photo* 184 (Jan 1983):67.

Aufsberg, Lala. "Kühles Nass," ca.1935. Beautiful woman standing on rock, rear view, holding pitcher of water on right shoulder, spilling it down her back. KS:19.

Auerbacher, Dominique. (French 1955-) Color Polaroid SX-70. Kneeling woman on bed, facing camera, head & shoulders resting on covers, butt. elevated. S.

Avedon, Richard. (US 1923-) "Andy Warhol and Members of the Factory," 1969. SEM:?

———. *Avedon: Photographs, 1947-1977.* New York: Farrar, Straus & Giroux, 1978. Incl. "Contessa Christina Paolozzi," 1961, nude from waist up (86); "Julie Driscoll," 1968, nude from waist up (114).

———. "Nastassja Kinski." *Photo* 200 (May 1984): color cover; woman prone w snake on seamless.

Avril, Simone. Color, woman's breast decorated to look like fancy pastry, or perhaps an ice cream desert w topping. *Photo* 184 (Jan 1983):67.

Bach, Rudolf. *Die Frau als Schauspielerin.* Tübingen, Ger.: Wunderlich, 1937. 29 photos.

Bacon, Leonard B. "Linear." Supine woman, right arm over face. *AAP* 48 (1934):10.

Baege, Alexander. *Schönheit im Bild. Beauté ...* Thielle: Die neue Zeit, 1963.

Bailey, David. (UK 1938-) "Jane Birkin," 1969. Nude portrait. "Sharon Tate and Roman Polanski," 1969. Nude portrait, from waist up. Both works found in *Mois de la Photo a Paris* Paris: Paris Audiovisuel, 1984:(118-119).

———. *Amen Baby and Goodbye to All That.* New York: Coward-McCann, 1969. Incl. studio shots of "Jane Birkin," "Sharon Tate," "Marisa Berenson," [as a leaping fashion model] & a seated pregnant woman smiling at us.

————. Polaroid of seated semi-nude woman with large album on her lap covering her chest. *Camera* 53 (Oct 1974):47.

————. Blurred motion of a seated woman. *Camera* 54 (Dec 1975):24.

————. *Mrs. David Bailey.* New York: Rizzoli, 1980. 81 B&W photos.

————. *David Bailey's Trouble and Strife.* London: Thames & Hudson, 1980. Incl. 53 nudes of his then wife, the exotic (half Japanese-half European) Marie Helvin. The most human is Marie blowing bubble gum.(1)

————. "Marie in the Plastic Raincoat." Marie's torso visible through clear plastic raincoat FT:19.

————. "The Wedding Photograph." Actually two images, first of Marie in white veil & stockings face to wall, second Marie same costume face to camera. FT:20.

————. "The Horizontal Nude of Marie." Not really horizontal, but standing close to a wall, lit w a ring light. FT:21.

————. Ten studies from the *Mrs. David Bailey* ser. MEP.

————. *Nudes, 1981-1984.* London: Dent, 1984. Pessimistic series of images: women partially wrapped in bandages, their faces obscured, blindfolded; some images "distressed." All prints are dark, and all but two are hideous and evil.

————. "David Bailey." *Photo* 204 (Sep 1984):46-53. Selections from his 1984 book.

Bailly-Maître-Grande, Patrick. (French) "Let's Twist Again," 1989. Five segment Daguerreotype of reclining woman. BL:198.

————. Daguerreotype of woman's butt., w hand in small of back, holding square plate. KS:5.

Baiko, Hannes. *Aktfotografie in eigener Regie.* Flensburg, Ger.: Fravex, 1965. ["How to" manual]

Bakerman, Nelson. (US) "Wall Street Nudes," 1989. Magnificent shot of four women standing in front of large columns of a building facade. Part of a series on this theme of outdoor night-photography nudes. BL:145.

Baladi, Sylvain. Woman's torso frontal on oriental rug. *Photo* 268 (Jan 1990):117.

Baldinger, Richard. "Luisa," 1969. Standing pregnant woman in doorway. BWC:67.

Bali, Alain. *Miss You.* Le Mans, France: Jupilles, 1981. *Charme.*

Balla, Ann. (Australia 1939-) Ms. Balla's daughter, 1976. Hasselblad, Tri-X. *Camera* 60 (Sep 1981):10.

Balog, James. *Anima.* Boulder, CO: Arts Alternative Press, 1993. Incl. 12 color studio shots, men, women, & children, w a chimpanzee. Most unique: chimp w pregnant woman (16, 17, 32). Fiber optic lighting & strobes; Bronica 6x6; 80mm lens.

Baltauss, Richard. (French 1946-) "Eriko Matsuda and Tada Toshi, Nagoya, Japan," 1983. Studio shot of young man and woman standing 3/4 frontal. CP:46.

Banks, Iain. *Classic Glamour Photography.* London: Crown Pub., 1983. ["How to" manual]

Baptista, Helena. Color, supine black woman w oiled skin, in rocky cove. *Photo* 207 (Dec 1984):77.

Baranzelli, Dino. *Lady, Lady: 46 Immagini di Dino Baranzelli.* Milan: Baldini & Castoldi, 1969.

Barbieri, Gianpaolo. (Italian 1940-) "Verushka," 1975. Arrogant fashion model behind sheer fabric. DP.

————. *Artificial.* Paris: Love Me Tender, 1983. *Charme*

————. "Barbieri: Images Artificielles." *Photo* 185 (Feb 1983):58-63. Incl. nude portrait of "Iman," 1979, the supermodel from Somalia.

Barboza, Anthony. (US 1944-) Supine woman on bed with backlighting from window. Nikon F, 21mm, Tri-X. *Camera* 50 (Sep 1971):12.

————. "Portrait of Anita Russell, Nude." Fashion model standing 3/4 frontal, arms folded across chest, head tilted to her left, long blond hair flowing over her left shoulder. FT:41.

————. Color, Polaroid; standing woman frontal, behind stainless steel pipes. SII.

Barnard, Anne. (French) Woman bent over black-velvet-covered pillar, 1989. "My interest in the nude is tactile; it's an interest in the touch of sight. My concerns are with the sensual, with desire, with the erotic, with looking." *CENTER Quarterly* 14 No. 2 (1992):18.

Barnes, Barney. "Nude." Right profile of supine woman. *AAP* 54 (1940):126.

Barns, Larry. (ed.) *The Male Nude in Photography.* Waitsfield, VT: Vermont Crossroads Press, 1980.

Baronio, Joyce. *42nd Street Studio.* Pyxidium Press, 1980. Incl. 19 studio portraits of Times Square sex industry people: mostly women.

————. Six studio works of women. She delights in gradations of grey. She used either a Pentax 6x7 or a Rollieflex 6x6 format, f/16 at T:1/4 to 1/15. CAEP.

————. Portraits of 9 women from "42nd Street" series: a few are not in her book. NEW:16-25.

————. "Portrait from 42nd Street Studio," 1979. Lovely portrait of young mother and daughter sitting on seamless backdrop; interesting highlight/shadow emphasis. *Aperture* 107 (Summer 1987):23.

Barr, Bill and Camelli, Allen. *Barely Speaking.* New York: Crown Publishers, 1969.

Barreau, Daniel. (b.1942) (*et al.*) *Sekai No Nudo.* Tokyo: Kyodo Tsushinsha Kaihatsu Kyoku, 1970.

————. Woman prone on rock ledge. N.

————. Woman standing amid pine trees. N.

————. Woman standing under pine tree branch. N.

————. Four works in NEW: overhead view of supine woman in tall grass (134); similar shot, but closer to figure (135); standing woman frontal w teddy bear, doll, & peasant house b.g. (136).

Barreaux, Adolphe. (ed.) *Famous Photographers Photograph Beautiful Women.* Louisville, KY: Whitestone Publications, 1959.

————. *Glamour and the Camera.* Greenwich, CT: Whitestone Publications, 1968.

Barrett, Dean. *The Girls of Thailand.* Hong Kong: Hong Kong Pub. Co., 1980.

Barry, John Underwood. *Venus through the Lens.* London: Thorsons, 1942. 59 plates.

Barry, Peter. *Girl Loves Girl.* Herrsching, Ger.: VWI-Verlag, 1980.

————. *Techniques of Photographing Women.* Secaucus, NJ: Chartwell, 1981.

————. *Techniques of Pin-up Photography.* N.p.: Colour Library International, 1982.

————. *The Art of Mud Wrestling.* N.p.: Arlington House, 1984.

Barsby, Jack. "Sun Daughter." On clifftop, standing woman w arms raised. This is a very familiar pose & photo, reminiscent of FKK shots. *AAP* 49 (1935):169.

————. "Salome." Kneeling woman, left profile, raising arms to beseech a mask on a pillar. *AAP* 55 (1941):101.

Barth, Hermann. *Neigung, Liebe, Leidenschaft.* Hanover, Ger.: Witte, 1931. Incl. von Riebicke, Manassé.

Bartoloni, Gary. "Daphnis." [ca.1990] Infrared, standing woman rear view, against massive tree trunk. Massive print: 30x40". *Photography in New York* 5 (Sep/Oct 1992).

———. Infrared, standing woman frontal in right corner of landscape [ca.1990]. 30x40" print. *Photography in New York* 5 (May/Jun 1993).

Bartosch, Günter. *Der Akt von Damals.* [Erotic photographs from the collection of Ernst and Günter Bartosch] Munich: Herbig, 1976.

Barzilay, Frédéric. (French) *Les Corps Illuminés.* Paris: Mercure de France, 1965.

———. Woman's butt. & sheets, 1985. BL:180.

Basch, Peter. (German 1921-) Rear view of woman in rocky cleft, 1955. A:237.

———. *Glamour Photography.* Greenwich, CT: Fawcett, 1956. ["How to" manual]

———. Silhouette of kneeling woman against high key background, 1956. AVK:116.

———. *Photo Studies.* Greenwich, CT: Fawcett, 1957. ["How to" manual]

———. (contr.) *Photography Interpretations: A Creative Study of the Female Form.* New York: Milestone Books, 1957.

———. *Gestalt und Gestaltung.* Seebruck, Ger.: Heering, 1958.

———. *Peter Basch's Camera Records the Beauty of Woman.* Louisville, KY: Whitestone Publications, 1959.

———. *Der Akt in Licht und Schatten.* Seebruck, Ger.: Heering, 1960.

———. *Peter Basch Photographs Beauty.* Louisville, KY: Whitestone Publications, 1960.

———. *Peter Basch's Guide to Figure Photography.* New York: Amphoto, 1961.

———. *Magische Schönheit. Portrait, Pin up, Akt.* Bonn, Ger.: Verlag EBH, 1962; 1963; 1965. 133 photos.

———. *Exotische Schönheit. Porträt, Tanz, Akt.* Bonn: Verlag EBH (Europäischen Bücherei Hieronimi), 1965.

———. *The Nude as Form and Figure.* New York: Amphoto, 1966.

———. *Erotische Momente.* Bonn, Ger.: Verlag der EBH, 1967.

———. *Girls.* Munich: Heyne, 1972.

———. Works in NIP: magnificent backlit shot of woman's seated torso (84-85); dancing black woman on backlit seamless (87); color image of seated woman in plush chair (95); woman's torso (98); black woman reclining on right side, front to camera, HK b.g. (102).

———. Dynamic studio shot of dancing woman. N.

Bassman, Jack. Crouching woman in forest undergrowth. NIP:131.

Bata, Vulovic. (Serb) Color, well-tanned woman crouching in yellow heels, rear view, before ocean b.g. *Photo* 207 (Dec 1984):86.

Batho, Claude. (French 1935-81) "Le Bain," 1980. Older female child in bathtub with water. SEM:38.

Battistini, Robert. Color, portrait of French celebrity Charles Biétry in a shower room w three other men; he is the only one looking at camera. *Photo* 266 (Nov 1989):108.

Baubion-Mackler, Jeannie. (French 1942-) Window and woman's torso, heavily shaded. *Camera* 60 (Sep 1981):12.

Baumann, Arnaud. Self-portrait of leaping man in small domestic interior. BTM:33.

———. *Carnet d'adresses.* Paris: Le Dernier Terrain Vague, 1984.

————. "Nus et Celebres." *Photo* 196 (1984):30-35. Nude portraits of French celebrities.

Baumann, Manuel. (Swiss 1947-) Four frames of woman backlit from window in a garret-like setting. *Camera* 50 (Feb 1971):28.

————. "Sequence 24.4.72—Kneeling." [kneeling?] Twenty-four frames of woman in sheets slowly appearing and turning over. Nikon F, 50mm, Tri-X. *Camera* 51 (Oct 1972):35.

Bäumer, Gertrud. *Die Frauengestalt der Deutschen Frühe.* Berlin: Herbig, 1928; 1929; 1935; 1939; 1940; 1950.

————. *Gestalt und Wandel: Frauenbildnisse.* Berlin: Herbig, 1939.

Bauret, Gabriel. *Nouveaux Nus.* Paris: Contrejour, 1981.

Bauret, Jean-François. (French 1932-) Pregnant woman standing 3/4 in studio; she faces right, but turns her head and looks our way. *Camera* 49 (Sep 1970):27.

————. *Jean François Bauret: Photographies...* [Catalog of Exposition de l'A.R.C. au Musée d'Art Moderne de la Ville de Paris, 30 Sep.—1 Nov. 1971.] Paris: H. Calba, 1971.

————. "Woman and Child," 1971. Seated woman and child in lap, studio shot. Biblioteque Nationale, Paris. IPM.

————. "Trois Femmes," 1969. Three old women in studio portrait. SEM:48.

————. *Portraits d'hommes nus connus et inconnus.* Paris: Balland, 1975.

————. "Daniel Hamot," 1975. Studio shot, 3/4, of middle aged man w gold-rim glasses. AVK:176.

————. *Portraits nus.* Paris: Contrejour, 1984. Incl. 46 nude portraits: men. women, children. The most penetrating gaze is that of "Florence," 1978 (cover photo).

————. "Jean-François Bauret." *Camera International* 1 (Nov 1984):32-41. Series of nude portraits.

————. (ed.) *Il Corpo Rivelato.* Florence, Italy: Chiostro Brunelleschiano, 1983.

Bayard, Emile. (French 1868-1937) *Le Nu Esthétique.* Paris: E. Bernard, 1902.

————. *L'Academie en Plain Air: Étude Artistique Illustrée de Cent Compositions en Colours d"Apres Nature.* Paris: Nouvell Libraire Artistique, 1905.

————. *La Pudeur dans l'Art et la Vie.* Paris: A. Mericant, 1909[?].

Bayles, David P. (US 1952-) Woman's front torso. *Camera* 54 (Sep 1975):7.

————. Woman in heavy shadows reclining fully clothed with one breast hanging out. *Camera* 60 (Sep 1981):16.

————. Rock in shape of giant butt.; supine woman in foreground, 1986. CP:61.

Beauvais, Alain. *Nuits X.* Paris: Éditions Du Parc, 1984. *Charme.*

Beauvais, Robert. (ed.) *Photographies Inconvenantes 1900.* Paris: Balland, 1978.

Beck, Maurice. Two oiled-up women seen from hips up, stand pelvis to pelvis, but lean back, holding hands. [RPSGB collection] *Creative Camera* 230 (Feb 1984):1274.

Becotte, Michael. (US 1945-) Color polaroid of black woman's pregnant frontal torso. *Camera* 53 (Oct 1974):26.

Beeke, Anthon. *Alphabet.* Hilversum, Netherlands: De Jong, 1970. Women models arranged on studio floor into representations of letters in the alphabet. Most interesting shots are the studio out takes of the work in progress.

Bègue, René le. Rear view of standing woman [from *Camera Work* 16 (1906)]. NN:64.

Behm, Hans Wolfgang. *Reigen der Keuschheit.* Egestorf, Ger.: Laurer, 1928. Incl. Lotte Herrlich, M. Weidemann.

Behr, H.A. von. "Adoration." Kneeling black woman, arms raised, right profile. *AAP* 54 (1940):92.

Beinhorn, Volker. (German) Beautiful shot of kneeling woman, sort of on all fours, 1987. BL:193.

Belanger, Marion. (US) "Body/Fragment," 1990 (33x53"). Grouping of panels of body parts. *CENTER Quarterly* 14 No. 2 (1992):6.

Bellas, Bruce Harry. (US 1909-74) *Bruce of Los Angeles.* Berlin: Bruno Gmünder, 1990.

Bellia, Jean-Pierre. (French) Blue tinted backlit shot of reclining woman nestled amid large piece of driftwood on beach. *Photo* No. 291 (Jan./Feb. 1992):50.

Bellmer, Hans. (1902-75) *Hans Bellmer Photographien.* Hannover: Kestner Gesellschaft, 1984. Fuzzy amateurish nudes from the 1930s. Also, mannequins posed in "erotic" ways.

———. Multi-exp. shot of woman stradling bicycle, 1946. RK:69.

Belloc, Auguste. (French) Standing woman seen from back, ca.1854. BL:36.

Bellocq, E.J. (US, 1873-1949) Two images of prostitutes in New Orleans, 1929. CS:51, 52.

———. Storyville prostitute, New Orleans, 1912. LN:14.

———. Szarkowski, John. (ed.) *Storyville Portraits: Photographs from the New Orleans Red-Light District, circa 1912.* New York: Modern Museum of Art, 1970. 33 plates.

Bellone, Roger. *Photographier le Nu.* Paris: Solar, 1980. ["How to" manual]

———. *Le Nu.* Paris: Solar, 1982. ["How to" manual]

Benanteur, Dahmane. (French 1959-) "Promenade Érotique Parisienne." *Photo* 185 (Feb 1983):90-97. Women revealing themselves on the streets of Paris.

———. "Promenade Érotique Parisienne." *Photo* 195 (Dec 1983):46-53. Series of 9 exhibitionist shots of a woman, Raphaelle, at famous sites in Paris; she is quoted extensively in the accompanying text on her impressions of the project.

———. *Erotic Excursion in Paris.* 1988.

———. *Dahmane.* Berlin: Benedikt Taschen, 1990.

Benda, Arthur. (1885-1969) Collaborated w Dora Kallmus. *See entry under* d'Ora, Madame.

Benedict-Jones, Linda. (US 1947-) Woman coming up stairs topless; slightly blurred motion. *Camera* 60 (Sep 1981):34

Benham, Sarah. (US 1941-) Blurred motion standing woman against geometric background; heavy shadows, 1979. Hasselblad, Tri-X. *Camera* 60 (Sep 1981):19.

Bennett, George. (b.1945) *Mannequins.* New York: Knopf, 1977.

Benson, John. (US 1927-) Woman standing on window seat with beagle sitting between her legs; they look toward us. *Camera* 53 (Sep 1974):22.

Benson, Richard. (US, 1943-) "Meriden, Connecticut," 1969. Clothed man & nude woman face us while standing in forest. CS:.

Bentzen, Benno. [Fritz Meisnitzer] *Akt im Lichtbild.* Munich: Wappen-Verlag, 1967.

———. *Der Moderne Akt in Schwarzweiß und Color.* Neumünster, Ger.: Benser, 1968. 50 B&W, and 26 color nudes. ["How to" manual] *See also* Meisnitzer, Fritz.

Béraud, Rémi. *Surfaces Sensibles.* Paris: P. Montel, 1971.

Berekmeri, Steve. (b. 1924) *Nudes in My Camera.* South Brunswick, NJ: A.S. Barnes, 1971.

Berg, André. *Catalogue.* Paris: Pin-up Edition, 1981. Mostly studio shots of Henriette Allais, onetime *Playboy* model (featured in centerfold of March 1980 issue), in fetish costumes, i.e., rubber dresses, black leather and chains.

Bergaud, Jacques. *Close-Up.*

———. Color, soaped up woman's butt. *Photo* 205 (Oct 1984):cover.

Berghash, Mark. (US 1935-) "Double," 1987. Ektacolor print. SEM:184.

———. "Magic Square," 1987. Ektacolor print. SEM:185.

Bergon, Paul. *Art Photographie le Nu & le Drape en Plain Air.*. Paris: C. Mendel, 1898.

Berko, Ferenc. (Hungarian 1916-) Studio shot, 3/4 woman from shoulders to knees, black background, harsh light emphasizing form. AVK:114.

———. Woman's torso seen behind translucent material, 1950. DP.

———. HK frontal view of woman's torso & thighs, 1951. NN:189.

———. Seven studio shots of women. PL:108-17.

———. 3/4 silhouette of woman. NIP:78.

Berland, Steve. *Posing the Nude.* N.p.: Berland Graphics, 1975.

Berlin, Peter. From "Doppelganger" series, 1980, photo of kneeling man frontal on left, standing man on right. BTM:33.

Bernard, Bruno. *Liebelei mit der Kamera.* Bonn, Ger.: EBH, 1968.

———. Color, supine woman next to log on a beach. NIP:96.

———. *Schönheit war ihr Schicksal: Glanz und Elend des Covergirls.* Munich: Universitas, 1981.

Bernard, Eric. Color, standing woman frontal, in blue bathroom. *Photo* 184 (Jan 1983):74.

Bernard, José. *Das Evangelium des Leibes.* Leipzig, Ger.: Parthenon, 1927. 48 nature nudes.

Bernhard, Ruth. (US 1905-) "Classic Torso," 1952. Actually, a frontal studio shot of a kneeling woman, w left knee against her chest, right elbow resting upon it. NN:139; *Photography in New York* 5 (Jan/Feb 1993):n.p.

———. "In the Box," 1962. Woman wearing headband reclining in cardboard box on floor. DP.

———. "Two Forms," 1963. Torsos of white woman & black woman embracing. AVK:117.

———. Six woman nudes. PL:128-37.

———. *Ruth Bernhard: The Eternal Body. A Collection of Fifty Nudes.* Carmel, CA: Photography West Graphics, 1986. 50 masterly photos, taken 1934-76; list of plates & frontispiece. Though dedicated to Edward Weston it is not "straight photography". Slight diffusion & studio lighting are obvious throughout. Form is the motive, and her work has a classic look. She sought to illuminate the spirit of the body and to "indicate ideal proportion".

Bernheimer, F. *Weibeskultur.* Leipzig, Ger.: Parthenon, 1928. Incl. Fiedler; Kernspecht; Lotte and Rolf Herrlich.

Bernstein, Gary. *Burning Cold.* New York: Harmony Books, 1978.

Bernstil, Christiane. *Ich fing an, mich zu fragen ...* Hamburg, Ger.: 1981.

Berstein, Shalmon. Pregnant woman supine on hammock. NIP:140.

Berquet, Gilles. *Les Limbes de L'Ange.* Paris: Éditions Rares, 1989.

Berrebi, Alain. Supine woman on sand dune. *Photo* 184 (Jan 1983):62

Berrebi, Sonia. Woman standing in forest. *Photo* 184 (Jan 1983):63.

Bertrand. [pseud.] Left profile of standing woman in dance pose; HK print. HS.

Berwin, Derek and Barber, David (b.1951). *Creative Techniques in Underwater Photography.* London: B.T. Batsford, 1982. Some nudes.

Bettini, Richard [Riccardo]. Muscular man tugging at rope. BB:68.

———. Muscular man shoveling. BB:69.

———. Seated woman's torso. BB:73.

————. Three works in HS: woman's torso seated; seated man; woman prone, LK b.g.

Bez, Frank. *Frank Bez Photographs Face and Figure*. Louisville, KY: Whitestone, 1964.

————. *ABC Photos*. Concept by Stephanie LeVanda. n.p., 1967. 26 plates.

————. *The Nude Indoors*. N.p., 1974. 40 color slides, 1 audio tape.

————. *The Nude Outdoors*. N.p., 1974. 40 color slides, 1 audio tape.

Biancani, Laurent. *Le Nu*. Paris: Éditions V.M., 1978.

————. *Nude Photography the French Way*. New York: APBPC, 1980.

————. *Miroir de Femme*. Paris: V.M., 1984. *Photographie de charme*.

Bianchi, Tom. Man falling head first into pool, 1988. *Photography in New York* 2 (May/Jun 1990).

————. *Out of the Studio*. New York: St. Martin's Press, 1991. Male nudes.

Biehn, Betty. *The Model*. New York: Ridge Press, 1958. The author, a favorite nude model, as portrayed by several leading photographers.

Bijeard, Patrice. Mirror b.g. & supine woman on bed. *Photo* 184 (Jan 1983):63.

Bilek, Miroslav. High contrast shot of woman's torso against tree trunk. NIP:248.

Binde, Gunar. (Latvian 1933-) Woman seated on flooor, left arm resting on ornate [cast iron?] chair; strong contrast between light & shadow, 1982. CP:85.

Binder, Alex. (German) Woman standing back to wall, w intricate window lattice casting a pattern upon her face & torso, ca.1935. USII:113.

————. Supine woman on towel, propped up on her elbows, ca.1935. USII:114.

Bird, Walter. Supine blond woman on furry b.g., ca.1930s. NN:122.

————. *Beauty's Daughters: Studies of the Female Form*. New York: Long, 1940.

————. *More Eves without Leaves*. New York: Atlas, 1941.

————. *Curves and Colour*. New York: Atlas, 1943.

Birke, Roland. *Feuer & Flamme*. Kehl, Ger.: Swan, 1981.

Birkett, J.G. Standing woman frontal, like a classical statue of Zeus holding thunderbolts. HS.

————. Woman in dynamic pose w outstretched arms facing camera. HS.

Bisang, Bruno. (Swiss 1952-) "Bruno Bisang." *Photo* 289 (Nov 1991):56. 5 woman nudes.

Bisch, Stéphane. Color, woman straddling white outdoor chair. *Photo* 257 (Feb 1989):80.

Blake, Rebecca. *Forbidden Dreams*.

————. Color; reclining woman with black pumps. *ASMP Book 3: Professional Photography Annual*. New York: Annuals Publishing Co., 1984. p. 4.

Blakey, Roy. *He*. New York: Blaze Interprises, 1972.

Blanch, Andrea. *Vogue* [English] (Aug. 1992).

Blanchard, Stan. "Mother and Children." Woman in rocking chair w infant and toddler. BWC:6.

Bloch, Alice. *Harmonische Schulung des Frauenkörpers*. Stuttgart, Ger.: Dieck, 1926.

Blok, Diana (Dutch 1952-) and Broekmans, Marlo (Dutch 1953-) *Invisible Forces*. Amsterdam: Uitgeverig Bert Bakker, 1983. The most wonderful lesbian nudes: creative and emotional.

————. Two images later published in their book. *Camera* 60 (Sep 1981):24-25.

————. Two women on studio backdrop. S.

————. Series of 9 photos from *Invisible Forces*. NEW:146-55.

————. "Pietà in Black & White," 1983. White woman/black woman in pietà-like pose. DP.

————. Polaroid of standing woman frontal w string wrapped around her; seems to be from same series as *Invisible Forces*. SII.

Blok, Rimmy. (Dutch) Color, woman straddling racing bicycle on what appears to be a putting green. *Photo* No. 298 (Jan./Feb. 1993): 56.

Blom, Geneviève. (Belgian) Color, supine woman near pool. *Photo* 184 (Jan 1983):76.

Blue, Patt. "Mortimer," 1975. Man's frontal torso in tall grass of field. DH:58.

Blumenfeld, Erwin. (US 1897-1969) "Nu sous le voile moullié," 1938. LN:26.

———. Woman's frontal torso against mirror, 1938. AVK:99.

———. Rare solarized negative print of seated woman rear view, 1938. One does not see too many of this type of print. *Photography in New York* 4 (May/Jun 1992):n.p.

———. "Elongated Nude," ca.1940s. Color, seated woman, optically distorted *à la* Kertész. NN:170.

———. *Blumenfeld: My One Hundred Best Photos.* [Bern, 1979] New York: Rizzoli, 1981. Incl. best photo-reproductions of his nudes: "Nude," 1938, solarization effect on woman's head & torso (46); "Bosom," 1937, silhouette of right profile of woman's torso (52); "Nude," 1937, solarization effect on woman's torso (56); "Nude à la Seurat," 1947, HK setting w kneeling woman on left, standing woman on right (64); "Nude," 1943, left profile of woman's torso, HK b.g., shadow pattern projected onto her skin (66); "Nude," 1954, HK print of woman's butt. & thighs (81); "Nude," 1943, studio shot of kneeling woman, rear view, overhead light (86); "Breast," 1938 (94); "Carmen, the Model for Rodin's *The Kiss*," 1937, old woman seated in studio, w sagging skin & poignant gaze (101); "Nude," 1937, slightly out-of-focus woman's breasts w dramatic lighting (103); "Nude," 1936, woman's torso, rear view, against black b.g. (108); "Study," 1945, multi-exp. of woman's torso in HK setting (109); "Nude in Mirror," 1938, woman's torso framed in unknown fabric placed against mirror, giving a double image (114); "Nude," 1954, unique lighting of woman standing against black b.g. (120); "Nude," 1954, outline of standing woman in HK setting (121); "Nude under Wet Silk," 1938, woman's torso frontal under wet silk (133).

———. *Erwin Blumenfeld.* Paris: Contrejour, 1984.

Bock, Ulrike and Waldschmidt, Arno. *Das Mädchen und der Knopf.* Hamburg, Ger.: Merlin, 1969.

Bodart, Pierre. (French) Color, reclining woman with open legs lies on rocky, railed ledge. *Photo* 291 (Jan./Feb. 1992):50.

Bogdanowa, Irina Arsenjewna. (ed.) *Gekleidet in Licht und Schatten: Russische Aktphotographie, 1970-1990.* Weingarten, Ger.: Weingarten, 1991.

Boháč, Vilém. (b.1920) Abstract nude, sex unknown. AA:106.

———. Multi-exp. abstract image of woman. AA:88-89.

Bohnhoff, Andreas. (German) Woman seated in director's chair, 1987. BL:184.

Boiffard, Jacques-André. (French 1902-61) Supine woman on bed, head hanging over the edge, her face toward us, the body receding out of focus, 1930. RK:62.

———. Naville, Pierre. "Jacques-André Boiffard." In *Atelier Man Ray, 1920-1935.* Paris, 1982.

Boisseau, Laure. Color, seated woman on motor-scooter. *Photo* 184 (Jan 1983):66.

Bokelberg, Werner. "Pinup," 1977. Studio shot, standing woman in black hose & heels rear view, her butt. displayed to maximum erotic advantage. KS:41.

Bondarowicz, Marv. *Snap Shots.* N.p.: Printed Matter, Inc., 1976.

Bonetti, Luca. (Swiss 1947-) Standing woman seen from hips up, next to a window. Nikon FTN, 35mm, HP4. *Camera* 50 (Sep 1971):23.

Bonicatti, Alan. *Vulcano.* New York: Amethyst Press, 1991.

Bonneau, Stéphane. (French) Under-the-counter perspective of woman's torso with scarf and high-cut briefs. *Photo* 291 (Jan./Feb. 1992):57.

Bonnenblust, P.A. Color, woman prone under umbrella on beach. *Photo* 232 (Jan 1987):69.

Boon, Louis Paul. *Blauwbaardje in de Ruimte.* Amsterdam: Paris-Manteau, 1973. Theatrical female nudes as illustrations for literary work in Dutch. Mostly barebreasted woman w dagger & cape.

Booth, Pat. *Self Portrait.* London: Quartet Books, 1983. The former fashion model (now artist/novelist) presents herself in several nudes which she describes as erotic, inspired by the work of Man Ray, Bill Brandt, and Horst.

Bordes, Patrick. "Patrick Bordes." *Photo* 214 (Jul 1985):44, cover. Color, supine woman on yellow raft (cover); Color, one full figure woman nude.

Borissov, Sergei. (Russian) "Sergei Borissov." *Photo* 262 (Jul 1989):98. Color, standing woman frontal, w red hammer & sickle painted on her chest. (99)

Borrebach, Hans. *Figuurfotografie.* Amsterdam: L.J. Veen, 1969. ["How to" manual] Incl. 58 glamour nudes & semi-nudes.

―――. *Sex in de Fototgrafie.* Amsterdam: L.J. Veen, 1969. ["How to" manual] Glamour the Dutch way.

Borremans, Guy. (Canadian 1936-) Woman standing on ledge of rocky outcropping above foaming surf. Nikon F, 21mm, Tri-X developed in Acufine, which indicates push processing. *Camera* 51 (Sep 1972):35.

Borrero, Elsa. "Waters Go to the Sea...Greens V," 1991. Double exp. Cibachrome color print of standing woman frontal seen from waist up, showering[?]. *Puchong Folios* (New York) 1 (Spring 1991):27.

Botti, Giancarlo. Unremarkable, glamour view of standing woman on beach. N.

Bottius, Emmanuel. Woman doing backwards handstand on seamless. *Photo* 257 (Feb 1989):88.

Boubat, Édouard. (French 1925-) "Le grain de beauté, 1950 Paris." Rear view of woman seated on small bed in dark corner of room. JL:11.

―――. "Étude, 1980." 3/4 frontal of young woman removing a T-shirt. JL:12.

―――. "Nu renversé, 1980." Supine woman on carpeted floor, viewed from above, with cat at right. JL:13.

―――. "Mexique," 1980. Young [Mexican?] female reclining on bed, partly covered with rumpled sheet. SEM:37.

―――. "Hommage à Rousseau: Jardin des Plantes, Paris," 1980. After famous jungle scene, but this model's back is turned to us. The painting is better. CP:108.

Boucher, Pierre. (b.1908) "Nude at St. Tropez," 1933. Glorious woman's torso w ocean b.g.; a strong antecedent to the type of nudes Lucien Clergue would create forty years later. NN:109.

―――. Montage of headless woman standing in desert, 1936. AVK:85.

―――. Montage of headless woman on the steps of the Telouet Kabash, Morocco, 1937. NN:109.

―――. "Superimposition," 1938. Woman seen from waist to knees, landscape b.g. NN:109.

―――. Delightful print of woman's butt., thighs, & lower back, overlaid with swirling graphic pattern. BB:70.

―――. *Boucher, Photo Graphiste.* Paris: Contrejour, 1988.

Boughton, Alice. Platinum print of supine woman on cot, 1906. *Photography in New York* 1 (May/Jun 1989):24.

Bourboulon, Jacques. *Mädchen Natürlich*. Kehl, Ger.: Swan, 1980. *Charme*.

———. *Coquines*. Paris: Contrejour, 1982. *Charme*.

———. *Attitudes*. Paris: Carre, 1984. *Charme*.

———. *Il Tait une Fois*. Paris: Éditions Rares, 1990. *Charme*.

Bourdin, Guy. (French 1933-) Color, 2 women on mattress; one on left is nude, w heavy makeup & red lipstick on nipples, *Vogue* [German](Apr 1979). AVK:149.

———. Color image of female belly visible through a part in tall grassy area. SEM:96.

Bourdin, Serge. *Le Compte de mes 1001 Nus*. Paris: self published, 1969.

Bourgeois, Jean-Pierre. *Les Secrets de la Photo de Charme*. Paris: Book Stop Editions, 1984. Unpaged, color. French equivalent to glamour nudes. Tropical beaches and beautiful young women with seamless tans. He favored a Nikon F2, 28, 55, 85, and 105mm lenses, Kodachrome 25 or 64 ASA, polarization filter, & 81A filter.

———. *Starlettes de Charme*. Paris: Love Me Tender, 1984.

Bourgeois, Jean-Pierre and Drieux, Christine. *Les Secrets de la Photo de Charme*. Paris: Love Me Tender Editions, 1981.

Bourgeron, Jean-Pierre. (ed.) *Nude 1900*. Dobbs Ferry, NY: Morgan & Morgan, 1980.

Bouvier, Patrice. (French 1953-) "Nu cru," 1987. Female reclining on her back upon tilted board, causing a diagonal line from lower lft to upper rt. Mons venus is prominent and near center. SEM:87.

Bovi, M. *Malerische Kinder-Akte*. Stuttgart, Ger.: J. Hoffman, 1896.

Bovis, Marcel. *Nus d'Autrefois: 1850-1900*. New York: G. Wittenborn, 1953.

Bowdoin, Daniel. (US) "An American Angle." *Creative Camera* 307 (Dec/Jan 1991):33-35. Comment on censorship; incl. his "Teresa in White No. 36," n.d., frontal standing woman (¾) wearing headscarf and open bathrobe, nipples and mons painted white.

Boys, Michael. *The Book of Nude Photography*. New York: Knopf, 1981.

Brandt, Bill. (UK 1904-83) "Nude in a Room," 1961. IPM.

———. *Perspective of Nudes*. New York: Amphoto, 1961. Not a word by Brandt, but simply 90 plates of nudes in two basic categories: seated women, and body fragments. Most are high contrast prints. The possibilities of limited equipment are strikingly evident in this collection. His ancient Kodak police camera featured a wide angle lens & generous depth of field.

———. Nine photos of women from *Perspective*. PL:176-89.

———. *Shadow of Light*. New York: Da Capo Press, 1977. Ch. 7 incl. nudes from 1940s—50s.

———. *Nudes, 1945-80: Photographs*. Boston: New York Graphic Society, 1980. 100 plates of women nudes, arranged in six sections: 1) Victorian interiors, 2) more interiors, 3) fragment views outdoors [what are we looking at?], 4) high contrast women's body parts, 5) high contrast images of women in apartment, 6) woman on pebble-strewn beach, normal contrast. Many of these images were first published in his *Perspective*.

———. "Nude," 1953. Wide angle fairly high contrast reclining woman (back to camera) on pebbled beach. LN:39.

———. *Bill Brandt*. Ser.: I Grandi Fotografi; anno 1, n. 12. Milan, Italy: Gruppo Editoriale, Fabbri, 1982.

———. Eleven woman nudes previously published. NEW:103-13.

———. *Bill Brandt.* Ser.: Les Grands Maîtres de la Photo, 11. Paris: Union des Éditions Modernes, 1984.

Braquehais, Bruno. "Nude," ca.1856. Smiling supine woman on divan. CS:12.

———. "Nu voilé," 1854. Woman reclining on divan under sheer material. LN:9.

———. Salt print of standing woman, rear view, 1854. USI:126.

———. Salt print of standing woman, rear view, left foot on divan, 1854. USI:127.

Brassaï. [Gyula Halá] (French 1894-84) Scenes from brothels, technically qualify as nudes, in *The Secret Paris of the 30's.* New York: Pantheon, 1976. Adapt. from *Paris de Nuit,* 1933.

———. "Une Fille de Joie," 1932. CS.

———. Torso of supine woman [orig. pub. *Minotaure*], 1933. RK:56.

Brauns, Walther. *Den Freien die Welt!* Egestorg, Ger.: Laurer, 1926. 101 nature nudes.

Braus, Gunter; Scheid, Uwe; Wick, Rainer (eds.) *BilderLust: Erotische Photographien Aus Der Sammlung Uwe Scheid.* Heidelberg: Edition Braus, 1991. Well produced, but too many 19th C works. Incl. Joe Gantz, Guglielmo Marconi, Eugène Durieu, Auguste Belloc, Louis Camille d'Olivier, Wilhelm von Gloeden, Vincenzo Galdi, Guglielmo Plüschow, Frank Eugene, H. Matthiesen, Jószef Pécsi, Othmar Streichert, Madame d'Ora, E.J. Bellocq, Rudolph Koppitz, Hermann Schieberth, Gerhard Riebicke, Helmi Hurt, J. Bayer, Heinz von Perckhammer, Dorothy Wilding, Manassé, Walery (France), František Drtikol, Edward Steichen, Angelo (France), Trude Fleischmann, Olga Wlassics, Man Ray, Karel Ludwig, Roye (UK), Franz Roh, Gertrude Fehr, Heinz Hajek-Halke, Weegee, Horst P. Horst, Lucien Clergue, Fritz Henle, Jean Dieuzaide, George Krause, Nelson Bakerman, František Maršálek, Jan Saudek, Curt Stenvert, Herbert Döring, Karin Székessy, Martin Schreiber, Erwin Olaf Springveld, Joel Peter-Witkin, Toto Frima, Les Krims, Serge Nazarieff, Taishi Hirokawa, Christian Vogt, Martin Pudenz, Günter Zint, H.W. Hesselmann, Thomas Karsten, Manfred-Michael Sackmann, Volker Corell, Hermann Försterling, Marlo Broekmans, Pierre Molinier, Wolfgang Pietrzok, Lieve Prins, Virgilius Šonta, Thomas Lüttge, Frédéric Barzilay, Michael Fehlauer, Andreas Bohnhoff, Pavel Šešulka, Erasmus Schröter, Sandra Russell Clark, Collette (USA), David Hamilton, Volker Beinhorn, Evelyn Krull, Sven Marquardt, Klaus Mitteldorf, Patrick Bailly-Maître-Grand, Robert Shlaer.

Brecher, Paul. [Walter Menzl] *Die Liebenden: Eine Photograph.* Kreuzlingen, Ger.: Erophi-Verlag, 1965.

Brehm, Heribert. (b.1955) Color, series of 5 multi-exp. images of woman & superimposed beams of light. NEW:55-57, 60-61.

Brenert, Michel. (Belgian) Woman kneeling in rocky cove. *Photo* 268 (Jan 1990):120.

Breuer-Courth, Carl. *Enthüllte Schönheit.* Stuttgart, Ger.: Schöbelverlag [ca.1940].

Brieger, Lothar. *Das Frauengesicht der Gegenwart.* Stuttgart, Ger.: Enke, 1930.

Bridges, John C. *Pictorial Figure Photography.* Boston: A.P.P., 1950.

Brigidi, Stephen. (US 1951-) Two women in bathtub. Hasselblad, Tri-X Pro. *Camera* 60 (Sep 1981):18.

Brigman, Anne W. (US 1869-1950) "The Cleft of the Rock," 1907. Diffuse shot of woman standing in cleft of large rock formation. [from *Camera Work* 38 (1912)] NN:68.

———. "Dawn." Probably a self portrait (according to J. Lewinski); reclining woman on rocky ledge, overlooking mountain b.g. [from *Camera Work* 38 (1912)] NN:70.

———. Woman reaching for the sky, pictorial style. NIP:46.

Brinkerhoff, Val. M. *The Reflecting Nude.* N.p., 1988.

Broekmans, Marlo. (Dutch 1953-) "Dualité," 1986. Woman's butt. on fragment of statue, reflected in mirror on floor. KS:67.

———. *Marlo Broekmans.* Text by Regis Durand. Amsterdam: Focus, 1989.

Brones, Lee. *Pro Techniques of Artistic Figure Photography: Success through Simplicity.* Los Angeles: HP Books, 1990. ["How to" manual]

Brook, John. "Moon in Leo," 1967. Man & woman on bed embracing. BWC:21.

Brooks, David. (b.1933) *Glamour Photography.* Los Angeles: Petersen Pub. Co., 1974. ["How to" manual]

Broome, L.E. *Posing Patterns for Creative Photography.* New York: Hastings House, 1958.

Brown, Barry. (US 1935-) Woman with back to us, standing in large window posing in an X composition. Sinar 4x5, 90mm, FP4. *Camera* 50 (Sep 1971):22.

Brown, Manning P. HK shot of kneeling woman, profile right, forehead touching knees. BB:3.

———. Seated woman in HK setting. BB:32.

Brown, Tim. *Shaken & Stirred.* New York: Putnam Pub. Group, 1984.

———. *Only Two Can Play.* Limpsfield: A Dragon's World, 1985. Color, 36 shots of beautiful women executed in the highest commercial studio quality. But that is the problem: they look like a slick ad campaign. Text by John Welz is intended to be humorous look at the game of heterosexual love & sex, from a man's perspective.

Bruguière, Francis. (US 1880-1945) "Daphne," 1915. IPM.

———. "Solarization," 1925. Series of 3 solarized prints; supine women & men. CS:82, 83, 84.

———. Enyeart, James. *Bruguière.* New York: Knopf, 1977. Incl. "Vanity," 1915, seated woman w peacock (11); "Juno," 1915, diffuse image of seated woman w peacock (11); "Juniper," 1915, pictorialist print of standing woman bending down towards small vase on floor (12); "Daphne," 1915, diffuse profile of reclining woman (13); "Experiment," ca.1926, multi-exp. image of woman's torso (28, 29); "Rosalinde Fuller and other Models," ca.1936-40, series of four prints, three of them solarized, featuring complex entwining of women's torsos (94-98). Enyeart thought that unlike Man Ray's solarizations, which were limited to line reversal, Bruguière's were more abstract.

Bruno of Hollywood. [Anthony Bruno] (US 1894-1976) *Figure Photography: Lighting and Composition.* New York: Photo Guild Publications, [1940?].

———. *Art Photography, Figure Lighting, and Composition.* London: Thorsons, 1948.

Bryant, Elizabeth R. *A Room with a View: Photographic Compositions Using the Male Nude.* N.p., 1980.

Buckland, David. (UK 1949-) "Sphinx," 1978. Siobhan Davies in extended/exaggerated crawl on studio floor. WE:199.

———. Triptych of "Siobhan Davies," 1986. Woman in dynamic poses: beautiful work. SEM:186-87.

———. "Muss Es Sein/Es Muss Sein," 1988. Terner-like diptych of 4 men. BTM:3.

Bugat, Jacques. "Jacques Bugat." *Photo* 229 (Oct 1986):90. Six shots of clothed man & nude woman embracing in field.

Bückmann, Karl. *Von der Sünde gegen die Natur.* Berlin: Verl. Dt. Leibeszucht, 1940.

Bull, Charles Sinclair. "Starlet," 1930. Blond woman standing profile to camera against black background, chain around waist, propped up against gigantic scimitar. AVK:112.

Bullock, Edna. (Wife of Wynn) "David at Bottom of Dune," 1984. Supine man on sand dune. NN:211.

Bullock, Wynn. (US 1902-76) "Nude," ca. 1940s. Woman reclining with arm behind head, visible from head to butt.; solarized. *Camera* 51 (Jan 1972):25.

———. "Woman + Thistle," ca. 1950s. Woman crouches in window of derelict woodframe house. *Camera* 51 (Jan 1972):26.

———. *Wynn Bullock.* New York: Aperture, 1976. Incl. "Nude in Cobweb Window," 1958, woman's torso behind dirty window (37); "Nude by Sandy's Window," 1956, woman supine on window seat (39); "Nude in Dead Forest," 1954, supine woman in forest clearing (43); "Navigation without Numbers," 1957, woman w infant on black bedspread[?] (81); Barbara," 1956, woman's back framed by barn window (83); "Woman + Thistle," 1953 (87).

———. *Retrospective.* Rochester, NY: Light Impressions, 1979[?]. 30 slides.

———. Bullock, Edna. (ed.) *Wynn Bullock Photographing the Nude.* Salt Lake City, UT: Peregrine Smith Books, 1984. Mostly from the 1950s.

Burghardt, Wilm. *Körperausdruck und Kunst.* Dresden, Ger.: Verlag Schönheit, 1939.

———. *Körperbildung und Harmonie.* Dresden: Verlag Schönheit, 1939.

———. *Lebenswille und Lebensführung.* Dresden: Verlag Schönheit, 1940.

———. *Lob des Schönen Menschen.* Dresden: Verlag Schönheit, 1940.

———. *Der Schöne Mensch in der Natur.* Dresden: Verlag Schönheit, 1940.

———. *Sieg der Körperfeude.* Dresden: Verlag Schönheit, 1940.

———. *Ein Sonnenland. Ein Kinderland. Bilder Helmut Hollmann.* Dresden: Verlag Schönheit, 1940.

Burkhardt, Hellmut. *Aktfotografie.* Halle, Ger.: Fotokinoverlag, 1958. ["How to" manual]

———. *Aktstudien.* Halle, Ger.: Fotokinoverlag, 1965. 89 photos.

Bürkle, Rolf. *200 Aktfototips.* Munich: Laterna Magica, 1980. ["How to" manual]

Burnet, Alison. (US) "Cityscape," 1992 (22x30"). Close up of crouching nude, sex unknown. *CENTER Quarterly* 14 No. 2 (1992):6.

Burns, Marsha. (US 1945-) Seated woman, arms behind back, thighs and tummy vissible. Linhoff 4x5, FP4, summer afternoon daylight. *Camera* 60 (Sep 1981):5

———. Woman standing nude, 1978. *Photography Year 1982.* Alexandria, VA: Time Life Books, 1982. p. 228.

———. Featherstone, David. *Postures: The Studio Photographs of Marsha Burns.* Carmel, CA: Friends of Photography, 1982.

———. "Kevin, Seattle," 1985, in P. Weiermair, *Frauen...,* (36). Male nude.

———. "Reddition," 1987. Two works: one woman, one man. Strong sidelight in studio seems typical of Burns. SEM:40, 41.

Burns, Michael. (US 1942-) Nude girl in heavy shadows visible from chest to feet, reclining on sofa. Linhoff 4x5, Tri-X. *Camera* 60 (Sep 1981):20.

Busselle, Michael. *The Complete Book of Nude and Glamour Photography.* New York: Simon & Schuster, 1981. ["How to" manual]

———. *Beyond Glamour: A Guide to Nude Photography.* New York: Sterling, 1987.

Buten, Howard. *Gymnopédie.* Paris: Éditions Imagine, 1984. Boys.

Butyrin, Vitaly. (Lithuanian 1947-) "Seaside Cottage," 1983. Photo-montage of seashore, birds, & women. CP:144.

Calavas, A. (French) Sequence of 16 shots of male nude in studio. ca.1900. BL:64

Calba, Henry. *Nu et Photographisme*. Paris: Photograpie Nouvelle, 1969.

Calderon, Hervé. (Mexican) Woman seated in wall niche, arms raised. *Photo* 257 (Feb 1989):87.

Calisti, Claudio and Hyvonen, Tuula. *Venus Liberty*. Legnano, Italy, 1978.

Calle, Sophie. *La Fille du Docteur*. N.p., 1991. 250 edn. book. Something about a bourgeois daughter turned into a stripper.

Calletti, Fabrice. Color, supine woman on rock. *Photo* 280 (Jan 1991):52.

Callahan, Harry. (US 1912-) Three shots of his wife, Eleanor. PL:86-97.

———. *Eleanor*. New York: Calloway, 1984. Incl. 16 nudes of his wife.

Callens, Henri. Color, woman's butt. f.g., Roman aqueduct b.g. *Photo* 232 (Jan 1987):71.

Campbell, Carolee. Man prone on bed, woman's torso in mirror. YK:73.

Campbell, Heyworth. (b. 1866) (ed.) *The Body Beautiful*. New York: Dodge Pub. Co., 1935.

———. (ed.) *The Body Beautiful*. Vol.II New York: Dodge, 1936. He thought there may be only a slight difference between beauty and ugliness, or they may be poles apart. "A healthy, wholesome mind will sense only the ennobling power of the beautiful." Incl. N. Thorp Humphreys, Werner W. Greeven, Manning P. Brown, Lee & Burger, Remie Lohse, Tliford McSherry, Windmann Studios, Renato Toppo, Edward E. Adams, Lionel Heymann, Forman Hanna, Atelier von Behr, Rudolf Hoffman, Joseph Dorin, Pix Publishing, Wynn Richards, Howard S. Redell, Globe Photos, Don Wallace, Grace Lamb, John S. Nichols, Tracy Webb, Thomas O. Sheckell, Andre Roosevelt, Richard Bettini, Pierre Boucher, W. Strosahl, Pincus Rice, Alenxander Alland, Dayton Snyder.

———. *Art and Photography of the Body Beautiful: A Collection of Prize Photographs*. New York: Wiley Book Co., 1950.

Capor, H.H. *Akte*. Vienna: Paperpress, 1984.

Caprio, Joseph. *Men, Men*. Lausanne: Favre, 1986.

Caraso, Maxime. Unique shot of standing woman on rock ledge, seen from below, sky b.g.; she holds an Indian blanket. *Photo* 257 (Feb 1989):83

Cardish, Daniel. (Canadian) 3/4 supine (large breasted) woman on the sand; infrared. *Photo* 298 (Jan./Feb. 1993): 51.

Cardot, Heinz. [Ludwig Friedrich] *Das Neue Deutsche Aktwerk*. Hamburg, Ger.: Danehl, 1965.

Carlquist, Sherwin John. (b. 1930) *Natural Man: Photographs*. Claremont, CA: Pinecone Press, 1991.

Carner, Bill. (US 1947-) Photo of his wife, 3/4, blurred motion up and down, in their apartment, 1971. Leica M2, 28mm, Tri-X. *Camera* 51 (Sep 1972):36.

Carpet, Edouard. (Belgian) Man supine in wheelbarrow on filed. *Photo* 184 (Jan 1983):63.

———. Supine woman on parquet floor. *Photo* 257 (Feb 1989):83.

———. Standing woman frontal atop fireplace mantel. *Photo* 268 (Jan 1990):120.

———. Left profile of standing woman bending over at sink. *Photo* 280 (Jan 1991):54.

Carroll, Lewis. [Charles Lutwidge Dodgson] (English 1832-98) Cohen, M.N. (ed.) *Lewis Carroll's Photographs of Nude Children*. Philadelphia: Rosenbach Foundation, 1978.

———. Cohen, M.N. (ed.) *Lewis Carroll, Photographer of Children: Four Nude Studies*. New York: Crown Publishers, 1979.

———. Aspin, R. "Lewis Carroll." *British Journal of Photography* 6259 (1980):656. On his fascination w nude girls, 1856-80, and of scandal over his work.

Carson, Ganahl. "Supplication." Kneeling woman w hands on head in repulsive act of obeisance. Not an unusual choice of subject for pictorialists. *AAP* 48 (1934):121.

Carter, William. (b. 1934) *Eighteen Nudes*. Seattle, WA: Silver Image Gallery, 1987.

Cartier-Bresson, Henri. (French, 1908) "Couple," 1933. Rear view of man in pool of water with woman whose legs are wrapped around his waist. JL:15.

———. "Nu dans l'eau," 1933. Woman with shaved mons supine in pool. JL:17; LN:32; CS:56.

Casanova, Patrice [male] (French 1945-) and Guetary, Helene (French 1957-). *Skin Deep*. Los Angeles: Melrose Publishing, 1984. Several semi-nudes, dancers painted and choreographed by Guetary; photographed by Casanova.

Casoy, Jairo. (Brazilian) Color, seated woman on studio posing block, brown tinted image; excellent lighting. *Photo* No. 298 (Jan./Feb. 1993): 59.

Cass, Eli. *Wall Street Guide to Stacks and Blondes*. New York: Kanrom, 1962.

Castro, Rick. *Castro*. N.p.: Tom of Finland, 1991.

Cataldo, Didier. (Swiss) Supine woman's torso w window lattice shadows. *Photo* 280 (Jan 1991):64.

Catany, Toni. (Spanish 1942-) Male feet and torsos, with brown tint and high contrast, 1987. SEM:72-75.

Celati, Gianni (b.1937), and Gajani, Carlo. *Il Chiodo in Testa*. Pollenza, Italy, 1975. Erotic nudes.

Cerati, Carla. "Studio di Nudo," 1974. Woman seated in dark chair, her knee in foreground, her torso in background. DP.

———. *Forma di Donna*. Milan, Italy: Mazzotta, 1978.

Chalmet, Etienne. Woman's torso frontal, behind half-open car window. *Photo* 268 (Jan 1990):118.

Chambard, Jean-Pierre. (French) Color, standing woman frontal, placed in neo-classical garden architecture. *Photo* 207 (Dec 1984):86.

———. Color; buns, hips, thigh, reclining against blue sea b.g. *Photo* 298 (Jan./Feb. 1993): 56.

Chamberlain, David. *Classic and Contemporary Nude Photography*. London: Blandford, 1989.

Chaplain, Daniel. *Sexissimo*. Paris: A. Balland, 1970.

Chapman, David. (ed.) *Adonis: The Male Pin-up, 1870-1940*. London: Gay Men's Press, 1989.

Chapou, Jean. Color, one woman's breast over another woman's mons venus. *Photo* 184 (Jan 1983):66.

Chappell, Walter. (US 1925-) *Human Form*. Chicago: Pyramid Editions, 1985. Book of 12 collotypes.

———. "Father and Son, Wingdale, New York," 1962. Man w erect penis holding infant. CS:101. (child pornography laws would not permit this to be seen today).

Charbonnier, Jean-Philippe. (French 1921-) "Les coulisses des Folies-Bergères," 1960. Young female dancer standing nude backstage, talking with two clothed men. JL:21.

———. "Dans l'atelier de mon père," 1969. Woman in artist's studio partially wrapped in classical "drapery" looks at us. JL:19.

———. "Un nu allemand," 1972. Woman's wet torso in sunlight with sky background. JL:18.

———. *Jean-Philippe Charbonnier: 300 Photographs, 1944-1982*. Paris: Paris Audiovisuel, 1983. Incl. "Sunday in Spring, Paris, 1970," supine woman on floor of apartment, light from window in b.g. casting upon her a bright square pattern (182); "Belyy and Steel, Paris, 1970," supine woman w steel chair (183); "6pm in Summer, Sommières, France,

1974," brilliant print of woman in sun hat reclining on right side, upon an air mattress (192).

Chastin, Jean-Marc. *Cocktail de Reves Erotiques*. Prigueux, France: Éditions le Charme, 1991. *Photographie de charme*.

Chatrow, Dimitri. *Mon Album de Petites Filles*. Paris: Éditions de la Moulette, 1990.

Chesi, Gert. *Femme Nue. Aktfotos*. Schwaz, Ger.: Galerie Eremitage, 1970.

Chimples, Mark. One work from his "Terminal Pastures" series, 1990. Woman kneeling before wall of barren room, back to camera. *Puchong Folios* (New York) 1 (Winter 1991):33.

Chochola, Václav. (Czech 1923-) Two close-up images of seated woman. AA:19, 22.

Chris, C. (French?) Underexposed color, reclining woman, prone, head up, on beach looking out to sea; strong backlight. *Photo* No. 291 (Jan./Feb. 1992):51.

Ciccone, Stan. (US 1926-) 3/4 woman next to ruined window, with vines hanging down in front of her, 1971. Nikon F, 20mm, Tri-X. *Camera* 50 (Sep 1971):6.

————. Two nudes (male?), 1972. Two negs sandwiched. Hasselblad, 50mm, Tri-X. *Camera* 51 (Sep 1972):39.

Claass, Arnaud. (French 1949-) "Laura, Nice," 1984. Young woman lying on bed with drapes blowing over her. SEM:39.

Clark, Sir Kenneth. *The Nude: A Study in Ideal Form*. New York, 1956; 1959. True, there are no photographs in his treatise, but one should be aware of Clark's ideas on the nude in painting & sculpture. This bibliography offers a fair amount of evidence that some photographers have studied the nude and come up w their own interpretations of "ideal form".

Clark, Larry. (US 1943-) *Teenage Lust*. New York: Larry Clark, 1983. Several nudes of teenage delinquents, some of which are sexually explicit.

————. Two photos: 1) teenage lovers kissing in back seat of car; she is on top of him holding his penis, 2) male and female in missionary position, with another erect male standing on left. *Aperture* 93 (Winter 1983):70.

————. "Runaway." Overhead view of supine teenage male as he stares at us. BTM:37.

Clarke, Bob Carlos. *Obsession*. Paris: A. Mosley, 1981.

————. *Dark Summer*. London: Quartet, 1985. Series of erotic & sometimes fetishistic imagery involving fantasy studio settings and beautiful models fitted out in leather, rubber, & high heels.

Claude, Bruno. (French) Color, 3/4 woman with gloves, stockings, and sheer fabric. *Photo* 298 (Jan/Feb 1993):59.

Claxton, William. "Peggy Moffitt: the Topless Swimsuit," 1964. Fashion photo of standing woman in black swimsuit which does not cover her breasts. From *The Rudi Gernreich Book*. New York: Rizzoli, 1991. In *Photography in New York* 4 (Nov/Dec 1991):n.p.

Clement, Michele. Coupland, Ken. "Michele Clement." [The woman and her work] *Communication Arts* 33 (Mar/Apr 1991):70-80.

Clemmer, Jean. *Nues par Jean Clemmer*. Incl. interview of Paco Rabanne with Patrick Rambaud. Paris: P. Belfond, 1969.

————. *Canned Candies: The Exotic Women & Clothes of Paco Rabanne*. London: Skilton, 1969.

Clermont, Nicolas. Color, woman supine on beach. *Photo* 207 (Dec 1984):80.

Clergue, Lucien. (French 1939-) Eluard, Paul. *Corps Mémorable.* Paris, 1957. Incl. 12 fragmentary beach nudes of young woman.

———. Six beach nudes, women models, fragment approach. PL:118-27.

———. "To Mark Time." *Camera* 45 (March 1966):16-29. Several of his seascape nudes created in the Camargue, 1958-64.

———. *Naissance d'Aphrodite.* Text by Fédérico Garcia Lorca. Trans. by Grace Davis. New York: Brussel & Brussel, 1966.

———. *Née de la Vague.* Paris: Belfond, 1968; 1978.

———. *Genèse: 50 Photographies sur des themes d'Ames choisis par Saint-John Perse.* Paris: Belfond, 1973. 50 photos.

———. *She/Sea.* Paris: P. Belfond, 1974.

———. From the series *Nus de la Ville* (1975), woman reclining back on an L joint of a steel pipe. Interesting compositional device. BL:141.

———. Color Polaroid SX-70 self-portrait with male and female models and workshop participants. *Camera* 57 (Sep 1978):11.

———. *Lucien Clergue: Belle des Sables.* Marseilles: Éditions Agep, 1979.

———. "L'ombre sur la plage, 1980 Camargue." Supine woman on tire-tracked beach. JL:23.

———. "Étude dans l'atelier," 1980. Two torsos of reclining women under window, which provides backlighting. JL:25.

———. "Couple dans la Chapelle, 1981 Arles-Montmajour." Two women standing in crucifix pose against stone wall. JL:22.

———. *Nude Workshop.* New York: Viking Press, 1982.

———. *Eve est Noire.* Monza: Selezioni d'Immagini, 1982.

———. *Visions sur le Nu.* Paris: Filipacchi, 1982.

———. *Practical Nude Photography.* New York: Focal Press, 1983.

———. *Lucien Clergue.* Paris: Musee d'Art Moderne de la Ville de Paris, 1984. Photos, 1954-84, including many nudes.

———. *Eros and Thanatos.* New York: New York Graphic Society, 1985. Incl. "Raised Arm at Camargue," 1960: vertical frame of woman's breast & extended arm pointing up (70); "Nude in the Forest," 1976: standing woman under tree, viewed from ground level (98); "Nude in the Forest, Yosemite," 1974: man standing between rock & tree trunk (99); "Caco in the Quarries, Les Baux," 1975: woman on face of quarry wall (100); "Caco in the Large Herbarium, Forêt du Lot," 1975: woman standing behind sheer fabric (102); "Her Wound is Deep, Her Soul is Light," 1983: color polaroid montage of supine woman, beach, & footprints (n.p.); "Nude Among the Stars," 1981: color under exp. shot of prone woman on sea rocks, water background w pinoint light reflections resembling stars (n.p.); Nude at Les Baux," 1978: woman's suping torso (n.p.).

———. *Passion de Femmes: Une Leçon de Photographie.* Paris: Éditions P. Montel, 1985. Extensive discussion by Clergue about how and why he makes nudes. An outstanding overview of his work to date, if you read French. If not, the photos (110 color and B&W) are worth examination. He used Minolta 35mm cameras and technical data indicate his favorite apertrue is f/16: the critical sharpness of the images attest to the small f/stop.

———. Sealfon, Peggy. "Meet the Masters." *Petersen's Photographic* 13 (Jan 1985):14.

Clermont, R.M. (b. 1922) *Nus Antillais.* Paris: Éditions Prisma, 1961; 1965.

———. *Tropical Beauty*. London: Charles Skilton, 1962.

———. Two works in NIP: LK setting, outline of standing woman (114); prone woman in HK studio shot (115).

Close, Chuck. (US 1940-) Johnson, Ken. "Photographs by Chuck Close." *Arts Magazine* 61 (May 1987):20. Essay incl. large scale color Polaroid prints (40x80") assembled into panel installations: "Bertrand II," reclining man; "Mark Diptych II," man's penis; "Laura I," unusually flat-chested woman reclining; "Laura," close-up fragment of the same woman's chest. These stark images were intended to provoke thoughts about the body in culture, but they seem more like billboards than photographs.

Clotaire, Deheul. Color, multi-exp. of woman's torso & colored light streaks. *Photo* 184 (Jan 1983):100.

Cloud, Greg. *L.A. Dreams*. London: Gay Men's Press, 1989. As the intro. says, "Male flesh is the thread that connects his work." 30 color beefcake nudes, some inventively set in outdoors urban settings.

Clovis, Elmont. *The Topless Bathing Suit: An Exhaustive Survey in Words and Photographs*. New York: MacFadden, 1965.

Clyne, Jim. (ed.) *Exquisite Creatures*. New York: Morrow, 1985. Incl. Gilles Larrain, Deborah Turbeville, Robert Mapplethorpe, Roy Volkman.

Cohen, Herbert. *Nacktheit und Sexualität*. Leipzig, Ger.: Parthenon, 1929.

Cohen, Sorel. (Canadian 1936-) Male nudes in HP.

Coigny, Christian. (b.1946) *Hommes*. Lausanne, Switzerland: P.-M. Favre, 1982.

Coleman, Judy. Cameron, Franklin. "Genesis: the Polaroid Transmutations of Artist-Photographer Judy Coleman." *Petersen's Photographic* 16 (Feb 1988):26-30. Originally a journalist, Coleman unites painting and photography; in "Falling Bodies" giant nudes seem to be hurtling through a black void.

Collignon, Martha. Color, woman's mid-section upon yellow inflatable raft. *Photo* 207 (Dec 1984):75.

Collum, Charles R. *Dallas Nude*. New York: APBPC, 1980.

———. *New York Nude: A Photographic Essay*. New York: Amphoto, 1981.

Colmano, Marino. (US 1948-) Color, woman's breast, and shadow on wall. Nikkormat FT, 105mm, Ektachrome. *Camera* 50 (Sep 1971):27.

Colombo, Attilio. Trans. by Lydia Davis. *Fantastic Photographs*. New York: Pantheon Books, 1979; originally published as *La Photographie Fantastique*. Paris: Contrejour, 1979.

Concari, Attilio. *Max* (Jly 1992).

Conde, Linda. *Muheres*. Sao Paulo, Brazil[?]: Art Editoria, 1985.

Connor, Linda S. (US 1944-) "Nude over Landscape," 1969. Woman in fetal pose at base of rocky cliff. BWC:51.

———. Woman supine on bed under mosquito netting, 1976. CS:124.

Cooper, Emmanuel. (ed.) *Fully Exposed: The Male Nude in Photography*. London: Unwin Hyman, 1990.

Coplans, John. (UK 1920-) Studio shots of fat old man with lots of body hair. SEM:118-19.

———. *John Coplans: Autoportraits*. [Ex. cat., Centre de la Vieille Charite, Marsailles, 30 June–3 September 1989] Marsailles, France: Musees de Marsailles, 1989.

———. Weiermair, Peter. (ed.) *John Coplans*. [Ex., cat., Frankfurter Kunstverein, 2 June–8 July 1990] Frankfurt, Ger.: Der Kunstverein, 1990.

Cordon, Paul de. *Girls of the World Famous Crazy Horse Saloon Paris France*. Zurich: Verlagspresse, 1971. Photos by de Cordon: the young women dancers of the *Crazy Horse Saloon*. This book appears to be a promotional piece for the owner, M. Bernardin.

Cordus, Sylvain. (French) Woman's roped torso, high contrast, diffused type print. *Photo* No. 291 (Jan./Feb. 1992):54.

Corell, Volker. (US?) "Russ Meyer and Kitten," 1985. Color shot of large breasted woman on Nautilus machine with Meyer filming her. BL:171.

Cornet, Jeanloup. Color, double exp. of man & woman on bed, overhead shot. *Photo* 184 (Jan 1983):99.

————. Color, woman supine on bed, w circular mirror bisecting her torso. *Photo* 207 (Dec 1984):80.

Cosindas, Marie. (US 1925-) Male nudes in HP.

Costa, Bill. "Altar of Love," 1990. Standing man frontal, on Leopard skin covered divan, in corner of room. *Photography in New York* 3 (Nov/Dec 1990).

————. "They Stripped Him...," 1990. Standing man frontal, leaning back against wall in which steel I-beams form a cross. *Puchong Folios* (New York) 1 (Fall 1990):11.

————. "The Courtesan," 1991. Standing man rear view, against marble wall. *Photography in New York* 4 (Nov/Dec 1991).

————. "Bill Costa." *Puchong Folios* (New York) 2 (Autumn 1991):2, 21-27, 41-44. Incl. "A Man Must Dream a Long Time to Live with Grandeur," 1991, bejeweled man leaning back against marble wall; "Abandoned on My Bed...," 1984, man prone on bed; "Love's Altar," 1990 [see entry above]; "The Aspara," 1990, man in wool socks prone on divan; "When I See Him Lying Naked, I feel Like Saying Mass on His Chest," 1987, supine man on bed under window; "Men with the Tenderest Flesh are Made of Marble," 1985, man's frontal torso against wall, w classical Apollo in f.g.; "To Be Embraced...," 1991, man standing amid ruins of brick building; "The Gardener is the Loveliest Rose in His Garden," 1991, muscular black man stands frontal in abandoned urban lot; "I Am the Sprirt...," 1991, man standing frontal in corner of room; "Boy in the Attic," 1991, man standing in barren room, w doll in chair. Costa prefers to use 35mm cameras & natural light for all of his nudes.(21)

Cotier, James. *Nudes in Budapest*. N.p., 1991. 28 plates.

Cotonnet, André. (French) Woman painted blue standing up holding a picture frame in studio setting. *Photo* No. 298 (Jan./Feb. 1993): 56.

Coudray, Daniel. (French) Color, woman's torso with red flower in crotch. *Photo* No. 291 (Jan./Feb. 1992):49.

Couturas, Philippe. (French) Color, seated woman's torso, wearing one piece high-cut swim-suit with straps pulled down to reveal beautiful breasts. *Photo* No. 291 (Jan./Feb. 1992):52.

————. Color, back torso reclining on side, with red shirt and well tanned hips and butt. *Photo* No. 298 (Jan./Feb. 1993):45.

Cox, Paul. Boy standing near woman's hip. BWC:18.

Cox, Paul. (Dutch 1940-) Woman supine on couch under window, with clothed young woman running towards us from a porch outside, in b.g. left of frame. Nikon, 24mm, Plus-X (ASA 100). *Camera* 50 (Sep 1971):25.

Cozzi, Angelo. (b.1934) *Scoprirsi Donna*. Ivrea, Italy: Priuli & Verlucca, 1977.

———. *Innocence in the Mirror.* New York: Morrow, 1977.

Crane, Barbara. Blurred motion, standing frontal woman framed by man's thigh & arm, 1967. BWC:25.

Cravo Neto, Mario. (Brazil 1947-) "Dóra," 1980. Pregnant hispanic with very large round nipples, sitting down in studio very darkly lit. SEM:47.

———. "Pelourinho 1," 1987. Young man hung by heels in a darkly lit studio. Ugly. SEM:213.

Cremer, Jan. *Theun de Winter: De Billen van Jan Cremer.* Photos by Philip Mechanicus. Amsterdam, 1975. Incl. 10 photos of women's butts.

Crichton, Bob. *Photographing Women.* London: Macdonald, 1984.

Crosbie, John F. Four works in HS: woman w windblown hair & raised arms; seated woman's torso & head, hands behind back; an almost identical shot; standing woman w long hair bending backwards.

Crossett, Edward C. "Straight Lines and Curves." Kneeling woman against large posing block. *AAP* 62 (1948):127.

Cuervo-Arango, José R. (Spanish 1947-) Polaroid of two girls, 1980. *Camera* 60 (Sep 1981):13.

Cunningham, Imogen. (US 1883-1976) "On Mount Rainier," 1915. Series of 5 male nudes [her husband]. *Imogen!* pp. 34-8.

———. "Roy on the Dipsea Trail," 1918. Diffuse rear view of standing man in natural landscape. NN:204.

———. "Bath," 1925. Woman standing in bathtub, seen from back. *Imogen!* (46)

———. "Breast," 1927. Close-up fragment, breast and its shadow. WP:39.

———. "Triangles," 1928. Fragment, statue-like study of breast, arm, and thigh. WP:36.

———. "Nude," 1928. Museum Folkwang, Essen, Ger.. IPM.

———. "Two Sisters," 1928. Close-up of two seated women against wall. CS:44; DP; AVK:90.

———. [Portia Hume], 1930. Supine woman, visible from head to lower chest. WP:41.

———. "Nude," 1932. Kneeling woman, bent at waist, chest to thighs. WP:38

———. "Her and Her Shadow," 1936. Fuzzy image of a woman's breast and its shadow. *Imogen!* p. 47.

———. *Imogen Cunningham: Photographs.* Seattle: University of Washington Press, 1970.

———. *Imogen!* Seattle: University of Washington Press, 1974.

Currin, Tony. (b.1936) *Black Woman.* New York: Camera/Graphic Press, 1978.

Curto, Paulo. "Paulo Curto." *Photo* 226 (Jul 1986):76. Color, one woman nude; one woman semi-nude.

Cuvelier, Paul and Hanne, Jean van. *Epoxy.* Bonn, Ger.: EBH, 1970.

Dablow, Dean. (US 1946-) Woman against tree, seen from waist to feet. *Camera* 60 (Sep 1981):6.

Daelen, Eduard. (ed.) *Die Schönheit des Menschlichen Korpers.* Düsseldorf, Ger.: Ulrich & Steinbecher, 1907.

Dallas, Pat. *Dallas in Wonderland: the Adventures of a* Playgirl *Photographer.* Los Angeles: Reed Books, 1978.

Dallen, Eugene. Supine woman's chest & head. HS.

Dames, Hermann and Stoss, Hermann. *Gesunde Schönheit.* 2 vols. Berlin: Hausarzt-Verlag, 1923-24.

Daniel, Jay. (US 1953-) Russell, Anne. "Shirts and Skins: Jay Daniels Looks at our Basic Uniforms." *American Photographer* 16 (May 1986):70.

d'Armand, Jean. Backlit seated woman. HS.

Dater, Judy and Welpott, Jack. *Women and Other Visions.* Dobbs Ferry, NY: Morgan and Morgan, 1975. Woman nudes in portrait approach.

Dater, Judy. (US 1941-) Embracing man & woman. BWC:26.

————. Portrait of two seated women, 1973. *Camera* 54 (Dec 1975):32.

————. "Imogen & Twinka at Yellowstone," 1974. On left, an elderly Imogen Cunningham with Rolleiflex strapped around her neck; on right is model Twinka, leaning against tree. DP.

————. "Man with Horse's Skull," 1979. Color, standing man holding skull of horse before his face. NN:190.

————. *Judy Dater: Twenty Years.* Tuscon, AZ: University of Arizona Press, 1986. Various nude portraits, including some of herself out in the southwestern desert. Also, the famous "Imogen and Twinka," 1974. Reproduction quality is better than the 1975 book.

Dau, Harro. *Die Schönsten Mädchen der Welt.* Munich: Heyne, 1974.

Davenport, Alma. [female] (US 1949-) Blurred motion of woman standing near a towel on the wall. This self-portrait is double exp. on Polaroid film, taken with a Speed Graphic, 1975. *Camera* 60 (Sep 1981):15

David-Tu, Alain. (b.1949) Three color works in NEW: kneeling woman on cheap blue plastic sheet (81); woman seated on couch, her head wrapped in gauze (82); standing woman frontal wrapped in gauze (83).

Davidson, Bruce. (US 1933-) "Topless Restaurant, San Fransisco," 1965. Female stripper lying on back with face next to that of a smiling customer. SEM:155.

Davis, Frank. "La Petit Joyeuse." Dancing woman in hackneyed pose. *AAP* 48 (1934):158.

Davis, Lynn. (US 1944-) "David Streeter, 1985, Big Sur California" in P. Weiermair (ed.), *Frauen...*, p. 82.

————. Weiermair, Peter (ed.) *Lynn Davis.* [Ex. cat., Frankfurter Kunstverein, 11 April–13 May 1990] Frankfurt, Ger.; Frankfurter Kunstverein, 1990. Incl. 33 male & female nudes, 1975-84. Most powerful shots are those of young women dancers.(30-34)

Davis, Meldoy D. (1959-) *The Male Nude in Contemporary Photography.* Philadelphia: Temple University Press, 1981.

Day, Fred Holland. (US 1864-1933) "The Vision," 1907. Grotto with standing man; very diffuse image, pictorial. DP.

————. Standing man grasping rope overhead; pictorially diffuse image. CS:35.

Dean, Roy. *A Time in Eden.* Los Angeles: Rho-Delta Press, 1969.

————. *Before the Hand of Man.* Los Angeles: Rho-Delta Press, 1972.

————. *The Naked Image.* Los Angeles: Rho-Delta Press, 1973.

————. *The Ecstasy of Eden.* Los Angeles: Rho-Delta Press, 1975.

————. *In Search of Adam: A Photographic Odyssey.* Los Angeles: Rho-Delta Press, 1975.

————. *Man of Moods.* Los Angeles: Rho-Delta Press, 1976.

————. *Roy Dean Nudes.* Los Angeles: House One of California, 1977.

————. *Virile Image of America.* Paris: Masculin Internationale, 1978.

————. *The Dean's List.* Los Angeles: Rho-Delta Press, 1980.

Degas, Edgar. (French 1834-1917) Two overexposed prints of seated women, 1895. CS:31, 32.

De Genevieve, Barbara. *Politics, Parody, and the Male Nude.* N.p., 1979. 31 slides.

————. "Four Graces," 1979. Essentially, a portrait of 4 penises. BTM:47.

Deiss, Joseph L. (US 1942-) Solarized supine woman on dirt and rocks. *Camera* 53 (Sep 1974):37.

Dejaiffre, Didier. (Belgian) Woman's supine torso. *Photo* 268 (Jan 1990):120.

De La Vergne, A.B. "Study." Kneeling woman, right profile, oiled skin, hands on hips, head back. *AAP* 50 (1936):149.

Delessert, Pierre-Michel. *Impressions in Black.* Paris: Inter-forum, 1985. Portraits of black women.

Deletang, Gilles. *Femmes Magnifique.* Paris: Pink Star, 1984. 28 pregnant women.

Dell'Orto, Alberto. Color, studio shot of woman in red briefs, 3/4 frontal, oiled skin, head bowed. *Photo* 204 (Sep 1984):cover.

De'Lisle, Gordon. *Of Woman, Love and Beauty.* Melbourne: Joey Books, 1970.

————. Woman reclining on stone bench. N.

————. Woman standing in forest. N.

De Louis, Javier. (US) Woman's front torso covered with sheer fabric *à la* Tenneson. *Photo* 298 (Jan/Feb 1993): 54.

Delul, J. (Dutch) Color, woman's butt. over blue plate, which rests on red cloth. *Photo* 232 (Jan 1987):61.

Demarchelier, Patrick. (French 1944-) Livingston, Kathryn E. *Patrick Demarchelier: Fashion Photography.* Boston: Bulfinch Press, 1989. Color, semi-nude portrait of model Christie Turlington, with arms crossed, hair wet, and waist "draped" almost in the classical manner (21); a similar classical treatment of a woman standing looking at us (103); seated woman on velvet-like material, head thrown back, hands behind head (105); woman supine on roof edge in city (106); woman leaning on table in studio shot with head bowed (109).

————. "Patrick Demarchelier." *Photo* 266 (Nov 1989):52. A nude portrait of model Paulina Porizkova [according to the caption, which is wrong].(55)

————. Woman hanging from a tree-limb with seascape b.g. *Vogue* [Italian] (Jly 1992).

Demachy, Robert. (French, 1859-1936) "Struggle," 1890. Woman surrounded by swirling graphics. [from *Camera Work* 5 (1904)]. NN:66.

————. "Nude," ca.1900. IPM; LN:20.

————. "Nude Study." [from *Camera Work* 16 (1906)] NN:65.

————. Jay, Bill. (ed.) *Robert Demachy.* New York: St. Martin's, 1976. Leading French pictorialist and master of the gum bichromate print abandoned photography in 1914. Incl. grainy & diffuse images: seated woman (20); seated woman (21); seated & veiled woman (24); seated woman w flowers (26); standing woman (29); seated woman on bench (31); seated woman (37); two women in classical "drapery" (38); seated woman w arms raised (42); seated woman (44); seated woman (46); seated woman (47); seated woman (48); seated woman (49).

————. Naggar, C. (ed.) *Robert Demachy: Photographe.* Paris: Contrejour, 1980. Incl. seated woman on bench (23); woman standing against wall (24); woman leaning against large rock (25); seated woman (27); standing woman w right elbow raised in front of face (29); standing girl in garden (30); woman before mirror (31).

————. "Demachy." *Photo* 157 (1980):104.

———. "Robert Demachy." *Photo* 265 (Oct 1989):66. Incl. 2 woman nudes.

———. *Robert Demachy: Pictorialist.* Paris: Booking International, 1990.

———. Seated woman on bed. NIP:47.

Demarais Studio Press. *Erotic Photography: An Exhibition.* N.p.: Demarais Studio Press, 1981.

Dembélé, Fifi. (Monaco) Beautiful tanned breasts, in color, framed in wet purple fabric of some sort. *Photo* 298 (Jan./Feb. 1993):45.

De Meyer, Adolf. (1868-1946) "Etude de danse," 1912. Barechested woman in bizarre mask in front of a window (?). LN:27; CS:53.

Denes, Gabriel. (ed.) *Nudes of All Nations: A Collection of 48 Photographic Studies.* London: Routledge, 1936.

Dennin, William. "Sun Worship." standing woman rear view, arms raised [but this is almost certainly a studio shot]. *AAP* 56 (1942):88.

Depet, Philippe. Color, woman baring her chest, revealing strange mask on her stomach. *Photo* 184 (Jan 1983):76.

Deratte, Antoine. (French) "Marina, la femme pompier," 1992. Cover photo, color, of woman painted gold, wearing a French firefighter's helmet. Fuji Velvia; Canon T-90; impressive resolution and color. *Photo* No. 298 (Jan./Feb. 1993):

Deutsch, Helene. Two works in HS: woman bending over, left profile, in grassy field; standing woman right profile, 3/4, backlit.

Devereaux, Gregg. (Canadian 1945-) Five frames of a woman standing on seamless paper, wearing dark trousers, hands in pockets; slightly humorous. *Camera* 50 (Feb 1971):18.

Dicampos, Peter. *From Holland with Love.* Amsterdam: Aquarius Publishers, 1970. Incl. 18 nudes in a photojournalistic style suffused w the aura of hippies; by "one of the brightest young talents in Holland today." All Dutch models from "swinging Amsterdam".

Dichavičius, Rimantas. (Lithuanian) *Blossoms Among Blossoms.* Vilnius, Lithuania: Mintis, 1989. Incl. 77 splendid outdoor nudes, all women, mostly on the seashore.

———. "Rimantas Dichavicius." *Photo* 262 (Jul 1989):120. Incl. 5 woman nudes taken outdoors; esp. woman prone on sand. (124)

Dicker, Jean-Jacques. Two women seated on windowsill. NIP:139.

———. "Jean-Jacques Dicker." *Photo* 204 (Sep 1984):26-31. Incl. 7 women nudes shot in his apartment.

Dicker, Sahara de. Color, woman's breast being injected [extracted] w syringe. *Photo* 184 (Jan 1983):66.

Dickinson, Janice. "Janice Dickinson." *Photo* 288 (Oct 1991):88. Incl. 6 self-portraits in high fashion style, & 1 standing nude of model Iman.

Diebold, Philippe. Woman pulling up her skirt to reveal her butt. *Photo* 280 (Jan 1991):63.

Diener, Christian. (ed.) *Paare: Meister der Erotischen Fotografie.* Munich: Heyne Bilderpaperback, 1971. Incl. nudes by K. Shinoyama, Tassilo Trost, Will McBride.

Diener, Christian and Schünemann, Walther H. (eds.) *Meister der Erotischen Fotografie.* Munich: Heyne Bild-Paperback, 1972. Incl. Guy Bourdin, Guido Mangold, C. Vogt.

Diénes, André de. (US 1913-85) "Shirley Levitt," 1945. Dancing woman on beach. A:236.

———. Outdoor frontal shot of standing large-breasted woman, her head thrown back, viewed from ground level, 1950. DP.

———. Woman standing near shaded window, holding doorknob, 1950. AVK:138.

———. Woman supine on beach w conch shells, 1950. AVK:118.

———. *Nus.* Paris: Société Parisienne d'Éditions Artistiques, 1956.

———. *The Nude.* New York: Putnam, 1956. 2nd edn., London: Bodley Head, 1961.

———. *Nude Patterns.* London: Bodley Head, 1958.

———. *Classic Art Photography.* Los Angeles: Trend, 1959.

———. *Impression.* Kiel, Ger.: Fravex, 1961.

———. *Best Nudes.* London: Bodley Head, 1962. 107 plates.

———. *Schönheit im Bild.* Thielle: Die neue Zeit, 1965.

———. *Sun Warmed Nudes.* Los Angeles: Elysium, 1965.

———. *Natural Nudes.* New York: Amphoto, 1966.

———. *Western Akt.* Flensburg, Ger.: Stephenson, 1967.

———. *The Glory of De Dienes Women.* Los Angeles: Elysium, 1967.

———. *Western Nudes.* New York: Bell Pub., 1968.

———. *Die 64 Besten Sexfotos.* Flensburg, Ger.: Stephenson, 1970.

———. *Nudes, My Camera, and I.* London: Focal Point Press, 1973.

———. *Nude Variations.* Garden City, NY: APBPC, 1977.

———. *The Best Nudes.* Tokyo: Haga Shoten, 1979.

———. Four works in NEW: woman seated on beach w legs raised (126); standing woman right profile, holding tambourine in desert dunes setting (127); leaping woman on California beach (128); standing woman in dramatic pose amid desert cliffs (129).

———. "Adieu André de Diénes." *Photo* 214 (Jul 1985):74. Incl. 8 of his woman nudes.

Dienst, Paulgünther. *Akt-Photographie zu Hause.* Wiesbaden, Ger.: Reichelt, 1960. ["How to" manual]

———. *Akt-Photographie und Diapositiv.* Wiesbaden, Ger.: Reichelt, 1963. ["How to" manual]

Di Grappa, Carol. (ed.) *Fashion Theory.* New York: Lustrum, 1980. Incl. nudes by D. Bailey, A. Barboza, H. P. Horst, E. Lennard, C. von Wangenheim.

Dieuzaide, Jean. (French 1921-) "Françoise aux Mousses, 1980 Ardizas." Woman kneeling on bank of stream. JL:29.

———. "Lucien Clergue et son modèle, 1981, Saintes-Maries-de-la-Mer." A great photographer focuses on a standing woman. JL:28.

———. Reclining woman, on her left side, in a pine forest, her head obscured by the foliage, 1988. BL:143.

Dinther, Lenni van. (Dutch 1953-) "Persona Grata," [series] 1987. Man seated in poorly lit studio. SEM:194.

———. "Persona Grata," [series] 1987. Double exp. of standing man, left profile. *La Recherche Photographique* 4 (May 1987):78.

Dizdar, Dejan. (Serb) Supine woman on bed. *Photo* 184 (Jan 1983):61.

Doisneau, Robert. (French 1912-) "Oeil en coulisse et hommages respectueux, 1952 Paris." Backstage, an old man in a great-coat walks with a partially clad woman dancer. JL:30.

———. "Le concert Mayol, 1953 Paris." Standing woman in heels, seen from back. JL:31.

Dojc, Yuri. (b. 1946) *Marble Woman.* Willowdale, Canada: Firefly Books, 1993.

D'Olivier, Louis Camille. (French) Standing woman, her back to us, she turns her head over her left shoulder and we see her face. *Camera* 53 (Feb 1974):8.

———. Seated woman. ca. 1855. BL:37; USI:125.

Dolmetsch, François. *On the Other Side of the Moon.* New York[?]: F. Dolmetsch[?], 1989[?].

Domingue, Jean-Pierre. "Jean Pierre Domingue." *Photo* 270 (Mar 1990):106-107. Incl. 17 year old French model Stéphanie Schneider, studio HK setting.

Donelli, Maurice. (French) Disgusting color shot of woman wrapped in plastic like a piece of meat. *Photo* 291 (Jan/Feb 1992):49.

Donger, Fernand. *Ethik der Nacktheit.* Leipzig, Ger.: Parthenon, 1927. 48 nature nudes.

Donovan, Flynn. (US 1951-) Woman before a shaded window, on bed lying on right side, knees drawn up. Leica M4, 50mm, Plus-X. *Camera* 50 (Sep 1971):34.

Donovan, Terrence. *Glances.*

———. "The Black Pirelli." *Photo* 233 (Feb 1987):56. Incl. 11 color glam shots of semi-nude black women for the Pirelli calender.

d'Ora, Madame. [Dora Kallmus] (Austrian 1881-1963) "Anita Derber," 1922. Standing woman in dance-like pose, almost enveloped in velvet backdrop. DP

———. Side torso of woman with bouquet of flowers. Color photo, soft focus, 1925. BL:80.

———. "Josephine Baker," 1928. The American-born chanteuse kneeling, profile right. A:255.

———. "Kaja Marquita," 1930. Woman in pearl bracelet & necklace, nude from waist up. DP

———. "Fräulein von Martinow," ca.1930. Rear view of standing woman holding circular mirror. USII:130.

———. "Fräulein Eskenasy," ca.1930. Woman's semi-nude portrait. USII:100.

———. "Fräulein Rivelli," ca.1930. Seated woman on bench against wall. USII:101.

———. "Fräulein Hübel," ca.1930. Standing woman w sheer fabric draped over left arm. USII:105.

D'Orazio, Sante. "Sante D'Orazio." *Photo* 289 (Nov 1991):42. Incl. *charme* shots of supermodels Stephanie Seymour, Rachel Williams, Cindy Crawford, Naomi Campbell.

———. "Rachel, Rachel." *Playboy* (Feb 1992):66. 6 color nudes of fashion model Rachel Williams in classic glamour style.

———. Nudes of fashion modèl Stephanie Seymour. *Playboy* (Feb 1993):70-77.

Doren, Arnold. Negative image of woman's torso, 1968. BWC:75

Dorin, Joseph. Seated woman w nail polished fingers. BB:22.

———. "Grief." Kneeling woman in right profile, in "pictorial" attitude of grief. *AAP* 49 (1935):144.

Döring, Herbert. (German) Yellowed and severely reticulated shot of woman with open legs, 1990. BL:151.

Dorr, Nell. *In a Blue Moon.* New York: G.P. Putnam's Sons, 1939. Incl. a beautiful selection of 31 photos of children and teenage girls in the tropical setting of the Florida Keys in 1929. Generally, she favored backlighting, which made the b.g. HK, lending each image a timeless quality.

Downes, Bruce. "The Nude in Photography—Is it Art?" *Popular Photography Color Annual* (1957):62-75. Woefully uninformed piece which maintains the camera only records reality, often making the unclothed body seem naked rather than nude. Downes thought "...the archives of photography can boast of few successful or, more accurately, acceptable nudes."(63) Nevertheless, he managed to incl. F. Henle, J. Rawlings, C. Schorre, F. Fonssagrives, I. Penn. *See individual entries.*

Drtikol, František. (Czech 1883-1961) Various figure studies in the 1920s. IPM.

———. Standing woman w very long hair, ca.1920. USII:78.

———. Kneeling woman w headband, ca.1920. USII:80.

————. Smiling woman, seated, arms raised, ca.1920. USII:81.

————. "Faun," 1924. Seated boy frontal on posing block. *Photography in New York* 3 (Mar/Apr 1991).

————. "Movement," 1927. Backlit standing woman in wide stance, making theatrical gesture. WE:198.

————. *Le Nus de Drtikol.* Paris: Librairie des Arts Decoratifs, 1929.

————. Magnificent study of standing woman, arms raised, grasping a rope strung across studio, 1929. Museum Folkwang. *Die Fotografische Sammlung.* Essen, Ger.: Museum Folkwang, 1983:(87).

————. Portrait of young woman embracing herself, 1929. CS:59.

————. "The Youth." Actually, 2 young smiling women visible from chest up, one on left w hands on shoulders of one on right. *AAP* 47 (1933):164.

————. "Frantisek Drtikol." *Camera* 47 (Jan 1968):22-31. Several studio woman nudes, characterized by dynamic poses & dramatic shadow patterns.

————. *Drtikol.* Rochester, NY: Light Impressions, 1977. 9 photos in 46x38cm portfolio.

————. "Les Nus Oubliés." *Photo* 127 (1978):36. Incl. Drtikol.

————. *František Drtikol.* Prague: Pressfoto, 1981. Pamphlet & 12 photos in white cardboard folder, incl. 3 nudes: "Nude Study," 1928, standing woman frontal, w dramatic lighting; "Nude Study," 1931, seated woman w band of light across her chest; "Breast," 1934, actually a close-up view of supine woman taken from behind her head, so that the top of her head & top of chest are visible against black b.g.

————. "Franticek Drtikol."[sic] *Photo* 181 (1982):66.

————. *Drtikol.* [Ex. cat.] Köln, Ger.: Rudolf Kicken, 1983.

————. "František Drtikol." *Camera International* 1 (Nov 1984):22-31. Typical strong directional lighting with models' shadows upon backdrops include "Nude," 1927, standing woman holding two large disks; "The Bow," 1928, woman on her left side stretching on curved surface; "Composition," 1927, woman standing on one leg, arms raised; "Composition," 1928, woman with arms raised, standing and bending backwards; "The Circle," 1927, supine woman on floor, with circle cut-out in front of her.

————. Farova, Anna. "Frantisek Drtikol. Mysticisme et Sexualité." *Clichés* 26 (1986):48.

————. Farova, Anna. (ed.) *Frantisek Drtikol.* Munich: Schirmer/Mosel, 1986.

————. *František Drtikol Fotografie.* Prague: N.p., 1988.

————. *František Drtikol.* Prague: Panorama, 1989.

————. Sayag, Alain. "Saudek/Drtikol," *Camera International* 26 (Summer 1990):56-65. Some Drtikol work not published elsewhere, e.g., a woman supine on studio floor, behind a large translucent bit of drapery, 1927 (63); a woman in the lower third of the frame, shouting [screaming ?], her shadow looming large on the backdrop, 1927 (64).

————. Clothed working man bending over in foreground, w standing woman in athletic pose in b.g. NN:96.

————. Seated woman wearing hat, circle b.g. NN:97.

————. Two standing women frontal, right arms raised and bent at elbow behind their heads. CS:81.

Dubin, Steven. *Arresting Images: Impolitic Art and Uncivil Actions.* New York: Routledge, 1992.

38

Duckworth, Paul. *The Nude: 101 Moods*. Text by Mildred Steagg. New York: Universal Photo Books, 1961.

Duforêt, Jean. (French) Color, woman supine on straw with unreal cloudy sky background. *Photo* 298 (Jan/Feb 1993):45.

Dukat, Michael. (Swiss) 3/4 standing woman with her back to us, agn wall, with interesting dappled light from louvered window cover. *Photo* 298 (Jan/Feb 1993):49.

Dunas, Franck. (French) Wonderfully shadowed woman's upper torso reclining with hand holding onto something phallic. *Photo* 298 (Jan/Feb 1993):48.

Dunas, Jeff. (US 1948-) Color, woman seen from rear, wearing mink coat, flashing a crowded sidewalk, 1975. A:263.

———. *Captured Women*. Los Angeles: Melrose Publishing, 1981. Color photos of young/beautiful women in a style that borrows from both high fashion and glamour photography.

———. *Mademoiselle, Mademoiselle!* New York: Grove Press, 1982; 1984.

———. *Voyeur*. New York: Grove Press, 1983.

———. Three color photos: 1) a woman on a balcony, seen from inside a room, 2) woman reclining on mattress in empty room, seen from several meters away, 3) two women lying together. He used a Mamiya RZ-67 & Ektachrome 64, except for the last shot, recorded on 35mm format Kodachrome 64. CAEP.

———. "Jeff Dunas." *Photo* 227 (Aug 1986):30. Color, 7 *charme*/fashion shots of women, w clothed men as props.

Duncan, Kenn. *Nudes*. New York: Dance Magazine, 1970.

———. *More Nudes*. New York: Danad Pub. Co., 1971.

Dunnett, Ronn. (Canadian) Woman's backside draped over wood 2x4 amid pile of chrome bumpers. *Photo* 291 (Jan/Feb 1992):55.

Du Four, Gordon. *Das Aktbild als Kunstwerk*. Leipzig, Ger.: Parthenon, 1926. 50 photos.

———. *Dämon Weib*. Leipzig, Ger.: Parthenon, 1929. 48 nature nudes.

Dupain, Max. (Australian) "Nude with Pole," ca. 1930s. Standing woman with arms raised, behind vertical pole. *Art and Australia* 30 (Spring 1992):97.

Dupouy, Alexandre. Dusk light, woman's torso rear view, next to tree trunk. *Photo* 280 (Jan 1991):62.

Dureau, George. (US 1930-) "Wilbert Hines," 1977. Portrait of a Black man missing half of his left arm. SEM:111. He enjoys photographing men with amputations.

Durieu, Eugène (Jean-Louis-Marie). (French 1800-74) Collaborated with Delacroix on male and female nude photographs, some of which appear in HP.

———. "Nu masculine," 1854. LN:7.

———. Seated semi-nude woman, ca.1855. BL:39.

———. Standing man frontal, ca.1855. BTM:21.

———. Seated semi-nude woman w pillow on lap. USI:121.

Dutton, Allen A. (US 1922-) Photomontage involving a woman's torso, 1969. BWC:69.

———. "The Gobi Caravan," 1973. Photomontage of three female humanoid beasts. NN:194.

———. *The Great Stone Tit*. Tempe, AZ: R. Dixon, 1974.

———. *Compendium*. Phoenix, AZ: Dutton, 1977. This unique volume incl. 69 photomontages beyond category (perhaps one could state that these are fantasies, or dreams on paper: parts of women's bodies arranged in serial compositions).

Duval, Didier. (French 1949-) Two pictures: one seated woman with elbows and head on desk; another of same woman filing a toenail; 1974. Nikon F2, 50mm, Tri-X, daylight. *Camera* 53 (Sep 1974):26-27.

Dyer, William B. "L'Allegro," 1902. Standing woman w symbols. WE:half-title page.

Easley, Thomas and Smith, Mark E. *The Figure in Motion.* New York: Watson-Guptuill, 1986. Intended for drawing students, each studio shot was meant to convey the origin of the pose, the present, & the future (where the movement is leading). Incl. full figure shots of men, women, & two women together.

Eakins, Thomas. (US 1844-1916) "Male Nudes Wrestling," 1883. Albumen print. CS:15.

————. Young men at swimming hole, 1883. CS:28.

————. Studio shot of standing woman wearing black mask [for anonymity?], just behind a prone woman on floor, 1883. CS:29.

————. Studio shot of three women, two standing, one seated (wearing a massive blindfold [for anonymity?]), 1883. NN:39; CS:30.

————. *The Olympia Galleries Collection of Thomas Eakins Photographs.* Philadelphia: Olympia Galleries, 1976.

————. *Photographer Thomas Eakins.* Philadelphia: Olympia Galleries, 1981.

Efstatiadis, Eustash. (Greek) Two buxom standing women in white room. *Photo* 268 (Jan 1990):120.

Egerland, Christine. (ed.) *Atropin: Frauen-Foto-Zeitung.* Berlin: Petra Panther, 1982.

Eggbrecht, Axel. *Junge Mädchen.* Berlin: Reimer, 1932. Incl. 32 photos of model Hedda Walther.

Eggleston, William. (US 1939-) "Greenwood, Mississippi," 1971. Color, standing man frontal in derelict bedroom. CS:128.

Egli, Richard A. (Swiss 1945-) Sixteen frames of a woman's head and upper torso; many facial expressions. *Camera* 50 (Feb 1971):19.

Eglington, Judith. *Earth Visions.* [Toronto]: Martlet Press, 1973.

————. Man[?] supine under swiftly flowing water. NIP:192.

Ehm, Josef. (Czech 1909-) Solarized print of seated woman, ca.1930s. NN:111.

————. "Nude Study," 1962. Studio shot of blonde woman seated in art nouveau chair. CP:272.

————. Solarized print of breasts. AA:23; very similar work (25).

————. Woman's head & torso. AA:24.

Eichler, Wolfgang. "Wolfgang Eichler." *Photo* 283 (Apr 1991):40. Incl. 1 semi-nude woman.

Eichmann, Heinrich. *Kunststudien über den Nackten ...* Berlin: Hessling, 1900.

Eidenbenz, Willi. (Swiss 1902-) Double exp. studio shot of striped light pattern projected upon a reclining woman, 1955. DP.

Elisabeth B. *Das ist ja zum Peepen.* Frankfurt, Ger.: Eichorn, 1983.

Ellenzweig, Allen. *The Homoerotic Photograph: Male Images from Durieu/Delacroix to Mapplethorpe.* New York: Columbia University Press, 1992.

Eluard, Nusch. [Maria Benz] (German 1906-46) 3 photo-montages of women in dynamic poses, ca. 1936. RK:209. She posed for Man Ray and Picasso.

Elvin, Sue. (b. 1951) *Mother & Daughter.* Cammeray, Australia: Horowitz Grahame, 1985.

Emili, Marco. "Marco Emili." *Photo* 228 (Sep 1986):88. Color, 8 semi-nude *charme* shots of women; one full figure nude woman.

Emji, M. Man & woman apparently in 40s stand frontal, heads covered w elaborate masks in imitation of old people. *Photo* 232 (Jan 1987):81.

Emrich, Bill. *Photographs of Men.* Berlin: Janssen Verlag, 1993. 60 plates.

Ender, Klaus. *Mein Modell.* Leipzig, Ger.: Fotokinoverlag, 1971; 1973; 1976; 1979; 1982. ["How to" manual]

Englich, Ivan. (Czech 1934-) Chest of woman w light disk b.g. AA:33.

Enkelmann, Siegfried. (German b.1905) "Tänzerin," 1940. Color, studio shot, dancing woman w red veil. A:328.

Enos, Chris. [female] (US 1944-) "Richard," 1969. Standing man between classical statues. BWC:66.

———. Side view of woman's butt. to lower chest. Yashica 35, 105mm, Tri-X (ASA 100). *Camera* 54 (Sep 1975):13.

———. Three women standing, one little girl in black dress holding a wine glass. *Camera* 60 (Sep 1981):23.

Erler, R.G. *Der Kunstlicht-Akt des Amateurs.* Vienna, 1949.

Erwitt, Elliot. (US 1928-) "Nudist Camp, Kent (England)," 1968. First image is that of a middle aged couple seated on a bench, the woman knitting; while the second image is that of various men, women, and children outside. SEM:164-65.

———. Woman walking away from us through gap in sand dune. NIP:150.

Eugene, Frank. (US 1865-1936) "Adam and Eve," 1898. LN:23.

———. "Nude—A Study," 1910. Woman with short hair seated on carpet-like studio backdrop. *Camera* 48 (Dec 1969):42.

———. "Male Nude Portrait," 1913. Platinum print. CS.

Evans, John A. (US 1949-) Woman standing near interior doorway looking at TV set in next room; darkly lit. Pentax, 55mm, Tri-X, 500w photoflood. *Camera* 51 (Sep 1972):7.

Evansmith, Florence & Henry. "Poise." Rear view of standing woman greased up to look like classical statue. *AAP* 50 (1936):101.

Even, Alain C. Color, woman in fetal pose, rear view, seamless & model painted white; red apple f.g. *Photo* 232 (Jan 1987):65.

Everard, John. *Adam's Fifth Rib.* Boston: American Photographic Pub., 1935.

———. *Life Lines.* Pelham, New York: Bridgeman, 1936.

———. *Living Color.* London: Routledge, 1938.

———. *Portrait of a Model.* London: Routledge, 1939.

———. "Nude Study," ca.1930s. Standing woman in HK setting w hoop. NN:123.

———. *Nymph and Naiad.* London: Routledge, 1940.

———. *Eves without Leaves: A Book of Studio Nudes.* 1940.

———. *Judgment of Paris.* London: Routledge, 1941.

———. *My Hundred Best Studies.* London: Bodley Head, 1954.

———. *Second Sitting: Another Artist's Model.* London: Bodley Head, 1954.

———. *Oriental Model.* London: R. Hale, 1955.

———. *Künstler-Modelle (Artist's Model).* 3 vols. Göttingen, Ger.: Musterschmidt, 1956-60.

———. *In Camera.* London: Robert Hale, 1957.

———. *Sculptor's Model: A Third Sitting.* London: Bodley Head, 1958.

———. *Model in Movement.* London: Bodley Head, 1959; 1963.

———. *Model in Shadow.* New York: Tudor Pub. Co., 1965. 64 photos.

Evergon (Canadian 1946-) "Re-enactment of Goya's «Flight of the Witches, ca. 1797-1798»," 1986. Fuzzy semi-nudes in four panels of large Polaroid prints. SEM:196-97.

Ewing, William. (ed.) *Dance and Photography.* New York: Holt, 1987. Incl. work by W.B. Dyer, D. Buckland, F. Drtikol, R. Koppitz, W. Albee, A. Mucha, J. Abbe, R. Mapplethorpe. *See individual entries.*

Fabian, Rainer. (photographer) Freyermuth, Gundolf S. (ed.) *Der Erotische Augenblick.* Hamburg, Ger.: Stern-Buch, 1984.

Falcetti, Carlo. Color, woman's torso frontal, oiled skin. *Photo* 207 (Dec 1984):76.

Falda-Robert, Natacha. (French 1947-) Girl on floor next to "French doors", with balloons. Pentax, 20mm, HP4. *Camera* 50 (Sep 1971):20.

Fani-Kayode, Rotimi. *Black Male/White Male.* London: GMP 1988. Nigerian photographer's erotic, abstract, and portrait images.

Fankhauser, Eduard. *Nacktheit vor Gericht.* Thielle: Die Neue Zeit, 1941.

Farber, Robert. *Images of Woman.* Garden City, NY: APBPC, 1976.

————. *Moods.* 1980.

————. *Farber Nudes.* New York: Amphoto, 1983.

————. Three B&W & three color nude fragments. CAEP.

————. *By the Sea.* 1987.

————. *Classic Farber Nudes.* New York: Amphoto, 1991.

Farina, Ferruccio. *Cartoline Intime: Sogni Proibiti dei Nostri Nonni.* Milan: Rusconi Imagini, 1981.

————. *Venus Unveiled.* N.p.: Magna Books, 1989.

Fauchard, Stéphane. Color, woman seated on bedding. *Photo* 207 (Dec 1984):86.

Faucon, Bernard. (French 1950-) "The Sixteenth Room of Love," 1985. Color, couple on mattress in yellow room. NE:181.

————. "*Le petit bouddha,*" 1988. Oriental boy, covered with spakled gold paint, kneeling in cave. SEM:228.

Fee, James. *Photographer's Forum* (Sept. 1992).

Fegley, Richard. *Dreams.* New York: Playboy Press, 1982.

Fehlauer, Michael. (German 1953-) "Visionen 4," 1985. Bizarre altar scene in cave setting. BL:182.

————. "Frau mit Federn," 1985. Standing woman against black b.g., holding flick blade, feathers in her hair. USII:184.

Fehr, Gertrude. (Swiss) Solarized torso, 1938. BL:130.

Feidler, Franz. (German 1885-1956) *Narre Tod, mein Spielgesell.* Dresden, Ger.: Verlag Schönheit, 1923.

————. *Künstlerische Aktaufnahmen.* Berlin: Union, 1925. 24 plates.

Feiler, Jo Alison. Under window of domestic room, supine woman on couch. *Photography in New York* 4 (Mar/Apr 1992):n.p.

Feiller, Franz. "Befreit." Rear view of standing woman w arms raised, on bow of rowboat in lake. *AAP* 47 (1933):94.

Feininger, Andreas. (US 1906-) "Nude II," 1935. Negative image of high contrast outline of standing woman. In Van Deren Coke, *Avant Garde Photography in Germany, 1919-1939.* New York; Pantheon, 1982:(100).

————. *Frauen und Göttinnen. Von die Steinzeit bis zu Picasso.* Köln, Ger.: Schauberg, 1960.

————. *The World Through My Eyes.* New York: Crown, 1963. Incl. "Standing Nude." Woman's torso, rear view (30).

Feminist Anti-Censorship Task Force Book Committee. *Caught Looking: Feminism, Pornography, and Censorship.* East Haven, CT: Long River Books, 1992. Many images of sexual behavior decorate the text.

Fenton, Roger. (UK) "Study of a Partially Draped Young Lady," 1855. CS:15.

Ferrazzutti, Pam. (Canadian 1941-) Rear view of two girls near sea cliffs, 1974. Bronica S2A, 50mm, Tri-X. *Camera* 54 (Sep 1975):31.

Ferri, Fabrizio. (Italian 1950-) "Fabrizio Ferri." *Camera International* 7 (Ete 1986):90-99. Eight stunning nude portraits of women, high key backgrounds. Large format camera.

Ferrier, Arthur. *Lovelies.* New York: Atlas, 1943.

Ferry, Gérard. (French) Two women prone on bed reading comics. *Photo* No. 298 (Jan./Feb. 1993):46.

Feurer, Hans. "Hans Feurer." *Photo* 195 (Dec 1983):82-89. Incl. color shots for calendar, featuring models Lorraine Eve, Lise Thorensen, Mary Moore.

Fevrier, Patrick. Color, woman's torso supine on grassy dune. *Photo* 207 (Dec 1984):85.

Fiala, Jaromír. High contrast view of woman's torso. JS:IV.

Fierce, Brad. Woman with ornate necklace, seated on ancient-looking tri-cycle. *Photo* 292 (Mar 1992):57.

Fily, Marc. (French) Seated woman with sunlight on face, breasts & knees; prize winner. *Photo* 298 (Jan/Feb 1993):49.

Fiorella, Stephen. One image from series "Swimmers," 1978-87. Two women floating on their backs in a lake, composed almost in a yin-yang shape. *Aperture* 111 (Summer 1988):39.

Fischer, Guillermo. (Columbian) Woman reclining on boulder outdoors. *Photo* 184 (Jan 1983):61.

Fischer, Hans Waldemar. *Körperschönheit und Körperkultur, Sport, Gymnastik, Tanz.* Berlin: Dt. Buchgemeinschaft, 1928. Incl. G. von Riebicke.

Fischer, Klaus. (b.1934) *Aktfotografie.* Leipzig, Ger.: Fotokinoverlag, 1979; 1980. ["How to" manual]

Fischerová-Rosslerová, Gertruda. (Czech b.1894) "Nude Man," ca.1920s. Rear view of standing man, black b.g. NN:206.

Fitz, W. Grancel. "Photomontage," 1938. Actually, a multi-exp. print of seated woman's torso in LK setting w harsh sidelighting. *Photography in New York* 4 (Mar/Apr 1992).

Fitzsimmons, Michele and Schmidt, Diane. *The Chicago Exhibition.* Los Angeles: Melrose Publishing Group, 1985. 54 urban nudes of Fitzsimmons, first exhibited in 1981. Schmidt wanted to make nudes that expressed an emotional relationship between woman & environment. They are more like portraits than figure studies. Nikon F, Tri-X, Panatomic-X, D-76.

Fleischer, Alain. "La rouleau compresseur," 1987. Double exp. of inverted woman & toy tractor in f.g. *La Recherche Photographique* 4 (May 1988):61.

Fleischmann, Trude. (Austrian 1895-) *Trude Fleischmann: Fotografien in Wein, 1918-1938.* [Vienna?], Wirtschafts-Trend, 1979.

————. *Trude Fleischmann: Fotografien 1918-1938.* [Catalog of exhibition at Galerie Faber, 18 Mar—30 April 1988.] Vienna: Galerie Faber, 1988. Unpaged. Incl. "Nude," 1925,

seated woman, left profile, head turned toward black b.g.; "Claire Bauroff," 1925, seated woman on black b.g.; "Claire Bauroff," 1925, kneeling woman w dramatic gesture (cover photo).

———. Seated woman on black velvet covered block in studio, 1930. BL:120.

Flasche, Phil. *Photographing the Male.* New York: Crescent Books, 1983.

———. *Phil Flasche: Male Photographer.* London: Gay Men's Press, 1987.

Flemming, Peter. *Junge Liebe.* Flensburg, Ger.: Uhse, 1970.

Florschutz, James H. (US 1949-) Woman's front torso (shoulders to crotch) next to window, hands folded at crotch. Zeiss Ikon, 50mm, Kodak Recording film (ASA 1600), 15 sec. exp. *Camera* 50 (Sep 1971):14.

Flössel, Barbara. (German 1946-) Woman on floor, leaning back on hands, head wrapped in gauze, sardines (?) sprinkled over her, in front of a mirror, which reflects the scene. Nikon F2, Tri-X. *Camera* 60 (Aug 1981):9.

Flynt, Robert. Series of 5 [underwater?] man nudes. *Photo Metro* (June/July 1992):12-13.

Fonssagrives, Fernand. "The Diver," 1936. Woman under water after just breaking the surface. Elegant, simple, beautiful. *Aperture* 111 (Summer 1988):5; a.k.a. "Joie de l'ardeche (Lisa Fonssagrives)," 1936. *Photography in New York* 2 (Jul/Aug 1990):6.

———. Color, 6 exp. studio shot of standing woman in dance poses. Each exp. has a different color, because he employed colored gels for each exp. *Popular Photography Color Annual* (1957):71.

———. Birnbaum, Hugh. "Body Language." *Camera Arts* 3 (Apr 1983):38-46, 79, cover. Discussion of Fonssagrives's lighting and posing strategies. Incl. eight women nudes.

Fontana, Franco. (Italian 1933-) *La Linea dell'Immagine.* Milan: Editphoto, 1978.

———. "Piscina," 1983. Color, from subsequent book of same name; Woman's torso with pool and butt. in b.g. DP

———. "Franco Fontana." *Photo* 201 (June 1984):104-111. Incl. 6 color studies of women's torsos in different arrangements.

———. Color, Polaroid; two images of women poolside. SII.

———. *Piscina.* Milan, Italy: Diapress, 1984. Incl. 32 color nudes of young women in and around an outdoor swimming pool. Special emphasis on form (few faces are visible).

Fontcuberta, Joan. [male] (Spanish 1955-) Breast and whiskered armpit. Hasselblad, FP4. *Camera* 60 (Sep 1981):36.

Fonteyne, Karel. (b.1950) *Entre Chien et Loup.* [1983?] *Charme*

———. Five works in NEW: Grainy high contrast shot of supine woman on table in barren room (163); supine woman in bathtub, w pumpkin covering her head (164); standing woman holding pumpkin (165); woman straddling hood of Rolls Royce (166); standing woman rear view, removing her shirt on a farm road (167).

———. *Black Earth.* Gent, Belgium: Imschoot, Uitgavers, 1990.

Forbath, Albert. "Movement." Frontal standing woman nude from waist up, arms covering face. *AAP* 48 (1934):120.

Forster, Richard. (Swiss) Color, pregnant woman standing near fence. *Photo* 207 (Dec 1984):76.

———. Color, extremely rich bronze toned supine woman in rapids-type stream. *Photo* 232 (Jan 1987):61

Försterling, Hermann. (German) Triple print of woman's crotch and man's head, 1989. BL:172.

Foster, Alasdair. (ed.) *Behold the Man. The Male Nude in Photography*. Edinburgh, Scotland: Stills Gallery, 1988. Incl. D. Buckland, G. Riebicke, Y. Gregory, M. Owen, G. Marconi, Durieu, F.R. Yerbury, V. Galdi, H. von Manen, A. Baumann, P. Berlin, H. Sato, G.P. Ray, L. Clark, D. Herbert, M. White, H. Koeble, C. Vogt, E. Rubinstein, J. Spence, B. De Geneviève, E. Teske, J.–M. Prouver, B. Henson, G. Anthony. *See individual entries.*

Fournel, Georges. Woman prone on rocks, forest b.g. *Photo* 184 (Jan 1983):71.

Fox, James A. (Belgian 1935-) "Lutteur turc," 1986. 36 frame contact sheet of man posing in studio. SEM:69.

Fraiche, Marcel. Color, supine woman on top of grassy dune. *Photo* 184 (Jan 1983):75.

Franchi de Alfaro, Luciano. III. (US 1945-) Color Polaroid SX-70. Male & female nudes. S.

———. Four multi-exp. color Polaroid works featuring men's & women's torsos. SII.

Frankel, Haskel. (ed.) *Form Photography: The Art of the Camera, with More Than 100 Great Studies of Beauty*. New York: MACO, 1960.

Frapie, Frank R. "Alice." Woman standing on rock ledge. *AAP* 58 (1944):82.

Frasnay, Daniel. *Paris. Cancan*. Bonn, Ger.: EBH, 1959.

Freed, Arthur. Supine woman between man's legs: she seems to be in ecstasy, 1969. BWC:47.

———. Supine woman w legs bent at waist, knees together on floor, 1969. BWC:65.

———. *Eight Photographs*. New York: Doubleday, 1971. Incl. one nude: woman standing behind a tree limb in a forest.

Freehand, Julianna. (b.1941) *Elizabeth's Dreams: A Photographic Tapestry of Woman, Her Relationships, Her Life*. Croton-on-Hudson, NY: Menses, 1984.

French, Jim. *Man; Photography*. New York, 1972.

———. *Another Man; Photography*. Village Station, New York: State of Man, 1974.

———. *Quorum*. Village Station, New York: State of Man, 1976.

———. *The Art of the Male Nude*. N.p.: Colt Studio, 1988.

———. *Opus Deorum*. State of Man Pub., 1992. Man nudes.

Fridel, Jacky. (French) Color, rear view of woman standing in pumps on baroque architecture, prominent blue sky background, her skirt pulled up to the waist. *Photo* 291 (Jan/Feb 1992):49.

Fried, Georg A. *Akt im Lichtbild*. Lauf,?: Zitzmann, 1965.

Friedlander, Lee. (US 1934-) *Lee Friedlander: Nudes*. New York; Pantheon Books, 1991. Series of very literal & direct studies of women's bodies, made w Leica 35mm & apparent on-camera flash. He seems not to be concerned w beauty of form, but rather fascination w objects that happen to be adult female humans.

Friedman, Victor. "Two Figures," 1989. Multi-exp. of 2 reclining women & cubist artwork. *Photography in New York* 2 (May/Jun 1990):18.

Friedrich, Hans. (intro.) *Frauen: Fotos aus aller Welt*. Gütersloh, Ger.: Bertelsmann, 1958. Incl. Rittlinger, Henle, Suschitzky, Tuggener, Winquist, Klages, Schuh, R. Angenendt.

Frima, Toto. (Dutch 1953-) Color, Polaroid, woman upside-down, 1980. A:203.

———. 50x60 color Polaroid of woman lying on her back. BL:158.

———. "Toto Frima." *Creative Camera* 309 (April/May 1991):16-19. Five self-portraits.

Fritsch, Gustav. (ed.) *Nackte Schönheit: Ein Buch for Kunstler und Artze*. Stuttgart, Ger.: Herman Schmidt's Verlag, 1906.

Fritsch, Hans-Joachim. *Sonne, Mädchen und Kamera*. Hamburg, Ger.: Danehl, 1968.

Frontoni, Angelo. *Welstars ohne Hülle*. Rastatt, Ger.: Moewig, 1979.

Fujii, Hideki. (Japanese 1934-) "Flame," 1981. Color, woman from waist up, body painted in flames motif. CP:321.

Fukase, Masahisa. Double portrait of his wife & mother in-law, nude from waist up. NIP:138.

Fukuda, Kazuhiko. *Chibusa no Bigaku.* Tokyo: Akane Shuppan, 1981.

Funke, Jaromir. Blurred image of woman's arms & a breast, 1935. AVK:91.

Fürst, Peter H. *Der Nakte Mann.* Wuppertal, Ger.: Schwarz, 1970.

Fury, Scarpo. Woman's frontal torso, LK b.g. HS.

Futtermann, Marilyn. *Dancing Naked in the Material World.* New York: Prometheus Books, 1992. About strippers.

Gabor, Mark. (b.1939) *The Pin-Up: A Modest History.* New York: Universe Books, 1972. 271p.

Gaffney, Joe. *Relief: La Photo en Trois Dimensions.* Paris: Love Me Tender, 1983. *Charme* in 3-D, w viewing glasses.

Gagnon, Michael. (Canadian) Standing woman near window in derelict room, her bathrobe open to reveal chest. *Photo* 280 (Jan 1991):67.

———. Supine woman in bathtub, reading an upside-down newspaper. *Photo* 291 (Jan/Feb 1992):57.

———. Supine woman wearing basketball shoes in barn hayloft. *Photo* 298 (Jan/Feb 1993):52.

Gaillard, Didier. *Femmes Fatales.* Los Angeles: Melrose Publishing, 1984.

———. "Didier Gaillard." *Photo* 288 (Oct 1991):60. Incl. 3 blurred motion studies of standing woman in studio.

Gainsbourg, Serge. *Bambou et les Poupées.* Paris: Filipacchi, 1981.

———. "Serge Gainsbourg." *Photo* 283 (1991):20. Color, 10 woman nudes.

Galetil, Lara. (Belgian) Kneeling woman on white dropcloth. *Photo* 298 (Jan/Feb 1993):55.

Galdi, Vincenzo. (Italy) "Nude with Net," ca.1895. Albumin print of woman standing w net. USI:173.

———. Albumin print of seated woman w left arm raised, ca.1895. USI:177.

———. Albumin print of two seated teenage boys in "Roman" sandals, ca.1895. USI:201.

———. "Draped Man with Dagger," ca.1900. BTM:22.

———. "Two Youths," ca.1900. Two teenage males w large penises face the camera. BTM:35.

———. Seated woman covering face with elbow, 1905. BL:71.

———. Teenage girl w urn & leaves, against wall. USII:59.

Gamer, Dieter. *Mädchenfotografie — die groß Chance.* Wilhelmshaven, Ger.: Gamer, 1982. ["How to" manual]

Gantz, Joe. (US 1954-) "Girl on a Pedestal," 1977. Young woman in dance studio crouching on a pedestal as if she were about to take flight. LN:60.

———. "Untitled # 1." Young woman hanging on to a barre in a dance studio. SEM:202.

———. "Women on Pedestals." Three women and two girls stand on display pedestals in an art gallery, while some pigs run across the lower foreground. SEM:201. Also appears in *Fantastic Photographs.*

———. "Joe Gantz." *Photo* 200 (May 1984):186-93. Incl. 7 color works of men & woman in group activities at a conference room setting; most of the women seem to be spreading their legs open for no apparent reason.

———. "Feminine Behavior," 1984. In a conference room, nude woman w spread legs on carpeted floor, bride on pedestal, cheerleader in mid-air, 3 nude women berate a man in underwear. DP.

————. "Seals," 1984. 6 women on shower-room floor, prone, raised up on arms, heads back, mouths wide open, as if imitating a seal bark. Did these women understand they were being degraded? AVK:191.

————. *Culture, Myth, Allegory.* San Francisco: View Press, 1984.

————. "Hommage II," 1985. Young woman decorated with red and white flowers hangs onto a curved bar, her legs spread. Color. BL:cover.

————. *The Possibility for Love.* San Francisco: View Press, 1987.

Garde, Anne. (French 1946-) "Le dos de Laure [Vernière], 1979 Bordeaux." Woman resting on her right side upon a massive concrete bulwark. Garde wanted to feminize this "oppressive" piece of military architecture. JL:40.

————. "Rita [Renoir] à l'hôtel du Lion d'Or, 1976 Vezelay." Woman seated in luxury restaurant with cape open to reveal her breasts. JL:41.

Gardelli, Romolo. (Italy) Kneeling woman, right profile, torso leaning back, head not in frame. *Photo* 280 (Jan 1991):60.

Garland, Madge. *Die Schöne Frau im Wandel der Zeiten.* Vienna: Albert Müller, 1962. Incl. Cecil Beaton, Armstrong-Jones, P. Basch, List, Man Ray.

Garlock, Albert Nat. Standing woman in field. HS.

Garmier, D. Prone woman chained to bed. *Photo* 280 (Jan 1991):66.

Garude, Victor. Chest to head view of standing woman frontal, arms raised. HS.

Gasché, Willi. *Moderne Aktfotos.* Bern: WIGA-Verlag, 1968.

Gaté, Jean-François. (French 1952-) Blurred motion, clothed woman standing next to unclothed woman holding a hat. *Camera International* 17 (Automne 1988):102.

Gates, Jeff. (US 1950-) Woman's torso and head, heavy shadows. Nikon, Tri-X. *Camera* 60 (Sep 1981):35.

Gatterman, Robert. (Canadian) Ironic scene of woman back to camera, seated atop gravestone, which is engraved "Strange." *Photo* 291 (Jan/Feb 1992):56.

Gatewood, Charles. (US 1942-) Enormously obese female reclining on her right side, out in the woods, 1977. SEM:163.

Gehrke, Claudia. *Mein Heimliches Auge....Album Erotischer...* Tübingen, Ger.: Gehrke, 1982.

Geijerstam, Bengt af. Frontal torso of plump supine woman. PK.

Gelpi, René G. Hispanic woman standing frontal in bathroom of derelict Bronx tenement, holding a cigarette. NIP:146.

Gelpke, André. (b.1947) Snapshot of woman sex performer in Hamburg, Ger.. NIP:136.

————. Series of 7 images about strippers & sex show performers. NEW:168-75.

————. *Sex-Theater.* Munich: Mahnert-Lueg, 1981.

Genthe, Arnold. (US 1869-1942) *Book of the Dance.* New York: Mitchell Kennerly, 1916. His goal: to show "some of the phases of modern dance tendencies that could be recorded in a pictorially interesting manner." Incl. anonymous young women (they are not creditied in the index of dancers) in dance poses, yet they do not appear intentionally posed. "Classic Dancers," 12 works, incl. one in color titled "Daphne", [woman playing Pan pipes](145-67); and one standing woman in the section "The Biyar School."(206)

————. Diffuse studio shot of kneeling woman in heroic pose. [from his *Book of the Dance*] NN:115.

————. Five diffuse studio shots of dancing women, from his *Book of the Dance.* PL:64-71.

————. (ed.) *Highlights and Shadows.* New York: Greenberg, 1937. Anthology on state of the art in conservative photography of the nude. Why conservative? Because you will find no surrealists like Boucher, or experimentalists like Man Ray. Great majority of works are studio nudes: models in 98% of images are buxom young women. All of the works seem deliberately posed against a black or white b.g. Emphasis is always on the form, as suggested in the title. Each photo is explained on a technical level: large format cameras, slow film, slow lenses, and plenty of D-76.

Featured photographers [in approximate page order]: Lionel Heyman, Herbert Matter, H.S. Ulan, Paul J. Woolf, John F. Crosbie, Jarold Lane, Grace F. Lamb, Ricardo Bettini, Alexander Alland, T.C. Wright, Manasse Ricoll, Lazlo Wilinger, Ralph Sommer, Eric Godal, Albert Peterson, Howard S. Redell, Leni Schur, W. Strosahl, Buck Hoy, Ernst Kassowitz, Don Selchow, Ricard Richards, Helene Deutch, Jean D'Armand, Thomas Owings, Heinz von Perckhammer, Thomas O. Sheckell, Henry P. Smith, Scarpo Fury, Pincus, Rice, Alexander Paal, Tracy Webb, S. Alexandroff, John McSherry, Eugene Dallen, James Allen, Renato Toppo, Thomas H. Uzell, Blanche De Koven, J. George Birkett, Montgomery Roberts, Luba Lovitsch, Victor Garude, Richard Hudson, Ivan Sarakoff, Bertrand, Albert Nat Garlock.

————. Six works in HS: seated woman in dramatic/dance pose, LK setting; woman's chest & left hand; kneeling woman, hands on head, LK setting; standing woman frontal, LK setting; dancing woman in LK setting; woman's chest & both hands.

Geordias, Dorothée. Color, standing woman frontal, w arms raised, carrying a riding whip in hands. *Photo* 207 (Dec 1984):78-79.

Georgiades, Andreas. (Cypriot) Woman's torso in partially open window. *Photo* No. 298 (Jan./Feb. 1993): 55.

Geradts, Evert. *Pin-up.* Enghein, Netherlands: Artefact, 1984. *Photographie de charme.*

Gervasutti, Claudio. (Italian) Color, woman standing in ruined factory holding a piece of red fabric. *Photo* 298 (Jan/Feb 1993): 56.

Gescheidt, Alfred. "Practice Safe Sex." Clothed man playing a standing woman rear view as though she were a violin. *Puchong Folios* (New York) 1 (Spring 1991):41.

Gesinger, Michael. (US 1949-) "Nude Girl Lying in a Field of Ferns and Grass," 1973. Double exp. of woman on her side among ferns. Mamiya 220, 80mm, Isopan 100, daylight. *Camera* 53 (Sep 1974):39.

————. Rear view of woman seated in grass. Mamiya 220, Isopan 100. *Camera* 54 (Sep 1975):30.

Gettys, Belinda Anne. (b. 1944) *The Nude: A Photographic Study of the Male Form.* Atlanta, GA: N.p., 1977. Incl. 16 slides.

Geyer, Michael. (German) Color, woman crouching on beach boulder. *Photo* 268 (Jan 1990):107.

Geysels, Ludo. (Belgian 1944-) From the series "L'alliance artistique," 1979. Male and female semi-nudes costumed in filthy rags and smeared with dirty looking makeup, appears to be an influence on the sadist Peter-Witkin. Color print. SEM:216.

Ghenne. *Indiscrétions.* Paris: Pink Star Editions, 1984. *Photographie de charme.*

Giacobetti, Francis. Series of color posters featuring young women in studio setting, ca. 1980.

————. *Les Filles du Crazy Horse.* Paris: Love Me Tender, 1983. Ten women dancers of the famous Parisian strip club.

————. "Francis Giacobetti." *Photo* 208 (Jan 1985):58-67. Studio shots, full figure studies fo women.

————. "Giacobetti." *Photo* 223 (Apr 1986):72. Four studio shots, LK setting, woman w light bands projected upon her.

Giard, Robert. (US 1939-) Male nudes in HP. Has done female nudes.

Gibson, Ralph. (US 1939-) *Deja-vu.* New York: Lustrum Press, 1973. 1 female nude.

————. *Somnambulist.* New York: Lustrum Press, 1973. 5 nudes.

————. *Days at Sea.* New York: Lustrum Press, 1974. 4 nudes.

————. *Syntax.* New York: Lustrum Press, 1983. Incl. 6 nudes.

————. *L'anonyme.* New York: Aperture, 1986.

————. *Tropism.* New York: Aperture, 1987.

————. *A Propos de Mary Jane.* Paris: Contrejour, 1990.

————. Standing woman with crossed arms, clothed in black from waist up; nudes from navel to mid-thigh, 1972. SEM:57.

————. "Nude with Feather," 1974. Woman holding feather between her buns. SEM:54; DP.

————. Reclining woman with stockings; high contrast frame in which the figure is seen from navel to mid-thigh, 1974. SEM:55.

————. "La Bella d'Anguilla," 1979. NEW:192.

————. "Le Gambe," 1980. NEW:193.

————. "Ralph Gibson." *Photo* 230 (Nov 1986):70. Five fragment studies of women.

————. Standing woman, of whom we see only from chest to knees, 1987. SEM:56.

————. Two frames of women's breasts seen from side angle, the women in an apparently crouched position, 1987. SEM:58.

Giese, Fritz and Hagemann, Heldwig. (eds.) *Weibliche Körperbildung und Bewegungskunst.* Munich: Delphin, 1924. 80 photos.

Giller, Patrick. (French) Woman looking at camera sponging herself in sudsy bathtub. *Photo* No. 298 (Jan./Feb. 1993): 48.

Ginnever, Ronnie. [female] (US) Self-portrait in mirror. Olympus 35mm point and shoot, Tri-X (ASA 1600). *Camera* 50 (Sep 1971):37.

Gioli, Paolo. (Italian 1942-) "Polaroid (Camera Optica)," 1985. Woman's pubic area and male hand to the right. Polaroid color transfer print. SEM:182.

Girard, Sylvie. (French 1948-) (ed.) *Obscures Objets du Plaisir.* Paris, 1986. *Photographie de charme.*

Gittings, Paul Linwood. "Atalanta Reflects." Right profile of woman's torso; diffuse print. *AAP* 52 (1938):91.

Gizard, Stéphane. (French) Man & woman embrace against wooden beach fence. *Photo* No. 298 (Jan./Feb. 1993): 46.

Gladys. (French 1950-) Reclining woman on sofa. Pentax, Tri-X. *Camera* 60 (Sep 1981):27.

Glaser, Nina. *Outside of Time.* 1991[?].

————. Helfand, Glen. "A Portrait of the Artist as a Straight Woman." *The Advocate* (24 March 1992):80. Nina Glaser, a heterosexual, enjoys popularity among the homosexual community. Glaser's photographs have appeared in homosexual publications to critical acclaim.

Glass, Zoltan. *Neue Weg der Aktfotographie.* Stuttgart: Karl Hoffman, 1955. 65 photos.

49

———. Studio shot of standing woman holding large piece of a Calder-like mobile, 1955. AVK:140.

Glaviano, Marco. (Italian 1942-) *Elles: Les Plus Belles Filles du Monde.* Paris, 1986. Incl. semi-nudes of top fashion models Ashley, Carol Gramm, Stephanie Seymour, Joan Severence, Julie Wolfe, Tara Shannon, Claudia Heidelmeyer, Kim Davis, Kristen Hocking, Victoria Kennedy, Carrie Nygren, Lisa Berkley. He used Nikon F3 outdoors, Hasselblad in studio; Tri-X dev. in D-76. Prints made on Kodak Elite paper.

———. "Marco Glaviano." *Photo* 229 (Oct 1986):42. Highlights from *Les Plus Belles.*

———. "Marco Glaviano." *Photo* 231 (Dec 1986):68. More highlights from *Les Plus Belles.*

———. *Models: Sittings, 1978-1988.* Santa Barbara, CA: Day Dream Publishing, 1988. Incl. fashion models semi-nude, virtually same as *Les Plus Belles Filles.*

Globe Photos. Kneeling woman, frontal, face inclined toward right bottom center. BB:34.

Gloeden, (Baron) Wilhelm von. (1856-1931) Lentz, Ron. (ed.) *The Boys of Taormina.* N.p., 1950.

———. *Taormina: Début de Siecle.* Paris: Chene, 1975.

———. *Photographs of the Classic Male Nude: Baron Wilhelm von Gloeden.* New York: Camera/Graphic Press, 1977.

———. Barthes, Roland. (ed.) *Wilhelm von Gloeden.* Napoli: Amelio, 1978.

———. Leslie, Charles. (ed.) *Wilhelm von Gloeden, Photographer.* New York: Soho Photographic Publishers, 1977.

———. Mussa, Italo. *Wilhem von Gloeden.* Munich: Galleria del Levante, 1979.

———. Ammann, Jean-Christophe. (ed.) *Wilhelm von Gloeden.* [Ex. cat., Kunsthalle Basel, 15 Jul–9 Sep 1979.] Basle, Switzerland: Kunsthalle, 1979.

———. Puig, Herman. (ed.) *Von Gloeden et le XIXe Siecle: Eugene Durieu, Charles Simart, Guglielmo Marconi, Vincenzo Galdi, Guglielmo Pluschow, Baron Wilhelm von Gloeden, Auteurs Anonymes.* Paris: H. Puig, 1980.

———. Falzone Del Barbaró, Michele. *Le Fotografie di von Gloeden.* Milano: Longanesi, 1980.

———. Leslie, Charles. (ed.) *Wilhelm von Gloeden.* Innsbruck, Austria: Allerheiligenpresse, 1980.

———. Hieronimus, Ekkhard. *Wilhelm von Gloeden: Photographie als Beschworung.* Aachen, Ger.: Rimbaud, 1982.

———. *Wilhelm von Gloeden. Akt. Photographien.* Aachen: Kiefer & Albers, 1983.

———. Woody, Jack. (ed.) *Taormina, Wilhelm von Gloeden.* Pasadena, CA: Twelvetree Press, 1986.

———. Pohlmann, Ulrich. *Wilhelm von Gloeden: Sehnsucht nach Arkadien.* Berlin: Nishen, 1987.

———. *Akte in Arkadien.* Dortmund, Ger.: Harenberg, 1987.

———. *Wilhelm von Gloeden.* Dortmund, Ger.: Harenberg, 1988.

———. *Wilhelm von Gloeden.* Berlin: Galerie Janssen, 1991.

———. A bit odd for Gloeden, two young women [Arab?] standing against white wall, 1910. USII:61.

Glover, Thomas. Five Sado-Masochistic nudes w women as models. *Photo* 221 (Feb 1986).

Gnade, Michael. (b.1941) *Akt.* Düsseldorf, Ger.: Knapp, 1980. ["How to" manual]

─────. *Perfect Nude Photography*. Windsor, England: Fountain Press, 1984. ["How to" manual]

Goblet, Philippe. (Belgian) Color, 3/4 standing woman frontal, in white netting. *Photo* 232 (Jan 1987):84.

Godal, Eric. Two works in HS: portrait of young woman against horizontally striped b.g.; portrait of woman, arms behind head.

Goersch, Hans. *Aktfotos im Studio*. Bayreuth, Ger.: Schwarz in Komm, 1969; 1970. 40 photos. ["How to" manual]

Godlewski, Willy. *Schönheit und Tanz*. Berlin: Bartels, [ca.1940]. 16 photos.

Goldin, Nan. (US 1953-) "Patrick Fox and Teri Toye on their Wedding Night, New York City," 1987. Color, young couple seated, embracing. WP:154.

Goldsmith, Arthur. *The Nude in Photography*. New York: Ridge Press, 1975. Incl. George Adams, Jack Bassman, E.J. Bellocq, Ferenc Berko, Bruno Bernard, Ruth Bernhard, Gary Berstein, Shalmon Berstein, Miroslav Bilek, Bill Brandt, Annie Brigman, Harry Callahan, R.M. Clermont, Lucien Clergue, Pat Crowe, Imogen Cunningham, Robert Demachy, Jean-Jacques Dicker, E. Durieu, Allen Dutton, Judith Eglington, Elliot Erwitt, Alfred Forsberg, Françoise Nicolas Fried, Hideki Fuji, Masahisa Fukase, René Gelpi, André Gelpke, P. Gowland, Dudley Gray, Milton Greene, Henriette Grindat, Edward Hardin, Arnold Henderson, F. Henle, Walter Hirsch, E. Hosoe, Thom Jackson, Christopher James, Alfred Cheney Johnson, J. Brian King, Peter Kovach, Dick Kranzler, L. Krims, Dorothea Lange, Norman Lerner, George Platt Lynes, Man Ray, Joseph Marotta, Eric Meola, Duane Michals, Paul Mitchell, Barbara Morgan, Kenn Mori, F.M. Neusüss, Arnold Newman, Dianora Niccolini, Don Ornitz, John Rawlings, Donald Reis, David Reiss, Eva Rubenstein, Alan Sass, Charles Schenk, Ronald Seymour, Atsushi Shiiki, Larance N. Shustak, Bill Silano, Peter Simon, Aaron Siskind, Arnold Skolnick, J. Frederick Smith, Neal Spitzer, Ruth Thorne-Thomsen, Peter Tooming, Karen Tweedy-Holmes, Todd Walker, E. Weston. *See individual entries.*

Goldstein, Martin and McBride, Will. *Lexicon der Sexualität*. Wuppertal, Ger.: Jugenddienst, 1970.

─────. *Lexicon der Sexualaufklärung*. Frankfurt, Ger.: Fischer, 1974.

Goodwin, Henry B. (Swede 1878-1931) "Carin B.," 1920. Gum bichromate print of supine woman, visible from chest up. In *The Frozen Image: Scandinavian Photography*. New York: Abbeville, 1982. Unpaged.

Gordon, Larry Dale. Six color images of women, four of which involve a liquid: water, milk, or honey. All studio work, except one taken at Cabo San Lucas, Mexico. He used Nikon F 35mm cameras and Norman strobe lights. CAEP.

Görgens, Bernd. *Edle Nacktheit*. Berlin: Auffenberg, [ca.1925]. 43 photos, incl. Drtikol, Seidenstücker, Reibicke, Herrliche.

Gorman, Greg. *Greg Gorman*. Vol. I. N.p.: CPC Pub., 1989.

─────. "Greg Gorman." *Photo* 270 (Mar 1990):18. From his book, studio nudes taken in natural light incl. models Iman, Brigitte Nielson, Rosetta, Lisa Ann, Janice Dickinson, Taniz Coleridge.

─────. *Greg Gorman*. Vol. II. Tokyo: Treville, Co., 1992. Unpaged.

─────. "Greg Gorman." *Photo* 292 (Mar 1992):44-49. Incl. "Mitzi Martin and Kayce Martin," 1990 (two short haired women embrace); "Djimon," 1991 (black man seated on

pedestal); "Grace Jones and Ulrick Neumann," 1989 (the actress seated, the man at her feet); "Three Men," 1991 (three men seen from behind, jumping up in Mohave Desert); "Ulrick with Lines," 1989 (standing 3/4 man frontal, with geometric lines painted on his skin); "Nick," 1991 (standing 3/4 man frontal, holds his crotch).

Gorsen, Peter and Molinier, Pierre. *Essay über den Surrealistischen Hermaphroditen.* Munich: Rogner und Bernhard, 1972.

Goss, James M. (US 1945-) Beautiful woman sitting in wicker rocking chair lit from draped window in background. *Camera* 53 (Sep 1974):21.

————. Grainy image of rear view of standing 3/4 woman wearing silver bracelets. *Camera* 53 (Sep 1974):29.

Gotlop, Philip. *Eve Unveiled: 48 Studies.* London: Jarrolds, 1941.

————. *Feminine Figure.* London: Thorsons, 1949.

————. *The Technique of Nude Photography.* London: Thorsons Publishers, 1950.

————. *Figure Photography.* New York: Grayson, 1952. 48 photos; 31 lighting diagrams.

Goude, Jean-Paul. (French 1940-) "Nigger Arabesque, New York," 1978. Black woman standing on left leg facing to left of frame, holding a microphone. Bizarre. Color print. SEM:99.

————. *Jungle Fever.* Paris: Love Me Tender, 1982. *Photographie de charme,* including model Grace Jones.

Gowin, Emmet. (US 1941-) "Edith and Elijah," 1968. His wife & infant in doorway. BWC:10.

————. *Emmet Gowin: Photographs.* New York: Knopf, 1976. Incl. 11 nudes of his wife Edith & the kids.

————. "Edith," 1974. His young wife reclining. SEM:172.

————. "Edith (Berry Necklace)," 1971. Young woman standing in a sort of back yard with some berries around her neck, her white dress down at the waist. SEM:173.

————. "Edith and Elijah," 1974. Young pregnant woman and her son lying down in a brook. SEM:173.

————. Five photos of Edith ca.1970. NEW:119-25.

————. "Edith," 1984. Woman sitting in barn window, her belly lumpy, flabby, and sagging. Not beautiful. SEM:174.

————. "Edith," 1987. Same as 1984, except she holds a Ball preserves jar and pours water towards herself; and we are treated to a double image: fruit appears on her belly. SEM:175.

————. *Emmet Gowin.* Boston: Bulfinch, 1990. Incl. several nudes of Edith, e.g. the pissing woman (1971), some of which were already pub'd in his 1976 monograph, & SEM.

Gowland, Peter. (US 1916-) *Figure Photography.* Greenwich, CT: Fawcett, 1954.

————. *How to Take Glamour Photos.* Greenwich, CT: Fawcett, 1955. ["How to" manual]

————. *Glamour Techniques.* Greenwich, CT: Fawcett, 1958. ["How to" manual]

————. *Photographing Glamour.* Greenwich, CT: Fawcett, 1959. ["How to" manual]

————. *The Secrets of Photographing Women.* New York: Crown, 1981. ["How to" manual]

Graeb, Gerhard. (ed.) (b.1919) *Der Foto-Akt. Bilderbuch der Aktfotografie.* Seebruck, Ger.: Heering, 1970. ["How to" manual]

Grabner, Alfred. (German 1896-1978) "Seichtes Wasser," 1935. Woman standing in lake, bending forward. USII:35.

─────. *Die Aktphotographie*. Vienna: Höfels, 1939; 1940; Die Galerie, 1947. ["How to" manual]

Graffeo, Karen. (US 19?) , 1988. Manipulated image of woman standing in an interior doorway. *Aperture* 115 (Summer 1989):53.

Graham, William M. *What is a Woman?* Los Angeles: Elysium, 1966.

Grahm, Gustave. "Youth," [1946?]. Teenage girl seated on lakeside dock. *AAP* 61 (1947):105.

Grahmann, Karl. *Herrliche Nacktheit*. Berlin: Auffenberg, 1933. 40 photos by Seidenstücker, Perckhammer, Riebicke, Herrlich, Drtikol.

Grainer, Franz. (1871-1948) "Weiblicher Rückenakt," 1925. Seated woman, right profile [classicism deluxe]. In *Sammlung Otto Steinert*. Essen, Ger.: Museum Folkwang, 1981:(24).

Gran, Walther. *Nacktbaden*. Leipzig, Ger.: Parthenon, 1928; 1930. 48 photos.

Granta, Roberto. Brief series on French actress Eleonora Vallone. *Photo* 228 (Sep 1986):44.

Grasselt, Karl Heinz. "FKK-Paar," 1983. Color, beautiful & seamlessly tanned couple stand on sandy beach. A:330.

Grau, Paul. (Swiss 1950-) Grainy image of seated woman, thighs to navel only. Pentax 35mm, 80mm, ASA 1000 film, 1,000-watt lamp vertical to model. *Camera* 53 (Sep 1974):10.

Gray, Dudley. (US 1939-) Color, 3/4 shot of woman standing next to a window at the end of a small, derelict kitchen; her back is to us, 1970. Nikon F, 28mm, Ektachrome. *Camera* 50 (Sep 1971):18-19.

─────. Color works in NIP: daylight interior shot of prone woman on couch (13); supine woman (14-15); yellowish unflattering shot of supine woman (236-37); two women visible from the waist down resting on a submerged rock ledge (238-39);prone woman on bed w blue cover (240).

Gray, Jon. *The Manual of Nude Photography*. Text by Michael Busselle. New York: Simon & Schuster, 1983. 100 color; 200 B&W. Well organized, and for this genre well done.

Gray, Orlande. *Sandrine à la Plage*. Paris: Éditions Rares, 1990.

Greene, Milton H. Color, studio shot of standing woman frontal in wet gauze w flowers in hair. NIP:231.

Greenfield, Lois. "David Parsons, Daniel Ezralow and Ashley Roland," 1986. Three semi-nude dancers leaping through the air. WE:159.

Greeven, Werner W. Kneeling woman in LK setting, left profile, right arm raised. BB:2.

─────. Woman appears to be falling through black b.g. BB:6.

─────. Kneeling woman. BB:20.

─────. Woman in LK setting, reclining on left side. BB:33.

─────. Woman's torso viewed from near floor level against black b.g. Print tilted so she lines up diagonally: chest at upper left, knees at lower right. BB:48.

─────. Standing woman in dancelike pose, against black b.g.. BB:59.

Gregor, Miro. (b.1930) Brandt-like shot of face, breast, & elbow. AA:77.

─────. HK & LK silhouettes of breasts. AA:78.

─────. Two women, one LK & one HK. AA:79.

Gregory, Yvonne. "Rythm," 1923. Crouching man. BTM:10.

Grenfell, Katya. (English 1957-) *Naked London*. London: Quartet, 1987.

Grey, David. Blurred motion of woman in front of window. *Camera* 51 (Sep 1972):10.

Grimaldi, Philippe. (French) Woman prone on bed. *Photo* 298 (Jan./Feb. 1993): 51.

Grindat, Henriette. Two prone women in gravel pit. NIP:137.

Groebli, René. (Swiss 1927-) Woman supine on bed w kneeling child, 1953. NN:159.

————. Woman's torso near window [from *Das Auge der Liebe* (1953)]. NN:157.

————. Five woman nudes expressive of intimate moments in daily life. PL:138-47.

————. Blurred motion shot of woman seated on edge of bed, arms raised, holding an article (of clothing?). *Camera* 54 (Jly 1975):35.

Groot, Claus. *Sollen wir nackt gehen?* Leipzig, Ger.: Parthenon, 1927. 48 nature nudes.

Gruber, Leo Fritz. (ed.) *Antlitz der Schönheit.* Köhln, Ger.: Schauberg, 1965. Incl. L. Strelow, R. Winquist, I. Penn, Man Ray, P. Basch, Nadar, A. Genthe, P. Halsman, C. March, H.H. Baumann, G. Hoyningen-Huene.

Gruber, Leo Fritz and Renate. (eds.) Trans. by Michael Rollof. *The Imaginary Photo Museum.* NY: Harmony Books, 1981. Chapter on "The Nude", (129-44).

Guillou, Philippe. (French) Standing woman holding fluffy grey cat. *Photo* 291 (Jan./Feb. 1992):59.

Guimaraes, Norma. (Brazilian 1950-) *Corpos.* Sao Paulo: Massao Ohno, 1987.

Guittet, Michel. Supine woman's butt. on beach. *Photo* 257 (Feb 1989):88

Guttman, Georges. Color, woman prone on seamless. *Photo* 207 (Dec 1984):75.

Gysler, Jean-Pierre. (Swiss) Woman standing amid swirling white sheet. *Photo* 184 (Jan 1983):71.

————. Color, woman's breast & hand, which holds photo of woman's butt. & hand. *Photo* 232 (Jan 1987):64.

Haak, Ken. *Private Collection.* New York: Rosehill Press, 1986.

Haan, Karl de. (b. 1929) *Happy Sunday.* Frankfurt, Ger.: M. Bucher, 1969.

————. *Sunday Sue.* London: Fountain Press, 1970.

————. Blond woman in bathtub. N.

————. Blond woman on knees stroking a pigeon on the floor. N.

Habrecht, Max. "In the Morning." Seated woman stretching. *AAP* 49 (1935):145.

Haenchen, Karl Ludwig. *Der Weibliche Akt.* Berlin: Selbstverlag, [ca.1935].

Haffner, Mary. (ed.) *Sensuality Captured by the Great Photographers of the World.* New York: Putnam Publishing Group, 1983.

Haï, Läm Son. Color, woman's left breast. *Photo* 207 (Dec 1984):cover.

Haisch, Arthur G. *Naked in a Box.* Basel, Switzerland: 3-D World, 1982.

Hajek-Halke, Heinz. (German 1898-1983) Double exp. of standing woman, one light one dark, both same model, 1938. BL:131.

————. Seated woman left profile, reticulated image. NN:188.

Hall, Shirley M. "À la Mode." Seated bare-chested woman gazing into mirror. *AAP* 60 (1946):99.

Hallé, Kiuston. [female] (French 1952-) "Trois Grâces," 1985. Three women stand before two mirrors against studio backdrop. SEM:193.

————. "Cariatide," 1985. Woman stands sideways on studio backdrop, her head not visible; strong directional light aimed at her back. SEM:192.

————. "Kiuston Hallé." *Camera International* 2 (Mars/Avril/Mai 1985):40-49. Eight fragments of women in harsh directional lighting; low key backgrounds.

Hallgren, Christopher. Three exp. sequence in one frame of running woman seen from behind. *Camera* 47 (May 1968):11.

Halmi, Robert. *Photographing Women Simplified.* Garden City, New York: Amphoto, 1976.

———. *La Fotografia de Mujeres: Una Vsion Actual.* Madrid: Ediciones Daimon, 1977.

Halsman, Philippe. (US 1906-79) "Dali's Skull," ca.1950. Dali in profile; b.g. composed of seven women posed to form the likeness of a human skull. NN:180; NIP:110.

———. Several theatrical studio works in NIP: "Nightmare Girl," woman in Japanese mask straddling a pig statue (109); "Body Face," standing woman frontal w face projected onto her torso (111); "Nude with Dali's Mask," 3/4 frontal standing woman wearing a black hood (112); "Where is the Can Opener?" woman straddling a suit of armor (113).

Halus, Siegfried. Parker, William E. "On the Recent Photography of Siegfried Halus." *Aperture* 82 (1979):34-53. Begun in 1976, series of eighteen multi-exposure photographs, shot at night with a 6x6 camera and a flashlight for up to six minutes each. Models discovered their own poses. The work attempted to deliver thoughts from the unconscious, and the images are doors giving access to "childhood visions and spiritual hungers." (36-37)

———. Color, supine woman on Indian blanket w outline of yellow light, 1981. AVK:192.

Hamilton, Charles Franklin. (US 1947-) *Photographing Nudes.* Englewood Cliffs, NJ: Prentice-Hall, 1980. ["How to" manual]

Hamilton, David. (b.1933) *Rêves de Jeunes Filles.* Paris: R. Laffont, 1971.

———. *Les Demoiselles D'Hamilton.* Paris: R. Laffont, 1972.

———. *Sisters.* New York: Morrow, 1973.

———. *Collection Privée.* Paris: R. Laffont, 1976.

———. *David Hamilton's Private Collection.* New York: Morrow, 1976. Same as *Collection Privée.*

———. *Souvenirs.* London: Collins, 1978.

———. *The Young Girl: The Theme of a Photographer.* New York: Morrow, 1978.

———. *La Danse.* Kehl, Ger.: Swan, 1979.

———. *Geträumte Welt.* Kehl, Ger.: Swan, 1980.

———. *The Best of David Hamilton.* London: Collins, 1981.

———. *Tendres Cousins.* Paris: Filipacchi, 1981.

———. *Tender Cousins.* New York: Quill, 1982.

———. *A Summer in St. Tropez.* London: Collins, 1982.

———. *Hommage a la Peinture.* Santa Barbara, CA: Arpel, 1984.

Hamilton, Herbert. "Mindloge I," 1970. Photomontage w women in different poses. BWC:54.

Hammind, Paul. *French Undressing: Naughty Postcards, 1900-1920.* London, 1976.

Hammit, Howard. "Quest." Photomontage of standing woman and statues of a grasshopper & stork. *AAP* 58 (1944):126.

Hammond, Rita. (US 1924-) Standing woman near window. Leica M2, Tri-X. *Camera* 51 (Sep 1972):27.

Hanna, Forman. "Sunlit Brush." Woman seated on cliff ledge looking at a bush. *AAP* 48 (1934):157.

———. "Greeting to the Sun." On clifftop, standing woman w arms raised. *AAP* 49 (1935):168.

———. "Canyon Fragrance." standing woman smelling flowers of bush. *AAP* 55 (1941):122.

———. Young woman [teenage?] standing next to large rock. BB:16.

Hanson, Raymond E. "The West Wind." Standing woman on dune, arms raised. *AAP* 48 (1934):90.

Hardin, Edward. Images in NIP: swaying woman's torso, HK b.g. (31); right profile of woman's torso, LK b.g., skin treated w dark glossy liquid (176); similar effect upon woman's torso rear view (177).

Harding, Goodwin. Pregnant woman in bathtub, 1970. BWC:15.

———. Woman prone on sand, 1970. BWC:63.

Harm, Genevieve. Back of woman's torso. AIS:n.p.

Harrison, Martin. (ed.) (1945-) *The Naked Eye: Great Photographs of the Nude.* Photos selected by David Bailey. New York: Amphoto, 1987.

Hartung, Friedrich. *Mucker und Lichtmensch.* Leipzig, Ger.: Parthenon, 1928.

Haskins, Sam. (South African 1925-) *Five Girls.* New York: Crown, 1962. Five ch. on five women: Bes, Gill, Anna, Helmi, Shirl. The best representative of glamour in the 1960s: busty women, smiles, laughter, sometimes ludicrous makeup. Tech: Rolleiflex, HP3, daylight or tungsten floods aimed through tracing paper.

———. *Cowboy Kate and Other Stories.* Paris: Éditions Prisma, 1966. Humorous nudes.

———. *November Girl.* London: Bodley Head, 1967.

———. An old man's head between a woman's thighs. N.

———. "Breasts in Picture Frames," Pentax 6x7, 150mm, high speed Agfachrome in available light (10); "The Girl on Settee," Pentax 6x7, 150mm, Tri-X (38-39). *Camera* 50 (Sep 1971).

———. *Haskinsposters. A Book of Miniposters Designed and Photographed by Sam Haskins.* New York: Crowell, 1972.

———. *Sam Haskins Photo Graphics.* Geneva: RotoVision, 1980. Unpaged. Incl. 36 multi-exp. color shots of women looking very much like good commercial calender art. All images created in-camera.

———. Photomontages of women similar to those in *Photo Graphics*: 8 color, 1 B&W. MEP.

———. "Nude with Wings." Color, woman's silhouette & four leaves superimposed as "wings". NN:174.

Hattersley, Ralph. *Ralph Hattersley: The Human Form.* Rochester, NY: Rochester Institute of Technology, 1986.

Hatton, Norman. *Norman Hatton: Photographs of Men.* Edited by Volker Janssen. Berlin: Janssen Verlag, 1991.

Hausmann, Raoul. (1886-1971) Woman's breast & hand, ca.1930. AVK:89.

———. "Nude on Beach," ca.1930. Woman supine on beach pebbles. NN:91.

———. Two women on sandy beach in identical pose: reclining on right sides, backs to camera, ca.1930. USII:135.

Hawkes, E.B. "Study of the Nude." Woman kneeling on dune, right profile, staring at her palms. *AAP* 47 (1933):165.

Hawkins, G.L. "Dawn." Standing girl frontal, lakeside. *AAP* 50 (1936):154.

Hayashi, Masahide. (Japanese) *Children's Corner.* 1971.

Hayes, Danielle B. (ed.) *Women Photograph Men.* New York: Morrow, 1977.

Hearsum, Timothy. (US) "Facing the Light." *Photo Metro* (Nov. 1992):19. Two women and a man (standing 3/4) facing camera hold identical portraits of a bearded man.

Hedgecoe, John. (English 1936-) *Possessions*. New York: A & W Publishers, 1978. Unpaged. Incl. 55 women nudes, some color. Shot in an English country house (i.e., mansion), it attempts an interpretation of the daily hedonism of rich men's girlfriends.

———. *John Hedgecoe's Nude Photography*. New York: Simon & Schuster, 1984. ["How to" manual] Well produced, and focused on the artistic nude, unlike most in this genre.

———. *John Hedgecoe's Nude and Portrait Photography*. New York: Simon & Schuster, 1985.

Heinecken, Robert F. (US 1931-) Niece, Robert. *Photo Imagination*. New York: Amphoto, 1966. Incl. 7 works (10, 14, 15, 48, 59, 74).

———. "Motion," 1965. In *American Photography: The Sixties*. [Ex. cat., 22 Feb.–20 Mar. 1966] Lincoln, NE: University of Nebraska, 1966:(20).

———. "3 Views of Figure in Six Sections," 1966. *Artforum* 4 (Feb 1966):58.

———. Lyons, Nathan. (ed.) "Robert Heinecken." *The Persistence of Vision*. [Ex. cat., George Eastman House, June–July 1967] New York: Horizon Press, 1967:(20-31). Incl. "Figure Blocks," 1966 (30); "Figure Cube," 1965 (29); "Figure in Nine Sections," 1965 (31); "Figure Interior/Venus," 1965 (25); "Figure Parts," 1966 (28); "Multiple Solution Puzzle," 1965 (27); "Refractive Hexagon," 1965 (26).

———. "Figure/Flower," 1968. In *Contemporary Photographs*. [Ex. cat., 23 Sep–27 Oct 1968] Los Angeles: UCLA Art Galleries, 1968:(33).

———. "Figure in Six Sections," 1965. *Art in America* 56 (Jan/Feb 1968):75.

———. Belz, Carl I. "The Photography of Robert F. Heinecken." *Camera* 47 (Jan 1968):6-13. Series of 6 woman nude montages.

———. *Mansmag*. N.p., Robert Heinecken, 1969. Artist's book of 12 lithographic prints based on photos from men's magazines. Edition of 120.

———. "Figure Cube," 1965. In *Photographic Imagery*. [Ex. cat., 7-25 Jan 1968] San Diego, CA: San Diego State College, 1968:(10); *Affect/Effect*. [Ex. cat., 9 May–8 June 1969] La Jolla, CA: La Jolla Museum of Art, 1969:(13).

———. "Quartered Figure," 1966. In *Recent Aquisitions 1969*. [Ex. cat.] Pasadena, CA: Pasadena Art Museum, 1969:(37).

———. "24 Figure Blocks," 1966. *Art in America* 57 (Sep/Oct 1969):57.

———. Article by Heinecken: "Manipulative Photography." *Contemporary Photographer* 5 (Aug 1969):73.

———. "Composite: Robert Heinecken." *Photography of the World*. Tokyo, 1969. Incl. 4 works.

———. "Fading Playmate," 1969. *California Photographers*. [Ex. cat., 6 Apr–9 May 1970, Memorial Union Art Gallery] Davis, CA: University of CA, 1970:(62).

———. Wilson, Tom Muir. (ed.) *Into the 70's*. [Ex. cat., 1-30 Apr 1970] Akron, OH: Akron Art Institute, 1970:(60-63). Incl. 3 works.

———. Four works from 1970: *Three Photographers: Curran, Parker, Heinecken*. [Ex. cat., 2-27 Nov 1970] Northridge, CA: California State College, 1970.

———. "Fractured Figure Sections," 1967. *Artscanada* 144/145 (Jun 1970):21.

———. "Square Multiple Solution Puzzle #2," 1967. *Creative Camera* 72 (Jun 1970):n.p.

———. "Robert Heinecken." *Photography of the World*. Tokyo, 1970:(73-76). Incl. 4 works.

———. "Transparent Figure/Foliage no. 1 and no. 2," 1969." *Print* 24 (May/Jun 1970):56.

———. "14 or 15 Buffalo Ladies," 1969. *Village Voice* 15 (15 Oct 1970):19.

———. "Figure/Sections/Beach," 1966. *The Art of Photography.* New York: Time-Life Books, 1971:(161); Swedlund, Charles. *Photography.* New York: Holt, 1974:(xv).

———. Jay, Bill. (ed.) *Views on Nudes.* London: Focal Press, 1971:(150-51). Incl. "Sectioned Figure," 1966; "Figure/Flash/Flower," 1968.

———. "14 or 15 Buffalo Ladies #1," 1969. *Aperture* 15 no.3 (1970):83.

———. "Periodical #5," 1971. *Graphic/Photographic.* [Ex. cat., 12 Mar–23 Apr 1971] Fullerton, CA: California State College, 1971.

———. "Strokes," 1970. *Photography Invitational 1971.* [Ex. cat., 14 Jan–11 Feb 1971, Univ. Arkansas Art Gallery] Fayetteville, AR: Univ. Arkansas, 1971:(17).

———. "14 or 15 Buffalo Ladies #1," 1969. *22nd National Exhibition of Prints.* [Ex. cat.] Washington, DC: Library of Congress, 1971; *Through One's Eyes* [Ex. cat] Fullerton, CA: Muckenthaler Cultural Center, 1973:(27); *New York Times* 21 Oct 1973:(D:31).

———. "14 or 15 Buffalo Ladies #2," 1969. *Light.* Rochester, NY: Light Gallery, 1976:(34).

———. "14 or 15 Buffalo Ladies #3-11," 1969. *San Fransisco Camera* 1 no.5 (1971):18; *New Images in Photography.* [Ex. cat., 24 Mar–21 Apr 1974, at Lowe Art Museum] Coral Gables, FL: Univ. Miami, 1974:(29).

———. Gassan, Arnold. *A Chronology of Photography.* Athens, OH: Handbook, 1972. Incl. "Composite," 1970 (231).

———. "Square Multiple Solution Puzzle," 1967. *Art and Artists* 60 (Mar 1971):26; *Arts in Virginia* 20 (Spring 1971):20.

———. "Lips/Figures," 1969. *Fifteen Photographers.* [Ex. cat., 28 Feb–17 Mar 1972, Pensacola Junior College] Pensacola, FL, 1972:(7).

———. "Periodical #5," 1971. *The Multiple Image.* [Ex. cat., 26 Apr–24 May 1972] Kingston, RI: Univ. Rhode Island, 1972:(22-23).

———. *Robert Heinecken: Photographic Work.* [Ex. cat., 11 Jul–6 Aug 1972] Pasadena, CA: Pasadena Art Museum, 1972. 8p. Incl. 5 works.

———. "Lingerie for a Feminist Suntan," 1972. *Emulsion '73.* [Ex. cat.] Walnut Creek, CA: Walnut Creek Civic Arts Center, 1973; Werner, Donald L. (ed.) *Light and Lens* Bobbs Ferry, NY: Morgan & Morgan, 1973:(82); *Artweek* 4 (22 Sept 1973):11-12; *Southern California 100.* [Ex. cat.] Laguna Beach, CA: Laguna Beach Museum of Art, 1977; *Modern Photography* 41 (May 1977):770.

———. Upton, John. *Minor White/Robert Heinecken/Robert Cumming.* Long Beach, CA: CA State Univ., 1973:(18, 21-23). Incl. 6 works.

———. "Erogenous Zone System Exercise," 1972. Craven, George. *Basic Photography.* New York: Prentice Hall, 1974:(192); Craven, George. *Object and Image.* Prentice Hall, 1975:(192); *The Dumb Ox* 6/7 (Fall 1977/Spring 1978):28; Coleman, A.D. *Light Readings.* New York: Oxford, 1979:(175).

———. "Four Figures," 1970. Doty, Robert. (ed.) *Photography in America.* [Ex. cat., 20 Nov 1974–12 Jan 1975, at Whitney Museum of American Art] New York: Ridge Press, 1974:(208).

———. "Cliche Vary/Fetishim," 1974. *Journal of the Los Angeles Institute of Contemporary Art* 1 (Jun 1974):40; Wise, Kelly, (ed.) *The Photographer's Choice.* Danbury, NH: Addison House, 1975:(47); Upton, Barbara & John. *Photography.* Boston: Little, Brown, 1976:(336); Snyder, Norman. (ed.) *The Photography Catalog.* New York: Harper &

Row, 1976:(192); *Contemporary Trends*. [Ex. cat., Photographic Gallery of Columbia College, Chicago]:(34); *Modern Photography* 40 (Jul 1976):103.

————. "Cliche/Vary Autoeroticism," 1974. Multi-image color panels of woman in the make-up and lingerie of a pin-up model. *18 UCLA Faculty Artists*. [Ex. cat., 30 Sep–26 Oct 1976, at Frederick S. Wright Art Gallery] Los Angeles: UCLA, 1975:(17); *Camera* 54 (Dec 1975):11; *Contemporary Trends*. [Ex. cat., Photographic Gallery of Columbia College, Chicago]:(34); Szarkowski, John. *Mirrors and Windows*. [Ex. cat., 28 Jul–2 Oct 1978, at Museum of Modern Art] Boston: NY Graphic Soc., 1978:(61); *Camera Mainichi* (Japanese) 10 (Nov 1978):59; Witkin, Lee D. and Landon Barbara. *The Photography Collector's Guide*. Boston: NY Graphic Soc., 1979:(160).

————. "Cliche/Vary Lesbianism," 1975. *Light*. Rochseter, NY: Light Gallery, 1976:(34); *Contemporary Trends*. [Ex. cat., Photographic Gallery of Columbia College, Chicago]:(34); *Photo/Synthesis*. [Ex. cat., 21 Apr–6 Jun 1976, Herbert F. Johnson Museum of Art] Ithaca, NY: Cornell Univ., 1976:(15); *Bolaffiarte* (Cornell Univ.) 7 (Oct 1976); *The Dumb Ox* 6/7 (Fall 1977/Spring 1978):28.

————. "Figure Horizon," 1971. *Repeated Images*. [Ex. cat., Slocumb Gallery] Johnson City, TN: East Tennessee State Univ., 1975:(2).

————. "Invitation to Metamorphosis," 1976. *First All California Photography Show*. [Ex. cat., Laguna Beach Museum of Art] Laguna Beach, CA, 1976.

————. "V.N. Pinup," 1968; "Periodical #8," 1972. In *Soft Shoulders*. Chicago: Columbia College, 1976; *Artweek* 7 (1 May 1976):15.

————. "Untitled #15," 1974. *Light*. Rochester, NY: Light Gallery, 1976:(34).

————. Tucker, Jean. (ed.) "Robert Heinecken." *Aspects of American Photography*. [Ex. cat., 1-30 Apr 1976, at Gallery 210] St. Louis, MO: Univ. Missouri, 1976:(30). Incl. 1 color work.

————. Hagen, Charles. "Robert Heinecken." *Afterimage* 3 (Apr 1976):8-12. Incl. 11 works.

————. *One Eye Open, One Eye Closed. Three Photographers Look at the Nude*. [Ex. cat., 3-22 Dec 1976] Calgary, Canada: Alberta College of Art, 1976. Incl. 4 works.

————. Coleman, A.D. *The Grotesque in Photography*. New York: Ridge Press, 1977:(200-205). Incl. "Breast Bomb," 1967; "Costume for Feb.,'68," 1968; "Refractive Hexagon," 1965; "Sectioned Figure," 1966; "24 Figure Blocks," 1966; "V.N. Pinup," 1968.

————. "Autoeroticism," 1974. *Eros and Photography*. [Ex. cat.] San Fransisco, CA: Camerawork Gallery, 1977:(83).

————. "Space/Time Metamorphosis #1," 1975. Tucker, Anne. (ed.) *The Target Collection of American Photography*. [Ex. cat., 25 Feb–1 May 1977, at Museum of Fine Arts, Houston, TX]:(36).

————. "Periodical #9," 1972. *Los Angeles Herald Examiner* (5 Mar 1978):E10.

————. "Five Figures in Vertical Hold," 1969. *The Dumb Ox* 6/7 (Fall 1977/Spring 1978):28.

————. "Refractive Hexagon," 1965. *The Dumb Ox* 6/7 (Fall 1977/Spring 1978):28; Szarkowski, John. *Mirrors and Windows*. [Ex. cat., 28 Jul–2 Oct 1978, at Museum of Modern Art] Boston: NY Graphic Soc., 1978:(47).

————. "Breast Bomb," 1967. *23 Photographers. 23 Directions*. [Ex. cat.] London: Walker Art Gallery, 1978:(40).

————. "Figure Interiors," 1966. *Artweek* 9 (30 Sep 1978):11.

———. "Typo-Lingerie," 1965. *Friday Magazine. A Journal of Art and Politics* (15 Sep 1978); *San Fransisco Examiner* (5 Sep 1978):21.

———. *Robert Heinecken.* New York: Light Gallery, 1979. Portfolio of 3 works.

———. Borger, Irene. "Relations: Some Work by Robert Heinecken." *Exposure* 17 (Summer 1979):36. Incl. 7 works.

———. "Autographic Glove/Lace," 1974. Multi-image panel of woman. CS.

———. Enyeart, James. (ed.) *Heinecken.* Carmel, CA: The Friends of Photography, 1980. Works from 1964-76: multi-image large scale works assembled in grid-like structures. Extensive commentary by Heinecken, who calls himself a paraphotogrpaher, because his images are found already made in the mass publication media. His subjects often involve sexuality & nudes. Incl. 225 item bibliography listing every article, book, citation, or exhibition on Heinecken.

Heisz, Emma. "Nude." Rear view of seated woman, arm raised to cover face; HK print. *AAP* 50 (1936):147.

Heckel, Roswitha. *Liebensleben. Bilder mit Irene.* Munich: Rogner u. Bernhard, 1978; 1980; 1982.

Heller, Amy. Multi-exp. of semi-nude woman seated in chair, w four women in motion superimposed across the lower half of print. *Viewfinder: Journal of Focal Point Gallery* 16 (1992).

Helwich, Othmar. *Der Freilicht Akt.* Vienna: Helwich, 1940; 1949. 35 photos.

———. *Senta. Sonnige Jungmädchenbilder.* Vienna: Helwich, 1944. 62 photos.

Hendin, Arnie. *Nude Landscapes.* New Hyde Park, New York: University Books, 1968.

Henderson, Arnold. Woman supine on plastic sheet. NIP:196-97.

Henle, Fritz. (US 1909-) Crouching woman on huge boulder, seen from her back, 1953. AVK:119; NIP:101: *Popular Photography Color Annual* (1957):64.

———. "Torso," 1953. Rear view of woman's torso, beach b.g. NN:134.

———. "Nude Under Ferns," 1954. Woman's butt. visible among ferns. BL:142.

———. "Running Nude," ca.1950s. Long distance shot of woman running down a sand dune. NN:131.

———. Works from NIP: negative print of woman's torso frontal (32); color, woman dripping wet, seated poolside (94); seated woman on beach (100).

———. Color, woman seated on beach boulder. *Popular Photography Color Annual* (1957):65.

———. *Figure Studies.* London: Studio, 1954; 1956; 1957; 1962. Dedicated to his model Marguerite. Photos created in summer of 1953, incl. 47 works, mostly on beach; from full figure to fragment studies. It is Henle's appreciation of the beautiful in the human form. He strove to depict in a realistic way the variety of common moments in daily life. Incl. tech. info., e.g., Rolleiflex cameras.

———. (contr.) *The Female Form.* London: Arco, 1958.

———. Hall, N. and Burton, B. (eds.) *Great Photographs: Fritz Henle.* London [ca.1950s]. Mr. Rollei (nicknamed for his manual on Rollei cameras) used a Rolleiflex for all shots, incl. "Nude in Studio," woman reclining on her right side back to us, in HK setting (6); "Beach Nude," woman seated on sandy beach, w tire tracks behind her (7); "Mexican Beauty," the young woman model Nievis (who posed for Diego Rivera), standing against a wall (10); "Beach Nude—Torso," lower rear torso of woman, beach b.g. (19).

———. *Fritz Henle.* St. Croix, U.S. Virgin Islands: Henle, 1973. Unpaged. Incl. "Torso," 1953, woman crouching on beach boulder; "Torso," 1954, actually woman's butt. w HK b.g.; "Beach Nude," 1973, upper body & head of supine woman on surf-caressed beach.

Henri, Florence. (US 1893-1982) Woman supine on blanket w conch shell, 1930. DP.

Hensen, Bill. "Image No.9," 1977. Overhead shot of supine man in LK setting. BTM:55.

Herbert, David. *Le Nu.* Paris: Bordeas, 1985.

Herbert, Donald S. "Physique." Left profile of standing woman w short hair, pushing against wall on left of photo. *AAP* 49 (1935):95.

———. "Two Men with Rope," 1938. Studio shot of 2 husky men hauling rope. BTM:39.

Herbert, James. *Stills.* Altadena, CA: Twin Palms, 1992. 54 duotones. Grainy soft focus shots of lovers in bed.

Hereford, S.L. "Figure in High Key." Kneeling woman left profile, arms behind head. Very buxom young woman in HK image. *AAP* 57 (1943):111.

———. "Figure—Low Key." Same shot as *AAP* 57, but this time the figure is outlined in white against LK b.g. *AAP* 59 (1945):119.

Herlaut, Remy. Color, two women frontal, painted silver. *Photo* 207 (Dec 1984):85.

Herman, G. [Ferdinand Max Sebaldt] *Nackte Warheit.* Berlin: Walther, 1909. 16 plates.

Hermans, Willem Frederick. *Fenomenologie van de Pin-up Girl.* Amsterdam, 1950.

Herrlich, Lotte. *Edle Nacktheit.* 3 vols. Dresden, Ger.: Verlag Aurora, 1920-21.

———. *Die Aktphotographie.* Halle-Saale, Ger.: Verlag von Wilhelm Knapp, 1923.

———. *Neue Aktstudien.* Hamburg, Ger.: Heldt, 1923.

———. *Akt-Kunst.* Berlin: Schümann, 1924. 6 nature nudes.

———. *In Licht und Sonne.* Dresden, Ger.: Aurora, 1924. 20 nature nudes.

———. *Rolf. Ein Lied ...* Kettwig, Ger.: Lichtkampf-Verlag, 1924. 30 plates.

———. *Seliges Nacktstein.* 2 vols. Hamburg, Ger.: Heldt, 1927.

———. *Das Weib: Dreissig Lichtbilder.* Rudolstadt: Der Greifenverlag, 1928. 77 photos.

———. *Der Kinderakt und Anderes.* Hamburg, Ger.: Heldt, 1928. 55 photos.

———. *Der Weibliche Akt.* Hamburg, Ger.: Seggern, 1928. Portfolio of 12 prints.

Herron, Don. "Cookie Mueller, Actress, NYC, 1982." Overhead shot of supine woman in bathtub. *Photography in New York* 4 (Jul/Aug 1992):n.p.

Hesselmann, Herbert W. *Princess in Blond und Tango.* Munich: Bahia, 1984. *charme*

Hester, George M. *The Classic Nude.* Garden City, New York: Amphoto, 1973.

———. *Man.* Garden City, New York: Amphoto, 1975.

———. *Woman.* Garden City, New York: Amphoto, 1975.

Heyman, Lionel. Diffuse fragment of kneeling woman. BB:14.

———. Glamour shot of seated woman frontal, arms behind head. HS.

———. Seated/kneeling woman, backlit. HS:cover.

Hicks, Roger William. *Techniques of Pin-up Photography.* Secaucus, NJ: Chartwell Books, 1982.

Hill, Oliver. (b. 1887) *The Garden of Adonis.* London: P. Allen, 1923. 48 plates.

———. *Pan's Garden.* London: P. Allen, 1928.

Hill, W.G. "Combat," 1918. Two men in a wrestling pose in a studio setting. LN:15.

Hilliard, John. "Naked," 1981. Color, woman standing against tiled bathroom wall. NN:187.

Himelfarb, Harvey. (US 1941-) Woman partially standing on chair in window-encircled room, with television on. Hasselblad, 38mm, Tri-X. *Camera* 50 (Sep 1971):17.

Hirokawa, Taishi. (Japanese) Color shot of standing woman holding photos of breasts and crotch in front of her, 1985. BL:161.

Hirsch, Walter. Woman supine on cluttered bed, holding her crotch. NIP:123.

Hirsch-Tennent, Laurie. (US) "Desert Form," 1992. Woman's torso with something projected onto it; over this we see the words of a poem in white characters. *CENTER Quarterly* 14 No. 2 (1992):8.

———. "Nautilus," 1991. Woman with knees drawn up, a photograph of a nautilus projected onto her; over this we see a poem written in white characters. *CENTER Quarterly* 14 No. 2 (1992):8.

Hirth, Paul and Daelen, Eduard. (eds.) *Die Schönheit der Frauen.* Berlin: Herman Schmidt's Verlag, 1905. Incl. 280 photos by E. Büchler, J. Agélou, G. Plüschow, E. Schneider.

Hochhausen, Sandy. "Bill," 1969. Crouching figure on rock. BWC:52.

Hockney, David. (UK 1937-) "Peter Showering, Paris," 1975. CS:115.

———. "Brian," 1982. Color Polaroid assembly (using 66 SX-70 prints) featuring a standing man. NN:191.

———. "Nude, 16th June 1984." Color photomontage in the Cubist manner, of actress Theresa Russell, on commission from her husband, film director Nicolas Roeg. It is one of the few woman nudes Hockney has done. *Hockney on Photography.* New York: Harmony 1988:(107).

Hoepffner, Marta. (German 1920-) Solarized print of woman w arms raised. DP.

Hoeppe, Noëlle. (French 1958-) Woman before mirror, moving slightly, 1983. LN:57.

Hoffman, Rudolh. Fragment view of seated woman w folding arms. BB:21.

Hohmann, Joachim S. *Frauen von Damals.* Frankfurt, Ger.: Förster, 1979.

Holder, Geoffrey. (US 1930-) *Adam.* New York: Viking Press, 1986. He always wanted to record the soul. This black photographer from Trinidad praised Swedish cinematographer Sven Nykvist as an early influence, and also hailed Peter Basch as an influence, primarily because Basch was interested in dance. Holder was a professional dancer before he was a photographer, and the 54 nudes of black men impart a dancer's sense of movement.

Holderman, Karl. Color, floor view of woman's breasts against sky b.g. *Photo* 207 (Dec 1984):85.

Holme, Bryan. (ed.) *The Human Figure.* Tokyo: Shueisha, 1983.

Holme, Geoffrey. (b.1887) *Faces and Figures.* London: Studio, 1939.

Holz, George. (US 1957-) Hurwitz, Laurie S. "The Man Who Loves Women." *Photo/Design* 7 (Jan/Feb. 1990):56. From Tennessee, he went to school in California and worked as Helmut Newton's assistant in the early 1980s before doing his own commercial work (album covers). Began a B&W nude portfolio ca. 1985, and his agent often sends it along with his commercial portfolio to prospective clients. "Found Objects" nudes seem to have been inspired by Leonardo, who wrote that some objects were interesting because they had form and function intended to fit human needs.(76) Holz said "I find women erotic and sensual. I'm very attracted to them sexually."(56) The article contains two nudes: antlers and springs.

Holtzman, Eliot. (US 1953-) Woman's torso on sheets, 1977. Hasselblad, Tri-X. *Camera* 60 (Sep 1981):33.

Hooker, Dwight. *Playboy's Super! Sauber! Schön und Sexy! The Playboy Photographer.* Hamburg, Ger.: Nelson, 1979.

Hoppé, E. O. Seated woman on divan, soft-focus glamour, 1920. AVK:104.

———. *Schöne Frauen.* Munich: Bruckmann, 1922. 36 mezzotint prints.

Horst, Horst P. (US 1906-) Tardiff, Richard and Schirmer, Lothar (eds.) *Horst: Sixty Years of Photography.* New York: Rizzoli, 1991. Some nudes.

———. *Form.* Altadena, CA: Twin Palms, 1991. Incl. 21 male and female studio nudes with Spartan emphasis on form.

———. "Lisa on Silk," 1940. Seated woman on silk draped posing blocks, left profile in diagonal composition. *Photography in New York* 4 (Nov/Dec 1991):n.p.

———. "Odalisque," 1943. Setup that might have pleased Ingres: buxom young woman in ornate headress reclining on large pillows, holding a fan in her left hand. Horst noted that he used tungsten photo-floods, and aimed at a "classical look"; the model was a favorite of New York painter Bernard Lamotte. FT:87; *Horst*:85.

———. Color photo of seated woman, her back to camera, 1980. BL:138.

Horvat, Frank. Four images from his *J'Aime le Strip Tease,* in which dancers of the Crazy Horse Saloon (Paris) have light patterns projected upon them. PL:190-97.

———. "Mythologies–Circe," 1991. Color, photomontage of woman embracing furcoated man on rusting ship w goats. KS:32.

———. "Mythologies–Minos," 1991. Color, photomontage of kneeling woman on a stage. KS:33.

Hoshino, Choichi. *Meiji Ratai Shashincho.* 1970.

Hosoe, Eikoh. (Japanese 1933-) *Man and Woman.* New York: Camerart, 1961.

———. *Otoko To Onna.* Tokyo: Camera Art Sha, 1961.

———. *Killed by Roses.* 1963.

———. *Kamaitachi.* 1969.

———. Two women stand and embrace; side view. *Camera* 48 (Sep 1969):9.

———. *Embrace.* Tokyo: Shashin Hyoronsha, 1971.

———. *Ordeal by Roses.* 1971.

———. "Embrace # 50," 1971. Black man's back and side with white female butt. in background. SEM:82.

———. "Embrace # 60," 1970. Three torsos of differing skin tones pressed together facing the left of frame in studio. SEM:83.

———. Woman's hips and butt. on side, on studio floor, with male hand to the right, palm up, an apple on it. Nikon, Tri-X. *Camera* 53 (Sep 1974):11.

———. Four torsos crunched together. NIP:37.

———. *Human Body.* N.p.: Nippon Geijutsu Shuppansha, 1982.

———. *Eikoh Hosoe: Photographs, 1960-1980.* Rochester, NY: Dark Sun Press, 1982.

———. Strand, Mark. "What's a Body to Do?" *Vogue* 175 (Aug 1985):84.

———. *Eikoh Hosoe.* Carmel, CA: Friends of Photography, 1986.

———. Four studio works from the "Embrace" series. *Photography in New York* 3 (Mar/Apr 1991).

Hough, John David. *Nude Reflections.* San Francisco: Townhouse Books, 1975.

Howes, Geoff. *Photographing Beautiful Women.* New York: Sterling, 1986. ["How to" manual]

Hoy, Buck. Two works in HS: woman's torso frontal; woman's breasts, LK b.g.

———. "Sunset." Backlit seated woman. rear view. *AAP* 54 (1940):93.

———. "Statue." Kneeling black woman w buxom figure. *AAP* 55 (1941):100.

———. "Longing." Supine woman, arms behind head. *AAP* 56 (1942):128.

———. "Light and Shadow." Studio shot of backlit seated woman w arms raised. *AAP* 61 (1946):104.

Huber, Rudolf C. "Aktstudie...von drei ägyptischen Mädchen," 1875. Study of three Egyptian women, 2 standing, 1 seated. Albumin print. USI:139.

———. "Aktstudie von zwei Ägypterinnen," 1875. Two semi-nude Egyptian women. Albumin print. USI:141.

———. "Gruppe von drei sitzenden ägyptischen Mädchen in entspannter Haltung," 1875. Three seated Egyptian women. Albumin print. USI:143.

———. "Rückenakt einer Ägypterin," 1875. Rear view of standing Egyptian woman. Albumin print. USI:145.

Hudson, Richard D. Right profile of kneeling woman. HS.

Hugnet, Georges. (French 1906-74) Woman clothed, standing on beach contemplating 2 pair of breasts rising from the sand, 1947. RK:27.

———. *"Le Magnifique domaine de Trebaumec,"* 1947. Photo-montage: woman's thighs & butt. flying into cabin window follwed by three goats. RK:212.

Hugues, Richard. (French) Most beautiful shot of woman's butt. in swiftly moving stream water. *Photo* 291 (Jan/Feb 1992):54.

Huhn, Michael. *Michael Huhn: Photos.* London: Editions Aubrey Walter, 1992.

Hujar, Peter. (US 1934-87) *Portraits in Life and Death.* New York: Da Capo, 1976. Unpaged. Disjointed mix of portraits, 1974-75, and dead people, 1963. Incl. "T.C.," supine woman; "Linda Moses," supine woman; "Michèle Collison," supine woman.

———. *Peter Hujar.* Basel, Switzerland: Kunsthalle Basel, 1981.

———. "Bruce de Saint Croix," 1976. Young man standing looking at camera. SEM:42.

———. "Daniel Schock," 1981. Young seated male in studio, holding his erect penis. AVK:179.

———. "Peter Hujar Nudes." *Aperture* 114 (Spring 1989):27-29. Disgusting "Seated Male Nude," 1980; and mediocre "Black eyed Susan," 1979.

———. *Peter Hujar.* New York: NYU, 1990. Incl. "T.C.," 1976 (50); "Nicolas Moufarrege," 1981 (65); Bruce De Saint Croix," 1976 (64); "Robert L., Bending," 1978 (74); "John Heys, Nude," 1985 (75).

Hümmer, W. *Ohne Mode.* Leipzig, Ger.: G. Fock Verlag, 1902. 20 plates.

Humphreys, N. Thorp. Color, kneeling blond woman, right profile, torso tilted back, hands pressed on floor. BB:cover.

———. Kneeling woman, profile right, both hands on floor, next to her right thigh. BB:15.

———. Blond woman supine, same model as on cover. Surprising display of public hair [for this time period]. BB:51.

———. Blond woman lying on right side, propped up on right elbow. BB:52.

———. Slightly unpleasant view of kneeling woman, head out of frame. BB:57.

———. Seated woman, head out of frame. BB:75.

Hunger, Egon. (ed.) *Aktfotografie: Variationen und Tendenzen.* Leipzig, Ger.: Fotokinoverlag, 1987. Poor quality photo-reproductions from the former communist East Ger. Incl. mostly nude portraits by M. Backhaus, E.M. Boege, K. Elle, K. Fischer, W.

Fröbus, G. Gueffroy, I. Hartmetz, P. Kersten, J. Kirchmair, L. Lobeck, E. Mahn, M. Nitzschke, M. Paul, H. Praefke, K. Prause, G. Rattei, R. Rössing, G. Rössler, H. Schilling, G. Senkel, U. Steinbrück, N. Vogel, H. Vogel-Henning, W. Wandelt, G. Webber, R. Weisflog, V. Wilhelm, R. Zeun, H. Ziems.

Hunter, Debora. (US 1950-) Double exp. of woman's back and flower, 1974. [Bio. incorrectly mentions this image as a seated woman.] Graflex, 135mm, infrared film, daylight. *Camera* 54 (Sep 1975):36.

Hurault, Charles. "Étude du Nu." Woman's chest & crossed hands; HK print. *AAP* 49 (1935):106.

Hurt, Helmi. (German) Two women in dramatic kneeling pose face each other before a lake. A bit contrived. 1924. BL:95.

Hurth, Robert and Hurth Sheila. *How to Photograph the Human Figure.* Los Angeles: HP Books, 1991.

Huÿbers, Ton. (Dutch 1949-) "The Family," 1987. Three children lying atop a woman, who lies on top a man in a studio. SEM:136.

Immele, Anne. Supine woman in wheat field. *Photo* 280 (Jan 1991):65.

Inamura, Takamasa. *Kirameku Hanabana (Dazzling Flowers).* Tokyo: Nikon Salon Books, 1990. Incl. 24 color, 48 B&W. Exquisite woman nudes, many in a theatrical or dance pose; proving what amazing work can be done despite the anti-pubic hair censorship of the Japanese government.

Ingram, Linda. (US) "Pandora's Box," 1992 (diptych of lead frames and glass covers, 12x18x2 1/2"). Disturbing shots of crouching nudes, sex unknown. As she writes: "I enclose photographs of figures in small boxes...to focus upon repression and confromity, whether it be self-induced or socially imposed." *CENTER Quarterly* 14 No. 2 (1992):10.

Ingrand, Patrick. (UK) Color, woman's torso frontal, in barn window. *Photo* 184 (Jan 1983):68.

Ionesco, Irina. (Romanian 1935-) *Temple aux Miroirs.* Paris: Seghers, 1977.

———. "La favorite," 1978. Woman standing on round tray, wears much jewelry. JL:38.

———. "Métamorphoses de Marie-France, 1978 Paris." Two photos of woman [?] in heavy make-up, long gloves, fishnet stockings, and sharp instruments. JL:39.

———. *Cent Onze Photographies Érotiques.* Paris: Eurographic, 1980.

———. Series of 8 portraits of exotically costumed women, w extreme theatrical makeup. NEW:138-45.

———. *Passions.* Paris: Pink Star Editions, 1984.

———. *Le Divan.* [Paris, 1984?]

———. "Nude," 1985. Young woman, full figure study, apparently resting on a black velvet backdrop; flowers in vase in foreground. Slightly ridiculous. SEM:171.

———. "Ionesco recrée Bardot." *Photo* 211 (Apr 1985):96-103. Color, glamour shots of 14 year old girl, her daughter Eva.

———. "Harem," 1986. Studio shot of seated woman on draped posing block, wearing stockings & corset, opening her legs to reveal her vulva. *La Recherche Photographique* 5 (Nov 1988):14.

———. Brief color series on French actress Agnes Soral. *Photo* 228 (Sep 1986):44.

———. "Irina Ionesco." *Photo* 234 (Mar 1987):66. Color, 6 woman nudes in theatrical style, of actress Anne de Broca.

———. *Les Immortelles.* Paris: Contrejour, 1991.

Isenfels, Paul. *Getanzte Harmonien.* Stuttgart, Ger.: Dieck, 1928. 120 photos.

Isserman, Dominique. *Anne Rohart.* Munich: Schirmer/Mosel, 1987. Incl. 17 photos of a woman (Ms. Rohart) w a white sheet in a French chateau. Simple, elegant, timeless.

———. "Isserman." *Photo* 235 (Apr 1987):54. Highlights from *Anne Rohart*, who is quoted as saying Dominique gave her a space in which she "found her place."

Italiani, Giulio. *Il Nudo nella Fotografia.* Rome: Fotografare, 1969. 95 plates.

Ito, Toshiharu. (Japanese 1953-) *Tokyo Shintai Eizo.* Tokyo: Heibonsha, 1990.

Iverslien, Gry. *Men: For Women Only.* London: Columbus, 1988. Man nudes.

Izon, Noel. *Venus Explored: A Study of the Female Form.* N.p.: Rebecca Press, 1980.

Jablonski, Chris. (Australian) Color, magnificent rear torso shot of woman pulling up her red T-back briefs. *Photo* No. 291 (Jan./Feb. 1992):50.

Jabur, Rudy. (b.1952) Six color shots of three women on a beach at night. *Photo* 212 (May 1985).

Jachna, Joseph. Fist in f.g., standing woman in b.g., 1969. BWC:45.

Jackson, Thomas. Two studies of woman's torso in window frame. NIP:212, 213.

Jacoby, Max. (German 1919-) Pregnant woman reclining on divan with two toddlers on her knees; they touch her expanded belly. Pentax, 35mm, Tri-X, artificial light. *Camera* 49 (Sep 1970):16.

———. Standing woman in ruined building in Berlin. Pentax Spotmatic, 35mm, Tri-X (ASA 800). *Camera* 50 (Sep 1971):29.

Jacqdot, Claude. LK setting, supine woman on bed under window. *Photo* 184 (Jan 1983):70.

Jacquet, Marcel. (Spanish) Color, woman standing in desert environment, tossing red article of clothing into the air. *Photo* No. 291 (Jan./Feb. 1992):52.

———. Color, woman on hands and knees, scaling large diagonal rock. *Photo* No. 298 (Jan./Feb. 1993): 57.

James, Christopher. Woman's butt. & hands. NIP:39.

Jan, Hermann Ludwig and Hildenbrand, Hans. *Das Lebende Modell.* Leipzig, Ger.: Schumann, 1904. 20 plates.

Janah, Sunil. *The Second Creature.* Calcutta: Signet Press, 1949. 64 plates.

Janiš, František. (Czech 1925-) Front view of seated woman. AA:68.

———. Abstract LK women nude. AA:65-66.

———. Fragment of woman's breast & thigh. AA:62.

Janssen, Volker. (ed.) *Bilder aus der FKK-Bewegung der 20er Jahre.* Ser.: Der Nackte Mann in der Fotografie; Bd. 1. Berlin: Fotokunst-Verlag, 1987.

Jay, Bill. *Views on Nudes.* New York: Focal Press, 1971.

Jeanmougin, Yves. *Nous, Les Femmes.* Edited by C. Balez. Paris: Contrejour, 1980.

Jennings, Thomas. (b. 1914) *The Female Figure in Movement.* New York: Watson-Guptill, 1971.

Jensen, Jens S. Four frames of woman standing, reclining, crouching, among rocky cliffs. *Camera* 50 (Feb 1971):30.

Jensen, Robert. (US 1950-) Blurred motion study of man and woman walking in small bedroom. Mamiya 220, Panatomic, 8 sec. exp. at f/11. *Camera* 52 (Jly 1973):24.

Jesse, Nico. *Frauen in Paris.* Text by André Maurois. Hamburg, Ger.: Wegner, 1954; 1958.

Jésus, Sergio. Color, woman's hip. *Photo* 207 (Dec 1984):80.

Jírů, Václav. Seated woman combing her hair before open window. JS:II.

Jobst, Norbert. *Jobst Nudes*. Los Angeles: Academy Press, 1978.

———. *et al. The Natural Man*. Los Angeles: D. Lambert, 1975.

Joel, Yale. *Creative Camera Techniques*. New York: Random House, 1979.

Johnston, Alfred Cheney. (US 1893-1971) "Drucilla Straine," 1928. Semi-nude seated woman in studio, draped with sheer material, wearing white high heeled shoes. LN:34; DP.

———. *Enchanting Beauty: Studies of the Human Form in the Nude*. New York: Swan, 1937. 93 plates.

Jolitz, William R. *Deborah's Dreams: A Victorian Fantasy*. Chicago: Playboy Press, 1976.

Jones, Terry. (ed.) *Private Viewing*. London: New Leaf Publishing, 1983. 76 B&W, 127 color.

Jonas, Irène. Color, woman's torso on blue satin sheet. *Photo* 232 (Jan 1987):64.

Jonvelle, Jean-François. (French 1944-) *Mistress*. Paris: Love Me Tender, 1983. *Charme*.

———. "Jonvelle: Le Livre le plus érotique de l'année." *Photo* 187 (Apr 1983):28-39. Highlights from *Mistress*.

———. *Jonvelle*. *Charme*.

———. *Jonvelle Marrakech*. Paris, 1986. *Charme*.

———. *Jonvelle St–Barthelmy*. Paris, 1986. *Charme*.

———. *Jonvelle Venise*. Paris, 1986. *Charme*.

———. "Jean-François Jonvelle." *Photo* 230 (Nov 1986):98. Four *charme* shots of woman on bed.

———. *Jonvelle Bis*. Paris: Nathan, 1989. *Charme*.

———. Lucas, Nicole. "Jonvelle bis." *Photo* 259 (Apr 1989):46. Incl. 6 unpublished woman semi-nudes *charme* style.

Jorgens, Gunilla. *Schoolgirl Sex*. London: Luxor Press, 1971.

Journiac, Michel. (French 1943-) "Arletty. Piège pour un travesti," 1972. Three photographs of a transvestite. SEM:206-7.

Jousson, Pierre. *La Femme: Photographies*. Paris: Maspero, 1964.

Jullien, Philippe and Neagu, Philippe. *Le Nu 1900*. Paris: A. Barret, 1976. Superior photoreproduction of nudes created during the period between 1890 & 1910. Infuriating lack of titles & dates; Incl. rare color works from Edmond Goldschmidt (138-40, 142-43); also G. Marconi, B. Braquehais, Durieu, d'Olivier, Julien Vallou de Villeneuve, F. Nadar, Marie-Alexandre Alophe, Puyo, Steichen, Eakins, F. Eugene, Demachy, White & Steiglitz, C. Schenk, Paul Bergon, A. Brigman, Le Bègue, Bonnard, Gloeden, Heinrich Zille, Pierre Louys.

Kaasik, Toomas. (Russian) "Night Dream," 1989. Double exposure of woman reclining and standing on bed. *Aperture* 116 (Fall 1989):46.

Kai, J. "Profile." Crouching woman between two urns. *AAP* 47 (1933):147.

Kaida, Tamarra. "Kris and Paul," 1980. Adolescent male standing beside man in desert. AVK:180.

Kaleya, Tanya. *Woman*.

———. *Les Hommes*. New York: Harmony Books, 1975.

Kalmus, Yvonne. *et al.* (eds.) *Women See Men*. New York: McGraw Hill, 1977. Incl. Penny Rakoff, Sarah Leen, Joanne Leonard, Vivienne Maricevic, Starr Ockenga, Bernis von zur Muehlen, Carol Weinberg. *See also* Hayes, Danielle B.

Kane, Art. (US 1925-) *The Persuasive Image: Art Kane*. [Masters of Contemporary Photography ser.] Los Angeles: Crowell, 1975. Incl. 9 color nudes, some of which attempted

something new in "men's magazine" imagery: close-ups of women's pubic hair cut & styled into different shapes. [Unusual report of auditioning models for this project.]

―――――. Color, 8 shots of man & woman in barren kitchen in simulated sex acts. MEP.

―――――. *Paper Dolls*. Los Angeles: Melrose Publishing Group, 1984. Women wearing masks and little if anything else.

―――――. Five shots of male/female couple, seen shoulders to knees, undressing or holding each other. Nikon camera, 105mm lens, Plus-X film, Dynalite strobe. CAEP.

Kanny, Jean-Claude. Color, supine woman balanced upon two pillars. *Photo* 257 (Feb 1989):77.

Karadag, Cerkes. (Turk 1953-) *Nuans*. Ankara, Turkey: Dost Kitabevi Yayinlari, 1989.

Karczok, Kurt. *Akt-Aufnahmen-Abc. Der Menschliche Körper in Foto und Film*. Munich: Gemsberg-Verlag, 1970.

Karpf, Nikolaus. (ed.) *Schule der Aktfotogrfie*. Munich: Verlag Grossbild-Technik, 1979. ["How to" manual]

Karsten, Thomas. (German) Polaroid SX-70 color montage of reclining pregnant woman, 1986. BL:169.

―――――. Studio shot of woman in ballet shoes seated on pedestal, back to camera, legs widely splayed, hands on butt., head turned left. KS:46.

―――――. "Kathrin/Berlin," 1991. Color, 24 Polaroid SX-70 images arranged to show the same standing woman in 2 frontal & 4 rear views. KS:34-35.

Kassowitz, Ernst. Supine woman's head & chest, LK b.g.

Katz, Brian M. "Appearing out of," 1969. Reclining woman on floor, w distorted image on b.g. wall. BWC:42.

Katz, Joel. (US 1943-) Color, woman's hip in front of window. Nikon F, 21mm, Ektachrome. *Camera* 50 (Sep 1971):cover.

―――――. Rather bony looking woman, standing in a room, leaning against wall, viewed from above her right shoulder. Nikon F, 21mm, Tri-X. *Camera* 51 (Sep 1972):38.

Kay, Barry. *Die Anderen Frauen*. Frankfurt, Ger.: Fricke, 1976.

Keller, Josef. *Mädchen...nichts als Mädchen*. Starnberg, Ger.: Keller, 1963.

Keller, Pierre. (Swiss 1945-) "Lyon," 1987. Something furry [a woman's public area?]. Cibachrome. SEM:94.

Kells, Harold F. "Salome (Remorse)." Pictorialist extravagance: kneeling woman, antique vase, severed head on floor, man's portrait in b.g. presumably John the Baptist. *AAP* 49 (1935):129.

―――――. "Grecian Nocturne." Two seated women w classical Greek urn & roses. *AAP* 50 (1936):175.

Kelly, Jain. *The Urban Nude*. New York: Palladium Press, 1981.

―――――. (ed.) *Nude: Theory*. NY: Lustrum Press, 1979.

Kelly, John. *Successful Glamor Photography*. New York: APBPC, 1981.

―――――. *Erotik-Foto. Der Playboy-Fotograf*. Derendingen, Ger.: Habegger, 1983.

Kelly, Tom. "Marilyn Monroe." Famous color image of the young actress reclining on red [velvet?] b.g. NN:129.

Kemmochi, Kazuo. (Japanese 1928-) *Ninfetto Junisai No Shinwa*. 1969.

―――――. *Junisai No Shinwa*. 1970.

Kent, Sarah. "Male Nude," 1982. Beach setting, supine male fragment, man's penis at center. NN:212. Kent saw the penis not as a symbol (in feminism) of oppression, but as a reminder of warmth, intimacy, and pleasure.

Kennedy, Andrew. *Shoreleave*. Berlin: Bruno Gmünder, 1988.

Kernan, Sean. (US 1943-) Woman's rear torso. Hasselblad, 150mm, Tri-X, daylight. *Camera* 54 (Sep 1975):8.

Kerry, Allen. (US) Standing man holding some sort of grid. *Photo* No. 298 (Jan./Feb. 1993):48.

Kertész, André. (Hungarian 1894-) *Distortions*. New York: Knopf, 1976. Distorted women nudes similar in effect to carnival fun-house mirrors.

————. "Distortions" #16, #79, #29. RK:102-103.

————. From his "Distortions" series, standing woman frontal w arms atop head, before fun-house mirror. *Photography in New York* 4 (May/Jun 1991):n.p.

————. "Nude," 1939. Woman's torso w semi-classical statue head f.g. CS:88.

Kessels, Willy. (Belgian 1898-1974) Bauret, Gabriel. "Trois Surréalistes," *Camera International* 26 (Summer 1990):66-75. Includes a few semi-abstract nudes by Kessels.

Kesting, Edmund. (German 1892-1970) "Sun of the Midi," 1928. Solarized print of supine woman & prone man on beach. In Maria Morris Hambourg, *The New Vision. Photography between the World Wars*. New York: H. Abrams, 1989:(62).

King, J. Brian. Two images in NIP: soft focus portrait of woman, HK b.g. (134); silhouette of woman's mid-section (184).

King, Kathleen. (US) Ektacolor print of woman's torso and head with right arm raised, an anatomical drawing of a woman's breasts projected onto her; the drawing shows the breasts sectioned, or cut out to reveal mammary glands and related tissue; the model holds a melon before her left breast, and it too is cut out to reveal a core which resembles the breasts in the drawing; 1991. Reminds one of Francesca Woodman's works 15 years earlier. *CENTER Quarterly* 14 No. 2 (1992):11.

Klasson, Eva. (Swedish 1948-) Hair [pubic area?] being pulled up, 1976. SEM:90-1.

————. *Le Troisieme Angle*. France: Birth Editions, 1979.

Klarry, C. (b. 1837) *La Photographie du Nu*. Paris, 1902. 56p.

Klemm, Erich. *Girls, Girls*. Munich: Verlag Laterna Magica, 1973.

Klooss, Reinhard and Reuter, Thomas. *Kraft und Schönheit. Die Geschichte der Körperkultur Bewegung in Deutschland*. Frankfurt, Ger.: Syndicat, 1984.

Koch, Adolf. *Gymnastik*. Leipzig, Ger.: Oldenburg, 1932. FKK nudes.

————. *Das Nacktkulturparadies von Berlin*. Leipzig, Ger.: Oldenburg, 1933. 34 photos.

————. *In Nature und Sonne*. Berlin: Weiß, 1949.

————. *Schönheit des Leibes*. Berlin: Verl. Dt. Leibeszucht, 1949.

Koch, Margarete. *L'Act. Der Act*. N.p., Internationaler Kunstverlag. 100 plates.

Koch, Max. *Freilicht. 50 Modellstudien*. Leipzig, Ger.: Int. Kunstverlag, 1897.

Koch, Max and Rieth, Otto. *Der Akt. 100 Modellstudien*. 10 vols. Leipzig, Ger.: Int. Kunstverlag, 1894-95.

Koelbl, Herlinde. (b. 1939) "Hermann Dollinger," 1983. Old man in studio portrait. AVK:181.

————. "Michael Ratajczak," 1983. Studio shot of supine midsection of man, w semi-erect penis. BTM:41.

————. *Men*. Cologne, Ger.: Taschen Comics Verlag, 1985.

————. *Manner*. Munich: C.J. Bucher, 1985.

Koeppe, Wolfhard. Panorama camera shot of tall young woman reclining face down in the shade of a rocky ledge. She is almost pure white. How did he achieve this effect? Part of series published orignially in the Swiss *Portfolio Photographie*. See *Photographis 87* (New York: Graphis U.S., 1987):125.

Köhler, Michael and Barche, Gisela. (eds.) *Das Aktfoto: Ansichten vom Körper im Fotographischen Zeitalter: Ästhetik, Geschichte, Ideologie.* [Catalog of exhibition in 1985 at Münchner Stadtmuseum] Munich: Bucher, 1985. 448p. Massive tome w 23 ch., mostly text. Incl. work by L. Albin-Guillot, L.F. de Alfaro III, C. von Alvensleben, D. Appelt, D. Arbus, J.–E. Atget, F. Attenhuber, D. Bailey, P. Basch, W. Baumeister, E.J. Bellocq, A. Benda, F. Berko, R. Bernhard, P. Berthier, I. Bing, D. Blok, P. Booth, P. Boucher, G. Bourdin, B. Brandt, A. Brigman, M. Broekmans, F.J. Bruguière, W. Bullock, M. Burns, L. Clergue, Colette, G. Courbet, I. Cunningham, B. Dahmen, J. Dater, R. Demachy, A. de Diénes, E. Dorfman, F. Drtikol, J. Dunas, E. Durieu, A. Dutton, S. Enkelmann, F. Eugene, B.J. Falk, R. Festetics de Tolna, F. Fiedler, T. Fleischmann, T. Frima, J. Gantz, H. Gebhardt, J. Geiser, B. de Genevieve, A. Genthe, F.J. Gillen, P. Gioli, W. von Gloeden, K.–H. Grasselt, J. Gross, J. Guy, B. Hagen, H. Hajek-Halke, K. Hallé, D. Hamilton, R. Hausmann, V. Hayd, F. Henri, L. Herrlich, H.W. Hesselmann, J. Hilliard, D. Hockney, H. Höch, M. Hoepffner, H.P. Horst, P. Houcmant, F. Jacobs, A.C. Johnston, A. Kertész, E.L. Kirchner, F. Knott, H. Koelbl, R. Kohmann, R. Koppitz, A. Krämer, A. Krauth, L. Krims, G. Krull, H. Kühn, H. Lander, H. Langdon, W. Larson, M. Lehmann, C. Leidmann, J.W. Lindt, H. List, W. Loth, E. Luxardo, C. MacAdams, D. Kallmus, A. Mahl, B. Malinowski, G. Mangold, M. Ray, P. Manzoni, G. Marconi, É.J. Marey, D. Matthes, L. Merlo, P. Molinier, S. Moses, F.–J. Moulin, O. Mühl, M. Müller, E. Muybridge, S. Nazarieff, H. Newton, D. Niccolini, T. O'Byrne, L.–C. de Olivier, D. Oppenheim, P. Outerbridge, W. Paine, R. Parkinson, D. Pedriali, I. Penn, F. Pezold, G. P. Lynes, W. Plüschow, R. Pöch, A. Rainer, K. Reichert, L. Reutlinger, G. Riebicke, H. Rittlinger, D. Rodan, H. Röttgen, F. Roh, U. Rosenbach, A. Sahm, L. Samaras, J. Schaumberg, X. Schawinsky, H. Schubotz, G. Schuh, B. Schultz, P. Schultz, A. Schultze-Naumberg, J. Schumacher, R. Schwarzkogler, T. Secchiaroli, C.G. Seligman, K. Shinoyama, J. Sieff, P.–C. Simart, T. Simpfendorfer, G. Spencer, E. Steichen, O. Steinert, B. Stern, A. Stieglitz, P. Streeger, F. von Stuck, K. Székessy, T. Shinkichi, I. Taubhorn, K. Teige, G. Tessmann, D. Turbeville, J. Uelsmann, O. Umbehr, J. Vallou de Villeneuve, C. Vogt, G. Vormwald, M. Weidemann, M. Weiss, J. Welpott, E. Weston, C.H. White, J. Wildbolz, M. Willinger, A. Zeller.

Köhler, Michael. (ed.) (b.1946) *Ansichten vom Körper: das Aktfoto, 1839-1987.* [Ex. cat.] Schaffhausen, Switzerland: Edition Stemmle, 1987. 20 chapters arranged topically, the most peculiarly Germanic being Ch. 7 "Freikörperkultur, 1920-1945" [roughly translated: free body culture, or nudism] featuring men & women dancing and exersizing outdoors in the sun, incl. works by M. Müller, Julius Gross, Kurt Reichert, H. Rittlinger. This volume is the better of Köhler's *Aktfoto* compilations if one were interested primarily in the quantity & quality of photoreproductions.

———. *Le Nu dans le Photographie, 1840-1986.* Schaffhausen, Switzerland: Edition Stemmle, 1987.

Kohmann, Rita. (German 1946-) Six high contrast grainy frames of two women with hideous tan lines horsing around. *Camera* 51 (Oct 1972):29.

———. Woman prone on dark satin-like sheets. Hasselblad, Tri-X. *Camera* 53 (Sep 1974):33.

—————. Four men, four women, one boy, one sofa, in beautifully lit room. *Camera* 60 (Aug 1981):8.

Kollár, František. (Slovak 1904-79) *František Kollár.* N.P.: L'Ubomír Stacho, 1989. Incl. "Nude," ca.1930s, woman's torso frontal, HK b.g. (35); "Nude," ca.1930s, woman's torso frontal, LK b.g. (36).

Kolleogy, F. *See* Jobst, Norbert.

Koppitz, Rudolf. (Austrian, 1884-1936) "Motion Study," ca.1926. A woman stands but bends gracefully backwards in front of three black-robed young women, as if they were supporting her in some way. IPM; LN:30 [gives date as 1923]; DP [gives date as 1927]; WE:180; USII:93 [gives date as 1927].

—————. Woman lying on rock in seascape, face up, 1925. BL:84.

—————. "Bewegungstudie," 1929 (32x39cm). Young woman (nude from hips up) bows her head, eyes closed, with three black-robed women close to her. *Photographies* 7 (Mai 1985):93.

Kosek, Pavel. (Czech) Two seated women face each other in one room, one on right bent over at waist, one on left looks left, 1967. *Camera* 48 (Sep 1969):30.

Koßmann, Robby and Weiß, Julius. *Mann und Weib.* Stuttgart, Ger.: Union, 1927.

Koundoulos, Nikos. *Junge Aphroditen.* Bremen, Ger.: Bertelsmann, 1965.

Kovach, Peter. Two works in NIP: prone woman among flora (183); photomontage of three seated women on beach, reminding one of K. Shinoyama (182).

Koven, Blanche de. Oiled woman, seated, right profile, head out of frame. HS.

Kranzler, Dick. Series of distorted color prints of women in fragment approach. NIP:164-70.

Kratochvil, Antonin. Six color fantasy images involving women. CAEP.

Krause, George. (US 1937-) "White Cotton Panties," 1977. Standing woman on table in studio, illuminated by one flourescent lamp at right. NEW:187.

—————. "Venus," 1979. White sheet attached to wall, woman sitting in it. NEW:186.

—————. *I Nudi/George Krause.* [Philadelphia?]: Mancini Gallery, 1980.

—————. "Swish," 1980. Woman partially seated amid black studio background, waving a white cloth. BL:144.

Krauss, Friedrich Salomo. *Die Anmut de Frauenleibes.* Leipzig, Ger.: Schumann, 1903; rev. edn. Vienna: Kosmos, 1923. 300 photos.

—————. *Die Anmut des Weiblichen Körpers.* Leipzig, Ger.: Verlags-Actien-Ges., 1906. Incl. von Edély, S. Fleck, V. Angerer, C. Scolik, J. Löwy.

—————. *Streifzüge im Reiche der Frauenschönheit.* Vienna: Kosmos, 1924. 140 photos.

Krauss, Rosalind E. *L'Amour Fou: Photography and Surrealism.* New York: Abbeville Press, 1985. Incl. Maurice Tabard, Georges Hugnet, Raoul Ubac, Brassaï, Man Ray, Hans Bellmer, J.–A. Boiffard, A. Kertész, Lee Miller, Nusch Eluard, Marcel Mariën.

Kraysler, Joseph. "Figure in Profile." Profile of woman's torso, HK print. *AAP* 49 (1935):107.

Kretty, Jean-François. Color, five studio shots of woman's butt.; one shot of woman's chest bound w rope. Apparent soft-box lighting. *Photo* 226 (Jul 1986):12.

Krims, Leslie. (US 1943-) Woman seated in chair near ceiling of room in which woman on right is in blurred motion, 1970. BWC:37.

—————."Nude with Leaping Cat," 1970. Cat leaps between chairs in front of a woman standing against a wall wearing ballet shoes. LN:53; DP.

———. Two works from series "Chicken Soup" which features his mother wearing large white briefs, preparing & eating chicken soup. NIP:246-47.

———. *Fictcryptokrimsographs: a book-work*. Buffalo: Humpy Press, 1975. Series of 40 Polaroid SX-70 photos, mostly of women being worked over; a fixation on breasts & nipples.

———. Color Polaroid SX-70 self-portrait, sitting in Bruer chair with topless young woman in his lap. *Camera* 57 (Sep 1978):10.

———. "Buffalo Fashion...," 1979. Another weird *tableau d'Krims*: man & woman holding fishing tackle, sliced bread, & bric-a-brac. CP:557.

———. Color photo of woman standing on a table in a room. What makes it unusual is the decor of both room and model, 1980. The former is painted floor to ceiling in a pattern of yellow, green, and orange, while the latter is decorated with colored strips of paper(?). BL:159.

———. "A Marxist Vision," 1984. An old woman peering into a microscope, 2 young women w sagging breasts, and a clothed woman, arranged in a room stuffed w bric-a-brac. DP

———. "Leslie Krims." *Photo* 230 (Nov 1986):56. Four theatrical arrangements w nude women; captured on Polaroid film.

Kroll, Eric. *Sex Objects*. Danbury, NH: Addison House, 1977. Portraits of young women who worked in the sex industry. Extensive interviews.

Krull, Evelyn. (German) "Körpersprache XV," 1986. Crouching woman holding on to dark pole. BL:194.

Krull, Germaine. (French 1897-1986) *Kara Mappe*. 2 parts. Leipzig, Ger.: Oldenburg-Verlag, 1923. Photos of young men & women, 6 prints in each part.

———. "Nude," 1926. Woman prone, shoulders to knees visible, in diagonal composition. WP:99.

———. Frontal torso of seated woman, left hand behind her neck, 1929. WP:100.

Krynicki, Andrzej. (Pole) Three women in domestic interior: one seated, one standing, one reclining. *Photo* 257 (Feb 1989):88.

Kuenster, Ken. (US 1931-) Color Polaroid SX-70. Woman's butt. & red curtain fringe. S.

Kühn, Heinrich. (German 1866-1944) Weiermair, Peter. (ed.) *Heinrich Kühn*. N.p.: Allerheiligenpresse, 1978. Two works from this foremost practitioner of the gum bichromate print in the pictorialist style: "A Nude," 1904, rear view of standing woman against desk (50); "Nude Girl," 1922, seated woman on bed (88).

———. "Akt," 1906. Two studies ofseated woman w long hair in *Sammlung Otto Steinert*. Essen, Ger.: Museum Folkwang, 1981:(18).

Kühn, Richard. *Die Frau bei den Kulturvölkern*. Berlin: Neufeld u. Henius, 1932. Incl. Perckhammer, W. Hege, Hoppé, Lendvai-Dircksen.

Kupfer, Christian. (comp.) *Internationale Aktfotografie*. Leipzig, Ger.: Fotokinoverlag, 1966. 140 photos.

Kunkel, Albert. *Nacktzauber*. Laipzig, Ger.: Parthenon, 1927. Incl. d'Ora, Bucovich.

Kurigami, Kazumi. "Kazumi Kurigami." *Photo* 225 (Jun 1986):98. Color, one studio shot of 2 seated women wearing veils; one shot of two standing men rear view, in dance poses.

Labadie, Gérard. (French) Color, supine woman on rock, arms over head, visible from waist up. *Photo* 184 (Jan 1983):74.

———. Color, supine woman on boat deck. *Photo* 207 (Dec 1984):76.

———. Color, woman's vulva w her hands on either side, gloved in pink & yellow. *Photo* 232 (Jan 1987):65.

———. Color, supine woman in harsh shadows & highlights. *Photo* 232 (Jan 1987):75.

———. Color, woman's torso rear view; she is pulling down her jeans. *Photo* 268 (Jan 1990):111.

———. Color, woman with blotches of ink on her skin reclining in a bathtub, holding a sponge and spraygun. *Photo* 291 (Jan/Feb 1992):52.

———. Color, woman's breast with tattoo on it, covered with water droplets. *Photo* 298 (Jan/Feb 1993): 52.

Lacey, Peter. *The History of the Nude in Photography.* New York: Bantam Books [paperback], 1964; London: Corgi, 1969. No captions, titles, or dates of individual works. All women models, with the implicit notion that the "nude" meant female. Lacey thought it was "...inevitable that she should become a favorite subject of photography."(7)

Incl. Durieu, Muybridge, Eakins, C. Schenk, Demachy, Steiglitz, F. Eugene, Le Bègue, A. Brigman, A. Genthe, E. Weston, H. Callahan, E. Sougez, F. Berko, L. Clergue, R. Bernhard, R. Groebli, J. Sieff, C. Swedlund, M. Newman, B. Brandt, F. Horvat, J.F. Smith, R. Wilson. *See individual entries*

———. *Nude Photography: The Art and Technique of Nine Modern Masters.* New York: Amphoto, 1985.

Lacoppola, Debbie. Woman's supine torso in rapids-type stream. *Photo* 268 (Jan 1990):95.

Lagarde, Gilles. *Als die Fotografie den Sex entdekte.* Munich: Heyne, 1982.

Lamb, Grace F. Four works in HS: kneeling woman, right profile, elbows on knees, hands on head; seated woman; seated woman w head on knees, rear view; seated husky man, right profile.

———. "Torso of a Man." Actually, left profile of seated man. *AAP* 52 (1938):157.

———. Studio shot of seated husky man. BB:41.

Lamb, Laura. *Lurch.* Vancouver, Canada: Western Front, 1991.

Lambersend, J-P. (French) Reclining woman on studio grey floor. *Photo* No. 291 (Jan./Feb. 1992):54.

Lander, Helmut. (b. 1924) *Torsi: Fotografiert und gezeichnet von Helmut Lander.* Bonn, Ger.: Verlag der EBH, 1966. 62 photos.

Landon, P. Pregnant woman seated on carpenter's horse. *Photo* 280 (Jan 1991):64.

Landow, Peter. (ed.) *Woman: 120 Photographs of Various Nationalities.* Berlin, 1925. Incl. Hoppe, Fiedler, H. Holdt, Franz Granier, J. Pecsi.

Lane, Jarold. Two works in HS: rear view of standing woman in diagonal composition; woman's torso frontal.

Lange, Dorothea. (1895-1965) "Torso, San Fransisco," 1923. Small-breasted woman's torso against wall, her arms folded behind her. WP:43; CS:45.

Lange, Ed. (b.1920) *Nudist Nudes.* Topanga, CA: Elysium Growth Press, 1991.

Lange, June. *The Wonderful Webbers: a Dedication.* Los Angeles: Elysium, 1967.

Larcher, David. *See* Vane, Norman Thaddeus.

Lari, Emilio. Color, brief series on French actress Marushka Detmers. *Photo* 228 (Sep 1986):44.

Larrain, Gilles. (French 1938-) Woman nudes published in Clyne (ed.), *Exquisite Creatures,* incl. brief bio. *See* Clyne (ed.).

Larson, William G. "A Study of the Nude." *Camera* 48 (Apr 1969):36-43. Unique motion studies of a woman.

Lartigue, Jacques-Henri. (French 1895-) "A bord du *Dahu II*," 1926. Two prone women sunbathing on a canvas awning. JL:46.

————. "Florette au Treyas", 1942. Cove-like beach setting with prone woman at water's edge. JL:45.

————. "Florette, 1944 Paris." Three photos of woman supine on floor, viewed from above, the photographer's legs visible on either side of her. JL:48-49.

Laryew. *Nus.* Paris: Librairie des Arts Décoratifs, 1920.

Lategan, Barry. (UK 1935-) Color work: double exp. of oriental woman w crossed arms; woman standing on river bank; supine woman in wheat field; soap lathered woman's torso, right profile; silhouette of woman's breast & left arm. B&W: 3 studio portraits of women. MEP.

Laughlin, Clarence John. "Memento of the Mae West Period," 1940. Double exp. of woman's front torso and ornate heart-shaped frame. NE:191.

Laurent, F. (Swiss) Color, standing woman left profile on sand dune, holding sheet above head in wind. *Photo* 232 (Jan 1987):74.

Laurent, Jacques. (French 1919-) (ed.) *Le Nu Française.* Paris: Éditions Jannink, 1982. Incl. Édouard Boubat, Henri Cartier-Bresson, Jean Philippe Charbonnier, Lucien Clergue, Jean Dieuzaide, Robert Doisneau, Irina Ionesco, Anne Garde, Jacques-Henri Lartigue, Man Ray, Harry Meerson, Fernand Michaud, Willy Ronis, Jeanloup Sieff.

Laurits, Peter. (Russian) "The Last Drop of the Shower," 1988. Triptych of crouching woman with something on her nose. *Aperture* 116 (Fall 1989):48.

Lauzon, Gilles. Rear view of woman's torso, soaped up. *Photo* 184 (Jan 1983):63.

Lavender, David. "Woman Undressing," 1975. Color, kneeling woman frontal, lifting off dress[?]. NN:171.

Lavigne, Christian. Color, prone woman's butt., open thighs, hands on each cheek. *Photo* 207 (Dec 1984):77.

Law, Craig. Woman seated against wall. Infrared. AIS.

Law, Mary E. (ed.) *Confronting the Uncomfortable: Questioning Truth and Power.* [Ex. cat.] New Haven, CT: Yale University Art Gallery, 1989. Some nudes.

Leao, Antonio. (Portugal) Blue toned print of woman supine on tanning bed. *Photo* 184 (Jan 1983):67.

Leatherdale, Marcus. Three works in NEW: standing woman left profile in leather pants, arms behind her (26); elegant shot of women seated on edge of sunken bathtub (27); woman against wall (30).

————. *Marcus Leatherdale, 1984-1987.* New York: Greathouse, 1987. 16 photos; 1 pamphlet.

Lebe, David. (US 1948-) Male nudes in HP.

Lebeck, Robert. (ed.) *Playgirls von Damals: 77 Alte Postkarten.* Dortmund, Ger.: Harenberg, 1979. 77 naughty postcards from another era.

————. *Kehrseiten. 80 Erotische Postkarten.* Dortmund, Ger.: Harenberg, 1980. 80 erotc postcards.

————. *Playgirls of Yesteryear.* New York: St. Martin's Press, 1981.

————. *Busen, Strapse, Spitenhöschen. Erotisch Postkarten.* Dortmund, Ger.: Harenberg, 1982.

————. *Die Erotische Postkarte.* Schaffhausen, Switzerland: Edition Stemmle, 1988.

Le Bihan, Theirry. Rear view of seated woman in polka-dot briefs. *Photo* 268 (Jan 1990):117.

Le Cabec, Pierre. Woman kneeling on seamless. *Photo* 184 (Jan 1983):61.

Lee & Burger. Double exp. of woman w shadow. BB:4.

————. Woman kneeling, harsh directional light throwing her shadow on backdrop. BB:13.

————. Semi-reclining woman in chair, a shuttered window throwing shadows onto her torso, BB:25.

————. Diffuse print of seated woman shot and framed at an angle which makes it appear as if she were leaning back against a wall. BB:31.

————. Slightly contrived shot of standing woman w her shadow thrown on backdrop. BB:35.

————. Standing woman, right profile, her torso arched backwards. BB:40.

————. Standing woman viewed from floor. BB:43.

————. Standing woman in slightly contrived pose. BB:53.

————. LK shot of seated woman. BB:61.

Leen, Sarah. "Males in Motion, I." Blurred motion shot of standing man frontal. YK:44.

Lefebvre, Thiery. Color, woman in sunglasses sitting in large steel sculpture. *Photo* 207 (Dec 1984):85.

Le Gray, Gustave. (French, 1820-80) "Etude de nu," 1849. Woman prone in corner of studio. LN:8.

Lehmann, Minnette. "Paul D.," 1977. Left profile of bearded standing man. NEW:190.

————. "Ursula S.," 1976. Standing woman frontal, visible waist up. NEW:191.

Lehndorff, Vera. *Vera Lehndorff & Holger Trülzsch: Oxydationen.* New York: Bette Stoler Gallery, 1985.

Leidmann, Cheyco. *Bananasplit.* Paris: Love Me Tender, 1983. 96 color *charme.*

————. "Bananasplit." *Photo* 184 (Jan 1984):26-33. Highlights from his book.

————. *Foxy Lady.* Kehl, Ger.: Swan, 1981; Paris: Love Me Tender, 1984. Color. *Charme*

————. *Ad/Art.* Paris: Love Me Tender, 1984. ["How to" manual]

Leigh-Smith, David. (English 1948-) Bare-chested middle aged woman supine in bed, under window looking out on typical English (Croydon) street and houses scenery. Pentax, 28mm, Tri-X. *Camera* 50 (Sep 1971):21.

Leighton, J. Harold. "Dolores." Like a classical statue, standing woman frontal. *AAP* 50 (1936):174.

Lelong, Didier. Right profile of crouching woman, w right arm extended. *Photo* 280 (Jan 1991):63.

Lemaire, Guy. *Corps à Cordes.* [Ex. cat.] Paris: Éditions Astarté, 1992.

Lembezat, Bertrand. *Eve Noire.* Neuchatel, France: Éditions Ides et Calendes, 1952.

Le Mené, Marc. (French 1957-) "Autoportrait," 1984. Seated male, double exposed. LN:64.

————. "Nu," 1987. Woman reflected in mirror, torso visible. Retouched with crayons. SEM:60.

————. "Nu," 1987. Blurred standing woman smoking cigarette, viewed from floor level looking up. Retouched with crayons. SEM:61.

Lendvai-Dirksen, Erna. (1883-1962) "Nude," 1921. IPM.

Lennard, Erica. (US 1950-) Woman in white stockings standing in a room, hands behind back. Leica M3, 50mm, Tri-X, daylight. *Camera* 54 (Sep 1975):32.

————. *Women, Sisters.* New York: Bobbs-Merrill Co., 1978. Unpaged. B&W nudes of young women taken with Leica M3, 50mm, Tri-X, available light.

———. "Nude," 1978. Woman seated on lace covered bed, rear view. FT:97. Her method is to look for vulnerability in a model, because even beautiful women have doubts about their looks (90).

Leonard, Joanne. "Man Sleeping [Bruce Beasley]." YK:45.

———. "Man in Mirror [Bruce Beasley]." YK:46.

Lerner, Norman. Woman's butt. against HK b.g. BWC:28.

———. Four superb studies of woman's torso against HK b.g. NIP:172-73.

———. Black woman against wall. Excellent tonal values. BWC:72.

Leroi, Philippe. (French) Color, woman standing in panties, blurred motion. *Photo* 298 (Jan./Feb. 1993): 56.

Leroy, Geneviève. *Nues*. Paris: A. Matthieu, 1979. The work of Claude François, a.k.a. Françoise Dumoulin.

Letbetter, Dennis. "Tropical Fish," and "Fish #3." Women's torsos with drawings of fish projected upon them. Infrared. AIS.

Leven, Barbara E. Studio shot in tradition of Dorothy Wilding, standing woman right profile, wearing high heels, right foot on gauze-draped posing block. *Photography in New York* 3 (Nov/Dec 1990).

———. "Odalisque," 1990. Hand-colored B&W print of woman's torso frontal, w enormous breasts. *Puchong Folios* (New York) 1 (Winter 1991):49.

Levy, Mervyn. *Akt und Künstler*. Munich: List, 1966; 1967.

Lewinski, Jorge. (ed.) *The Naked and the Nude: A History of the Nude in Photographs, 1839-1987*. New York: Harmony Books, 1987. Fourteen ch. resolutely trying to differentiate "nude" from "naked". He disagreed w Sir Kenneth Clark's definitions and thought an image of a naked person may be art, but not a nude. Incl. Jan Šplíchal, Clarence H. White, Eakins, Puyo, Le Bègue, Demachy, A. Brigman, Steichen, Emanuel, Sougez, Raoul Hausmann, Daniel Masclet, Drtikol, Pierre Boucher, J. Sudek, J. Ehm, A, Genthe, T. Nikoleis, W. Mortensen, Perckhammer, Molinier, Hajek-Halke, Berko, Hockney, Dater, Jan Šmok, C. Swedlund, A. Dutton, I. Cunningham, Mapplethorpe, Sarah Kent, E. Rubinstein, Groebli, Welpott, Manfred Paul, P. Tooming, Erwin Blumenfeld, D. Lavender, W. Plweinski, Haskins, Vogt, Halsman, Székessy, John Hilliard, Willy Zielke,Albin-Guillot, Walter Bird, John Everard, Roye, Tom Kelly.

Lewis, George P. "Ardjoeno." Kneeling woman right profile, in wall niche, wearing bizarre oriental mask. *AAP* 48 (1934):159.

Le Yaouanc, Alain. Color, surf nude, supine woman. *Photo* 268 (Jan 1990):107.

Lichfield, Patrick. (b. 1939) *Creating the Unipart Calendar*. London: Collins, 1983. Nudes.

———. Four color photos made in Death Valley for his Unipart calender. *Photo* 222 (Mar 1986):12.

Ligout, Ghislaine. (French 1960-) Series of 6 prints: man in forest, w erect penis. C:11-17.

Lievemont, Privat. (Belgian 1861-1936) Weizer, B. "Les archives photo du peintre Lievemont." *Photographica* (Brussels) 7/8 (1980):4. Recently discovered woman nudes.

Lindbergh, Peter. "Ariane Koizumi, Düsseldorf, 1985." Standing bare-chested woman holding a cigarette. NE:154.

———. "Marie Sophie, Paris, 1987." Standing woman against white wall; she holds a towel[?] to her abdomen. NE:155.

Lindström, Tuija. (Swedish) Infrared, left profile of pregnant woman's torso. PK.

————. "Out of Deep Water." *Creative Camera* 3 (1988):18-23. Five women nudes; text and photographs by the author. "The more you see of the dark side, the more you long for beauty...it's that simple."(19)

Lisa [pseud.] *Magic Train: A Story in Photographs*. London: Lane, 1938.

List, Herbert. (German 1903-75) Woody, Jack. (ed.) *Herbert List: Junge Männer*. Altadena, CA: Twin Palms, 1988. Incl. two semi-nude men ca.1930s, one seated, one standing before a mirror (64, 65).

————. Male nudes in HP.

Livick, Stephen. (Canadian 1946-) Darkly lit, reclining woman on bed, legs crossed, slight smile on face. *Camera* 57 (Jan 1978):31.

Lohse, Remie. (German) Woman seen from waist up, reaching up to a tree branch. BB:5.

————. Woman supine in field. BB:12.

————. Water thrown from bucket onto woman standing in lake, 1937. *Camera* 57 (Jun 1978):36.

————. *Rythm and Repose*. New York: Knopf, 1937.

Loges, Werner. *Das Paradies in der Felenschucht*. Nuremburg, Ger.: Zitzmann, 1958.

————. *Schönheit im Bild: Beauté et Nature*. Thielle: Éditions Die Neue Zeit, 1961; 1963; 1966.

Lorelle, Lucien. (b. 1894) *Photos et Propos sur le Nu*. Paris: P. Montel, 1960. 123 plates.

————. *Weiblicher Akt*. Bonn, Ger.: EBH, 1961.

————. *Akt. Fotos und Kommentare*. Bonn, Ger.: EBH, 1961; 1963; 1967; 1969. ["How to" manual]

————. *Akt-Auslee*. Bonn, Ger.: EBH, 1963. Incl. Brassaï, Clergue, Lorelle.

————. *Esthétique du Nu dans le Monde*. Paris: P. Montel, 1964. Unpaged.

————. *Akt in Farbe und Licht*. Bonn, Ger.: EBH, 1966; 1967.

Loriente, Paulo. (Portuguese) Color, unique backlit shot of woman diving backwards into water; slight blurred motion. *Photo* 280 (Jan 1991):51.

Lorieux, Jean-Daniel. *Coconuts*. Paris: Love Me Tender, 1983. All color *charme*.

Loth, Wilhelm. (German 1920-) Color, woman hanging upside-down by her knees, in stirrups, 1982. A:202.

Louys, Pierre. [Pierre Felix Louis] (French 1870-1925) Teenage girl standing against curtain, ca.1900. In Philippe Jullien, *Le Nu 1900*. Paris, 1976:(155).

————. Goulon, J.-P. "Pierre Louys photographe érotique." *La Recherche Photographique* 5 (1988):38. History of Louys' mania for photographing his many mistresses. Incl. 8 shots of teenage girls making an attempt at erotic poses.

————. *Die Lieder der Bilitis*. Bonn, Ger.: EBH, 1962.

Love, Robin. (female) (US) "Robin Love." *Photo* 192 (Sep 1983):56-63. Color self-portraits semi-nude at typical "American" locations.

Lovitsch, Luba. Kneeling black woman. HS.

Löwy, Franz. *Das Schöne Nackte Weib*. Vienna, 1921. 16 photos.

Lucie-Smith, E. *The Body: Images of the Nude*. London, 1981. Images from ancient Greece to the present, incl. photography.

Ludwig, Karel E. (Czech 1919-77) "Detail," 1941. Nipple and hand. BL:126.

————. "Nach dem Bad (After the Bath)," 1941. Woman's wet breasts & hands appear over tiled edge of bathtub. USII:106.

Lukácś, Georges (b.1933) and Mentlen, Josef von. *Bildgewordene Traume: Lehrbuch der Aktfotografie.* Landsberg am Lech, Ger.: Landsberger Verlagsanstalt, 1972. ["How to" manual]

Lunau, Peter. *Abstrakte Akte.* Berlin: Magdalinski, 1965. 50 photos.

Lupino, Stephan. "Stephan Lupino." *Photo* 204 (Sep 1984):74-79. Incl. 4 studio shots, women nudes.

———. Four studio shots of woman nudes. *Photo* 221 (Feb 1986).

———. *Lupino an Avant!* Munich, 1988. Incl. 34 nudes from the studio of this successful fashion photographer.

Lussa, Vincent. *Beauty from Eastern Europe.* New York: Stuart, 1964.

———. *Beauty Unadorned: Memorable Studies of the Female Nude.* London: Luxor Press, 1969.

———. *Grazien ohne Hülle.* Stuttgart, Ger.: Günther, 1969.

Lusson, Alain. Color, woman's breasts upon red f.g. *Photo* 184 (Jan 1983):67.

Lüttge, Thomas. (German) "Menschenkörper/Frau," 1980. Studio shot of woman on her right side, visible from the shoulder to the knees, w exquisite hip curve. BL:179.

Luxardo, Elio. (Brazilian 1908-69) "Nude," 1930. Seated woman's torso & head, harsh lighting. A:256.

Lynes, George Platt. (US 1907-55) "Nude in a Room." IPM.

———. Woody, Jack. (ed.) *George Platt Lynes: Photographs, 1931-1955.* Los Angeles: Twelvetree Press, 1981. Editor noted Lynes destroyed most of his nudes & erotic works, yet, this volume incl. 33 studio nudes, mostly men, 1933-55; 7 dance nudes of men, 1948; 2 nude portraits; 7 nudes interpreting Greek mythology.

———. Weiermair, Peter. (ed.) *George Platt Lynes.* Innsbruck, Austria: Allerheiligenpresse, 1982.

———. "Platt-Lynes." [sic] *Photo* 188 (May 1983):100-105. Incl. untitled [Elizabeth Gibbons], 1939, woman's torso frontal, w face, arms raised, fence b.g.(101); untitled [William Bailey], 1934, black man standing against wall(103); "Tex Smutney and Buddy Stanley," 1941, studio shot of standing man rear view in b.g., man's torso stuck in the floor in f.g.(105).

———. Crump, James. (ed.) *George Platt Lynes: Photographs from the Kinsey Institute.* Boston: Bulfinch Press, 1993.

———. Standing man frontal, w tattoo on left arm, 1930. CS:81.

———. Woman reclining on left side, back to camera, in bedroom set. NIP:79.

Lyon, Lisa. *See* Mapplethorpe, Robert.

Lyons, Robert Alan. (US 1954-) Fuzzy, grainy woman's torso. *Camera* 53 (Sep 1974):6.

———. Blurred shot of standing woman leaning on post; heavy shadows. *Camera* 54 (Sep 1975):11.

MacAdams, Cynthia. (US 1939-) *Emergence.* New York: Chelsea House, 1977. She wrote:"The women in *Emergence* have found their voice. They are warriors and saviors of the Aquarian age."(7) MacAdams wanted to be filled w the beings of other women, the essence of their souls, and this was acheived through the camera.(7) Out of 17 nudes we find portraits of Mary Dicterow (34); Joann Schmidman (35); Linda Van Winckle (44); Kristina Nethaway (45); Diane di Prima (55); Mary Jo Thatcher (84); Aloma

Ichinose Gruskoff (94); Sander Eller (96); Teda Bracci (101); Sylvia White (103); Twinka Theibaud (57, 111).

————. *Rising Goddess.* Preface by Kate Millett. Dobbs Ferry, NY: Morgan & Morgan, 1983. Works of 1977-82; 118 outdoor female nudes w ostensibly feminist intent. Many infrared shots. Most unique: pregnant woman's torso.(72)

McBride, Will. (b. 1931) Series of studio shots of men, women, & children posed in cardboard boxes. Unique. *See* Diener, Christian.

————. *Zieg Mal.* Wuppertal, Ger.: Jugenddienst, 1974; 1976; 1980.

————. *Boys.* Munich: C.J. Bucher, 1988.

McCormack, Dan. (b. 1944) *Body Light: Passages in a Relationship.* Accord, NY: Mombaccus Press, 1988.

————. *Being Without Clothes.*

McCoy, Dell A. *Artistic Reflections of Women.* Denver, CO: Sundance Books, 1986.

McDonald, Anne Arden. Image from her "Autonomy and Alchemy" series; self portrait of the artist supine on floor of derelict room, w feathers floating in air. *Photography in New York* 3 (Sep/Oct 1990):n.p.

McGinnis, Frank. Against black b.g., standing woman frontal, w sheet draped over her left shoulder. *Photography in New York* 3 (Mar Apr 1991).

MacLeay, Scott. (Canadian 1950-) "83D10 Series: The Primate Trilogy," 1983. Man and woman from waist up in poorly lit brown toned image; the woman has a hand over the man's mouth. Color print. SEM:190.

McNease, Thomas F. (US 1947-) Seated woman in room lit from window in background. Linhof Techni-Kardan 4x5, Tri-X, 8 sec. exp. at f/45. *Camera* 53 (Sep 1974):32.

Mächler, René. (Swiss 1936-) High contrast female fragments. *Camera* 47 (Jan 1968):14-21.

Mack, Ulrich. (German 1935-) Woman standing on stairway with large skylight overhead. Leicaflex SL, 21mm, Tri-X. *Camera* 50 (Sep 1971):11.

————. Six frames of woman standing in bathtub in middle of bare room. Hasselblad, 80mm, Tri-X. *Camera* 51 (Oct 1972):34.

McSherry, John. *Form Feminine.* New York: Greenberg, 1936.

————. Three works in HS: seated woman covering her chest w left arm; seated woman frontal; LK image of seated woman w arms behind head.

McSherry–Tilford. Left profile of kneeling woman, face to ceiling, hands on knees. BB:7.

Madonna [Madonna Ciccone]. *See* II. Photographer's Model. *See also* Schreiber, Martin H.

Maechler, René. *Paesaggi di Donna.* Text by Georges Thonet. Basel, Switzerland: Basilius Presse, 1965. Incl. 18 female nudes of a fragement type: extremely high contrast w black b.g. Printed on the heaviest cover stock imaginable.

Maeder, Suzie E. (English 1948-) Pregnant woman's supine torso, hand on belly, 1974. Nikkormat, Tri-X. *Camera* 54 (Sep 1975):18.

Maffait, Pierre. (Danish) Standing woman frontal in shower stall. *Photo* 232 (Jan 1987):71.

Magaud, Patrick. *Filles a Louer.* Paris: Love Me Tender, 1984.

————. *Exhibition in Paris.* Los Angeles: Melrose, 1985. Color photographs of a female model being semi-nude on the streets of Paris.

Magnus, Mayotte. Color, woman prone in LK setting, propped up on both elbows. *Photo* 209 (Feb 1985):11.

Mahl, Andreas (German 1945-) "Eva," 1982. A woman's breasts and lower face. Manipulated Polaroid. SEM:183.

———. Male torso, 1982. SEM:183.

———. Color, 3/4 frontal standing man w pig mask & large penis. A:205.

Maillard, J.–C. Color, woman's breast. *Photo* 207 (Dec 1984):86.

Maisel, Jay. Color, reclining woman in dark room with multi-colored lighting falling upon her from stained glass type windows. *ASMP Book 3: Professional Photography Annual.* New York: Annuals Publishing Co., 1984:(71).

Maitek, Henry. *Frau zu sein in einer Männerwelt.* Düsseldorf, Ger.: Krüger, 1975.

Malanga, Gerard. (ed.) *Scopophilia: The Love of Looking.* Toronto, Canada: St. James Press, 1985. Voyeurism is the theme here, incl. photos of diverse interests and quality from Walter Chappell, Lynn Davis, Arthur Elgort, Elliot Erwitt, Charles Henri Ford, George Krause, Alen MacWeeney, Sheila Metzner, Mellon [pseud.], Giani Penati, Larry Rivers, Peter Simon, Francesca Woodman.

Malin, Karin. *Nude Photography.* South Brunswick, NJ: A.S. Barnes, 1972.

Malinowski, Stan. (US 1936-) 5 color photos, all shot with Nikon F2, 80-200mm, Kodachrome 64. "Hands of a Haitian Masseuse," supine white woman, her breasts massaged by black hands; "Janice in Mustique," woman in white sheer skirt & ornate necklace standing in doorway; "O.K. So He's Got Silver Bullets," woman astride toy horse; "Somewhere between Venus and the Milky Way," woman's butt. in black bathtub, filled with water, milk poured between her legs; "Ultra Tan," woman supine on tanning bed. CAEP.

———. Color, seated young woman w open legs in men's pin-up style, 1984. AVK:158. [from *Penthouse* (1984)].

———. "Stan Malinowski." *Photo* 200 (May 1984):140-57. Incl. color glamour/erotic.

Manarchy, Dennis. "Dennis Manarchy." *Photo* 196 (Jan 1984). Incl. color works: "La fille motocycliste," 1981, woman painted gloss black & resting on motorcycle wheels (studio shot on 8x10 view camera w Ektachrome for an account w Carrera International); "Corps de femme huilée," 1981, supine woman's torso covered w glossy black liquid; (shot on Mamiya w Ektachrome).

Manassé [Olga & Adorian Wlassics]. Woman seated on straw matt in b.g., her painting is on an easel f.g. KS:74.

———. "Irene Schuchowa, Tänzerin," ca.1930. Kneeling woman w spherical object on lap. USII:103.

———. "Yvonne Molein, Tänzerin," ca.1930. Seated woman w headdress. USII:145.

———. Woman w menacing insect, ca.1930. USII:117.

———. Seated woman w champagne glass, ca.1930. USII:124.

———. Woman w crystal motif, ca.1930. USII:125.

———. Standing oil covered woman w brass gong, ca.1930. USII:131.

———. Supine woman w cigarette between lips, ca.1935. Brown toned print. USII:152.

———. Woman standing next to large globe, holding cigarette, ca.1935. USII:158.

———. Seated woman profile right, head back slightly, ca.1940. USII:118.

———. Seated oil covered woman w headband, ca.1940. USII:159.

———. Seated woman profile left, bobbed hair style, 1945. USII:157.

Mandelbaum, Ann. "The Float." Man prone on pool-born raft. DH:39.

Manen, Hans van. (b. 1932) "Picta: Self Portrait with Tijs Westerbeck," 1984. Seated man in business suit w nude man in his lap. BTM:25.

———. *Portrait.* [Amsterdam?]: De Haan, 1986.

Mann, Sally. (US 1951-) *Immediate Family.* New York: Aperture, 1992. Incl. several nudes of her 2 daughters & son.

———. Walla, J. "Artforum Gets a Nude Awakening." *New York* 25 (25 May 1992):9. Comment on *Artforum* using uncontroversial photographs by Mann in response to the anti-porn climate of the times.

Man Ray. [Emmanuel Rudnitshky] (US 1890-1976) "Nude," ca.1929. Studio shot of woman's frontal torso seated. *Photography in New York* 5 (Sep/Oct 1992):n.p.

———. "Electricité," 1931. Woman's frontal torso superimposed with wave-like white lines. USII:87.

———. "Cannes," 1933. Three women, two seated, one standing; grainy, but one of his best. *Camera Arts* 2 (Oct 1982):34.

———. "Meret Oppenheim," 1933. Full figure studio shot with unpleasant lighting. JL:52.

———. "Vénus en plâtre." Woman bent over plaster cast of a Venus-like statue. JL:51.

———. "Juliet en Couche," 1941. Supine woman on couch, fiber screen over finished print. *Photography in New York* 2 (Jan/Feb 1990):34.

———. Solarized woman nude. NIP:72.

———. *Man Ray: Photographs.* New York: Thames & Hudson, 1981; 1982. Incl. 33 woman nudes.

———. *Frauenbilder von Man Ray.* Köln, Ger.: König, 1982. 10 photos in portfolio.

———. Naville, Pierre. *Atelier Man Ray, 1920-1935.* Paris, 1982.

———. Fourteen works published elsewhere. NEW:87-102.

———. *Man Ray Nus.* N.p.: Galerie Octant, 1986.

———. *Man Ray.* Berlin: Benedikt Taschen, 1990.

———. *Man Ray: Derrière la Facade.* Paris: Galerie Alain Paviot, 1990.

Mansutti, Onorio. (Swiss 1939-) *Mansutti Photos?* Basel, Switzerland: Sphinx, 1981. The question mark in the title indicates the hybrid nature of these images. Unusual long rectangle format, collection of grainy photos of women w additional color graphic elements superimposed.

Manzanares, Jean-Louis. (French) Standing woman in shade, at left of frame, with brightly lit building facade in background. *Photo* No. 298 (Jan./Feb. 1993): 54.

Mapplethorpe, Robert. (US 1946-89) Bulgari, E. "Robert Mapplethorpe." *Fire Island Magazine* 3 (Jul 1978).

———. McDonald, R. "Getting Off (Turning Off?) on Mapplethorpe." *Leica Journal* (Los Angeles) (Oct/Nov 1978).

———. Amaya, Mario. (ed.) *Robert Mapplethorpe Photographs.* [Ex. cat.] Norfolk, VA: The Chrysler Museum, 1978.

———. Ginneken, L. van. "Mapplethorpe." *De Volkskrant* (Amsterdam) (18 May 1979).

———. Lifson, B. "Games Photographers Play." *Village Voice* (2 Apr 1979).

———. Lifson, B. "The Phillistine Photographer." *Village Voice* (9 Apr 1979).

———. Ellenzweig, Allen. "The Homosexual Aesthetic." *American Photographer* (Aug 1980).

———. *Black Males.* Amsterdam: Galerie Jurka, 1980. Incl. 25 studio nudes: black men's portraits, full figure, & torso shots.

———. Squires, C. (ed.) *Quattro fotografi differenti.* Milan, Italy: Idea Books, 1980.

———. Sheftel, Bruce. (ed.) *Presences: The Figure and Manmade Environments.* [Ex. cat.] Reading, PA: Freedman Gallery, Albright College, 1980. Incl. Mapplethorpe.

———. Ellenzweig, Allen. "Robert Mapplethorpe." *Art in America* (Nov 1981).

———. Puglienn, G. "Robert Mapplethorpe." *Zoom* 88 (1981).

———. Weiermair, Peter. (ed.) *Robert Mapplethorpe.* Frankfurt, Ger.: Frankfurter Kunstverein, 1981. Incl. 9 studio shots.

———. *Robert Mapplethorpe.* [Ex. cat., 10 Apr–17 May 1981] Frankfurt, Ger.: Frankfurter Kunstverein, 1981.

———. Hanhardt, John G. *et al. 1981 Biennial Exhibition.* [Ex. cat.] New York: Whitney Museum of American Art, 1981. Incl. Mapplethorpe.

———. Post, H. "Mapplethorpe's Camera Lusts for Exposing Sex Objects." *GQ* (Feb 1982).

———. Naef, Weston. (ed.) *Counterparts: Form and Emotion in Photographs.* [Ex. cat.] New York: Metropolitan Museum of Art, 1982. Incl. Mapplethorpe.

———. Grundberg, Andy. "Is Mapplethorpe Only Out to Shock?" *New York Times* (13 Mar 1983):32.

———. Saul, Julie. (ed.) *Photography in America: 1910-1983.* [Ex. cat.] Tampa, FL: Tampa Museum, 1983. Incl. Mapplethorpe.

———. *Lady Lisa Lyon.* New York: Viking, 1983. Incl. 77 photos of the one time women's bodybuilding champion; shaved body, but not the arm pits. For some photos, Lyons applied graphite lubricant to her skin.

———. "Lisa Lyon." *Photo* 188 (May 1983):84-89. Highlights from his book.

———. Novi, M. "Tutto il corpo di Lisa." *La Republica* (Rome) (10 Apr 1983). Review of *Lady.*

———. Chatwin, B. "The Gentle Touch of an Iron Lady." *Sunday Times Magazine* (London) (17 Apr 1983). Review of *Lady.*

———. Reavill, C. "Cunt be Beat." *Screw* (New York) (18 Apr 1983). Review of *Lady.*

———. Caujolle, C. "Une photographeie très musclée." *Liberation* (Paris) (29 Apr 1983). Review of *Lady.*

———. "Eine starke Frau." *Stern* (Cologne) (Apr 1983). Reveiw of *Lady.*

———. Chatwin, B. and Richards, D. "Strong Stuff: Lisa Lyon's Body Beautiful." *Tattler* (London) (Jun 1983). Reveiw of *Lady.*

———. Kolbowski, Silvia. "Covering Mapplethorpe's Lady." *Arts Magazine* 57 (Sep 1983):10. Review of *Lady.*

———. Simson, Emily. "Portraits of a Lady." *Arts News* 82 (Nov 1983):53. Review of *Lady.*

———. Jentz, T. "Robert Mapplethorpe, Restless Talent." *New York Photo* (Apr 1983).

———. "Robert Mapplethorpe faire de l'art avec des tabous." *Photo Reporter* (Paris) (Jan 1983).

———. *Robert Mapplethorpe, 1970-1983.* London: Institute of Contemporary Arts, 1983. Incl. 9 studio works in his unmistakable style: spare, but precise.

———. "Ken," 1983. Black man's back from head to lower butt., wearing black jock strap, against studio backdrop. SEM:113.

———. "Jill Chapman with Ken," 1983. White woman wearing black leather dress standing on studio backdrop facing camera, with black man in black jock strap standing close to her left, facing her. SEM:112.

———. "Dennis Speight," 1983. Black man standing 3/4, holding flowers. NN:210.

82

———. Eight works in NEW: tall black woman in Las Vegas floor show costume, standing frontal (7); graphite coated woman's body on seamless, standing left profile, left leg parallel to floor (8); kneeling black man (10-11); woman's torso right profile (12); woman's torso w revolver (13); Lisa Lyons pulling her shirt up (14); woman pinching her nipples (15).

———. Fernandes, Joyce. *Sex-Specific: Photographic Investigations of Contemporary Sexuality.* [Ex. cat.] Chicago: Superior Street Gallery [Art Institute of Chicago], 1984.

———. Five studio nudes in CAEP.

———. "Lydia Cheng," 1985. Spray painted (apparently) woman's frontal torso against black background. DP.

———. Friis-Hansen, Dana. (ed.) *Nude, Naked, Stripped.* [Ex. cat.] Cambridge, MA: Hayden Gallery, MIT, 1985.

———. *Robert Mapplethorpe.* Milan, Italy: Idea Books Edizioni, 1986. Incl. 7 studio works.

———. Fabre, Jan. *The Power of Theatrical Madness.* London: Institute of Contemporary Arts, 1986. Incl. 10 works based on a theater group's experimental performances in Antwerp, 1985.

———. Mayer, Charles S. (ed.) *Intimate/Intimate.* [Ex. cat.] Terre Haute, IN: Turman Gallery, Indiana State Univ., 1986.

———. *Black Book.* New York: St. Martin's, 1986. Incl. 45 nudes of black men.

———. *Robert Mapplethorpe: Photographien, 1984-1986.* Munich: Schirmer/Mosel, 1986.

———. *Ten by Ten.* Munich: Schirmer/Mosel, 1986. A greatest hits collection.

———. "Thomas and Dovanna," 1986. Black man standing w clothed white woman. WE:97.

———. Smith, Patti. *Robert Mapplethorpe.* New York: Bellport Press, 1987.

———. Horton, Anne. (ed.) *Robert Mapplethorpe.* [Ex. cat.] Berlin: Galerie Raab, 1987.

———. Marshall, Richard. (ed.) *Robert Mapplethorpe.* New York: Whitney Museum 1988. Incl. 27 works of the highest photoreproduction quality.

———. Male nudes in HP.

———. *Robert Mapplethorpe.* New York: Random House, 1992.

March, Charlotte. (German 1930-) *Mann, oh Mann.* Kehl, Ger.: Swan, 1976.

———. "Distressed" sepia toned print of man supine on bed. DP.

Marchael, James. Double exp. of man & woman standing in same place. BWC:47.

Marchais, Mario. (French) Woman wearing gas mask seated in derelict room w violin between her legs. *Photo* 184 (Jan 1983):69.

———. Standing woman frontal, in high heels, holding white sphere in barren room. *Photo* 268 (Jan 1990):120.

———. Kneeling woman with head back, on stone altar, Madonna statue above. *Photo* 291 (Jan/Feb 1992):56.

———. Two women wearing masks, standing in a cement-block room in natural lighting. *Photo* 298 (Jan/Feb 1993):48.

Marconi, Francois. (19th C France) "Femme nu posant," 1873. After Hippolyte Flandrin's *Jeune Homme assis sur un rocher* (1836). LN:6.

Marconi, Guglielmo. (French) Kneeling woman, ca.1860. BL:38.

———. Standing man w bound wrists, ca.1865-70. BTM:20.

———. Seated woman, ca.1870. BL:42.

———. Reclining woman, ca.1870. BL:43.

Marcus, Ken. 3 studio images of a black man & white woman embracing; 2 studio images of a woman in black boots weilding a whip; 3 studio images of a man & woman in various embraces. Pentax 6x7, Tri-X. CAEP.

Marhoun, Bohdan. (b.1921) Solarized print of woman's head & torso. AA:69.

————. HK print of seated woman, head out of frame. AA:67.

————. Solarized print of breasts. AA:23.

————. LK setting, HK outline profile of breast. AA:38.

————. LK setting, high contrast side lighting of woman standing behind vertical pole, w her arms raised. JS:V. Max Dupain made a very similar nude in the 1930s.

Maricevic, Vivienne. Standing man (dwarf) frontal. YK:52.

Mariel, Pierre. *Eva im Atelier.* Bonn, Ger.: EBH, 1965.

————. *Die Schönen von Paris.* Bonn, Ger.: EBH, 1965. Incl. Lucien Lorelle.

Mariën, Marcel. (Belgian 1920-) "Derrière le rideau fin de soliel," 1955. Woman's frontal torso w writing on it. RK:219.

————. Bussey, C. *Marcel Mariën: Rétrospective et Nouveatés, 1939-67.* Paris: Galerie Defacqz, 1967.

Mariey, Pierre. Standing woman frontal seen from waist up, blindfolded, wearing gigantic necklace. *Photo* 280 (Jan 1991):61.

Marin, Corrado. *Foto Glamour e Nudo.* Trieste: Edizioni Tecniche Fotografiche, 1970.

Mark, Mary Ellen. (US 1940-) Standing man in dance pose, w mask covering genitals. DH:63.

Marot, Gérard. *Les P'tits Mecs.* Paris: Éditions Photo'oeil, 1978; 1983.

Marot, Gérard and Marsan, Hugo. *Le Fils d'Ariane.* Poissy, France: Édition Imagine, 1986.

Marotta, Joseph. Woman sitting in chair in dimly lit room. NIP:254.

Marotta, Tom. (US 1946-) Seated woman with long dark hair, knees pulled up, looks at us. *Camera* 54 (Sep 1975):33.

Marquardt, Sven. (German) Seated woman in stockings looks at camera and has a man's head between her legs, 1990. BL:195.

Marsani, A.R. *Frauen und Schönheit in aller Welt.* Berlin: Limpert, 1939. Incl. Koppitz, Clausen, Hoinkis, Hoyningen-Huene.

Martin, B. (ed.) *Graphis Nudes.* New York: Graphis, 1993.

Martinez, Guy. (French) Woman kneeling, butt. & legs visible. *Photo* 280 (Jan 1991):66.

————. Woman reclining on sofa under sheer fabric. *Photo* 298 (Jan./Feb. 1993):54.

Martinez, V.B. (Spanish) Color, reclining woman on beach rock with sliced lime green cucumbers on her nipples and mons venus. *Photo* No. 291 (Jan./Feb. 1992):52.

Marton, Erwin. *Nus: Photographies.* New York: Editions A. de Milly, 1969[?].

Maršálek, František. (Czech) White wall with woman's butt. and lower back visible at lower right, 1980. BL:147.

Marzoni, Gian Franco. (Italian 1934-) *Tu, Tu Sola.* Milan: Baldini & Castoldi, 1969.

Masana, Josep. Pictorialist works from 1927: two prints of men; two prints of women. In Franco Foncuberta, *Ideas and Chaos: Trends in Spanish Photography.* New York: International Center of Photography:(132-35).

Masclet, Daniel. Woman reclining on right side in HK setting, ca.1930s. NN:92.

Masse, Roger. Color, supine woman in the heather. *Photo* 184 (Jan 1983):66.

Massart, Georges Yves. (b. 1932) *Victoria und das Pferd. Fotos.* Hanau, Ger.: Müller & Kiepenheuer, 1971.

Massol, Geoffroy. Supine woman on bed under window of attic room. *Photo* 268 (Jan 1990):116.

Mateyka, Rupert. *Akt im Brennpunkt.* Stuttgart, Ger.: Freya-Verl., 1966.

Matras, Hervé. Special effect: plate w supine woman, & brandy glass w kneeling woman inside. *Photo* 184 (Jan 1983):101.

Matsugi, Fujio. *Nude Beauty. No. II.* Tokyo: Sogeisha, 1950. Incl. 20 woman nudes comparable in approach & execution to any of the best contemporary western photographers.

Matter, Herbert. Supine woman on desert floor, low angle light, w tree branch, ca. 1940. AVK:102.

———. Rear view of standing woman on beach, walking to the surf, arms out at either side parallel to horizon. HS.

Matthiesen, H. (German) Soft focus standing woman, 1923. BL:75.

———. Soft focus kneeling woman, 1923. DP.

———. Soft focus supine woman on studio backdrop, 1923. USII:71.

Maupas, Éric. Supine woman on bed in small room. *Photo* 232 (Jan 1987):81.

Maurer, Ralph Ottwil. *Skulpturen aus Fleisch und Blut.* Berlin: Elsner, 1940. Incl. K. Wendler, F. Fiedler.

Maurizi, Maurizio. (Italian) Reclining woman on roof, with classical architrave in background. *Photo* 298 (Jan./Feb. 1993):44.

Mayne, Noël. *The Song of Songs, Which is Solomon's.* London: Skilton, 1969. 61 plates.

Mayou, Roger Marcel. (ed.) *Splendeurs et miseres du corps.* Paris: Mois de la Photo, 1988.

Meatyard, Ralph Eugene. Man standing frontal in bathroom, blurred motion. BWC:32.

Mechanicus, Philip. *See* Cremer, Jan.

Meerson, Harry. "Plein peau," 1967. Clothed man, nude woman, high key background. JL:57.

———. "Papillon," 1976. High contrast 3/4 shot of woman partially draped, with odd hair style. JL:56.

———. "Love Cat," 1978. Grainy 3/4 shot of woman holding fluffy white cat on her shoulder. JL:59.

Meier, Ernst. *Mädchen.* 4 vols. Schaffhausen, Switzerland: Verlag Photographie, 1978; 1981; 1982; 1984. Incl. Jacques Schumacher, Rikk Zimmerli, Antonius, Heribert Brehm, Uwe Ommer, Otto R. Weisser, Ernst Meier, Renaud Marchand, Jost Wildbolz, Heinz von Bülow, Lajos Keresztes, Balmelli, Inogo Harney, H.W. Hesselmann, D. Roy, W.D. Schleich.

Meisnitzer, Fritz. *Bewegte Form.* Kiel, Ger.: Fravex, 1964.

———. *Akt, Form, und Linie.* Stuttgart, Ger.: H.E. Günther, 1966. ["How to" manual]

———. *Dreaming of Eve.* South Brunswick, NJ: A.S. Barnes, 1970.

———. *Erotik in der Fotografie.* Munich: Heering, 1973. ["How to" manual]

———. *Fritz Meisnitzer: Der Moderne Akt in Schwarzeiß und Color.* Munich: Leterna Magica Richter, 1977. ["How to" manual] *See additional titles under* Bentzen, Bruno.

———. *Eva vor der Kamera.* Munich: Moewig, 1980. ["How to" manual]

———. *Erotik von der Kamera.* Rastatt, Ger.: Moewig, 1982. ["How to" manual]

———. *Glamour Fotografie.* Munich: Laterna Magica, 1984.

Mendelsohn, David. (US 1951-) Color Polaroid SX-70. Portrait of twins semi-nude. S.

Mentzler, Dora. *Die Schönhiet Deines Körpers.* Stuttgart, Ger.: Dieck, 1924; 1925; 1926-30.

———. *Gestaltete Bewegung. Neues der Dora-Menzler-Schule.* Stuttgart, Ger.: Dieck, 1926.

Meola, Eric. Color, supine woman on pink satin. NIP:12.

Mercier, Jean. (b.1947) *Un Beau Livre.* Montreal, Canada: Copilia Design, 1973.

———. *Les Series Finales, Les Series...* Montreal, Canada: Copilia Design, 1976.

Merckx, Antoine. Color, woman's mons venus w hands nearby. *Photo* 207 (Dec 1984):76.

Merila, Herkki-Erich. (Russian) "Communal Tango," 1988. Man and woman standing in cluttered studio-like room with daylight coming in from windows. *Aperture* 116 (Fall 1989):47.

Merkel, Siegfried (German 1925-) and Stibor, Miloslav. *Madschenlandschaften.* Düsseldorf, Ger.: Knapp, 1980.

Merkin, Richard and McCall, Bruce. *Velvet Eden: The Richard Merkin Collection of Erotic Photography.* New York: Methuen, 1979. Naughty nudes [pin-ups], 1895-1940.

Merlin, Gilbert and Frasney, Daniel. *Liebe in Paris.* Bonn, Ger.: EBH, 1961; 1965. 120 photos.

Merlin, Gilbert and Schmölke, Werner. *Sie. Profil, Begegnung, Akt.* Bonn, Ger.: EBH, 1962.

———. *Straßen der Liebe.* Bonn, Ger.: EBH, 1966.

Merlo, Lorenzo. (Italian 1935-) *Le Donne Hanno Radici nella Luna.* Casalecchio di Reno, Italy: Grafis Edizioni, 1991.

———. *Il Nudo Fotografico nell'Europa dell'Est.* Bologna, Italy: Grafis Edizioni, 1988.

Mertin, Roger (US 1942-) "Casual (?) Heart #1, 2nd Version," 1969. Supine woman w mirror over face. CS:123.

———. "Plastic Love Dream," 1969. Two standing women, bent slightly forward, seen from back, strong directional lighting. *Camera* 48 (Sep 1969):30.

Mervelec, Patrick de. (French 1945-) "La femme et son double," 1986. Female standing with head, arms and shoulders covered with light drapery; double exposed. SEM:170.

Messager, Annette. "Mes Voeux (My Wishes)," 1989-9. Unique installation of approx. 100 photos of body fragments assembled in oval shape on wall, held up by pieces of string. *Photography in New York* 4 (Jul/Aug 1992):cover.

Messens, Didier. (Belgian) Color, seated woman with green bathrobe pulled down, face and breasts lit, she gives us a sultry but not a cheap look. *Photo* No. 291 (Jan./Feb. 1992):49.

Messerli, Niggi. (Swiss 1950-) Woman seated on stool, backlit, head out of frame. Sinar 4x5, 150mm, Polaroid 52, daylight. *Camera* 54 (Sep 1975):10.

Metzner, Sheila. (US 1939-) *Objects of Desire.* New York: Crown Publishers, 1986. Incl. a few grainy color woman semi-nudes in a high fashion style.

———. "Nude," 1989. Soft focus shot of woman's torso right profile. *Photography in New York* 3 (Nov/Dec 1990).

Meyer, Bruno. *Weibliche Schönheit...* Stuttgart, Ger.: Klemm & Beckmann, 1905. 260 nudes, incl. those of R. Le Bègue, Egbert Falk, W. Hartig.

Meyer, D. *See* Jobst, Norbert.

Meyer, Pedro. "La Virgen Arrinconada." Kneeling Mexican woman frontal. PK.

Meyer-Kupfer, Hilde. Kneeling short-haired woman holding sheer fabric in left hand, ca. 1930. AVK:109.

Meyerowitz, Joel. (1938-) "Vivian," 1976. Ektacolor print of supine woman on bed seen through insect screen of slding door. CS:114.

Meylan, Frederic. "Frederic Meylan." *Photo* 283 (Apr 1991):90. Incl. 1 woman nude.

Mézière, Jean. (French 1949-) Color, Polaroid; standing woman frontal in plastic covered doorway w sheet of gauze running across lower half. SII.

—. Boring color frontal torso, female nude fragment, from series first published in the Swiss *Portfolio Photographie*. See *Photographis 87* (New York: Graphis U.S., 1987):122.

Mia. [pseud.] *Le Corps Secret*. Montréal: Éditions du Jour, 1969.

Michálková, Olga. (Czech 1933-) Woman resting on elbows, upon studio floor. AA:83.

Michals, Duane. (US 1932-) "Sequence." *Camera* 48 (Sep 1969):22-31. Sequence of images in the directorial mode for which he is now famous: "Paradise Regained", "For Balthus", "The Letter Hurts the Girl"(24); "The Voyeur's Pleasure Becomes Pain", "The Girl is Frightened by a Door", "The Sad Farewell"(27).

—. Man and woman in bedroom; he is blurred, unzipping his pants; she is nude standing on the right, looking at him. Nikon, 35mm, Tri-X, daylight. *Camera* 49 (Sep 1970):26.

—. *Sequences*. Garden City, New York: Doubleday, 1970. Nudes as part of stories: "The Girl is Hurt by a Letter" [orig. in *Camera* (1969)]; "Paradise Regained" [orig. in *Status* (Jan 1969)]; "The Young Girl's Dream"; "The Voyeur's Pleasure Becomes Pain" [orig. in *Camera* (1969)]; "The Fallen Angel"; "The Spirit Leaves the Body"; "The Birth of Eve".

—. *The Journey of the Spirit After Death*. New York: Winter House, 1971. Incl. 7 nudes.

—. *Real Dreams: Photo Stories by Duane Michals*. Danbury, NH: Addison House, 1976. Incl. 50 nudes.

—. "Fragrance—Your Personal Signal," 1979. Color, woman's upper frontal torso w face obscured by flowers. In Martin Harrison, *Appearences: Fashion Photography Since 1945*. New York: Rizzoli, 1991:(182).

—. "The Young Girl's Dream." Series of 5 images: man and woman [who lies on a couch]. SEM:176-77; NIP:190-91.

—. "Narcissus." Series of 5 images: young man crouching near a stream. SEM:178-79.

—. *Photographs*. Amsterdam: Idea Books, 1981. Incl. 2 nudes.

—. "Nude Denuded," 1982. Fragment type, shaved mons venus. LN:58.

—. Seven women nudes as part of sequence w text. MEP.

—. *Duane Michals: Photographies de 1958 à 1982*. Paris: Audiovisuel, 1982. Incl. 12 nudes.

—. "Violent Women," 1983. Multi-exp. of four blindfolded women in a small room. NE:173.

—. *Duane Michals: Photographs, Sequences, Texts, 1958-1984*. Oxford, UK, 1984. Incl. 3 nudes.

—. *Sleep and Dreams*. New York: Lustrum, 1984. Incl. 11 nudes, the most unique to Michals *œuvre* being a multi-exp. shot of a woman reaching for another woman standing against a wall (27).

—. *The Nature of Desire*. Pasadena, CA: Twelvetree Press, 1986. Incl. 16 nudes of men & women as part of sequences.

—. *Duane Michels Photographien, 1958-1988*. Hamburg, Ger.: Museum für Kunst und Gewerbe, 1989.

———. *Duane Michals: Now Becoming Then.* Altadena, CA: Twin Palms, 1990. Incl. 23 man & woman nudes; esp. portrait of Deborah Turbeville reclining on bed near window, 1976.

Michaud, Fernand. (French 1929-) "Nu," 1978. Woman bent forward, seen from behind, near sink, toweling off. JL:61.

———. "Nu," 1980. Three images: woman's back, and two of a young woman standing against an interior wall. JL:62-63.

Michaud, Fernand. *Fernand Michaud.* [Exhibition catalog] Arles: Musée Réattu, 1986.

Michel, J.–L. (French 1929-) Two supine women in Yin Yang pattern. N.

———. Two supine women, side by side, heels to heads, amidst dried leaves. N.

———. Studio shot of woman kneeling on plush chair, wearing white hose & chemise pulled up to reveal her posterior, 1972. KS:43.

———. *The Best Nudes.* Tokyo: Haga Shoten, 1979.

———. Four works in NEW: standing woman frontal, up against quarry wall (130); supine woman on floor of room w statuette in corner (131); woman prone on mattress, left leg hanging onto floor; her body & mattress are HK, while surrounding image is LK (132); overhead shot of supine woman on double bed (133).

Mignat, Émile. Color, floor view of woman's torso against sky b.g. *Photo* 207 (Dec 1984):81.

Mikolajczyk, M. (French) Color, woman's arms and torso in window of building with yellow facade. *Photo* No. 298 (Jan./Feb. 1993): 59.

Miller, Brigitte. Infrared, blue toned print, of woman's torso frontal, resting on left side. *Photo* 268 (Jan 1990):95.

Miller, Lee. [female] (US 1907-77) "Nude," 1931. Woman in fetal position lying on her right side, her back to camera. WP:69.

———. "Nude," 1934. Blurred, grainy image of woman's butt. RK:151.

———. Penrose, Anthony. *The Lives of Lee Miller.* London: Thames & Hudson, 1985. Incl. Lee in stereoscopic nude, 1928, taken by her father (15); Lee in bathtub at Stockholm Grand Hotel, 1930 (37); "Nude Bent Forward," 1931, woman's hips, lower back, & butt. (27).

Minkkinen, Arno Rafael. (Finnish 1945-) *Frostbite.* Dobbs Ferry, NY: Morgan & Morgan, 1978. Of 59 prints, 21 nudes in outdoor settings, mostly of himself, some w blurred motion, a few w a young woman.

———. *Image Primordial.* Barcelona, Spain: Impressio, 1991.

———. "Mattomies # 12," 1983. Man reclining in shallow water. SEM:70.

———. (ed.) *New American Nudes: Recent Trends and Attitudes.* Dobbs Ferry, NY: Morgan and Morgan, 1981.

Minks, Marlin. *Strips.* N.p., 1985.

Minolfi, Guiseppe. (Italy) Color, lovely woman dancing in seated circle of ten old men in what appears to be an Italian village. Unique. *Photo* 280 (Jan 1991):42.

Mitchell, Paul. Woman's torso & head against wall, her face turned away; marvelous study of light & shadow. NIP:252.

Mittledorf, Klaus. (Brazil) Color; standing woman seen from back, wearing an enormous black hat; only her legs and butt. appear, but they are in excellent shape, 1990. BL:196.

Mizer, Bob. *Physique.* Edited by Winston Leyland. San Francisco, CA: Gay Sunshine Press, 1982.

————. *Athletic Model Guild.* London: Gay Men's Press, 1987.

Módos, Gábor. *Akt: Album.* Budapest: Képzőművészeti Kiadó,1987. Female nudes.

Moeller-Dubarry, Baron. *Das Luxusweib.* Leipzig, Ger.: Parthenon, 1928.

Moeschler, Nelson. (Swiss) Fur coat framing a woman's torso. *Photo* 184 (Jan 1983):71.

Moffatt, Tracey. (Australian) "Pet Thang," 1992. Woman's chest with lamb in background. *Art and Australia* 30 (Spring 1992):97.

Moffett, Donald. (US 1955-) Male nudes in HP.

Moholy-Nagy, Laszlo. (Hungarian 1895-1946) "Two Nudes," ca.1925. Positive & negative prints of reclining & standing women. CS:71, 72.

————. "Belle Isle." Two seated woman, rear view, on filthy blanket. CS:73.

————. Haus, Andreas. *Moholy-Nagy.* New York: Pantheon, 1980. Incl. "Two Nudes," 1929, two women's torsos supine on blanket (68) [also in IPM]; negative print of "Female Nude," 1929, seated woman's torso, w leaf shadows (69); "Female Nude," 1931, positive and negative prints of grainy shot of woman supine on couch, upside-down, head out of frame (73, 74) [also in AVK:78].

————. Hight, Eleanor M. *Moholy-Nagy.* [Exhibition catalog] Wellesley, MA: Wellesley College, 1985. Incl. "Female Nude," 1929 [same as in Andreas Haus, above, but Hight's volume has both positive & negative versions](96); "Female Nude," 1931 [same as in Andreas Haus, above](97).

Mohr, Ulrich. *Das Bildnis der Eva.* Hamburg, Ger.: Mohren Verl., 1959. ["How to" manual]

Molinier, Pierre. (French 1900-76) "Luciano Castelli," 1974. Series of images of a transvestite in body stocking. SEM:204-5.

————. Kaleidoscopic montage of women w black stockings, ca.1970s. NN:188.

————. *Cent Photographies Érotiques.* Paris: Eurographic, 1979.

Mongeot, Marcel Kienné de. *Schönheit die Begeistert. Akt-Photographien.* Bern, Switzerland: Verl. Wissen u. Fortschritt, 1952.

Monroe, Robert. Two woman nudes presented in an unusual color spectrum. NEW:64, 65.

Montane, Jordi. (Spanish) Man's hand with fingers pinching woman's nipple. *Photo* 298 (Jan/Feb 1993): 46.

Monthubert, Fabien. "Fabien Monthubert." *Photo* 288 (Oct 1991):76. Incl. 3 woman nudes.

Montinho, José Carlos. (Portuguese) Standing woman at base of stone cross, seen from above. *Photo* No. 291 (Jan./Feb. 1992):57.

Moore, David. (Australian) "Landscape Nude," 1973. Arm and back, sex unknown, probably female. *Art and Australia* 30 (Spring 1992):97.

Moore, James. "James Moore." *Photo* 210 (Mar 1985):24-33. Color, 2 women glamour nudes.

Moore, Susan J. Reclining woman with landscape background, 1979. Infrared, and not very good. AIS.

Morales, Gustavo. Supine woman's torso, covered w dirt. *Photo* 184 (Jan 1983):78.

Moran, James Sterling. *The Classic Woman.* New York: Playboy Press, 1972. Incl. 22 color (almost all of a portrait type), 17 B&W (all scratched with hatchmarks). His inspiration was Renaissance painting. He sought to approach their "mood of timelessness and tranquility". For this amateur, photography of women is a labor of love. His technique: studio shots in his mid-Manhattan apartment; Polaroid materials, antique tapestries for b.g., natural afternoon light for B&W, one photo-flood for color.

Moreau, Michel. *Indiscretions.* London: Haney Place Publications, [1981?]. *Charme.*

————. *Felines.* Paris: Pink Star, 1982. *Charme*

————. *Nus.* Paris: Pink Star, 1983. *Charme*

————. *Exhibitions.* Paris: Pink Star Editions, 1984[?]. Unpaged, color, glamor/erotic. 73 photos on tropical beach settings, mostly the Bahamas and Seychelles; 11 women models with seamless tans. Moreau favored a Nikon F2, with 28, 50, & 105mm lenses, Kodachrome 64 ASA, and 81A filter. *Charme*

Moreck, Kurt. *Kultur und Sittengeschichte der neuesten Zeit.* Dresden, Ger.: Aretz, 1929. Incl. d'Ora.

Morgan, Barbara. (US 1900-) "Pregnant," 1945. Very LK setting for pregnant woman's torso. *Barbara Morgan.* Dobbs Ferry, NY: Morgan & Morgan, 1972:(109); BWC:20; NIP:77.

Mori, Kenn. Woman's breasts, thighs, arms. NIP:168.

Morris, H.H. "The Joy of Living." HK print of standing woman, right profile, hands behind head. *AAP* 55 (1941):176.

Morrison, Gavin. "Culmination," 1975. Infrared of woman standing in what appears to be a garden, wearing a cape, head back, right side and breast exposed to view. AIS.

Mortensen, William. (US 1897-1965) "Cinderella," 1930. Studio shot in HK setting, of seated woman w one shoe off and wearing one black stocking. More glamour than pictorial.

————. *Monsters and Madonnas.* Canton, OH: Fomo Publishing Co., 1936. Unpaged. Monsters=camera equipment; Madonna=the symbol of fruitfulness and growth, "of life and creative energy." Because Madonna is often held captive by Monster, salvation comes through reception of the "Will-to-Form". On the nude: "Personality is an exceedingly dangerous ingredient to admit into the nude, and must be rigidly excluded from any *plastic* representation of it."

Incl. "Stamboul," a semi-nude standing woman w daggers tucked into her skirt: she represents "joyless, defiant, and predatory" sexuality; "Fragment," woman's torso frontal made to look as a Greco-Roman statue; "Figurehead," woman's torso frontal viewed from ground level: he wanted to capture the symbol of the nude—"endless fecundity"; "Youth," standing woman frontal, looking very much like a pencil drawing; "Nude Study," seated woman w arms atop head; "Portrait of a Young Girl," head & chest of young woman, eyes cast down: HK acheived through minimum exp. & maximum development; "Frou Frou," semi-nude woman; "Cinderella," seated woman in studio wearing hose & only one shoe; "Preparation for Sabbot," a "grotesque" study of a young witch being rubbed w magic oil before taking off on her broomstick; The Heretic," young woman tied to rack w nails through her ankles: the tortured damsel theme.

————. Seated woman's torso made to look like a classical Greek statue [from *Monsters and Madonnas*], NN:118.

————. *The Model. A Book on the Problems of Posing.* San Fransisco: Camera Craft, 1937. Incl. several pictorial women nudes as illustrations, e.g. the frontispiece—"The Model", a studio shot of standing woman frontal, suitably diffused and retouched [without pubic hair of course]. This nude had to conform to Mortensen's idea of "empathy", it must make the viewers project themselves "into the object which we contemplate, and to participate, by a sort of inner mimicry, in its activity."(216) By empathy he meant, in other words, to identify oneself with an object.(217) He harshly criticized other

photographers' nudes because he thought them foolish, banal, and lacking empathy: he provided a seventeen item list of "bad" nudes.(218-23)

His discussion of the figure model was confined to white women; he divulged quite specific preferences in the type of woman he liked to work with. A two page discussion of breast types is illustrated with six photos; Mortensen identified three types of breast suitable for nudes: 1) pearshaped, 2) West European, 3) American. [What exactly was an "American" breast?](70) Of course, he discouraged the depiction of pubic hair because it was too "realistic".(73)

The basis of his pictorial view was not moral but magical. Mortensen thought the nude must appear ideal, not real. Ideality was destroyed whenever the nude appeared in familiar surroundings engaged in commonplace activities.(216) Even in the studio he cautioned the photographer to keep his model in a bathrobe whenever she was not actually posing, because "...both model and artist should protect themselves from the consequences of disillusionment."(216) Photographer's of the Mortensen school appear to have become extinct.

———. "Mutual Admiration." Standing woman left profile, on tip-toes, reaching up towards a Peacock on vertical stand. *AAP* 47 (1943):145. NN:117.

———. Coleman, A.D. "Disappearing Act." *Camera Arts* 2 (Jan/Feb 1982):cover, 30-38, 108-9. Three pictorial woman nudes.

Mortensen, William and Dunham, George. *How to Pose the Model.* 3rd edn. New York: Davis, 1937; 1956; 1960.

Moser, Christian. "Les Top Models de L'Agence FAM." *Photo* 228 (Sep 1986):72. Incl. nudes of Alison Cohn, Eugenie Vincent, Magalie Miens, Ahn Duong, Sophia Gondard, Arielle Burgelin [the best nude of this series], Ariane Koizumi.

Mosher, Eric. *The Eroticism of Presence.* N.p., 1986.

Moulin, F.J. "Couple Embracing," 1855. Daguerreotype of man & woman in erotic embrace. CS:1.

Mountbatten, Louis Alexander. (1854-1921) [Album of female nudes] England: N.p., ca. 1890.

———. (comp.) [Album of nudes] England: N.p., ca.1900.

Mozingo, James. "Daimian Pisces," 1969. Woman seated w infant, blurred motion. BWC:11.

Mucha, Alphonse. (Czech 1860-1939) Five dance studies, 1901. Woman in variety of dance poses w Victorian "cozy corner" b.g. WE:18-22.

Muehlen, Bernis von zur. "Striped Nude (Infrared)," 1976. Supine man in light spot on floor. YK:88.

———. "Peter." Infrared shot of standing man frontal in room corner (b.g.), w statue on pedestal in f.g. DH:61.

———. "Portrait of Peter." Man seated in chair frontal, in virtually empty domestic interior. DH:4.

Mulas, Ugo. (Italian 1928-78) "Nudo per un gioiello di Arnaldo Pomodoro," 1970. Seated torso of black woman w folded arms, 1970. DP.

Müller, Konrad R. (German 1940-) Grainy print of woman's torso, 1970 (9); grainy print of woman's hips and butt., 1970 (16). Rolleiflex, Tri-X. *Camera* 53 (Sep 1974).

Munkacsi, Martin. (US 1896-1963) "Torso." Woman's torso. IPM.

———. Woman's supine torso against HK b.g. AVK:97.

———. "Washing," 1929. Short-haired woman stepping into square tiled bathtub. Weaver, Mike. (ed.) *The Art of Photography, 1839-1989.* New Haven, CT: Yale, 1989:(438).

———. "Nude, Europe," ca. 1924-34. Soft focus image of woman supine on bed, arms behind head. *CENTER Quarterly* [Woodstock Center for Photography] 14 No. 2 (1992):24; CS:58.

———. Two untitled works from 1935: each featuring supine woman near pool, partly shaded w translucent umbrella. CS:76, 77.

———. *Nudes.* New York: Greenberg, 1951. Incl. 79 photos in soft focus style; mostly studio figure studies. Notable for absence of harsh lighting or stark tonal contrasts, these works emphasize a soft deliniation of the adult female form. Large format cameras were his favorite for this project. Last page lists tech. data for each print.

———. Oberli, Maureen. "Martin Munkacsi." *Camera* 57 (1978):14.

Munter, Pierre de. Factory room, w woman prone near the one window in shot. *Photo* 232 (Jan 1987):76.

Murat, J-F. (French) Woman's torso, painted gloss blue. *Photo* No. 291 (Jan./Feb. 1992):47.

Mure, Jean-Michel. (French) Color, reclining woman in wet blue slacks on beach. *Photo* No. 291 (Jan./Feb. 1992):50.

Murray, Joan. (US 1927-) "Surrender" Supine woman before a window; high contrast. Rolleiflex, Tri-X (ASA 800). *Camera* 50 (Sep 1971):15.

Nadar [Gaspard Félix Tournachon] (French 1820-1910) "Nude," 1860. Albumin print. CS:17.

Nakai, Koichi. (ed.) *The World of Eros.* Tokyo: Seibundo Shinkosha Publishing, 1990.

———. (ed.) *Muses.* 1992. Incl. Shuni Okura, Yoshihiro Tatsuki, Hideki Fuji.

Nakamura, Masaya. (Japanese 1926-) *Nus Japonais.* Paris: Éditions Prisma, 1959; 1965.

———. *Young Nudes: Studies from Japan.* Tokyo: CamerArt Publications, 1960.

———. *Nude.* Tokyo: Manichi Newspapers, 1969.

———. *Nude: East and West.* Tokyo: Camera Mainichi, 1970.

———. *Ema Nude in Africa.* 1971.

Narahara, Ikko. (Japanese 1931-) High contrast print of woman's torso with ball or balloon near her butt. *Camera* 53 (Sep 1974):8.

Natkin, Marcel. (b. 1904) *Photography of the Nude.* San Francisco: Camera Craft, 1937. 32 plates.

Naud, Gérard. 3/4 view of standing woman holding mirror in front of her face. *Photo* 184 (Jan 1983):78.

Navarro, Rafael. *Dipticos.* Zaragosa, Spain: PhotoVision, 1986. Incl. 8 nudes in outdoor settings.

Nazarieff, Serge. (Swiss 1935-) "Formentera," 1978. Color; seven female butts rise from a shallow seascape. BL:160.

———. *Naked Elements.* London: Quartet, 1982.

———. Hideously bad color reproduction of woman prone on pebble beach, overhead shot. KS:37.

———. *Le Nu Stereoscopique, 1850-1930 (The Stereoscopic Nude).* Paris: Filipacchi, 1985; Berlin: Benedikt Taschen, 1990.

Nazarieff, Serge and Strinati, Pierre. *Clair de Roche.* Geneva: B. Letu, 1981.

Nebojša, Rakić. Left profile of woman's torso. *Photo* 184 (Jan 1983):78.

Neelson, Lotte. *12 Akt-Entwürfe aus der Tanzkunst.* Hamburg, Ger.: Heldt, 1924.

Németh, Jósef. (Hungarian 1911-) *Pictures and Memories.* Budapest, 1947.

———. *Special Objectives.* Budapest, 1958.

―――. "Painter and His Model," 1958. Studio shot of painter in background, model seated in foreground, back to camera, reminiscent of 1930s. CP:749.

Nerses, John W. "Symmetry." Woman kneeling, torso angled toward camera; HK setting. *AAP* 58 (1944):83.

Neumiller, Michael. "Bedtime." Seated woman removing her chemise. *AAP* 50 (1936):100.

―――. "The Model." Diffuse image of seated woman, frontal, w neo-classical painting b.g. *AAP* 52 (1938):131.

Neusüss, Floris Michael. (German 1937-) "Self-Portrait," 1972. Standing woman back to camera, Neusüss facing her in background. CP:752.

―――. Three works in NIP: portrait of woman at oceanside, arms crossed, hair wet (33); silhouette of seated woman (158); woman prone on black sheet (159).

Nevo, Katia. (French) Woman's hips, with stockings, reclining on her side. *Photo* 298 (Jan/Feb 1993):51.

Newberry, James. (US 1937-) Plump reclining woman against dark background, fairly high contrast. *Camera* 60 (Sep 1981):7.

Newler, Michael D. (b.1946) Color, abstract rendition of kneeling woman. NEW:62.

Newman, Arnold. Color, reclining woman in extraordinarily cluttered small room. NIP:108.

Newman, Byron. "Byron Newman." *Photo* 199 (Apr 1984):58-67. Three color photos of supine woman at poolside.

―――. Color, studio shot of supine woman on floor, removing her panties (from *Lui* [1986]). AVK:159.

―――. Color studio shot of prone woman holding lipstick (from *Lui* [1986]). AVK:159.

Newman, Marvin. Sequence of woman stripper at work on stage. PL:168-77.

Newton, Helmut (1920-) Prone woman in pumps under large window. Pentax, 28mm, Tri-X, multi-flash and daylight. *Camera* 53 (Sep 1974):25.

―――. *White Women.* New York: 1976.

―――. *Sleepless Nights.* London: Quartet, 1978.

―――. *Helmut Newton: Special Collection. 24 Photos Lithos.* New York: Simon & Schuster, 1979.

―――. Lamarche-Vadel, Bernard. (b. 1949) (ed.) *Helmut Newton.* [Ex. cat.] Paris: Éditions du Regard, 1981.

―――. *Double Elephant Portfolio.* New York: 1981. 15 prints in an edition of 50.

―――. *Big Nudes.* New York: 1982.

―――. *Helmut Newton: 47 Nudes.* London: Thames and Hudson, 1982.

―――. Woman reclining on leather couch in foreground looks at her image on a television screen in background, with another woman crouching next to the screen. In *European Photography, 1982-1983*, pp. 122-23. Edited by E. Booth-Clibborn. Basle: Polygon Editions, 1982. Originally in *Vogue* [French] (Dec 1981).

―――. Eleven woman nudes previously published. NEW:114, 116-18.

―――. *World Without Men.* New York: 1984.

―――. *Private Property.* New York: 1984. 45 print limited edn. of 75.

―――. *Helmut Newton's Illustrated No.1--Sex + Power.* Munich: Schirmer/Mosel, 1986.

―――. *Helmut Newton.* New York: Pantheon Photo Library, 1987; Paris: Centre Nationale de la Photographie, 1986. 61 plates.

————. *Helmut Newton's Illustrated No.2--Pictures From an Exhibition.* Munich: Schirmer/Mosel, 1987. 32 plates.

————. "Korean Air Lines." Interior shot near window, w night scene of airline's illuminated billboard outside, a man holds a woman by the hips as he enters her from the rear. Unusually explicit even for Newton. *La Recherche Photographique* 5 (Nov 1988):88. One assumes the date of photo is before 1988.

————. *Helmut Newton in Moscow.* [Exhibition catalog] Moscow: Pushkin State Museum for the Visual Arts, 1989.

————. *Helmut Newton: New Images.* [Exhibition catalog] Bologna: Galleria d'Arte Moderna, 1989.

————. *Helmut Newton: Private Property.* London: Schirmer's Visual Library, 1990.

————. *Helmut Newton's Illustrated No.3--I Was There.* Munich: Schirmer/Mosel, 1991.

————. *Polawomen.* New York: Schirmer/Mosel, 1991. 101 duotones; 74 color.

————. *Helmut Newton: Archives de Nuit.* Munich: Schirmer/Mosel, 1993. 62 plates.

Niccolini, Dianora. (Italian 1936-) Close-up view of supine woman [on beach?]; angle of view is between her open legs. NIP:216-17.

————. Black man's torso frontal. DH:65.

————. Rear view of standing man in forest. DH:60.

Nichols, John S. [Solarized?] print of seated woman in HK setting. How did he achieve this effect? There is an outline of the figure, but also some tonal modeling. BB:44.

————. Seated woman's torso w same special effect as above. BB:45.

————. Supine woman w wire screen over her, causing shadows. BB:67.

Niczky, Joe. *Ich kannte sie alle.* Berlin: Quadriga-Verlag, 1984.

Nielsen, Knud. Woman standing in shower stall. *Photo* 184 (Jan 1983):79.

Niem, Freddie. *Sons of the Moon.* San Francisco, CA: Orchid House, 1991.

Niklaus, Chantal. (Swiss) Color, studio shot of young woman in bizarre body makeup. *Photo* 232 (Jan 1987):84.

Nikolaidis, George. *Japanese Nudes and the Amateur Photographer.* Rutland, VT: C.E. Tuttle, 1965.

Nikolas, Wolf. *Arjun: Photographs.* London: Gay Men's Press, 1987.

Nikoleris, Theodoros. (Greek 1898-) "Theodoros Nikoleris." *Camera International* 4 (Automne 1985):20-29. Eight adult female nudes similar to Drtikol. Excellent.

————. "Nude Study," 1930. Grainy print of classically posed standing woman. NN:116.

Nikolson, Chris. *Provocations.* Nyons, France: Le Club du Livre Secret, 1984. *Photographie de charme.*

————. *Les Dentelles de l'Automne.* [Paris, 1984?] *Charme*

Nishimura, Arthur H. (Canadian 1947-) Two butts on black background. *Camera* 52 (Jly 1973):33.

————. High key background, with woman's hips and chest on side seen in foreground, 1974. Three halogen lamps. *Camera* 53 (Sep 1974):15.

Nixon, Nicholas. (US 1947-) "Bebe and Clementine, Cambridge, 1985." Baby at mother's breast. SEM:134.

————. "Cambridge, 1986." Two shots: baby's penis; boy bending over backwards. SEM:135.

Noble, Richard. Two nudes featured in CAEP: a man & woman on a mattress; a woman in hose supine in bathtub.

Noblet, Xavier. LK shot of woman's torso frontal. *Photo* 280 (Jan 1991):66.

Noël, Bernard. *Le Nu.* Paris: Centre Nationale de la Photographie, 1986; *The Nude.* New York: Pantheon, 1986.

Nooijer, Paul de. (Dutch 1943-) Color Polaroid SX-70. Human butt. in grey hallway. S.

Nørgaard, Erik. *Da Bedstefar så Dobbelt: Historien om de Erotiske Stereoskopbilleder.* Copenhagen: Rhodos, 1974. Naughty nudes from the late 19th century to ca.WWI.

Norman, Eleanor L. "Poise." Standing woman in black skirt & elbow length gloves. *AAP* 55 (1941):149.

Normand, M. Le. Color, woman reclining on right side on bed in cheap hotel room. *Photo* 232 (Jan 1987):68.

North, Kenda. (US 1951-)"Barbara (Walden Hot Springs)," 1978. Hand colored dye transfer print. In *Photographs* (1988).

———. Female semi-nude, 1984. 20 x 24 Polaroid. Also in 1988 volume.

———. "Collaboration # 1," 1987. Female semi-nude. Cibachrome. See also # 2 and # 3 in same series, same date, in the 1988 volume.

———. *Kenda North: Photographs.* Tokyo: Gallery Min, 1988. Semi-nudes. Dye transfer, polaroid, Cibachrome.

———. *Kenda North.* New York: Aperture, 1990.

Oberle, Wolfgang (photographer) and Eichhammer, Angelika (text). *Mädchenfotografie.* Herrsching: VWI-Verlag, 1980.

———. *Erfolgreiche Mädchenfotografie.* Herrsching: VWI-Verlag, 1981. ["How to" manual]

Ockenga, Starr. [female] (US 1939-) *Mirror after Mirror: Reflections on Woman.* Garden City, NY: Amphoto, 1976.

———. Infrared image of standing man frontal, on crutches. YK:56.

———. Two women standing near window, heavy shadows for woman on left in doorway. *Camera* 60 (Sep 1981):11.

O'Connor, David. "Barbara's Hotel Room." Infrared photo of woman siting in plush chair, head back, face under a table lamp. AIS.

O'Connor, Florence C. "On the Dune." Against sky b.g., standing woman on sand dune w arms raised. *AAP* 52 (1938):170.

O'Dell, Dale. Infrared, brown tinted print of standing woman in mask, holding pair of wings looking as if designed by Leonardo, sky b.g., 1989. She wanted to make nudes that were not "male oriented", yet she enjoyed the play of light on the human body. She sculpted masks for her models, to hide their personalities and get beyond the "pretty body & pretty place imagery that...is too common in nude photography." O'Dell thought the masks converted models from humans to creatures "more integrated with the environment." *Viewfinder: Journal of Focal Point Gallery* 17 (1993).

Odilon, Alice. (French 1959-) "L'assiette," 1983. Young woman with arms raised showing off her hairy arm pits, seated before a plate of fish. SEM:208.

———. "Ventre dans le noir," 1985. Young woman reclining on her back wearing a black body stocking and a pregnancy prosthesis [not apparently fake at first glance]. SEM:209.

Oelman, P.H. "Pagan." Kneeling woman raising wine glass, smiling at us. *AAP* 56 (1942):151.

———. "Aurora." HK print of seated woman almost in reclining pose. *AAP* 57 (1943):110.

———. "Bookends." Books in middle, seated women on either side, forming bookends, HK print. *AAP* 58 (1944):167.

———. "Minuet." Standing woman in dance pose, HK print. *AAP* 60 (1946):131.

———. "Photography of the Nude." *AAP* 61 (1947):40-52. Incl. 6 studio shots of women, all but one are standing in HK setting w strong defining outlines of the figure. He found models among friends & neighbors, describing his favorite model: "...I like the long-legged slender type with a small firm bust, clear eyes, and expressive hands. She is the typical well educated American girl of today..."(42).

Ogawa, Katuhisa. *Hatsukoi Jurokusai.* 1970.

Oliver, Owen. *Hours: Twelve Figure Studies with the Miniature Camera.* London: Self Published, 1943.

Ommer, Uwe. (German 1943-) *Uwe Ommer. Photoedition 2.* Schaffhausen, Switzerland: Verlag Photographie, 1980. Color, young semi-nude women, often in blazing sunlight, in the best European glamour tradition.

———. Six color works in NEW: two black women w yellow gauze (70, 71); two standing women wrapped in yellow & red gauze (72); standing woman frontal holding ebam of light (73); woman crouching in room (74); black woman under gauze, on floor (75).

———. *Exotic.* Munich: Bahia, 1983.

———. "Black is So Beautiful." *Photo* 210 (March 1985):98-107. Color, black women semi-nude. Comments by Ommer.

———. *Black Ladies.* Paris: Les Éditions du Jaguar, 1986.

———. *African Sojourn.* Beautiful African women.

———. *Uwe Ommer.* Berlin: Benedikt Taschen, 1990. Unpaged. 47 color works, mostly of young African women.

———. "Uwe Ommer." *Photo* 283 (Apr 1991):82. Incl. 12 color photomontages of black women.

Ootake, Shoji. *Janet.* 2nd edn. Tokyo: Nihon Camera Co., 1974.

Opalenik, Elizabeth. Three beautiful nature nudes, of young women. In *1993 Woodstock Photography Workshops.* Woodstock, NY: Center for Photography, 1993:(11).

Oppi, David. Color, standing woman frontal on kitchen table. *Photo* 207 (Dec 1984):81.

Ornitz, Don. *Living Photography.* New York: MACO, 1962.

———. Series of color glamour shots. NIP:89-93.

Ortil, Hajo. [Hans Joachim Oertel] *Amazonen in Sonne und Baltenwind.* Nuremburg, Ger.: Zitzmann, 1955.

———. *Olympiafahrt.* Nuremburg, Ger.: Zitzmann, 1957.

———. *Wir Schwingen über Sonnenhang.* Nuremburg, Ger.: Zitzmann, 1957.

———. *Noch Sprudeln die Quellen Arkadiens.* Nuremburg, Ger.: Zitzmann, 1958.

———. *Holland Olé! Eine Lustige Piraterie.* Hamburg, Ger.: Danehl, 1961.

———. *Hinein in die Boote! Jugend Ahoi!* Hamburg, Ger.: Danehl, 1963.

Osaka, Hiroshi. Roth, Evelyn. "The Inner Limits." *American Photographer* 18 (Nov 1987):70. Osaka studies himself by looking at the bodies of others.

Osborn, Dana. (US) "Clouded Nude," 1992. Color computer generated reclining woman on cloud amid blue backgroud. Group show, Images '93, Guilford, CT.

Osman, Colin. *Amor.* London: Kings Road Pub., 1969.

Outerbridge, Paul, Jr. (US 1896-58) "Torso," 1923. IPM.

———. "Young Girl Nude with Shoes on," 1924. [Young woman] CS:60.

———. Color, woman standing w mask on. CS:64.

———. "Nude with Spiked Gloves." Woman's torso w steel-spiked gloves. CS:66.

———. *Photographing in Color*. New York: Random House, 1940. Incl. undated color plates: "Dutch Girl," seated women frontal w lace hat (pl.3); "Chinese Girl," portrait of semi-nude Asian woman (pl.9); "Beauty," standing woman frontal, arms behind head (pl.14).

———. "Outerbridge Retrouvé." *Photo* 136 (1979):38.

———. Howe, Graham and Hawkins, G. Ray. (eds.) *Paul Outerbridge, Jr.* New York: Rizzoli, 1980.

———. Howe, Graham and Markham, Jacqueline. (Text) *Farbphotographien, 1921-1939*. Munich: Schirmer/Mosel, 1981.

———. Dines, Elaine. (ed.) *Paul Outerbridge: A Singular Aesthetic. Photographs and Drawings, 1921-1941.* Laguna Beach, CA: Laguna Beach Museum of Art, 1981.

———. "Paul Outerbridge." *Photo* 181 (1982):54.

———. "Paul Outerbridge: der Vater des Pin-Up." *Foto-Magazine* 9 (1982):96.

———. Dreisphoon, Douglas. "Paul Outerbridge's Fashionable Fetish." *Arts Magazine* 60 (Apr 1986):24-28.

Ovenden, Graham. "Lorraine," 1964. Right profile of standing girl, reminiscent of pictorialist works. *Photography in New York* 5 (Jan/Feb 1993):n.p.

———. *Graham Ovenden: States of Grace. Photographs, 1964-1989.* New York: Ophelia Editions, 1993.

Ovenden, Graham and Mendes, Peter. *Victorian Erotic Photography.* New York: St. Martin's Press, 1973.

Owen, Mike. "Archer," 1986. Reminiscent of FKK nudes, standing man w bow & arrow in forest. BTM:13.

Owings, Thomas. Three works in HS: woman kneeling on dune; seated/kneeling woman wearing turban [not as hackneyed as it sounds]; standing woman, right profile, leaning back against LK set.

Paal, Alexander. Standing woman frontal, almost in silhouette. HS.

Pacé, Françoise. (French 1957-) Four experimental nudes using highlighted areas in shadows. C:27-31.

Paco. (Budapest) Double exp. of woman's torso against LK b.g., ca.1935. USII:121.

Paduano, Joseph. *Infrared Nude Photography.* Amherst, NY:Amherst Media, 1991. 80 pp. 50 sepia toned photos of women in natural environments.

Paillochet, Claire. (ed.) *Drunter & Drüber.* Zurich, 1984. Incl. J. Dunas, J. Gaffney, D. Gaillard, Chris Thomson.

Paine, Wingate. *Mirror of Venus.* New York: Random House, 1966. Incl. 24 women nudes of a restrained & demure type.

Palais, Didier. Color, supine woman, overhead shot. *Photo* 232 (Jan 1987):62-63.

———. Color, standing woman rear view, before row of oranges buses. *Photo* 232 (Jan 1987):69.

Palazzoli, Daniela. (ed.) *Il Corpo Scoperto Il Nudo In Fotografia.* Milan: Idea Books, 1988. Nudes from 1850 to 1984. Incl. Alphonse Mucha, Julien Valou de Villeneuve, Giacomo Caneva, Durieu, Franz Hanfstaengle, G. Marconi, Plüschow, Muybridge, Edgar Degas, Pierre Bonnard, V. Galdi, Gloeden, Francesco Paolo Michetti, Bruno Braquehais,

Leopold Reutlinger, E.J. Bellocq, A. Calavas, Rudolf C. Huber, Lehnert & Landrock, Heinriche Zille, Fred Holland Day, Willy Zielke, E. Steichen, C. White, H. Matthieson, R. Koppitz, Julius Gross, Hajek-Halke, Man Ray, Marta Hoepffner, Boris Ignatovic, Drtikol, R. Hausmann, E. Weston, I. Cunningham, Florence Henri, Stieglitz, d'Ora, Anton Sahm, A.C. Johnson, Manassé, Dorothy Wilding, Horst, Diénes, O. Steinert, Willi Eldenbenz, F. Berko, Carla Cerati, Brandt, Ugo Mulas, I. Penn, Mapplethorpe, R. Bernhard, R. Gibson, C. Vogt, André Berg, J. Sieff, H. Newton, J. Bourdin, Charlotte March, Bert Stern, F. Fontana, Gianpaolo Barbieri, L. Krims, Will McBride, D. Michals, Diane Arbus, Weegee, J. Dater, Werner Bokelberg, Dieter Appelt, D. Blok, J. Saudek, J. Gantz.

Palma, Louis Gonzalez. "La Luna," 1989. Right profile of bare-chested woman in studio, w giant crescent Moon tied to her head w coarse rope. *Photography in New York* 5 (Sep/Oct 1992).

Palladino, Joseph. "Shy Model." Seated woman frontal, on velvet covered posing block, her head bowed. *AAP* 47 (1933):144.

Panagl-Holbein, Carl F. "Claudia mit Roten Handschulen," 1990. Color, seated woman rearview, embracing herself w red gloves. KS:30.

————. "Sylvia," n.d. Woman's butt. & stockinged thighs. KS:49.

Papageorge, Tod. (US 1940-) "Rochester, New York," 1970. Woman doing headstand in room. CS:120.

————. "Zuma Beach, California," 1978. 1) nude beach scene; 2) woman with open legs lying in the surf, with three children in swimsuits perhaps three meters away. *Aperture* 85 (1981):18-19.

Papaioannou, Alex. Seated woman frontal, head thrown back. PK.

Paravagna, Paolo. (Italian) Color, woman seated on rock against seascape. *Photo* No. 291 (Jan./Feb. 1992):50.

————. Color, woman floating on back in brilliantly sunlit outdoor pool (she rests on some sort of underwater wall/pool divider). *Photo* 298 (Jan/Feb 1993):45.

Pare, Richard. (US 1948-) "L.V. Chicago," 1977. Color Polaroid print of woman's torso frontal. CS:130.

————. "Christmas, Garrison," 1978. Color Polaroid of woman's butt. CS:131.

Paris, Alain. Excellent tonal values in shot of woman's torso frontal, reclining on side. *Photo* 184 (Jan 1983):62.

Park, Bertram and Gregory, Yvonne. *Beauty of the Female Form.* London: Routledge, 1934. 48 photos. This husband & wife team in England were pioneers in the glamour market.

————. *Sun Bathers.* London: Routledge, 1935. 48 plates.

————. *Curves and Contrasts of the Human Figure.* Pelham, New York: Bridgman, 1936.

————. Harshly lit frontal torso of woman, 1937. NN:121.

————. *Eve in the Summer Light.* London: Hutchinson, 1937.

————. *Living Sculpture.* Pelham, New York: Bridgman, 1937.

————. *A Study of Light and Shadow on the Female Form.* London: John Lane, 1939.

Parkinson, Mary Ann. (US 1953-) Two obscure nude fragment type images in SEM:65. Also "Beth Reclining," 1987. Tight frame of woman's breast with pointy nipple and hip. SEM:64.

Parkinson, Norman. (UK 1913-) Color, prone woman on divan (from *The Vogue Beauty Book* [1951]). Apparently the first nude published in connection w *Vogue* magazine. NN:132.

———. *Sisters Under the Skin.* New York: St. Martin's, 1978. Unpaged. Incl. "Amy & Anne McCandless," color, twins lying on top of each other on seamless [cover photo]; "Tracy Ward," color, woman seated in plush chair reading copy of *Sisters Under the Skin,* w caption 'Parks, I would like to be in this book!'; "Mustique,' color, backlit woman's face & chest, supine; "Mary Ann Slinger in Trinidad," color woman prone on rock, near waterfalls; "My First Nude," the famous *Vogue* shot [see above], exp. of one minute at f/5.6, daylight in winter; "Promenade," girl walking down road in forest, back to camera; "Blue Fields River, Jamaica," color, kneeling black woman on stream in jungle.

———. "Norman Parkinson." *Photo* 208 (Jan 1985). Incl. color, 2 semi-nudes in a high fashion style, for the 1985 Pirelli calendar.

———. "Norman Parkinson." *Photo* 222 (Mar 1986):82. Color, 2 semi-nude women, 1 nude woman, high fashion style. [He can't help it: the fashion approach is ingrained.]

Parrella, Lew. (ed.) *Creative Camera: Three Profiles of Beauty by Ferenc Berko, Peter Basch, Wynn Bullock.* New York: MACO, 1960.

Parry, Roger. (French 1905-77) "Nude Study," 1929. Woman's butt. & legs. CS:80.

———. "Nude," 1931. 3/4 view of reclining woman propped up on left elbow. Curiously 19th century look. In Maria Morris Hambourg, *The New Vision: Photography between the World Wars.* New York: H. Abrams, 1989:(66).

Paternite, Stephen and Paternite David. (eds.) *American Infrared Survey.* Akron, OH: Photo Survey Press Publishing, 1982. Unpaged. Nudes listed under AIS abbreviation.

Pau, Sigi. *Erfolgreiche Aktfotografie.* Herrsching: VWI-Verlag, 1984. ["How to" manual]

Paul, Manfred. "Sabine at the Window," 1978. NN:169.

Paviotti, Mauro. (Italy) Studio shot, standing woman, leaning back on circular object. *Photo* 257 (Feb 1989):86.

Pawelec, Wladyslaw. (Polish 1923-) *Privat. Special Collection.* Nuremburg, Ger.: DMK-Verlag, 1983.

———. *Sylvia.* Paris: Éditions Acanthe, 1984. Color, amateur women models posing in a stereotyped glamour style.

———. "Suites Érotiques Polonaises." *Photo* 199 (Apr 1984):76-83. Incl. 5 woman nudes of a slightly erotic type.

———. *The Friends of Zofia.* Los Angeles: Melrose Pub., 1985.

Peccinotti, Harri. (UK 1938-) Color, 9 close-up fragment studies of women. MEP.

Pedriali, Dino. (Italian 1950-) *Dino Pedriali.* Frankfurt, Ger.: Frankfurter Kunstverein, 1986. Incl. 29 homoerotic nudes of teenage boys from the Roman underworld; all but three are LK studio shots.

———. *Pier Paolo Pasolini: "Testamento del Corpo".* Venice, Italy: Arturist, 1989.

———. *Dino Pedriali.* Kyoto, Japan: Kyoto Shoin, 1989.

Peel, Fred P. *Shadowless Figure Portraiture.* Canton, OH: Fomo, 1936.

Pegudo, Gallardo, Rafael. *La Fotografía del Desnudo.* Havana, 1950. Univ. of Florida.

Peillard, Bertrand. (French) Woman seated on sofa holding binoculars, with surprised expression. *Photo* No. 291 (Jan./Feb. 1992):51.

Peiser, Max. *Der Kinderakt. Das Kind als Modell.* Berlin: Int. Kunstverlag, 1895-96. 50 photos of children in nature.

Penn, Irving. (US 1917-) *Irving Penn: Earthly Bodies.* New York: Marlborough Gallery, 1980. 76 photos of women; printed ca. 1950.

———. "Nude 147," 1950. Woman on studio floor. Visible: her hip, pubic hair, thighs, plump belly. DP.

———. Three color shots on location at a Jamaican waterfall: a tall fashion model disports herself amid the flowing water. Bruce Downes thought these the most remarkable color nudes since the invention of color photography. *Popular Photography Color Annual* (1957):72-75.

———. Szarkowski, John. *Irving Penn.* New York: MOMA, [1984]. Incl. "Sculptor's Model, Paris, 1950", a plump standing woman rear view, on seamless (90); series of fragment nudes from his *Earthly Bodies*: Nos. 16, 65, 119, 92, 89, 130, 140, 99 [all plump women] (76-83).

———. *Passage: A Work.* New York: Knopf, 1991. Incl. "Sculptor's Model, Paris, 1950", (93); *Earthly Bodies* nudes Nos. 92, 111, 18, 65, 139, 132 (66-71); "Ungaro Bride [Marisa Berenson]," 1969, standing woman frontal 3/4, arms akimbo, costumed in bizarre makeup & metallic skirt (181); "Nubile Young Beauty of Diamaré, Cameroon," 1969, black woman seated on seamless (183); "Fashion [Marisa Berenson]," 1970, supine woman, right profile, torso raised off of seamless by resting upon elbows; she wears extensive chain-link jewelry (187).

Penneau, Sébastien. (French) Classic 3/4 standing woman largely hidden in shadows, yet standing out from high key background; beautiful. *Photo* No. 291 (Jan./Feb. 1992):59.

Penot, Albert. Woman prone on divan, under transparent veil, ca.1900. *Photography in New York* 5 (Nov/Dec 1992):n.p.

Perauer, Emil. *Crazy Horse Saloon.* Paris: Denoël-Gouraud, 1967.

Perckhammer, Heinz von. (German) Two women; one lying on sofa and one kneeling with her left hand on the reclining woman's thigh, ca.1930. Definitely erotic. BL:106.

———. Backlit woman standing against cloudy sky background, ca.1935. BL:98: USII:56.

———. "On the Dunne," (from *La Beauté de la Femme* [1933]). Slightly contrived pose of standing woman pointing skyward. NN:119.

———. Standing woman frontal, in field, w sky b.g. HS.

———. *Edle Nacktheit in China (The Culture of the Nude in China).* Berlin: Eigenbrodler-Verlag, 1928. 32 photos.

Perdrix, Olivier. (b.1958) Seven works in NEW: studio shot of standing woman holding plate glass, which casts unusual reflections on both her & the backdrop (32); standing woman holding large straws to her nipples (34); standing woman 3/4 w mask tied to butt., HK setting (36); disturbing shot of standing woman frontal 3/4 w two poles running through her head (37); woman's torso frontal w head covered by paper bag (38); woman's torso frontal w pieces of ribbon or tape seeming to flow from her crotch (40); seated woman in LK setting (41).

———. Series of 5 photos: studio shots of woman's torso and face, w various props, crumpled paper, dolls, ribbons. In *Angenieux: Carte Blanche A.* Paris: Contrejour, 1984:(45-49).

Pérez-Tobón, Ana Lucia. (Columbian) Amazingly rounded woman's butt., seated on fine sand, 1990. KS:51.

Perkins, B.R. "Nude Study." Seated/kneeling woman in head band, arms behind head, HK print. *AAP* 59 (1945):99.

Peryer, Peter. (New Zealand 1941-) Young woman reclining on side with knees drawn up, 1975. Rolleiflex. *Camera* 60 (Sep 1981):30.

Pécsi, Jószef. (Hungarian 1889-1956) *Der Akt.* Dachau, Ger.: Einborn-Verlag, 1918. 20 photos, incl. those of Germaine Krull.

———. *12 Aktaufnahmen.* Berlin: Mörlins, 1922. 12 photos.

———. Dancing woman, 1925. Very soft focus. BL:77.

Pesin, Harry. *2½ Hours with Judy in the Nude.* New York: Perspective Publications, 1966.

Peterka, Miroslav. Four men in swimsuits spying on nude women sunbathers on the other side of a fence. JS:I.

Peterson, Albert. Woman standing near waterfall. HS.

Peterson, C.A. *Photographing Unknown Beauties.* Los Angeles: Trend Books, 1958.

Peter-Witkin, Joel. (US 1939-) *Joel Peter-Witkin.* Pasadena, CA: Twelvetrees Press, 1985. Incl. 35 "distressed" photos which are technically nudes. He creates hideous scenes of deformed humans, some living, some dead, to show "the insanity of our lives". He also wanted to "create a dialog with The Infinite." The result is ugliness redefined as beautiful.

Petra, Alberto. (b. 1958) *Polaroid.* [Catalog of exhibition at Galerie fur Kunstphotographie, Nuremberg, 20 Jun—18 Jul 1986.] N.p., 1986.

Pétremand, Gérard. (b.1939) Remarkable series of 7 multi-exp. images of standing & seated women, painted w light: select areas of the body are illuminated w beams of light to produce unusual effect. NEW:48-54.

Peyer, Hans-Jürg, *Color Moods.* Zurich: Color-Verlag, 1971.

Pfeffer, Barbara. (US) Standing man in low key background, his back to us. Leica, 35mm, Tri-X. *Camera* 51 (Sep 1972):42.

Pfirter, Esther. (Swiss 1930-) Studio shot of standing woman. *Camera* 54 (Sep 1975):22.

Phillips, Donna-Lee. (ed.) *Eros & Photography.* NFS Press.

Phillips, Stephen John. (US 1957-) "Perfect One," 1987. Man and Woman with Mohawk hairdos in poorly lit studio. SEM:210.

———. "Lovers," 1987. Part of same series as above. Same style and lighting. SEM:211.

Piet, Nicolas. Woman prone, resting upon her elbows. *Photo* 280 (Jan 1991):63.

Pietrzok, Wolfgang. Female nude beyond category, 1989. BL:176.

Pilar, Zdenek and Rezac, Jan. (photographers) *Akt 125.* Hanau: Müller und Kiepenheuer, 1969.

Pinkard, Bruce. (b.1932) *Creative Techniques in Nude Photography.* New York: Arco Pub., 1984.

Pix Publishing. Rear view of standing woman viewed from floor level. BB:24.

———. Supine woman, raised up on elbows, head not in frame. BB:55.

———. Crouching woman seen from behind. BB:56.

Pizzarello, Charlie. From "Couples" series, 4 works in *Puchong Folios* (New York) 1 (Spring 1991): "Jora and Peter," 1991. Man & woman of nearly equal height standing in expressive poses, LK setting w strong side lighting (cover)[Also in *Photography in New York* 5 (Sep/Oct 1992)];. "Jora and Peter," 1991, same title, but man's & woman's torsos only (36); "Janet and Ann," 1991, seated woman w veil on left, and standing woman right profile on right; "Deidre and Franceso," 1991, woman's torso frontal, costumed in leather harness, her right nipple pierced w a small ring (35).

Planchais, Dany. Color, standing woman against haystack. *Photo* 184 (Jan 1983):74.

Planchon, Jean-Claude. (French) Color, well tanned seated nude with sunhat, *à la* David Hamilton. *Photo* 298 (Jan./Feb. 1993): 52.

Plewiński, Wojciech. (Polish 1928-) Print from "Penetrations" series, 1966-68. Woman's torso on left side of frame; clothed man leaning against tree on right side of frame. CP:814.

———. "Hanging Nude." 3/4 frontal view of woman hanging upside-down on a tree trunk, w street scene b.g. NN:172.

———. Poli, F. "Il nudo nella fotografia del Est Europo." *Torino Fotografia* (1985).

Plowright, Richard. (b.1940) *Himage.* Boston: Alyson Publications, 1990. Male nudes.

Plüschow, Guglielmo. (Italian, says BL) Horrid photos: man & woman, 1895; standing woman against wall, 1895; two youths, 1895; two girls standing, 1895. BL:67-69.

———. "Zwei sitzende Modelle," 1895. Two seated women look on the verge of breaking out into laughter. Albumin print. USI:171.

———. "Aktbildnis," 1895. Standing woman 3/4 frontal, head facing left. Albumin print. USI:175.

———. "Stehender Akt vor Palmblättern," 1895. Albumin print. Standing woman frontal, w palm leaf motif. Albumin print. USI:179.

———. "Junger Mann...," 1895. Youth posing w sword. Albumin print. USI:203.

———. "Zwei Jünglinge auf einem Sofa ruhend," 1895. Two youths seated semi-reclining, semi-erect penises. USI:205.

Pohanka, Reinhard. *Pikant und Galant: Erotische Photographie, 1850-1950.* Vienna: J&V Edition Wien, 1990.

Poisson, Philippe. (French) Color, woman's torso and arms with red boxing gloves. *Photo* No. 298 (Jan./Feb. 1993): 33.

Polacci, Pierre-Hugue. Color, woman's breasts w chain pulled across them. *Photo* 257 (Feb 1989):75.

Porter, Allan. (US 1934-) Study of a woman named Pamela, lying face down. Leica M4, 50mm, Tri-X (ASA 1600). *Camera* 51 (Sep 1972):26.

———. Woman seated on posing block, facing right of frame, her head bowed, hair hanging down to shade and obscure the face. Polaroid 190 camera. *Camera* 53 (Sep 1974):5.

———. Polaroid of woman supine on bed with cat near her chest. *Camera* 60 (Dec 1981):back cover.

———. *Wie ich sie sehe, wie ich sie sah.* Zurich, Switzerland: Verlag Bar, 1984. Incl. 17 nude portraits of models Maggie, Irene, Pamela, Yvonne, Daphne, Palma, Yuka, Rise.

Posar, Pompeo. Color, supine woman & flowerpot (from *Playboy* [1970]). AVK:156.

———. *Playboy's Nackt vor der Linse.* Hamburg, Ger.: Nelson, 1979.

———. Color, supine woman on bed (from *Playboy* [1983]). AVK:156.

———. Color, seated woman on white couch arm (from *Playboy* [1983]). AVK:157.

Pouget, Jean-Claude. (French) Color, woman's torso with facade of house projected onto her. *Photo* No. 298 (Jan./Feb. 1993): 29.

Poupel, Antoine. (French 1956-) *Antoine Poupel Images, 1982-1985.* [Ex. cat., Villa Medici, Rome, 24 Sep–14 Oct 1985.] Incl. 4 Polaroid SX-70 shots of supine woman; manipulated prints.

Powell, Jack. "Ilas." Seated woman frontal, in dancelike pose. *AAP* 50 (1936):148.

Powell, James. People on bed, blurred motion, 1970. BWC:30.

———. Crouching woman in leaves. BWC:48.

Power, Mark. (US) Two standing women [sisters] 3/4 view, 1968. *Camera* 48 (Sep 1969):12.

Presser, Gustave. "Nude Study." HK image of standing woman rear view. *AAP* 50 (1936):146.

Prévotel, Patrice. "Les Privautés de Prévotel." *Photo* 233 (Feb 1987):92. Incl. 11 erotic woman nudes.

Prince, Len. "Barry with Drum," 1990. Left profile of muscular black man's torso, drum held at mid-section. *Photography in New York* 3 (Nov/Dec 1990).

Prins, Lieve. (Dutch) "Lovers in Public Baths," 1990. Color xerographic prints of man & woman in amorous pose; very creative. BL:177.

Prošek, Josef. (b.1928) LK fragment of supine breasts. AA:6.

Prouver, Jean-Marc. Image from "Burial" series: bloody supine man w head wrapped in gauze. BTM:54.

Prouvost, Fr. X. Color, woman's torso in mirror on beach. *Photo* 207 (Dec 1984):76.

Prouvost, Françoise. (female) (French) "Sophie Marceau." *Photo* 216 (Sep 1985):44. Series of 18 studio shots of 18 year old actress. Mediocre.

———. "Anémone." *Photo* 218 (Nov 1985):34. Color, series on a French actress. Mediocre.

Pruszkowski, Krysztof. (Polish 1943-) "Dolores recto verso," 1984. Woman standing on studio backdrop; double exposure allows us to see her front and back. SEM:49.

———. "Dolores Nude," 1985. Quadruple exposure of woman's torso with arms and hands. LN:50.

———. *Krysztof Pruszkowski Fotosynteza, 1975-1988.* Lausanne, Switzerland: Musée de l'Elysée, 1989. Incl. series of 5 multi-exp. images of "Doloreze"; also "Waiting for Ludwik," 1986-87, left profile of pregnant woman's torso.

Pudenz, Martin. (German) Absurd [anti-nude ?] shot of standing middle-aged woman wearing a belt with bananas tied to it; she holds a balloon on a string, 1990. BL:163.

Pugin, Jacques. (Swiss 1954-) Woman stretching over tree stump at night. Several minute exp. with flashlight moved across her body. Hasselblad, Tri-X. *Camera* 60 (Sep 1981):8.

———. Three works in NEW: woman's butt. w taught & vertical string bisecting the cheeks (156); woman's torso frontal w geared apparatus in f.g. (158); woman's butt. in white G-string (159).

———. Color, Polaroid; woman's torso frontal against red b.g. SII.

Pussieux, Geneviève. Color, oiled woman's torso near lace curtain window. *Photo* 207 (Dec 1984):86.

Puyo, Charles. [Émile Joachim Constant] (French 1857-1933) "Nude against the Light," 1894. Grainy image of woman on window seat, flowers in her hair. NN:64.

Pyatkov, Roman. (Russian) "Love in the Kitchen," 1988. Two photos set in kitchen with window background, double exposure, w two women in an erotic embrace. *Aperture* 116 (Fall 1989):50.

———. "Open the Window, I'm Leaving...," 1988. Two photos set on table near window, double exposure with women's butts and legs visible. *Aperture* 116 (Fall 1989):51.

———. "Witches Sabbath," 1988. Two women jump in mid-air in an apartment, with reclining woman in background. *Aperture* 116 (Fall 1989):53.

Quinn, Billy. "For a Long Time My Dreams Kept Me Alive," 1991. Man seated w globe on lap; man standing behind him w feathered wings. Both seem to be wearing condoms. Unique laser print on varnished wood. *Photography in New York* 5 (Jan/Feb 1993):n.p.

Raba, Peter. (German 1936-) *Eva and Er.* Munich: Schumacher-Gebler, 1969. Man & woman explore nature and each other. Photographed Sep–Oct 1967 at Bayerischen Voralpenland, near Garmisch-Partenkirchen, on 6x6 format camera.

———. Man & woman embrace on forest floor. N.

Radisic, Pierre. (Serb 1958-) "Sortilèges 16.2.1983," Greased up male torso [black?]. SEM:81.

———. "Variations sur Marilou, 31.10.1984," Female hands on butt. SEM:79.

———. "Variations sur Marilou, 23.12.1984," Female hand on side of crouching woman. SEM:78.

———. "Pierre Radisic." *Camera International* 4 (Automne 1985):60-69. Article features 8 images from his series "Variations sur Marilou," 1984. Plain, harsh fragments of women. Pentax 6x7, 135mm, Agfapan 25, two flashes, cold-light enlarger, slight selenium toning.

Raffaelli, Ron. *Extases.* Montreal, Canada: Éditions Select, 1978.

———. *Passion: An Erotic Portfolio.* Chatsworth, CA: Chatsworth Press, 1989.

Rakoff, Penny. *Men Friends Undressed.* N.p., 1977.

———. Seated man, & clothed standing woman. YK:28.

———. Seated man's torso, frontal. YK:29.

Raley, Patricia and Winston, Alan (photographer). *Making Love.* Berlin: Ullstein, 1979.

Ramamurthi, D.S. *Nus d'Inde.* Paris: Éditions Prisma, 1966.

Rambow, Günter. *La Promenade de König Immerlustik.* Frankfurt: Kohlkunstpresse, 1968. Nudes.

———. *Marienerscheinungen in Kurhessen.* Darmstadt, Ger.: Olympia Press, 1969.

———. *Doris.* Frankfurt, Ger.: März-Verl, 1970. Numerous photos of woman's vulva, & woman w spread legs displaying her vulva in a wide variety of locales.

Rancinan, Gérard. Series of 5 woman nudes, slightly erotic. *Photo* 208 (Jan 1985):110.

Randall, Suze. *Suze.* New York: Dell, 1977.

Raso, Annie. (French) Color, right profile of running woman on beach as seen through a corrugated tube. *Photo* 232 (Jan 1987):64.

———. Color, woman's butt. & thighs on beach, water splashing against her, *à la* Clergue. *Photo* 298 (Jan/Feb 1993):60.

Rault, Jean. (b. 1949) *Unes-Nues.* Paris: Marval, 1988. 58 plates.

Rausser, Fernand. *Das Hoheleid. Schön bist du meine Freundin.* Freiburg, Ger.: Walter, 1974.

Rawlings, John. (US) *100 Studies of the Figure.* New York: Viking, 1951; 4th printing 1960. The model Evelyn Frey had an ease with nudity that seemed unique to Rawlings (a very successful fashion photographer for *Vogue*). She told him her comfort with being nude came from a childhood experience. As a girl in California the family doctor instructed her to recover from rheumatic fever by taking exercise outdoors in the nude, so she did so on a beach in front of her home. For this series, Rawlings favored daylight in his East 55th Street studio in Manhattan. Tech. notes [very detailed] (94-96). In studio he used 8x10 and 4x5 view cameras; beach scenes required a Rolleiflex. Film: Tri-X or Super XX. The only detail that dates the prints is Frey's classic 1950s makeup.

———. Standing woman in dress pulled down to the waist, hands on back of head, in high key room, ca. 1950. *Camera Arts* 2 (Oct 1982):39.

———. Two photos in *Popular Photography Color Annual* (1957): reclining woman (66); color shot (very diffuse) of seated woman in HK setting (67).

————. *The Photographer and His Model.* New York: Viking Press, 1966. Incl. 68 photos, 1 model, 3½ years work in variety of locales in & out of doors. Many shots invloved movement, for Rawlings an expression of the "inner self". Most images were exp. on Tri-X and developed in D-76, printed on Polycontrast RC paper. He used Nikon, Rolleiflex, & Hasselblad cameras, w normal to medium telephoto lenses, T 1/60 to 1/250, f/8 to f/16.

————. Three color shots of Betty Biehn in NIP: standing at waterfall hanging onto branch (104); seated in chair (105); leaning on large branch of driftwood (106).

Ray, Gypsy P. "Rusty," 1976. Overhead shot of supine man staring at us. BTM:34.

Ray, John. *More Love.* Paris: A. Balland, 1971.

Redell, Howard S. HK fragment of woman's butt., and because of the upward looking angle and her bent forward torso, her breasts are equally visible. BB:29.

————. Very detailed view of upper torso & face of supine & upside-down woman. BB:65.

————. Two works in HS: kneeling woman, left profile, backlit; seated woman against mirror.

Reich, Hanns. (ed.) *Eve Noir.* Munich: Reich, 1954; 1966. Incl. Reich, Mangold, Lebeck.

Reichert, Kurt. (German 1906-) [FKK photographer] Two standing men, rear view, throwing shot puts up into air, ca.1935. USII:33.

————. Seven men & women w arms raised on beach, ca.1935. USII:36.

————. Men & woman running on sand towards lake, ca.1935. USII:37.

————. Two men taking exercise on a Rhönrad [a two meter diameter steel tube frame w hand & foot grips], ca.1935. USII:41.

————. Two men & two women running on field, ca.1935. USII:47.

————. Woman leaping over beach, ca.1935. USII:49.

————. "Diskuswerfer," 1940. Standing man against sky b.g., holding discus. A:323.

————. *Von Leibeszucht und Leibeschönheit.* Berlin: Verl. Dt. Leibeszucht, 1940.

Reinhardt, Mike. "Mike Reinhardt." *Photo* 204 (Sep 1984):46-53. Incl. 2 women glamour nudes in color.

Reis, Donald. Four shots of women standing or sitting in domestic interiors. NIP:142-45.

Reiss, David. Frontal standing woman, and seated woman frontal against black b.g. NIP:222.

Renfrow, Charles. "Mother and Daughter in Bathroom," 1969. BWC:14.

Rensch, Angela. *Kind Frau.* New York: Benteli Verlag, 1992.

Renard, Arlinda Mestre. *Désir.* Paris, 1993.

Reuter, John. (US 1953-) Color Polaroid SX-70. Kneeling woman, head out of frame, torso frontal, on red seamless. S.

————. Color Polaroid; seated woman, semi-nude. SII.

Reutlinger, Leopold. Woman supine, ca.1890. BL:45.

————. Lebeck, Robert. (ed.) *Die Schönen von Paris. Fotografien aus der Belle Epoque.* Dortmund, Ger.: Harenberg, 1981.

Řezáč, Jan. (ed.) *Akty a Akty.* Bratislava, 1968. Incl. J. Ehm, V. Boháč, I. Englich, M. Gregor, A. Gribovský, V. Chochola, F. Janiš, B. Marhoun, O. Michálková, J. Prošek, V. Reichmann, J. Růžička, K. Skoumal, M. Stibor, J. Sudek, J. Šechtl, M. Šechtlová, R. Šída, J. Vávra, Z. Virt, P. Zora. *See individual entries.*

Rheims, Bettina. (French 1952-) "Strip-tease pour toutes." *Photo* (Apr 1981).

————. "Les nouvelles strip-teaseuses." *Egoïste* (1982).

————. Sonkes, Corinne. "Bettina Rheims." *Clichés* 2 (1983).

———. "Beth Tood, par Bettina Rheims." *Photo Revue* (Mar 1984).

———. Strand, Mark. "Animal Magnetism." *Vogue* (Apr 1984).

———. "Bettina Rheims, un certain regard." *Passion* (Jul 1984).

———. Nordrum, Lavasir. "Bettina Rheims." *Fotografi* (Sweden) (Jul/Aug 1984).

———. Edwards, Owen. "Exhibitions, Close Encounters." *American Photographer* (Jul/Aug 1984).

———. Mandery, Guy. "Bettina Rheims, des oiseaux et des nus." *Photomagazine* (Feb 1985).

———. Featured in *Die Schönen Geschöpfe*. Hamburg, Ger.: Stern, 1985.

———. Featured in *Nues*. Paris: Contrejour, 1985.

———. "Bettina Rheims." *Création* (Feb 1986).

———. "Bettina Rheims, dans les anneaux de Newton." *Photomagazine* (Feb 1986).

———. "Nudes: Bettina Rheims." *Collectors Editions* 2 No. 3 (1986).

———. "Bettina Rheims, un cathédral d'images." *Le Matin* 4 Sep 1986.

———. Featured in *Charlotte Rampling*. Munich: Schirmer/Mosel, 1986.

———. "Bettina Rheims." *Photo* (Apr 1987).

———. Monterosso, Jean-Luc. "La pureté des barbares." *Camera International* 12 (Sep 1987).

———. "Bettina Rheims—Féminin pluriel." *Studio Magazine* 8 (Nov 1987).

———. Monterosso, Jean-Luc. "Bettina Rheims—Une œuvre singulière." *Cimaise* 191 (Nov/Dec 1987).

———. *Cliché* 42 (Dec 1987).

———. "Transcending Limits." *Passion* (Nov/Dec 1987).

———. Souffland, Stéphane Durand. "Bettina Rheims traque les vraies femmes." *Media* 18 Dec 1987.

———. "Claudya par Bettina Rheims." *Photographie Magazine* 1 (Dec 1987).

———. Featured in Saint-Laurent, Cécil. (ed.) *Histoire Imprévue Dessous Féminins*. Paris: Herscher, 1987.

———. *Bettina Rheims*. Paris: 1987. Incl. 32 studio portraits, mostly of women.

———. Featured in *Nude I*. Tokyo: Asahi Shuppan Sha, 1987.

———. "Planche contact de Béatrice Dalle." *Zoom* 138 (Feb 1988).

———. Featured in *Nude II*. Tokyo: Asahi Shuppan Sha, 1988.

———. Featured in *Les Femmes de* Vogue Hommes. Paris: Albin Michel, 1988.

———. Featured in *Photographie Actuelle en France*. Toulouse, France: Galerie municiplae du château d'eau, 1988.

———. Featured in SEM.

———. Featured in *Le Mois de la Photo*. Paris: Audiovisuel, 1988.

———. Featured in *L'Année de la Photo*. Paris: Audiovisuel, 1988.

———. "Bettina Rheims." *Photo* 265 (Oct 1989):102. Highlights from forthcoming *Female Trouble*.

———. "Bettina Rheims." *Photo* 278 (Oct 1990):76. 6 portraits of women.

———. *Female Trouble*. Munich: Schirmer Art Books, 1991. Incl. 30 portraits of women.

———. "Lynn," 1990. Portrait of shorthaired woman w obvious silicone breast implant scars. *Photography in New York* 3 (May/Jun 1991).

Rheinboldt, Frank. *Tight Angles*. Erotic color fragments.

———. *Femmes à Géometrie Variable*. Paris: Filipacchi, 1983. *Charme*.

Rice, Pincus. Double exp. of front & rear of standing woman, head not in frame. BB:76.

———. Reclining woman in LK setting rests on left elbow. BB:77.

———. Woman's torso & right arm. BB:78.

———. Fragment type, LK setting, woman's profile, arm, knee, & breast. BB:84.

———. Supine woman, knees raised up. BB:85.

———. Two works in HS: standing woman, rear view, holding her very long hair; standing woman, rear view, 3/4 shot.

Richard, Yva. [pseud.?] (French) "Les années 1930: Yva Richard." *La Recherche Photographique* 5 (Nov 1988):48. Incl. 6 woman nudes of an erotic type.

Richards, Richard. Outdoor shot of woman leaning against large rock formation. HS.

Richards, Wynn. Woman seated on posing block, looking down upon us. BB:26.

———. Standing woman behind translucent star-patterned fabric. BB:30.

———. Standing woman on pedestal w cloud-like studio b.g. BB:36.

———. HK shot of woman w arms raised in expressive pose. BB:37.

———. HK shot of woman seated on posing block, her figure outlined. BB:38.

———. Woman reclining on right side, front view. BB:47.

———. Extraordinarily LK setting w standing turbaned woman. BB:82.

Richardson, Steve. *Photographer's Forum* (Sept. 1992).

Riche, Fran. "Family Sandwich." Man supine on bed, w girl, woman, & girl piled on top of him. DH:72.

Ricoll, Manassé. Two works in HS: very elegant print of seated woman on LK set; seated woman, face directed upward, arms behind head.

Riebicke, Gerhard. (German 1878-1957) "Diana," 1927. Standing woman in imitation of the ancient goddess, aiming bow & arrow skyward. A:322.

———. Man & woman in a dance pose of some kind, by a lake, ca.1930. BL:94.

———. Leaping man, ca.1930. BTM:11.

Rimandi, Piero. *L'Amour: The Ways of Love.* Text by Colin Wilson. New York: Crown, 1970.

Rittlinger, Herbert. (German 1909-) "Trixi," 1957. Color, woman seated on bow of half-submerged rowboat. A:329.

———. *Das Aktfoto: Problem und Praxis.* Düsseldorf: W. Knapp, 1960. ["How to" manual] Incl. Rittlinger, F. Henle, Z. Glass, Hajek-Halke, W. Zielke.

———. *Wir Zogen nach Friaul.* Nuremburg, Ger.: Zitzmann, 1960.

———. *Aktfotos am Strand.* Bayreuth, Ger.: Scwarz, [ca.1965]; 1967; 1969.

———. *Der Neue Akt. Wann, Wo, Wie, Warum.* Düsseldorf: Knapp, 1966. ["How to" manual] Illustrated w FKK nudes, mostly women.

———. *Mit Anmut Nackt Aktfotografien.* Hamburg, Ger.: R. Denehl's Verlag, 1970. Incl. 32 FKK nudes: young women outdoors enjoying nature.

———. *Aktfotos.* Bayreuth, Ger.: Schwarz, 1970. 40 photos.

———. *The Photographer and the Nude.* New York: Focal Press, 1972.

Ritts, Herb. (US 1952-) "Neith with Shadows, Front View, Pondridge," 1985. *Photography in New York* 5 (Nov/Dec 1992).

———. Three woman nudes & one man nude. *Photo* 221 (Feb 1986).

———. *Pictures.* Altadena, CA: Twin Palms, 1988. Unpaged. Incl. "Black Female Figure," 1987; "Neith with Tumbleweed," 1987, standing woman holding tumbleweed over her head; "Jump," 1987, three men in mid-air w butts to camera; "Male Nude with Bubble," 1987, a good man nude but ruined by having the genitals blacked out; "Consuelo,

Paradise Cove," 1987, gauze-draped head & chest of woman; "Brian and Tony in Sand," 1986, men embracing on sand dune; "Mimi and Tony," 1987, hermaphrodite in f.g., w Man b.g.; "Male Nude," 1987, man in extended crawl; "Three Male Torsos," 1986, "Tony and Brian," 1986, embracing men; "Tony and Mimi," 1987, two men embracing; "Female Torso with Veil," 1984, another gauzed figure; "Consuelo with Pine Branch," 1984, rear view of woman's torso w pine branch stuck to her head; "Male Nude with Tumbleweed," 1986; "Male Nude, Silverlake," 1985; rear view of standing man, no head visible at this angle; "Floating Torso, St. Barthelemy," 1987; supine woman's torso in ocean.

————. *Herb Ritts: Men/Women.* 2 vols. Altadena, CA: Twin Palms, 1989. Superior photo-reproductions. *Men* incl. 26 nudes, most of them absurdly demure, i.e., hands covering genitalia, cropping of picture to hide genitalia, etc. *Women* incl. 25 nudes. The most timeless image is "Lara, Puerto Vallarta, 1984," standing woman frontal, in archway w right hand at top of arch, left hand grasping side of arch, her head thrown back.

————. *Duo.* Altadena, CA: Twin Palms, 1991. Body builders Bob Paris and Rod Jackson together in amorous poses.

Rivas, Humberto. (Argentine 1937-) "Marcial," 1978. Man with long abdominal scar seated, looking at camera. SEM:45.

————. "Eva," 1985. Portrait of woman from waist up; stark realism. SEM:44.

————. "Magda," 1985. 3/4 frontal nude portrait of a woman with makeup; stark realism. SEM:46.

Rivière, M. Large breasted young woman seen from chest up. *Photo* 280 (Jan 1991):66.

Rix, Barabara. Seated woman propped up on right arm, on bed, in brilliant light. [Photograph in Angénieux advertisement] *Camera International* 3 (Ete 1985):6.

Robbins, Ken. (US 1946-) High key woman's torso, 1974. Hasselblad, 80mm, Tri-X, daylight. *Camera* 54 (Sep 1975):13.

Robert, François. (Swiss 1946-) Pregnant Asian woman supine in bathtub. *Camera* 53 (Sep 1974):34.

————. *Noëlle and the Twelve Nights of Christmas.* Chicago: Playboy Press, 1976.

Roberts, Montgomery. Kneeling woman frontal, hands on knees, head bowed. HS.

Roberts, Nancy P. "Self Portrait." Woman's butt. on sofa back. Soft contrast infrared. AIS.

Roche, Denis. (French 1937-) "26 juillet 1984, Varallo, Italie" Roche photographing himself and model in mirror. SEM:169.

————. "21 juillet 1986, Hôtel Acueducto chambre 216, Ségovie," Young woman lying face down on bed, viewed partially through spectacles, through which one lens gives us a completely focused view of her buns; the rest is fuzzy. SEM:168.

Rochebrune, B. de. 3/4 standing woman next to window, back to camera, 1985. KS:45.

Rogin, Ellen. (US 1943-) Rust colored image of ¾ standing woman in front of window. Nikon, Tri-X, printed on Agfa color paper. *Camera* 50 (Sep 1971):30.

Roh, Franz. (German 1890-1965) Reclining woman with cigarette in mouth, 1925. Boring. BL:129.

————. Double exp. of standing woman w arms behind head, & circular stairwell, ca. 1922-26. AVK:83.

————. Negative image of supine woman w cat, ca.1925. USII:88.

108

———. Fricke, Roswitha. (ed.) *Franz Roh: Retrospektive Fotografie.* Düsseldorf, Ger.: Edition Marzona, 1981. Incl. nude studies of 1922-28: series of 13 multi-exp. woman nudes w various superimposed backgrounds; 8 negative prints of women; 2 straight shots of women; 2 women in masks; the reclining woman w cigarette. In 1951, he claimed that a negative is sometimes a good image by itself. He strove to be a "musician of forms," surmounting the realism of the 19th century.(38, 39)

Rohl, Klaus Rainer. (ed.) *Dasda-Fotomädchen.* Hamburg, Ger.: Sonderheft Verl., 1980.

Ronay, D. "Susan in the Bath." Kneeling woman w smile on her face. *AAP* 47 (1933):146.

Ronis, Willy. (French 1910-) "Le nu provençal, 1949 Gordes." Woman bending over sink in room of peasant farmhouse. JL:65; LN:40.

———. "Nude with Cherries," 1955. Simple & delightful photo of seated woman near window holding a cluster of cherries over a bowl on a table. NN:157.

———. "Dans un sixième étage du Marais, 1949 Paris." Woman on bed. JL:67.

———. "Printemps 1955, banlieue sud." 3/4 rear view of woman at window about to open the shutters. JL:66.

———. "Les Nus de Ronis." *Photo* 156 (1980):32. Nudes, 1949-70, w comments by Ronis.

———. "Nu de bos," 1955. Back view of seated woman before curtained window, in *20th Century French Photography.* New York: Rizzoli, 1988:(92).

Roosevelt, Andre. Woman reclining on right side, rear view. BB:46.

———. LK shot of seated woman. BB:62.

———. Seated woman w head bowed. BB:71.

Rosenthal, David. Reclining woman on New York City rooftop. *Photo* 268 (Jan 1990):92.

Ross, Merg. "Pregnant Nude,"1969. Silhouette of seated pregnant woman's torso. BWC:33.

Rossi, Pierre. Color, woman's torso in forest. *Photo* 232 (Jan 1987):64.

Rossler, Gunter. (b. 1926) *Gunter Rossler Fotografien Akt.* Cottbus, Ger.: Galerie Kunstsammlung Cottbus, 1980.

Roth, C. *Skizzen und Studien für den Aktsaal.* Stuttgart, Ger.: Neff, 1896-97. 30 photos.

Rothman, Stewart. *Nudes of 16 Lands.* New York: APBPC, 1970.

Röttgen, Helmut. Two men in studio embrace & stare at us, 1981. AVK:178.

Rougeron, Jean. *Les Photos Interdits de Jean Rougeron.* Paris: Éditions Cyril Fargue, 1983. 120 color *charme* shots.

———. *Phantasmes.* Nuremburg, Ger.: 1984. *Charme*

———. *Fantasms II.* N.p.: Haney Place Ltd., 1986. *Charme*

Rouille, Andre. (b. 1948) *Le Corps et son Image.* Paris: Contrejour, 1986.

Rourke, Mickey. "Mickey Rourke." *Photo* 285 (Jun 1991):54. Incl. 10 semi-nudes of his girlfriend, Carré Otis, in presentation similar to a jeans ad: grainy shots of Otis & two or three well-chiseled men in biker outfits, Harley-Davidsons, etc.

Roussel, Yves. Color, woman's torso frontal covered w sand. *Photo* 232 (Jan 1987):69.

Rouvet, Christian. (French) Color, woman waist up in forest setting. Not color balanced and too amateurish. *Photo* No. 298 (Jan./Feb. 1993): 59.

Rouvet, Jacques. (French) Woman kneeling, torso and head back, hands resting on sandy beach; dark but beautiful print. *Photo* 291 (Jan/Feb 1992):54.

Rouvet, Jean-Claude. Bronze toned print, unique view of woman lying on beach w left arm extended toward camera. *Photo* 268 (Jan 1990):111.

Rouzer, Danny. *Glamour Photography.* Los Angeles: Trend Books, 1956.

Roversi, Paolo. Standing woman on studio seamless, 1986. In Martin Harrison, *Appearances: Fashion Photography Since 1945*. New York: Rizzoli, 1991:(284).

Roye [Horace Narbeth] *Perfect Womanhood*. London: Routledge, 1938.

———. "Nude." 3/4 frontal standing woman in garden-like setting. NN:125. Narbeth was a London portraitist, and arguably the first "Page 3 Girl" photographer [see *Daily Mirror,* (London) 14 Sep 1938].

———. *English Maid*. London: Routledge, 1939.

———. *Scottish Maid*. London: Routledge, 1940.

———. *Irish Maid*. London: Routledge, 1941.

———. *Welsh Maid*. London: Routledge, 1942.

———. *Desirée*. London: Camera Studies Club, 1942.

———. *Arthur Ferrier's Lovlies Brought to Life*. London: Chapman, 1942.

———. *Canadian Beauty*. London: Camera Studies Club, 1952.

———. *Nude Ego*. Bonn, Ger.: EBH, 1957; 1960; 1965; 1969.

Roye and Merlin, Gilbert. *Phantasien*. Bonn, Ger: EBH, 1958; 1961; 1964. 40 photos.

———. *Ekstasen und Visionen*. Bonn, Ger.: EBH, 1959; 1960; 1964. 54 photos.

Ruben, Ernestine. (US 1931-) "Emergence," 1987. Series of 8 images of a man in a studio posing 3/4. SEM:68.

———. *Ernestine Ruben: Photographs: Forms and Feelings*. Shaffhausen: Edition Stemmle, 1989. Nudes.

———. Double exp. of kneeling woman left profile, & forest scene. *Photography in New York* 2 (Jan/Feb 1990):20

———. Torsos of man & woman. *Photography in New York* 2 (May/Jun 1990).

———. "Still Life," 1992. Double exp. of woman's torso & water bubbles. *Photography in New York* 5 (May/June 1993):n.p.

Rubinstein, Eva. (US 1933-) "Cecilia and Eddie," 1970. Pregnant oriental woman in bed w black male. NN:214.

———. Portrait of standing woman, 3/4. Leica M4, 50mm, Tri-X. *Camera* 51 (Sep 1972):31.

———. Woman reclining on bed, reflected in mirror on wall. *Camera* 52 (Jan 1973):29. Her statement on the nude is one of the best ever written.

———. "Body and Bark," 1974. Man's lower torso on left, knarled wood on right. BTM:43.

———. Woman prone on sofa (under window?) with wonderful light-modeling. Ibid:30.

———. Woman curled up in 18th century chair. Ibid:32.

———. *Eva Rubinstein*. Dobbs Ferry, NY: Morgan & Morgan, 1974. Incl. "Nude Sitting on Bed," 1972; "Nude with Cushions," 1972; "Couple," 1971; Nude on Rock," 1974; "Torso and Bark," 1974; "Nude Torso in Sun," 1974 [woman's torso]; "Running Man, Connecticut," 1970 [man running down road away from camera].

———. *Eva Rubinstein*. Milan: Gruppo Editorial Fabbri, 1983. Incl. "Nikki at Window," 1978, standing woman near window; "Couple on Couch," 1970 [1971?], same image as 1974 book; "Rita on Couch," 1971, woman prone on couch; "Rita Standing," 1971, same as *Camera* 51.

———. Four works in NIP: rear view of woman's torso in flora (242); woman's torso frontal near window (242); man's torso (244); man running down road (245).

Rubin, Laura. (US 1949-) Photograph of Hilary Hammond wearing diaphanous gown, flowing in the wind on a Long Island grass-covered dune, 1971. Pentax, 55mm, Tri-X. *Camera* 51 (Sep 1972):29.

Ruby, Erik A. *The Human Figure: A Photographic Reference for Artists.* New York: Van Nostrand Reinhold, 1974. 338p.

Rudomine, Albert. (b. Russia/fl. France 1892-1975) *Albert Rudomine.* Arles, France: Rencontres Internationales de la Photographie, 1983.

————. "Rudomine: Le Classicism Retrouvé." *Photo* 190 (Jul 1983):76-81. Incl. 2 pictorial nudes: kneeling woman in archer's pose, & woman's butt. & legs (78, 79); right profile of kneeling woman (77); standing woman rear view, holding two masks (80); retouched photo of seated woman holding left breast [her belly has been trimmed by the retoucher's brush](81).

Rungholt. [Peter W. Rober] *Akt Aktuell.* Bonn, Ger.: Verlag der EBH, 1967.

Running, John. (US 1940-) Woman supine in stream, horizontal across frame, 1973. Nikon, Tri-X, T 1/1000. *Camera* 53 (Sep 1974):35.

Runtuwene, Ken. (Australian) "Le nu au Magnum." Disturbing image of supine woman on bed w pistol barrel in her mouth. *Photo* 274 (Jul 1990):89.

Russell Clark, Sandra. (US) "The Sensual Touch," 1988. Man and woman in soft focus upper torso shot. BL:189.

Rutter, John. "John Rutter." *Photo* 270 (Mar 1990):68. Incl. 3 woman nudes.

————. "John Rutter." *Photo* 283 (Apr 1991):26. Incl. 7 magnificent woman nudes.

Růžiča, Jaroslav. (Czech 1917-) Diptych of negative & positive prints of woman's torso. AA:92.

Saari, Beth. "Noelle," 1980. Supine girl on blanket. NEW:196.

Sabatier, Jacques. Color, woman seated in rear car seat, chest exposed, face obscured in shadow. *Photo* 232 (Jan 1987):75.

Sachs, Günter. *Madchen in Meinen Augen.* Munich: W. Heyne, 1974.

————. *Mirror Images.* Schaffhausen, Switzerland: Verlag Photographie, 1982. Incl. 41 color nudes, shot mostly outdoors at a rooftop on the island of Ibiza. Most nudes are of women standing on a large mirror. This film-maker turned fashion photographer tried to follow the maxim—"All accessories that do not fulfill a pure function are unnecessary." Not a word about artistic intent, but tech. data is first rate. He dismissed tech. info. in other books which gave only f/stops & shutter speeds. His method was to give exposure values along w precise increase or decrease in aperture for each shot. All photos made w Nikon cameras & wide angle lenses.

Sackmann, Manfred. (German) Two women in G-strings at some sort of beer hall, 1985. BL:170.

Sadan, Mark. Michael J. McNamara, "Blue Nude." *Popular Photography* 99 (Oct 1992):46-48. For the "Blue" series Sadan painted Welsh model Clare Gwilliam w blue paint. He then copied color negatives to slide film and used blue filtration when making the prints.

Sager, Helen. (Swiss 1949-) Woman seated in room near doorway and hall, her elbows on knees, looking at us. [Bio. incorrectly indicates three models.] *Camera* 53 (Sep 1974):19.

Sahlstrand, James. "Earth Mother—Enormous," 1969. Enormously fat woman standing 3/4 frontal, against black b.g. BWC:34.

Sahm, Anton. Smiling woman in black hat, gloves, pumps, & parasol, 1925. DP.

Sahm, Walter. Woman standing back to camera, leaning against wooden paneling, 1953. KS:40.

Said, Yasmine. Color, woman's torso supine & bronzed. *Photo* 207 (Dec 1984):77.

Salardenne, Roger. *Bei den Nackten Menschen in Deutschland*. Leipzig, Ger.: Oldenburg, 1930.

Salle, David. (US 1952-) *David Salle: Photographs, 1980 to 1990*. Edited by John Cheim. New York: Robert Miller Gallery, 1991. Incl. 57 woman nudes intended to serve as the basis for his paintings. They were taken with a Nikon point-and-shoot camera in his home or studio, using strong "theatrical lighting." A late 1950s hotel ambience was hinted at, further reinforced w the models' costumes—usually high heels & garters. He was quoted in the intro that "... small inflections of gesture and pose absorb me and perhaps no one else. I feel like I'm trying to internalize the meaning of a gesture. I am looking at the model and she is also partly me, or I'm *her* doing it." Also, "... the feeling in the work is protective of the model and uses *her* feelings in a delicate way. She is *performing* after all and the work strives to identify with her as much as objectify her. I feel as if I had created a feeling in the room where there is no transgression."

Salmoiraghi, Frank. (US 1942-) Woman 3/4, standing in jungle-like setting, viewed from a window. Nikon F, 105mm, Tri-X. *Camera* 50 (Sep 1971):33.

Salten, Rudolf. *Mehr Nacktheit*. Leipzig, Ger.: Parthenon, 1928.

Saltzman, Bob. "In the River from Blue Lake," 1986. Torsos of man and woman lying in stream with water flowing over them. *Aperture* 111 (Summer 1988):38.

Saltzman, Bob. *Bob Saltzman: Nudes and Other Beauties*. Latvia, 1992.

Salzmann, Laurence. *La Baie: Bath Scenes*. Philadelphia: Blue Flower, 1980. Romanian bathhouse.

Samaras, Lucas. (US 1936-) *Samaras Album: Autointerview, Autobiography, Autopolaroid*. New York: Whitney Mus. Am. Art, 1971. He always wanted to explore his body on film, & these Polaroid SX-70 prints are the result. He had no intention of going to photography school (because he had already been a professional artist for over a decade), and the Polaroid "came in handy". Several of these can be regarded as photographic nudes.

———. *Sittings, 1979-1980*. New York: Pace Gallery, 1980. Color polaroid series of nude portraits, w Samaras always at the edge of the frame.

———. *Photography Year 1982*. Alexandria, VA: Time-Life, 1982. Has one photo in book.

———. "Sitting, 94E, 1978-80." Arguably the easiest to look at in this odd series. A young woman seated has another woman lying in her lap. Polaroid print. SEM:198.

———. *Samaras*. New York: Aperture, 1987. Retrospective, 1969-86. Incl. Auto-Polaroids [1969-71]; Phototransformations (manipulated SX-70 prints)[1973-76]; 8x10 Polaroid Sittings [1978-80]; 20x24 Polaroid Sittings [1980].

Samuel, Deborah. "Trace," 1992. From the "Venus Passage" series, woman's torso frontal, w pubic area retouched. *Photography in New York* 5 (May/Jun 1993).

Sanchez, Laen. (French) Reclining woman in desert setting. *Photo* 298 (Jan/Feb 1993):55.

Sandel, L. *Das gefesselte Weib*. Leipzig, Ger.: Parthenon, 1930. 48 photos.

Sander, Ulrich. *Sinn der Nacktheit*. Dresden, Ger.: Schönheit, 1940. Incl. G. Riebicke.

San Francisco Museum of Modern Art. *The Nude in Modern Photography: An Exhibition of Photographs*. San Francisco: Art Museum Assoc. of America, 1983.

San Martin, Mariola. "Corps de Femme." *Photo* 236 (May 1987):158. Color, 6 outstanding works of buxom young women in domestic interiors. *Charme*

Sannes, Sanne. *The Face of Love*. South Brunwick, NJ: A.S. Barnes, 1972.

Sansone, Anthony J. *Rythm*. Brooklyn, NY: Sansone, 1935.

————. *Twenty "Nudeleafs"*. N.p., 1939[?].

Sant, Alain. Color, woman's torso frontal against sky b.g. *Photo* 232 (Jan 1987):cover.

Santuci, Richard. *Fine Figure Photography*. New York: Amphoto, 1970.

Sarakof, Ivan. Frontal view of woman's torso. HS.

Sarfati, Patrick. *Athletes*. Berlin: Bruno Gmünder, 1990.

Sasorith, André. Color, woman's pubic area w Daimler-Benz emblem resting upon it. *Photo* 184 (Jan 1983):74.

Sass, Alan. Photomontage of woman's torso, face, & breasts. NIP:155.

Sato, Hiro. "Self-portrait," 1987. Hairy seated man frontal, holding his genitals. BTM:33.

Saudek, Jan. (Czech 1935-) *Il Teatro della Vita*. Milan, Italy: Selezione d'Immagini, 1981.

————. *The World of Jan Saudek*. Millertown, NY: Aperture, 1983. Incl. best known nudes to date, plus unusual color portrait series of 5 couples, two photos each; the first photo has one clothed subject & one nude subject, but the second photo has these roles reversed (92-101).

————. Color, bald woman kneeling, shaving her face like a man, 1983. DP.

————. Four color works in NEW: seated girl (42); seated teenage girl (43); topless woman made up to look elderly (46); seated girl w rose, reminiscent of Plüschow (47).

————. "Target, Death of a Soldier," 1984. Hand-colored double exp. B&W print, of standing man frontal w arms out from sides parallel to floor. *Photography in New York* 4 (Jul/Aug 1992):n.p.

————. "Walkman," 1985. Color, reminiscent of a nude by Watteau or Boucher, except this prone woman on a couch wears a radio headset. KS:26.

————. "Jan Saudek." *Photo* 230 (Nov 1986):108. Color, five woman nudes in barren room.

————. *Jan Saudek: 200 Photographies, 1953-1986*. [Catalog of exhibition at Musée d'Art Moderne de la Ville de Paris, 18 Mar—10 May 1987] Paris: Paris-Musées, 1987.

————. "New York New York I and II," 1987. Two frames of woman from waist to feet; she wears tee shirt and black stockings; we see a front view and a backside view, emphasizing the butt. and crotch. Color print. SEM:224.

————. "Dancers in Paradise II," 1987. Two men, one woman, one child, flying around. Color print. SEM:225.

————. "Portrait of that Mysterious IDA Woman," 1987. Female torso and legs. Color print. SEM:224.

————. "Eva," 1987. Fat woman with flowers. Color print. SEM:227.

————. "Just Another Teen Queen," 1987. Double exposure young woman with flowers. Color print. SEM:226.

————. Sayag, Alain. "Saudek/Drtikol," *Camera International* 26 (Summer 1990):56-65. Some studio works.

————. Mrazkova, Daniela. (ed.) *Jan Saudek*. Prague: Panorama, 1991.

————. *Jan Saudek: Life, Love, Death, and Other Such Trifles*. New York: Art Unlimited, 1992.

Saunders, Gill. *The Nude: A New Perspective*. New York: Harper & Row, 1989. Focus is on painting, but incl. work of Roberta Graham (b.1954), E. Weston, Alfred Lys Baldry (b.1858), Brassaï, Brandt, Kertész, Mapplethorpe, Alvarez Bravo.

Savitry, Emile. "The Nude in Photography." *Camera* 33 (Jan 1954):10-15. Four women nudes described by the editor as "chaste", conjuring up *Beaux Arts* correctness.

Sawyers, Arthur. "Man," 1967. Reclining man before burned out hulk of automobile. BWC:40.

Scaioni, Egidio. (b. 1894) *La Photographie de Nu.* Paris: Éditions Prisma, 1950.

Scavullo, Francesco. (US 1929-) *Scavullo.* Edited by Sean M. Byrnes. New York: Harper and Row, 1984. B&W portraits, some nude: "Alice Ormsby Gore," 1972 (the most beautiful, nude from waist up) [Nikon camera, Tri-X film, single source flash] (57); "Joanne Hart," 1969 [Nikon, TX, single flash] (64); "Tattoo Charlie and Lorraine," 1978 [Hasselblad, TX, single flash] (81-82); "Paul and Lindy," 1971 [Hasselblad, TX, single flash] (79); "Margaret Broderick, Jerry Hall, Alvenia Bridges," 1975 [Hasselblad, TX, single flash] (105); "Geri Miller," 1972 (Stripper) [Nikon, TX, single flash] (106); "Ken and John," 1972 (Frontal standing male nudes) [Nikon, TX, single flash] (104); "Pat Cleveland and Juan Fernandez," 1973 (my favorite of the bunch: they are standing facing camera, she in front of him) [Hasselblad, TX, single flash] (136); "Margaux Hemingway," 1975 [Hasselblad, TX, single flash] (148); Sterling Saint Jacques," 1978 (black man dancing-running) [Hasselblad, TX, single flash] (214).

————. "Francesco Scavullo." *Photo* 289 (Nov 1991):72. Incl. models Cindy Crawford, Christy Turlington.

Schaeffer, Samuel Bernard. *Pose, Please.* New York: Knopf, 1936.

————. *Morning, Noon, Night.* New York: Knight, 1937.

Schäpfer, Hans R. (Swiss) Two standing women embrace, multi-exp., 1968. *Camera* 48 (Sep 1969):27.

Schaumberg, Johannes. "Amelie," 1984. Color studio shot of woman seated in chair. A:331.

Scheiberth, Hermann. (Austrian) Standing woman seen from waist up, 1910. BL:86.

Scheid, Karin. (ed.) *Hind Sight: The Posterior View in Nude Photography.* [German title: *Apros Po.*] Weingarten: Kunstverlag Weingarten, 1992. Butts, buns, etc.

Scheid, Uwe. (ed.) *Das Erotische Imago.* Dortmund, Ger.: Harenberg, 1987. Incl. E. Durieu, L.C. D'Olivier, B. Braquehais, R.C. Huber, G. Plüschow, V. Galdi, W. Gloeden. *See individual entries.*

————. *Das Erotische Imago II.* Dortmund, Ger.: Harenberg, 1987. Incl. A. Graebner, K. Reichert, H. Perckhammer, V. Galdi, W. Gloeden, H. Matthiesen, O. Streichert, F. Drtikol, Man Ray, F. Roh, Angelo, R. Koppitz, D. Wilding, M. d'Ora, Manassé, K.E. Ludwig, A. Binder, Paco, R. Housmann, M. Fehlauer. *See individual entries.*

————. *Freundinnen, Bilder der Zartlichkeit.* Dortmund, Ger.: Harenberg, 1989.

————. *Die Erotische Daguerreotypie: Sammlung Uwe Scheid.* Weingarten: Kunstverlag Weingarten, 1989.

Scheler, Wolfram. (German 1950-) Color, Polaroid; woman's torso frontal. SII.

Schenk, Charles. *Artistic Studies of the Human Body.* New York: Schenk, 1898. 60 plates.

————. *Artistic Studies of the Human Body.* New York: Charles Schenk Art Co., 1899. 32 plates.

————. *Draped Figures.* New York: Schenk, 1902. 36 plates of women posed a bit more dynamically than other nudes of the period, carefully costumed in revealing classical "drapery" [sheets of light fabric].

————. Six studio shots from his *Draped Figures.* PL:44-53.

————. Seated woman holding string of pearls (from *Draped Figures*). NN:113.

————. Two images from the *Draped Figures* series. NIP:58, 59.

Schertel, Ernst. *Die Eroberung des Weiblichen Körpers.* Leipzig, Ger.: Parthenon, 1926. 50 nature nudes.

————. *Nacktheit als Kultur.* Leipzig, Ger.: Parthenon, 1926. 50 nature nudes.

————. *Körperkultur und Kunst.* Leipzig, Ger,; Leipziger Magazin, 1927.

————. *Der Dienst am Körper.* Leipzig, Ger.: Parthenon, 1927. 50 nature nudes.

————. *Nacktkulter.* Leipzig, Ger.: Parthenon, 1927.

————. *Das Weib als Göttin.* Leipzig, Ger.: Parthenon, 1928. 48 nature nudes.

————. *Sonnige Welt.* 8 vols. Leipzig, Ger.: Asa-Verlag, 1928-29. Each vol. contains approximately 60 *Natur-Akt-Aufnahmen* (nature nudes, or FKK nudes).

————. *Das Paradies der Körper.* 5 vols. Leipzig, Ger.: Asa-Verlag, 1929. Similar to the *Sonnige Welt* series, each vol. contains 55 to 60 *Natur-Akt-Aufnahmen.*

————. *Der Sturm auf das Weib.* Leipzig, Ger.: Parthenon, 1931. Incl. B. Wolf, Kernspecht, Lotte & Rolf Herrlich, W. Horn.

————. *Weib, Wollust und Wahn.* Berlin: Pergamon-Verlag, 1931.

————. *Nacktkultur.* Leipzig, Ger.: Parthenon, 1933. 144 nature nudes.

Schild, Charles. *The Girls I Photographed Last Summer.* Rochester, NY: Sea Shore Pub. Co., 1983.

Schlesinger, John. (US) Man between woman's legs, on floor of domestic interior, LK setting. *Puchong Folios* (New York) 1 (Winter 1991):3.

————. Smith, P.C. "Complex Vision." 81 *Art in America* (March 1993):72-73. Two nudes: pregnant woman straddling a man, (72); woman sucking on man's semi-erect penis, (73).

Schlosser, Wilfried. (ed.) *Akt, Fotografie und noch Kein Durchblick.* Ludwigsau, Ger.: Fuldaer Verl., 1984. ["How to" manual]

Schmitz, Dieter. (b.1943) Color, two images of woman in erotic poses on marble block. NEW:76-79.

Schmölcke, Werner. *Akte: Studien, Kompositionen un Visionen.* Stuttgart, Ger.: Günther, 1963; 1964.

————. *Ferein, Ferein.* Stuttgart, Ger.: Günther, 1964.

————. *Das Geheimnis der Schönheit. Neue Akt.* Stuttgart, Ger.: Günther, 1965.

————. Text by Rolf Lasa. *Nackte Haut an heißen Künsten.* Hamburg, Ger.: Hapus-Verl., 1966.

Schmölcke, Werner and Paul, Wolfgang. *Glück auf Sylt.* Stuttgart, Ger.: Günther, 1966.

Schöbel, Volker. (German 1944-) Woman prone on cot in dark room, seen from shoulders to feet; dappled light from venetian blinds, 1974. Leica M2, Tri-X. *Camera* 60 (Sep 1981):28

Schofield, Jack. (ed.) *Nude and Glamour Photography.* London: Collins, 1982. ["How to" manual]

————. *La Photographie et la Charme Féminin.* Switzerland: Éditions Christophe Colomb, 1984.

Scholl, Bernard. Color, woman's butt. w sand on it. *Photo* 207 (Dec 1984):80.

Schommer, Alberto. (b. 1928) *Alberto Schommer.* New York: O'Reilly Galleries, 1992.

Schorre, Charles. Two grainy prints of standing woman in *Popular Photography Annual* (1957):68. Despite the title, Schorre's work is in B&W.

Schreiber, Martin H. *Madonna: Nudes 1979.* Berlin: Taschen, 1990.

————. "Madonna Like a Sphinx," 1979. BL:155.

———. "Self-portrait, 1979." Himself seated w woman's gartered & stockinged posterior to his left. KS:54.

———. *Bodyscapes.* New York: Abbeville Press, 1980. Saw woman as an "...incredible mobile piece of architecture." Incl. 43 works, all women reclining or studied in fragments w 35mm camera.

———. Woman's butt., 1983. KS:52.

Schreibman, Jane. (US 1950-) Rear view of woman kneeling on stool. Olympus, Tri-X. *Camera* 60 (Sep 1981):29.

Schryver, Hendrik de. (Belgian) Frontal standing woman behind translucent plastic. *Photo* 184 (Jan 1983):71.

Schröter, Erasmus. (German) Woman standing in front of a barre and mirror, 1982. BL:188.

Schröder, Bernd. (German) Woman holding her breasts. *Photo* 298 (Jan/Feb 1993): 51.

Schultze-Naumburg, Arthur. *Die Farb-Akt-Fotografie.* Hamburg, Ger.: Hapus, 1966.

———. *Aktfotos in der Bewegung.* Bayreuth, Ger.: Schwarz, 1970; 1971.

Schultze-Naumberg, Paul. *Die Kultur des Weiblichen Körpers als Grundlage der Frauenkleidung.* Leipzig, Ger.: Diedrichs, 1901; 1903; 1905.

Schulz, Arthur. *Italienische Acte.* Leipzig, Ger.: Scholtze, 1905. Portfolio of 50 prints of men, women & children in nature.

Schumacher, Jacques. *Jacques Schumacher. Photoedition 6.* Schaffhausen, Switzerland: Verlag Photographie, 1983.

———. "Jacques Schumacher." *Photo* 204 (Sep 1984):32-37. Images from his book; most unique: woman in heels, hose, & necklace, inverted upon a Breuer chair.(35)

Schwartz, Robin. (female) (US) "Robin Schwartz." *Photo* 205 (Oct 1984):62-67. Three images of women in mansion interiors; one photo of standing woman w man's hands grabbing her butt.

Schwartzman, Steven. Infrared double shot of pregnant woman's torso standing in a lake [?]. AIS.

———. *Bodies of Light: Infrared Stereo Nudes.* Austin, TX: SunShine, 1981.

Schwarz, Ted. (US 1945-) *Amphoto Guide to Photographing Models.* New York: Amphoto, 79.

Scime, Giuliana. (ed.) *Women in the Magic Mirror.* Milan, Italy, 1981.

Scopto, Philippe. (French) Woman in dark sunhat standing in doorway pulling down her panties. *Photo* 298 (Jan/Feb 1993): 48.

Scott, Franz. *Schönheit für Alle.* 5 vols. Leipzig, Ger.: Asa-Verlag, 1929. Each vol. is devoted to nature nudes similar to those edited by Ernst Schertel.

Scott, Roger. (Australian) "North Head," 1979. Reclining woman on her right side, rests on sea-rock, with clothed man in background. *Art and Australia* 30 (Spring 1992):96.

Scully, Ed. Modern Photography's *Guide to Figure Photography.* New York: Billboard Publications, 1969.

Šechtl, Josef. (Czech 1925-) Double exp. rear view of woman's torso. AA:91.

———. Double exp. front view of woman's torso. AA:88.

———. Right profile of seated woman against HK b.g. AA:9.

Šechtlová, Marie. (b.1928) Left profile of woman's head (w long ponytail) & torso, left arm on head. AA:8.

Sehlberg, Bo. (b.1944) *This is Christina.* [Christina Lindberg] Sweden, 1973.

Seidemann, B. *See* Jobst, Norbert.

Selby, Richard. *Know Your Number*. Munich: Graphics-Photos-Art, 1990. 37 nudes of young Asian woman arranged in 5 ch., each w a visual theme.

Selchow, Don. Two works in HS: woman's face & chest; seated woman in LK setting.

Semak, Michael. (Canadian 1934-) "Nude Couple," 1973. Heavy shadow, two supine women with mannequin hands on their crotches. CP:924.

———. *Monograph*. Toronto, Canada: Impressions, 1974. Incl. nudes w LK settings: 9 shots of entwined bodies; 16 prints of a woman reclining, one of which shows her abdominal (pregnancy) stretch marks to maximum effect.

———. *Michael Semak: Photographs, 1960-87*. Ottowa, 1987.

Serantoni, Louis. (French) Shoulders to thigh, woman standing against mirror. *Photo* 298 (Jan/Feb 1993):54.

Serbin, Vincent. "Reader's Gallery." *Camera 35* (Dec. 1979). Four photos.

———. "Featured Portfolio." *Petersen's Photographic* (Dec. 1980). Eight photographs.

———. *Today's Photographer* Issue 4 (1981). Two photographs.

———. *Today's Photographer* Issue 5 (1982). One photograph.

———. "First Photographic Invitational." *Camera Portfolio* Issue 4 (1982).

———. "Featured Portfolio." *Photographer's Forum* (1989). Five photographs.

———. *Pique* Issue 1 (1991). Cover photo.

———. "The Pilgrimage," 1993. Multi-exp. of standing woman 3/4, wearing mask, holding large rock. *Viewfinder: Journal of Focal Point Gallery* 17 (1993).

Sessler, George. Rear view of seated woman, very LK setting. PK.

Seufert, Reinhard. (comp.) *Pin Up*. Stuttgart, Ger.: Freyja-Verlag, 1964.

———. *The Porno-photographia*. Los Angeles: Argyle Books, 1968.

———. *Strip Voyeur*. Bonn, Ger.: EBH, 1970.

———. *Striptease International*. Munich: Amora Verlag, 1970.

Seufert, Reinhard and Tüllmann, Adolf. *Paris, Paris, Paris. Charme und Schönheit der Pariserin*. Stuttgart, Ger.: Günther, 1964. *Charme*.

Seymour, Ronald. Double exp. seated woman on couch, and supine woman in floor of livinf room. NIP:141.

Shaler, Bob. (US) "Nude," 1989. Hideous female nude in oval Daguerreotype. BL:200.

Shao, Hsi. *Jen t'i i shu she ying/Shao Hsi pien chu*. Taipei: Min Kuo 66, 1977.

Shaw, Robin. "Returning the Gaze." *Creative Camera* 307 (Dec/Jan 1991):36-41. Interview; incl. image of woman's hand on man's butt.; two images of nude woman holding a magazine showing photographs of men with erect penises. Challenges the feminist notion that women must not be aroused by images of men.

Shearer, Graham. "Shearer." *Photo* 274 (Jul 1990):cover, 98. Color, model Elle McPherson partly clad in gauze, walking on beach.

Sheckell, Thomas O. *Nude Figure Photography*. New York Institute of Photography, [ca.1935?].

———. A charming photo of prone woman on wooden plank [makeshift diving board?] over water. BB:58.

———. Standing woman looking up, holding onto Birch sapplings on either side of her. BB:64.

———. Three works in HS: kneeling woman, left profile; standing woman frontal, leaning back against tree trunk; ditto.

———. "Nude in High Key." Kneeling woman in glamour pose. *AAP* 56 (1942):150.

Shiiki, Atsushi. Grainy image of woman's butt. NIP:116-117.

Shillea, Thomas John. *Magenta Nights.* N.p., 1983.

Shinoyama, Kishin. (Japanese 1940-) "Nude." IPM.

————. *28 Girls.* Tokyo: Mainichi Newspapers, 1968. Anthology incl. 35 nudes. Yukio Mishima commented in this volume: "A beautiful nude photo is...sex in a locked glass case."

————. *Camera* 48 (Sep 1969) Incl. two women standing against high key backdrop cover their nipples and mons areas with hands (8); two women crouch together on studio floor, high contrast (20); two women visible from waist up, with heads tilted left; high contrast (21).

————. Two seated women on beach, seen from behind; high contrast, 1969. Nikon F, 20mm, red filter, Tri-X. *Camera* 54 (Dec 1975):31.

————. *Nude.* Tokyo: Camera Mainichi, 1970. Each ch. features a different theme: women in Death Valley, twins, a young black woman, a Japanese man & woman from the Tenjo Sajiki theatrical co., urban nudes.

————. *Nude.* 1971. 10 plates.

————. Seven images from "Twins" ser.; three images from ser. on black women. MEP.

————. *Kishin Shinoyama.* Tokyo: Nihon Hoso Shuppan Kyokai, 1985.

————. *Shinorama Man.* Tokyo: Japan Broadcasting, 1985. Results of massive color series designed for EXPO '85, which featured a theme of male & female movement. Color slides were projected on two screens w nine sections each (the nine sections corresponded to the nine camera assembly used to take the photos). Over 20,000 frames were made of men and women dancing, running, jumping.

————. "Kishin Shinoyama." *Photo* 225 (Jun 1986):106. Highlights of the Shinorama. *See above.*

————. *Camera International* 14 (Mars/Avril 1988):unpaged. Issue contains: "The Birth," seascape composition with woman's face in profile, and three nudes on beach; "Death Valley," woman in fetal pose in desert, evening light; "Twins," two women seated on rock seen from behind; "Twins," two women face each other, one standing, the other kneeling with her lips close to her partner's nipple; "Girl," standing woman in heavy eye make-up holding her left breast.

————. *Santa Fe.* Tokyo: Asahi Press, 1991. Unpaged. Exploration of New Mexican landscape with model Rie Miyazawa.

Shiraiwa, Tomiyasu. (Japanese 1940-) Color Polaroid SX-70. Body fragments. S.

Shiraoka, Jun. (Japanese 1944-) Two poorly lit female reclining nudes on bed in front of window, 1987. SEM:88.

Shore, Fred. (US 1935-) Seated woman, plastic wrapped, head down. Part of his "Naked Ladies" series. Pentax, 55mm, Tri-X. *Camera* 51 (Sep 1972):18.

————. Woman lying on steps under water, her head above water, 1972. Nikkormat FT, 35mm, Tri-X. *Camera* 53 (Sep 1974):36.

Shur, Leni. Standing woman in field, in dance/exercise pose. HS.

Shustak, Larance N. Two fisheye views in circular frames of woman on beach, & standing woman in kitchen. NIP:250, 251.

Sieff, Jeanloup. (French 1933-) Seven figure studies of women, more classical & demure [and thus not very unique] than his later work. PL:148-57.

————. *Jeanloup Sieff.* Paris: Éditions la Demeure, 1968. Incl. "Nu Noir," 1965, woman's torso (31); "Nu de dos," 1965, woman's torso (27); "Nu assis," 1965, woman seated in wicker chair (26); "Nu en diagonale," 1965, diffuse rear view of woman's torso (14); "Nu flou à la fenêtre," 1960, standing woman 3/4 rear view before a window (13); "Hommage à Seurat," 1964, standing woman frontal (cover).

————. Sudre, Jean-Pierre. "Jeanloup Sieff." *Camera* 48 (Apr 1969):6-13. Six nudes.

————. Series of four: woman lying on bed with sheets pulled down; she seems to be sleeping. *Camera* 49 (Sep 1970):36.

————. Woman kneeling on chair in corner of room, with windows on each side; front torso of woman in same corner. *Camera* 50 (Sep 1971):5, 8-9.

————. Polaroid of woman (side view) standing under a skylight, hands on knees, hair hanging in front of her face. *Camera* 53 (Oct 1974):26.

————. Standing woman before mirror, dressed in white bra, garters, hose, pumps, & sunglasses, 1974. DP.

————. Woman supine on bed, legs parted, vulva exposed; a bit explicit for Sieff, 1974. A:239; MEP.

————. *La Photo.* Paris, 1976.

————. *Best of Nudes.* Tokyo, 1980.

————. Collection of ten photos of women reclining on beds in positions a bit more erotic than usual for Sieff; many not published elswhere. MEP.

————. *Jeanloup Sieff.* Paris: Contrejour, 1982. Incl. works w descriptive titles: "Hommage à Seurat," 1964 (cover); "Nu lointain dans une maison campagnarde," 1972 (27); "Etretat," 1979 (28); "Portrait d'une dame assise," 1972 (30); "Femme nue gravissant une dune," 1970 (35); "Femme nu avec des lunettes," 1976 (38); "Photopublicitaire pour les chaussures Carel," 1981 (40); "Femme nue se hâtant," 1976 (41); "Femme nue dans une bibliothèque," 1976 (42); "Portrait de Dames avec groupe, essai pour une publicité de parfum," 1975 (53); "Portrait de Judy," 1964 (56); "Nu dans un miroir," 1972 (59); "Nu massif," 1979 (60); "Coiffeuse avec femme nue," 1976 (61); "Nu de dos, ve de haut," 1976 (62); "Nu de vos, vu d'en bas," 1981 (63); "Derrière," 1969 (65); "Ambroisine, vue de dos," 1972 (70); "Nu à la fenêtre, Ile de Ré," 1976 (72); "Nu sans tête," 1973 (73); "Nu blanc," 1967 (74); "Nu noir," 1979 (75); "Nu de dos," 1964 (76); "Derrière dans un collant," 1981 (77); "Silhouette nue de profil," 1974 (88); "Nu pompier," 1956 (87); "Silhouette nue de dos," 1961 (89); "Femme nue endormie dans un fauteuil," 1976 (90); "Femme nue éveillée dans un canapé," 1974 (91); Jeune femme sur un lit," 1972 (92); "Femme nue dans une pièce vide," 1976 (96); "Nu las sur un lit mou," 1969 (117); "Nu mou sans un lilas, Ile de Ré," 1976 (118); "Sein au soleil, Sardaigne," 1970 (119); "Ambroisine à même le sol," 1972 (120); "Femme volontairement provocante, sur un lit," 1974 (123); "Fin d'après-midi en été, Ile de Ré," 1976 (127); "Hommage à Platon (la caverne!)," 1975 (137); "Carolyn Carlson," 1974 (148, 149); "Portrait préraphaélite," 1975 (150); "Jeune femme, torse nu," 1975 (151); "Yves Saint-Laurent posant pour la publicité de son eau de toilette," 1971 (152); "Nu dans un comble," 1974 (153); "Par un jour pluvieux, 1975 (157); "Nu de dos avec poitrine," 1979 (170); "Barbara et Sonia, l'une dans l'autre," 1979 (171); "Portrait d'une amie enciente, 1969 (172); "Nu baroque montant un escalier lentement (hommage à Marcel Duchamp)," 1972 (175).

————. *Photographien.* Munich: Schirmer/Mosel, 1983.

————. *Torses Nus.* Paris: Contrejour, 1986. One chair, one velvet covered pedestal, and 39 semi-nude portraits, each w biography. Excellent photo-reproduction on thick 115 lb. paper. Sieff's attempt at preserving beauty forever: "...this book is a cemetary filled with mummified fragments of youth."

————. "Jeanloup Sieff." *Photo* 226 (Jul 1986):50. Highlights from *Torses Nues.*

————. "Jeanloup Sieff." *Camera International* 7 (Ete 1986):80-89. Selection of 8 "topless" women from his *Torses Nus.*

————. *Jeanloup Sieff: Photographs, 1953-1986.* Paris: Musée d'Art Moderne de la Ville de Paris, 1986. Has even more images than *Time Will Pass...*, although both are illogically arranged.

————. *Jeanloup Sieff.* Tokyo: Parco Shuppan, 1987.

————. *Jeanloup Sieff.* Tokyo: Goro Int. Press, 1990. Incl. works w fairly descriptive titles: "Hommage à Seurat," 1964 (38); "Nu las sur un lit mou," 1969 (50); "Femme nue gravissant une dune, Le Plya," 1970 (52); "Portrait d'une dame assise," 1972 (61); "Nu lointain dans une maison campagnarde," 1972 (62); "Nu dans un miroir," 1972 (63); "Femme nue sur un canapé," 1974 (65); "Silhouette nue de profil," 1972 (66); "Carolyn Carlson," 1974, supine woman in studio (67); "Par un jour pluvieux," 1975 (72); "Femme nue dans un pièce vide," 1976 (76);"Femme nue avec des lunettes," 1976 (77); "Jeune femme pensive regardent ses chassures," 1979 (86); "Photo de mode," 1979 (87); "Derrière dans un collant," 1981 (91); "Torses Nu Madeleine," 1985 (99); "Femme nue avec une natte," 1985 (100); "Charlotte Rampling," 1985 (101); "Torses Nus Sylvia," 1985 (106); "Publicité pour les chaussure Carel," 1986 (116); "Publicité pour Vittel," 1986 (117); "Bal à Versailles," 1987 (123); "Loulou de dos," 1987 (124); "Au loin, un abat-jour," 1987 (125); "Jeune femme torse nu, avec voilette," 1987 (129); "Bahamas," 1987, rear view of standing man on beach [a rare male nude for Sieff] (130); "Lingerie," 1987 (130); "Bain de Soleil," 1988 (138); "Sur un canapé," 1988 (141); "Derrière dans un collant," 1989 (147); "Patrick Dupond," 1989, seated man on posing block (149).

————. *Jeanloup Sieff, 1950-1990: Time Will Pass Like Rain.* Paris: Contrejour, 1990. Gigantic collection of his best work, incl. several of his women nudes.

————. *Jeanloup Sieff.* Berlin: Benedikt Taschen, 1991. A good brief overview of Sieff's best women nudes.

Siegal, Peter. "Simon and Susan." Clothed man seated on toilet bowl, standing woman rear view in bathtub. *Puchong Folios* (New York) 1 (Spring 1991):41.

Seivers, Ed. *People in My Corner.* Santa Monica, CA: Sievers, 1973. Series of 39 nudes, all set in corner of domestic room, near window, featuring young men & women, w various props.

Šída, Radoslav. (b.1924) Rear view of seated woman. AA:82.

————. Rear view of woman's torso. JS:VI.

Sigrist, Martin. (ed.) *Erotik in Der Modernen Fotografie.* Schaffhausen, Switzerland: Verlag Photographie, 1985. 318p.

Silano, Bill. Following in NIP: hideously poor color reproduction of standing woman in ocean (11); series of 3 desert nudes in poorly reproduced color (226-29).

Silverthorne, Jeffrey. (US 1946-) Polaroid, seated woman with arms raised, revealing hairy armpit. *Camera* 53 (Oct 1974):27.

———. Two works in NEW: seated woman frontal, against wall, her head covered w gauze (194); "Girl with Birchbark," 1980, standing teenage girl under clothesline w bark (195).

———. Polaroid; distorted image of man & woman visible from waist up. SII.

Simon, Peter. (US 1947-) *Decent Exposures.* Berkeley, CA: Wingbow Press, 1974. The photos are not nudist snapshots like the FKK works, or something from Elysium Press, but go beyond and make a unique visual statement, and have social-historical value. As the author/photographer stated: "...to be nude is not LEWD or INDECENT but simply our most natural state." Six chapters: I. children; II. nude beach; III. hippie commune in Vermont; IV. portraits of friends; V. at the Esalen Institute, California coast [ironic photo (94) of supine woman on sundeck, w cigarette in right hand]; VI. man & woman allegedly making love.

Simpson, Charles Walter. (b.1885) *Photography of the Figure in Color and Monochrome.* Boston: American Photographic Pub. Co., 1938.

Sinsabaugh, Art. (US 1924-) "Mark and Sherry #12," 1969. Sixteen men and women in a forest setting. CS:126; LN:36.

Sirůček, Vladimir. (Czech 1929-) In collaboration with Zdenek Zálesák (Czech 1936-), a color image of a standing woman, viewed from about knee level looking up. *Camera* 51 (Sep 1972):20.

———. Photomontage of seated woman w arms raised; print has cracked pattern. JS:VII.

Siskind, Aaron. (US 1903-) "Bill Lipkind 4," 1960. Rear man's torso. CS.

Skolnick, Arnold. Following in NIP: woman's butt. between man's legs (10); color, series on couple embracing (125-28).

Skrebneski, Victor. *Skrebneski.* New York: Ridge Press, 1969. Unpaged. Studio shots on grey seamless. No titles, no dates. Incl. men, women, groups of women, groups of men, groups of men & women, and a semi-nude portrait of Vanessa Redgrave. One camera, one light, and an occassional smile from a model, which is refreshing in such a serious art work.

———. *Skrebneski: The Human Form.* New York: Bantam Books, 1973.

———. *Skrebneski.* [Ex. cat.] Hamburg: Edition Photogalerie The Compagnie, 1982.

———. Eight studio shots of women w men; women in groups. MEP.

———. *Black, White, and Color: Photographs, 1949-1989.* Boston: Little, Brown, 1989. Some nudes.

———. "Skrebneski." *Photo* 270 (Mar 1990):60. Incl. 4 works.

———. "Three Studies from the Human Body in Movement," 1990. On one work, three rear views of one standing man. *Photography in New York* 3 (Sep/Oct 1990):6.

Skoumal, Karol. (b.1929) Rim lighting of woman's breast. AA:63.

———. Classical approach to woman's torso. AA:64.

Smart, Ted. *The Art of Nude Photography.* New York: Crown, 1983.

Smith, Beuford. (US 1939-) Pregnant black woman standing on rooftop in pouring rain. Nikon, 50mm, Tri-X. *Camera* 50 (Sep 1971):32.

Smith, Henry P. Dancing black woman. HS.

Smith, J. Frederick. Four studio nudes of women. PL:198-205.

———. Series of color glamour shots in NIP:232-35.

———. *Sappho by the Sea.* Text by Mary Arrigan McCarthy. New York: Belvedere, 1976.

Smith, Keith. (US 1938-) Male nudes in HP.

Šmok, Jan. *Akt vo Fotografii.* 1969. An attempt at a scientific treatise on photography of the nude, w poor English trans., and which seems more like a "how to" manual than anything else. However, a few of his studies are unique: out-of-focus women (145-47, 149). Incl. epilog w works of others: Miroslav Peterka, Václav Jíru, Zdeněk Virt, Jaromír Fiala, Bohdan Marhoun, Radoslav Šída, Vladimir Sirůček, Věra Váchová, Miloslav Stibor. *See individual entries.*

———. Double exp. of woman's torso (right profile), HK b.g., but only the front & rear surfaces are visible, pressed together. NN:192.

Snyder, Dayton. Woman's torso looking very much like a Greco-Roman statue. BB:83.

Sollers, Philippe. *Photos Licencieuses de la Belle Époque.* Paris: Les Éditions 1900, 1987.

Šoltész, Pavel. *Femina.* Prague: Vydav. Novinář, 1969.

Sommer, Frederick. (US 1905-) "Frederick Sommer, 1939-1962: Photographs." *Aperture* 104 (1962). Issue devoted to his work.

———. Deliberately out-of-focus 3/4 frontal female nude, 1961. CS:107.

———. Similar out-of-focus print of woman's breast, thighs, arm, 1965. CS:106.

———. Weiss, John. (ed.) *Venus, Jupiter and Mars: The Photographs of Frederick Sommer.* [Ex. cat.] Delaware Art Museum, 1980. Incl. out-of-focus fragment of woman's breast, thighs, & arm, 1965 (10).

———. Glen, Constance W. and Bledsoe, Janek. (eds.) *Frederick Sommer at Seventy-five.* [Ex. cat.] Long Beach, CA: CSU, 1980. Incl. out-of-focus standing woman 3/4 frontal (54); "Figure," 1963, out-of-focus print of seated woman (55).

———. *Sommer Images.* Tuscon, AZ: Center for Creative Photography, 1984. Incl. "Figure," 1961, out-of-focus woman's torso (3); "Figure," 1962, out-of-focus print of seated woman (56); "Figure," 1963, out-of-focus print of seated woman (57); woman's torso frontal, 1961 (60).

Sommer, Ralph. Five works in HS: seated woman w roses; standing woman left profile, head bowed; woman's torso frontal, LK b.g.; seated woman on draped block; kneeling woman, LK b.g.

Šonta, Virgilius. (Lithuanian) View of beach with partial female nude in lower right corner, 1985. BL:178.

Sostero, Michel. (Italian) Supine woman on rock, arms back, stretching out; she wears a black wristband. *Photo* 291 (Jan./Feb. 1992):56.

Sougez, Emanuel. (French b.1889) Kneeling woman, head out of frame, ca.1930s. He followed "straight photography" in the tradition of E. Weston. NN:91.

———. Five studio shots of women. PL:98-107.

Soulage, Christian. (French) Reclining woman, on back, wears dark stockings & opened shirt. *Photo* 298 (Jan./Feb. 1993): 46.

Sousa, Alfredo de. (French) Color, standing woman strongly sidelit with blue gridlike background. *Photo* 291 (Jan./Feb. 1992):49.

———. Blue and white high contrast shot of woman's head and upper torso (cut out of a men's magazine?) seen through rough hole in wall. *Photo* 298 (Jan./Feb. 1993): 52.

Souza, Joachim de. Color, supine woman on rocks, waterfall b.g. *Photo* 184 (Jan 1983):75.

———. Color, woman taking off shirt in forest. *Photo* 232 (Jan 1987):61.

Soverns, Wayne. Right half of woman's torso, black b.g., 1957. BWC:31.

Spanidis, Alexis. Color, special effect: standing woman frontal superimposed over shop windows. *Photo* 184 (Jan 1983):100.

Spano, Michael. Woman crouching, with grid-like shadows upon her, 1985. *Photo/Design* 7 (Dec. 1990):9. Reminds one of Holz's work.

Spence, Jo. "Omnimpotence," 1988. Standing middle-aged man in studio w balloon tied to his penis. BTM:47.

Spencer, Richard Grenville. "Pudeur." LK print of standing woman rear view, in attitude of grief. *AAP* 49 (1935):128.

————. "Mural Section No. 2." Rear view of seated woman w long hair & expressive pose. *AAP* 52 (1938):156.

Spitzer, Neal. Following in NIP: woman behind plastic sheet (156); photomontage of woman on bed (157).

Šplíchal, Jan. "Photomontage," 1974. Very grainy image of woman's torso. NN:6.

Stark, Koo. "Koo Stark." *Photo* 234 (Mar 1987):40. Former girlfriend of Prince Andrew of England, & B-movie actress, presents portfolio of 9 erotic woman nudes.

Stark, Ron. (US 1944-) Woman prone on bed, barely visible because of heavy shadows; gum bichromate print, 1974. Deardorff, 10" lens, Ektapan. *Camera* 54 (Sep 1975):29.

Stearns, Phillip Olcott. *See* Vane, Norman Thaddeus.

Stehle, Monika. (Swiss) Color, reclining woman (rear view) on black (velvet?) background. *Photo* No. 291 (Jan./Feb. 1992):51

Steichen, Edward. (US 1879-1973) "Dolores," 1902. Diffuse image of seated woman. DP.

————. "The Little Round Mirror," 1904 (from *Camera Work* 14 [1906]). Diffuse rear view of standing woman, gazing into a mirror. NN:68.

————. "The Model and the Mask," 1906. Gravure print. CS.

————. "La cigale," 1907. Standing woman in overall diffuse image. LN:22.

————. "Miss Sousa," 1933. Seated woman in plain studio. BL:117.

————. "Dixie Ray for Woodbury Soap," 1935. Seated woman in studio, right profile, wet skin, soap suds on her back. *Photography in New York* 3 ((Jan/Feb 1991):7.

————. "Pannochia," 1940. Color, black woman holding an ear of corn. DP.

Stein, Ralph. (b.1909) *The Pin-Up from 1852 to Now.* New York: Hamlyn, 1974.

Steinbach, Imogene Kay. *Reversals: Re-signifying the Nude in Photography.* N.p., 1990.

Steiner, André. (b. 1901) Seated woman in high contrast lighting, 1935. AVK:98.

————. *45 Nus.* Paris: Éditions Sun, 1947.

Steinert, Otto. (German 1915-78) (ed.) *Akt International.* Munich: Brüder Auer, 1954. 78 plates.

————. "Schwarzer Akt," 1958. Negative image of seated woman, frontal. *Die Fotografische Sammlung.* Essen, Ger.: Museum Folkwang, 1983:(128); DP.

Steinhauser, Judith H. (US 1941-) Polaroid cover shot of woman with flowers. *Camera* 60 (Sep 1981):cover.

Stellar, Stanley. *Stellar Men.* Berlin: Bruno Gmünder, 1992.

Stember, John. Color, 3 fashion style woman nudes. *Photo* 221 (Feb 1986).

Stendal-Hohenscheid, K. *Sinne, Seele und Sinnlichkeit.* Leipzig, Ger.: Parthenon, 1928. Incl. 48 plates by F. Fiedler, d'Ora, Lotte & Rolf Herrlich.

Stenvert, Curt. (German) "Neue dimensionen der kosmologie oder," 1985. Color montage. BL:150.

Stern, Bert. (US 1929-) "Marilyn," 1962. Portrait of Marilyn Monroe, prone in HK setting. *Photography in New York* 5 (Nov/Dec 1992):n.p.

———. "Marilyn Monroe," 1963. The actress is prone on a mattress, right profile, HK background. DP.

———. "Bert Stern." *Photo* 220 (Jan 1983):44. Color, series of 9 woman nudes in glamour style, yet theatrical because models are integrated into sets w pseudo-modern paintings. Created for Pirelli calendar 1986.

———. "Bert Stern." *Photo* 233 (Feb 1987):42. Color, model Michelle Eabry in a fish tank w tropical fish.

———. *Marilyn Monroe: The Complete Last Sitting.* 464p. 2,571 images; 375 color. [1992?]

Stettner, Louis. *History of the Nude in American Photography.* Greenwich, CT: Whitestone Publications, 1966.

Steevensz, Walter. *Sex à Gogo.* Bonn, Ger.: EBH, 1969.

Stewart, Charles. (1927-) *Nus de Harlem.* Paris: Éditions Prisma, 1961.

Stewart, Philip Gleason. (b. 1943) *The New-genre Nude: A New Fine Art Motif Derived from Nudist Magazine Photography.* N.p., 1986.

Stibor, Miloslav. (b.1927) Kneeling woman. JS:X.

———. Modified silhouette of seated woman. AA:48. Stibor is almost unique in his approach to the silhouette: onto the darkened figure a small spotlight is aimed, highlighting or reveavling select portions of the body. Similar to what commercial photographers today might call "painting with light."

———. Modified silhouette of woman's torso. AA:49-50.

———. Modified silhouette of supine woman. AA:52.

———. Modified silhouette of seated woman w arms crossed upon lap. AA:53.

———. Modified silhouette of kneeling woman frontal, arms raised. AA:35.

———. Reclining woman in LK setting. AA:57.

Stieglitz, Alfred. (US 1864-1946) Torso of large woman, 1919. DP.

Stoctay, G.G. *America's Erotic Past, 1868-1940.* San Diego, CA: Greenleaf Classics, 1973.

Stojko, Tone. *Okus Po Prahu (Taste of Dust).* Ljubljana, Slovenia: De Lavska Enotnost, 1981. Incl. 36 nudes (all women) on various themes: melancholoy shots in barren rooms; blurred motion studies; diffusion studies; outdoors imagery.

Stoklosa, Zbigniew. (Pole) Unique shot of four women standing in bathroom. *Photo* 268 (Jan 1990):114.

———. Woman's lower torso, echoed by form of tree trunk. *Photo* 280 (Jan 1991):65.

Stoll, Gigi. "The Pinch." Woman's torso frontal, w shadow of hand in pinch pose cast upon her chest. *Puchong Folios* (New York) 1 (Spring 1991):40.

Stolz, Albert. *Mannesschönheit durch gesunde Körperliche Ausbildung.* Munich: Stolz, 1910.

Stone, Sasha. *Femmes.* Paris: Éditions Arts et Métier Graphiques, 1933. 20 plates.

Stoß, Hermann. *Gesunde Schönheit.* Berlin: Hausart-Verl., 1926. 20 nature nudes.

Straker, Jean. *Nudes of Jean Straker.* London: C. Skilton, 1958.

Strand, Paul. (US 1890-1976) "Torso, Taos, New Mexico," 1930. CS; AVK:92.

Stratz, Carl Heinrich. *Die Schönheit des Weiblichen Körpers.* 44 vols. Stuttgart, Ger.: Enke, 1898-1941.

———. *Die Rassenschönheit des Weibes.* 22 vols. Stuttgart, Ger.: Enke, 1901-41.

———. *Der Körper des Kindes.* 12 vols. Stuttgart, Ger.: Enke, 1903-41.

Straus, Harley E. (US 1941-) Woman supine on floor. *Camera* 53 (Sep 1974):28.

Strauss, Irene. "Eumenides at Kyllene," 1969. Four men & one woman relaxing at a swimming hole. BWC:9.

Strebel, Lukas P. (Swiss 1950-) Woman's torso, 1971. Nikon F, 50mm, Tri-X, on camera flash aimed at ceiling. Print slighltly solarized. *Camera* 54 (Sep 1975):19.

Streichert, Othmar. (Austrian) "Blond & Schwarz," 1932. Brown toned photo of brunette woman w blond woman behind her. USII:77.

———. Brown toned photo of seated woman, profile right, her face to the camera, 1933. BL:79.

———. Standing woman, visible from waist up, 1935. USII:74.

———. Brown toned photo of seated woman on studio seamless, 1936. USII:75.

Strosahl, W. Woman supine on couch. BB:72.

———. Two works in HS: backlit seated woman; kneeling woman, rear view, arms parallel to floor.

Suhr, Werner. *Der Nackte Tanz.* Hamburg, Ger.: Laurer, 1927. 16 nudes by Riebicke.

Stuler, Jack. "Ernil," 1967. Supine pregnant woman in LK setting. BWC:22.

Stumpf, Holger. (German 1953-) Harshly lit woman's torso seen from side, her right arm raised level with her breast. Leica M5, Tri-X (ASA 25). *Camera* 60 (Aug 1981):8.

Stupakoff, Otto. (German) "Baden-Baden," 1977. Woman in foregound descending into circular pool; woman in background standing under shower head. *Camera Arts* 2 (Oct 1982):36-37.

Sturges, Jock. "Martine, the Last Day of Summer #1," 1989. Teenage girl standing frontal, hand behind head, on wet sandy beach. *Photography in New York* 3 (Mar/Apr 1991).

———. *The Last Day of Summer.* New York: Aperture, 1991. Portraits of teenage girls taken with large format camera, many at the beach.

———. *Jock Sturges: Standing on Water.* [Ex. cat.] Philadelphia: Paul Cava Gallery, 1992.

———. "Danielle; Oud Heusden, The Netherlands," 1992. Young woman standing w arms crossed in body of water up to her thighs. Flattering backlight. *Photography in New York* 5 (May/Jun 1993).

Sudek, Josef. (Czech 1896-) Grainy print of seated woman, ca.1930s. NN:111.

———. "Nu," 1951-54. Seated woman in LK setting. In Sonja Bullaty. *Sudek.* New York: Crown, n.d.:(12); AA:21.

———. "Nude," 1951-54. Standing woman, 3/4, rear view. In *Josef Sudek.* Prague: Panorama, 1986:(62); AA:20.

Sudo, Masato. *Photography Year 1982.* Alexandria, VA:Time-Life, 1982.

Sullivan, Constance. (ed.) *Nude: Photographs, 1850-1980.* New York: Harper & Row, 1980. Incl. F.J. Moulin, Braquehais, Roger Fenton, Nadar, Eakins, Degas, Clarence H. White, F.H. Day, F. Eugene, Dorothea Lange, Atget, Bellocq, A. de Meyer, Brassaï, Stieglitz, M. Munkacsi, H. Cartier-Bresson, Roger Parry, Drtikol, F. Brugière, P. Outerbridge, P. Strand, W. Chappell, F. Sommer, Todd Walker, A. Siskind, J. Meyerowitz, D. Hockney, T. Papageorge, Roger Mertin, R. Heinecken, Linda O'Connor, Art Sinsabaugh, Richard Benson, Richard Pare. *See individual entries.*

———. (ed.) *Women Photographers.* New York: Abrams, 1990. Incl. Imogen Cunningham, Nan Goldin, Germaine Krull, Lee Miller.

Sullivan, Jean. (ed.) *Photographing the Nude.* New York: Louis J. Martin, 1977.

Suren, Hans. *Der Mensch und die Sonne.* Stuttgart, Ger.: Dieck, 1924; 1925; 1930; 1936.

———. *Mensch und Sonne. Arisch-olympischer.* Berlin: Scherl, 1937; 1940; 1942.

Suter, Jacques. (French 1946-) Series of 8 color shots in the manner of David Hamilton. *Photo* 212 (May 1985).

———. Woman standing 3/4 against wall, wearing riding hat, white panties, and black leg warmers. *Photo* 298 (Jan./Feb. 1993): 54.

Sutlciffe, Frank Meadow. (UK 1853-1941) Male nudes in HP.

Suzuki, Akira. (Japanese) *Les Fleurs du Mal: Réhabilitation par mon Sexe.* Text by Charles Pierre Baudelaire (1821-67). 1968.

Swannell, John. *Fine Lines.* London: Quartet Books, 1982. A fashion photographer's female nudes. Incl. 46 studio works oddly cold and even arrogant, although the models (slender & tall) are glamorously made up, coiffed, and beautiful. A section of landscape nudes is incongruously inserted pp. 63-91.

———. *Naked Landscape.* London: Quartet Books, 1986. 59 sumptuously printed works focusing on women in the natural environment: many images are apparently set in the remote Scottish moors. This is quite different from *Fine Lines*, and of timeless value.

Swedlund, Charles A. Series of 7 multi-exp. studio shots. PL:158-67.

———. Multi-exp. image of woman standing in front of massive tree trunk; her head is missing. BWC:53.

———. *Charles A. Swedlund Photographs.* Cobden, IL: Anna Press, 1973.

———. *Stereo Photographs.* N.p., 1973. 15 photos; 1 plastic stereo viewer.

———. Color, supine woman w child on bed. NN:186.

———. "No. 365." Triple exp. of three women standing in field. NN:192.

Sylvain, A. *Nus de Tahiti.* Paris: Éditions Prisma, 1963.

Syndikas, Alexander S. *Optical Sculptures.* N.p., 1982.

Székessy, Karin. (German 1940-) *Les Filles dans l'Atelier.* Paris: Denoël, 1969. three or four women posing in an artist's studio, although there are some out-of-place infrared outdoor nudes as well. Either the publisher or the photographer had the quaint idea of airbrushing away any trace of pubic hair on the women, making them seem slightly inhuman, like mannequins.

———. "Drei Modelle am Nachmittag II," 1969. Actually four young women posed on & around a couch. In *Sammlung Otto Steinert.* Essen, Ger.: Museum Folkwang, 1981:(81).

———. Three standing women in blurred image. N.

———. Four women on a couch. N.

———. Two women on plush chair in surrealistic room. N.

———. Color, beautiful women lounging around. N.

———. "Die Füsse," 1972. Woman prone on floor, butt. elevated, another woman seated in the corner, laughing. KS:48.

———. Four young women of Holstein arranged in an intriguing composition: one standing, one reclining, and two seated. Hasselblad, Distagon, Tri-X. *Camera* 51 (Sep 1972):19.

———. *Paul Wunderlich und Karin Székessy Correspondenzen.* Zurich: Belser Verlag, 1976. Approx. 100 studio shots of young women, which her husband "paraphrased" into paintings, 1966-77.

———. *Best Nudes.* Tokyo, 1979.

————. Color photo of seated woman facing camera. She is partly wrapped in yellow streamers. An old man in business attire and great coat stands beside her, holding a Polaroid camera. The image is blurred, as if by camera motion. From a German calender. See *Photographis 85* (New York: Watson-Guptill, 1985):210.

————. *Madchen im Atelier.* 1985.

————. "Korsage," 1986. 3/4 rear view of standing woman in black corset-garters-stockings combination. KS:47.

————."Nude with Fish." Standing woman w paper bag over head, fish bones on table in f.g. NN:181.

————. "Blue Scene." Color, 4 young women posing in dark blue scene. NN:186.

————. *Karin Székessy. Photoedition 11.* Schaffhausen, Switzerland: Verlag Photographie, 1988.

Tabard, Maurice. (French 1897-1984) Double exp. of standing woman & shadows of hands. RK:23.

————. "Nu à l'échelle," 1929. Standing woman frontal, back against wall, shadows from window [?] projected upon her body. In Dominique Baqué, "Le Vide, et le noir, et le nu," *La Recherche Photographique* 11 (Dec 1991):119.

————. Gautrand, Jean-Claud. "Maurice Tabard." *Zoom* 102 (1983).

————. "Tabard." *Photo* 193 (Oct 1983):112-17. Incl. 1 multi-exp. woman nude.

Tachon, Jacqueline. (French 1959-) Portraits of 4 women, painted w intricate designs. C:36-39.

Tahara, Keiichi. (Japanese 1950-) "Keiichi Tahara." *Camera International* 7 (Ete 1986):70-79. Eight studio nudes. Has published "Eclats", 1985, a series of nudes in Japan. Beautiful and interesting work.

Tajiri, Shinkichi. Daguerreotype of standing woman, rear view, ca.1976. KS:36.

Takechi, Tetsuji. (Japanese 1912-) *Ai No Rimbu.* 1970.

Tarabon, René. Color, woman's torso frontal, in waterfall. *Photo* 184 (Jan 1983):76.

Tarag, Mylène. Color, woman seated on bow of rowboat, rear view. *Photo* 280 (Jan 1991):54.

Tatsuki, Yoshihiro. (Japanese 1937-) *Eves.* 1970.

————. Rear view of woman standing in pool of water (beach scene). N.

————. Woman walking on beach. N.

————. Woman standing on beached shipwreck. N.

————. *Aru Onna.* 1971. 10 plates.

————. *Girl.* N.p.: Chuo Koran-sha, 1971.

————. *California I Love You.* Tokyo: Camera Mainichi, 1973. Incl. 11 color snapshots of three young women in forests & on beaches.

Taubhorn, Ingo. (b.1957) Bedroom portrait of his parents, 1985. AVK:170.

————. *Mensch, Mann.* Schaffhausen: Edition Stemmle, 1986.

Taylor, Ralph V. "Dulci." Seated woman w bowed head, HK print. *AAP* 57 (1943):143.

Téboul, Sabine. (French) Color, very beautiful young woman standing on beach with both arms raised and holding onto a large piece of driftwood; she looks in our direction. *Photo* 291 (Jan/Feb 1992):46.

Ten Broeke, Rutger. (Dutch 1944-) Series of three strongly sidelit women's torsos, standing, seated, reclining; the detail & apparent sharpness are outstanding. NEW:160-62.

————. "Blanka, Carelage, Volvic, 1984." Standing woman, back to camera, in canyon-like setting. SEM:51.

————. "Blanka, Étang de Chancelade, 1984" Long distance shot of young woman crouching (rear view) in a placid lake, her butt. just above the water line. SEM:50.

Tenneson, Joyce. (US 1945-) *Joyce Tenneson: Photographs.* Incl. 3 works that might be thought of as nudes.

————. Three Polaroid images of old fat women. SEM:180-1.

————. "Joyce Tenneson." *Camera International* 3 (Ete 1985):60-69. Eight male and female nude portraits, including herself (rather demurely). (63)

————. *Au-delà.* Paris: Contrejour, 1989.

————. *Transformations.* Boston: Bulfinch Press, 1993. 80 color, 10 B&W. Retrospective of her pastel-like nudes, the models often wrapped in gauze.

Terner, Ron. *Nudes, 1975-1985.* City Island, NY: Focal Point Press, 1985. 28 images, mostly concentrating on men's & women's torsos. The later works have been manipulated & painted to look like abstract paintings. They are hybrid works, neither photos nor paintings: he describes them as Phototerns.

————. *Nudes, 1986-1991: Beyond the Boundaries.* City Island, NY: Focal Point Press, 1991.

————. "Photo Chemical Painting (Phototern)," 1993. Color, seated woman frontal, head out of frame, arms behind back. *Viewfinder: Journal of Focal Point Gallery* 17 (1993).

Terraz, Patrice. "Anny," 1988. Obese standing woman 3/4 frontal, arms akimbo, black b.g. *Photography in New York* 3 (Jan/Feb 1991); *Puchong Folios* (New York) 1 (Winter 1991):17.

Teske, Edmund. (US 1911-) Multi-exp. of flowers and man and woman in derelict room. BWC:70.

————. "Jeff Harris in the Role of Shiva." Double exp. of supine man w flowers & cliff. BTM:53.

————. *Images from Within.* Carmel, CA: Friends of Photography, 1980. Incl. 18 multi-exp. nudes; and the "Shiva-Shakti" series in which one image of supine man is superimposed upon various other images.

————. Male nudes in HP

Theewen, Gerhard. *Der Komplette Nudisten Salon.* Düsseldorf, Ger.: Salon, 1982.

Thiele, Walter. *Aktfotos, die jeder kann.* Halle, Ger.: Isert, 1940. ["How to" manual]

Thom, Graham. (Scottish) Merry widowed torso, with shaved mons venus. *Photo* No. 291 (Jan./Feb. 1992):59.

Thompson, Douglas. *Photographs by Douglas Thompson.* [Ex. cat., Thorburn Galleries, Sydney, Australia, 4-23 June 1974] Cammeray, Australia: House of Darrington, 1974.

Thompson, Francis Ehrlich. *Self-reflexive Portions.* N.p., 1986.

Thompson, Kenneth. *How and Why of Selecting and Posing the Model.* New York: Galleon, 1939.

Thompson, Warren Jr. (US 1947-) Woman's torso seen through broken window, 1973 p. 30; rear of squatting woman, 1974 p. 40. Nikon F, 24mm, Tri-X. *Camera* 53 (Sep 1974).

Thomson, Chris. (UK) *Photomodels.* Munich: Bahia, 1983. ["How to" manual]

————. *Private View.* Paris: Love Me Tender, 1983. ["How to" manual]

Thongsithavong, Manivone. Color, supine woman w white tubes wrapped around her open legs. *Photo* 184 (Jan 1983):75.

Thorek, Max. "The Nude in Photography." *AAP* 48 (1934):26-29. Pictorialist essay. "Photography of the nude is primarily an idealization."(26) In nature, human beings fit

better in a clothed state. [He is apparently *not* a proponent of FKK.] It is unnatural to see naked humans in nature. Pictorial nudes must be presented w "simplicity and in the abstract." Beauty of form must be conveyed not realistically, but in the abstract: idealized.(28)

————. "Odalisque." Waist up view of standing woman frontal, hands on hips in slightly glamour pose. *AAP* 48 (1934):29.

————. "Incentive." Clothed working man f.g.; diffuse image of standing woman frontal in b.g. Does this mean that a man must do hard labor to have sex w a woman? *AAP* 50 (1936):115.

————. "A Critic." Clothed middle-aged woman looks up at standing woman on pedestal. *AAP* 52 (1938):132.

————. "Judith." Woman in turban & jewelry, nude from waist up. *AAP* 54 (1940):127.

Thorne-Thomsen, Ruth. Infrared, woman reclining on right side, rear view, outdoors. NIP:223.

Thornton, John. (Australian 1946-) Color, 6 shots of women & water, claiming a debt to Surrealism [it is difficult to see the connection]. MEP.

————. Color, supine woman on balcony, w theater audience in b.g. A:262.

————. Following in NIP: color, glamour shot of supine woman in derelict room (161); color, woman painting line on road (162); standing woman in farmer's field (163).

————. *Pipe Dreams.* Kehl, Ger.: Swan, 1979; Paris: Éditions Dominique Leroy, 1983. *Charme*

————. Color, two glamour shots of a woman in barren room. NEW:67, 68.

Thorpe, David. *Raffiniert garniert. Kühn Perspektiven.* Rastatt, Ger.: Moewig, 1979.

Thrap, Thom Segelcke. *Freiluftleben und Sommersport im Wunderschönen Norwegen.* Oslo: Thraps Verlag, 1941.

Thür, Herbert. (German) Kneeling woman on fogged steps; she wears fairy wings. *Photo* 291 (Jan/Feb 1992):54.

Thurnher, Jeffrey. Black[?] woman in loin-cloth in front of black man holding a truck tire inner tube aloft. *Photo* 292 (March 1992):51.

Tiedge, Klaus. (ed.) *Aktfoto International.* Munich: Großbild, 1983.

Tilney, Frederick Colin. *The Principles of Photographic Pictorialism.* Boston: American Photographic Pub. Co., 1937.

Tolot, Alberto. *Photo* (Mar 1992):60-65. Incl. works w/out title or date: crouching woman holding her breasts; kneeling woman staring out at us; infrared 3/4 standing woman viewed from ground level, an intricate design drawn on her torso; woman w/out nipples; woman w antlers; crouching woman w large-diameter coiled rope.

Tooming, Peeter. (Estonian 1939-) Mud-spattered woman's torso on beach. NIP:221.

————. "Renouncement III." Woman standing 3/4 frontal, harsh side light, & cliff b.g. NN:169.

————. "Before the Rain," 1983. In gravel pit, woman stands, holding umbrella. CP:1042.

Toppo, Renato. Woman's torso & head, rear view, against black b.g.. BB:10.

————. Supine woman visible from waist up. BB:17.

————. Supine woman against black b.g. BB:23.

————. Ditto. BB:27.

————. Ditto. BB:28.

————. Seated woman. BB:42.

————. Heroic pose of supine woman, composed in frame w unique viewing angle. BB:49.

————. Heroic pose of woman reclining on left side, black b.g.. BB:50.

————. Very similar to BB:49, except we see almost her entire body. BB:63.

————. Woman's torso & head, left arm behind head. BB:74.

————. Total of four works in HS: seated woman; two photos of seated woman in dynamic pose; supine woman on velvet.

Torlowia, Giovani. Color, two women in purple lighting wrestle in a smiling pose. Too men's magazinish. *Photo* No. 298 (Jan./Feb. 1993): 59.

Torosian, Michael. (Canadian 1952-) Woman's torso, 1985. CP:1044.

————. *Aurora*. Toronto, Canada: Lumiere press, 1988.

Torriente, Norberto. *Sculptura Humana*. N.p.: NTD Photography, 1992.

Toscani, Oliviero. (Italian 1942-) Color, 18 shot sequence of woman on bed. MEP.

Tourdjman, Georges. (French/Moroccan 1935-) Blurred motion of woman under skylight, up against a wall, knees up. Nikon, 28mm, Tri-X. *Camera* 50 (Sep 1971):36.

————. Portrait of laughing woman, 1972. Nikon, 200mm, Pan X. *Camera* 51 (Sep 1972):25.

————. Harshly side-lit color image of woman's torso. Nikon, 105mm. *Camera* 53 (Sep 1974):cover.

————. Series of four images of standing woman covered w mud. In *Angenieux: Carte Blanche A*. Paris: Contrejour, 1984:(63-66).

Townsend, Julie. (US) "Trinity," 1991. Two plump white women and a black man wear paper bags with African faces drawn on them. She likes to make photos that are humorous, perverse, and mysterious. *CENTER Quarterly* 14 No. 2 (1992):15.

Townsend, William. (b. 1940) *Other Women*. Vancouver, Canada: R. Collins, 1972.

Tregaskis, Richard. *Women and the Sea*. Los Angeles: Elysium, 1966. Nudist snapshots: women at the beach.

Tranter, Tina. *The Lovers*. London: Skilton, 1971.

Traunig, Francis. (Swiss) Color, woman being crucified on lake. [How did he do this?] *Photo* 184 (Jan 1983):76.

Trauter, Tina. *Love in*. Bonn, Ger.: EBH, 1971.

Tremorin, Yves. (French 1959-) Two untitled works from 1985: an old pair of breasts; something old and hairy. SEM:124-25.

————. "De Cette Femme," 1991. Sagging breasts. *Puchong Folios* (New York) 1 (Spring 1991):38.

Tress, Arthur. (US 1940-) "Hermaphrodite," 1971. Frontal view of man standing outside in a formal garden between two rows of classical statues, concealing his genitalia between his thighs. SEM:43.

————. *Theater of the Mind*. Dobbs Ferry, NY: Morgan & Morgan, 1976. Incl. 3 works that might be considered nudes.

————. "Policeman," 1979. Police puppet being held over reclining man's pubic hair, with the other hand holding a pistol pointed at the puppet. SEM:200.

————. Two works in NEW: "Kent on Slide," 1979, overhead view of supine man on spiral slide (188); "Man with Lynx," 1979, prone man w stuffed Lynx between his legs (189).

————. "Butcher Fantasy," 1980. Man in S&M leather harness being held aloft by a meat hook in a butcher's room. SEM:201.

————. *Tress*. New York: St. Martin's, 1980. Incl. 39 man nudes of homoerotic type set amid the filth of New York city.

————. *Facing Up.* New York: St. Martin's, 1980. His attempt at making explicit his homoerotic fantasies, especially phallic fantasies.

————. Eight homoerotic nudes. *Photo* 221 (Feb 1986).

————. *Talisman.* New York: Thames & Hudson, 1986. Incl. 10 previously published works.

————. *Machinations.* London: Gay Men's Press, 1988.

Trichot, J-C. (French) Standing woman, bathrobe down at waist, w rocky surf below. *Photo* 298 (Jan/Feb 1993):55.

————. Male nudes in HP.

Trillat, Elsa. Color, brief series on French actress Sandrine Bonnaire. *Photo* 228 (Sep 1986):44.

Truitt, Warren. *Textures.* London: Gay Men's Press, 1990.

Trülzsch, Holger. *Verushka: Transfigurations.* Boston: Little, Brown, 1986. Color, model Vera Lehndorff painted to blend in with various backgrounds, brick walls, etc. Also body painted to suggest clothing. Great skill of the artist is evident.

Tsukahara, Takuya. *Tsukahara Takuya.* Tokyo: Gyarari Puresu, 1973.

Tuckerman, Jane. (US) Self-portrait. 4x5 view camera, Tri-X. *Camera* 60 (Sep 1981):14.

Tulchin, Lewis. *The Nude in Photography.* New York: Grayson Publishing, 1950.

————. *Photographing the Nude.* New York: Barnes, 1962.

————. *The Photography of Women: the Nude as Art.* New York: Barnes, 1964. ["How to" manual] Despite an absurdly pedantic writing style, Tulchin eventually revealed the secrets of glamour photography as a distinct form of photography of women. He defined glamour photography as "...a graphic method of glorifying the feminine qualities of women." (11) Visual sexual attraction sustains glamour, because men are most attracted by those physical traits which most differentiate women from men: breasts, hips, buttocks. Facial expressions are also important for glamour:"...a warm smile, a far-away look, a demure, coy, teasing languid look, a submissive, wanting-to-please look, or a saucy innocent look—as if to say «why do men look at me?»"(12-13) Add a certain look on the face to highlighted female body parts and glamour is the result.

————. *Creative Figure Photography.* South Brunswick, NJ: A.S. Barnes, 1967.

Tulet, Martine. (US) Woman in rags, covered w mud-like material, reclining in barren room. *Photo* 268 (Jan 1990):119.

————. Painted standing woman frontal, wearing "classical drapery" & carrying small ball in right hand. *Photo* 280 (Jan 1991):64.

————. White plastered semi-seated woman on black b.g. *Photo* 291 (Jan/Feb 1992):57.

————. Standing 3/4 woman painted white with black b.g. *Photo* 298 (Jan/Feb 1993):49.

Tunick, Spencer. Urban street scene (New York) w standing woman frontal, small monkey on her left shoulder, ca.1990. *Photography in New York* 5 (Jan/Feb 1993):74.

————. Woman standing frontal in an urn, placed in middle of New York street, ca.1990. *Photography in New York* 4 (May/Jun 1992).

Turbergue, J.–P. *Le Nu et la Pose.* Paris: Éditions Atlas, 1984. ["How to" manual]

Turbeville, Deborah. (US 1937-) "Mary Marks," 1981. A fat woman reclining in a chair; looks as though printed in 1881. LN:56.

————. *Les Amoureuses du Temps Passé.* Tokyo: Parco, 1985. Incl. 14 color works of beautiful fashion models posed semi-nude (soft-focus) to suggest the style of the 1930s, but these nudes are not merely imitations of work created in that era.

Turner, Pete. "Andy Warhol's Factory," 1970. Color studio shot of 6 people, 3 women clearly nude. AVK:146.

Tweedy-Holmes, Karen. (US 1942-) Magnificent top-lit woman's torso. NIP:219.

———. LK setting, seated man on couch, rear view. DH:8.

———. LK setting, standing man frontal holding infant. DH:7.

———. Man's frontal torso, harsh side-lighting. DH:62.

———. Seated man in garden. DH:59.

———. "Frank." Standing man frontal, wearing sunglasses; black b.g. YK:27.

Ubac, Raoul. (Belgian 1909-) Limbour, Georges. "Raoul Ubac." *XXme Siecle* (Sep 1958).

———. Ragon, Michel. "Raoul Ubac." *Cimaise* (May-June 1961).

———. *Rétrospective Raoul Ubac.* Charleroi, Belgium: Cercle Royal Artistique et Literaire, 1968.

———. "Ophelée," 1938. Multi-exp., supine woman, flowing water, ladders & leaves. RK:63.

———. "Les Combat des Penthésilées," 1939. Complex montage of women standing [original print rephotographed & solarized, the resulting positive image then rephotographed & resolarized]. RK:71.

———. "Group I, II, III," 1939. Three works very similar to "Les Combat..." RK:

Ulan, H.S. Three works in HS: oiled, seated woman, HK b.g.; seated woman w arms raised; ditto.

Ulbrich, Fritz. *Lebender Marmor. Der Mann, der 1500 Frauen...* Vienna: Verlag für Kulturforschung, 1931. 176 nudes.

Urfer, Roger. Kneeling woman frontal, face obscured w hair. *Photo* 184 (Jan 1983):78.

Uzzell, Thomas H. Seated woman, knees up to chest. HS.

Vachet, Yves. (French) Woman standing amid wheat feild, torso and head visible, hills in backgound. *Photo* No. 298 (Jan./Feb. 1993): 53.

Váchová, Věra. Unique print of woman's right hip & butt.: left side of figure is black, but the right side is HK. JS:IX.

Vallarino, Vincent. (US 1953-) Woman supine on sofa, window-lit. Deardorff, 210mm, Polaroid 52. *Camera* 54 (Sep 1975):14.

Vallhonrat, Javier. (Spanish 1953-) *Javier Vallhonrat.* Porin, Finland: Porin Taidmuseo, 1986.

———. *Animal-vegetal.* Madrid: Abril y Buades, 1986.

———. Triangular frame with contorted woman inside its parameters, 1987. SEM:188.

———. Round frame with reclining woman, 1987. SEM:189.

———. Oblong frame with woman reclining, 1988. SEM:189.

———. "Letter F, Madrid, 1989." Color photo of young woman in full figure profile manipulating a fine fabric into roughly the letter F. *Aperture* 122 (Winter 1991):cover.

Van Baaslem, R. Color, woman's torso behind water covered glass pane. *Photo* 298 (Jan/Feb 1993):56.

Vance, David. *Visions.* Coral Gables, FL: 1973.

———. *The Ultimate Book of Nudes.* N.p.: Greenleaf, 1976.

Vance, Norman Thaddeus. (ed.) *Six Nymphets.* [Photographs by David Larcher and Phillip Olcott Stearns] London: Kings Road Publishing, 1966.

Van Der Zee, James. (US 1886-1983) "Nude by Fire Place," 1923. Natural looking image of young woman seated/crouching left profile on rug before blazing fireplace. *La*

Recherche Photographique 5 (Nov 1988):back cover. Van Der Zee was a black photographer working in Harlem during its cultural renaissance of the 1920s.

Vangasse, Sylvia. Color, standing woman against tree, w clothed man pinning her neck against its trunk w a pitchfork. *Photo* 207 (Dec 1984):80.

Vanselow, Karl. *Die Schönheit.* Berlin: Verlag d. Schönheit, 1903.

Vargas, Ava. (comp.) *La Casa de Cita: Mexican Photographs from the Belle Epoque.* London: Quartet, 1986. Prostitutes in 1880s, allegedly.

Vaughan, Caroline. (US 1950-) Woman floating supine in water, 1974. Deardorff 4x5, 210mm, Versapan. *Camera* 54 (Sep 1975):20.

Vávra, Jaroslav. (b.1920) Breasts & arms. AA:116.

————. Double exp. of woman's torso & stone wall. AA:101.

————. Seated woman w strong graphic pattern projected upon her. AA:94.

————. Two standing women w strong graphic pattern projected upon them. AA:95.

Vecchi, Mirella. (Italy) Color, 2 crouching woman under lattice-work shadows. *Photo* 268 (Jan 1990):108.

Veillerot, Jean. Color, woman's torso supine, overhead shot on glossy red floor. *Photo* 184 (Jan 1983):75.

Velasquez-Fernandez, Eduardo. (Brazilian) Black man standing near window. *Photo* 298 (Jan/Feb 1993): 46.

Verges, Wolfgang, and Green, E.W. Kneeling woman frontal, head bowed, holding a fish in her lap. *Photography in New York* 3 (Mar/Apr 1991).

Verglas, Antoine. "Antoine Verglass." *Photo* 289 (Nov 1991):76. Incl. *charme* shots of models Julie Anderson, Nicole Beach [2 photos].

Véronèse, Marcel. *Mademoiselle 1+1.* New York: Crown, 1968. In a style somewhere between straight glamour and "art photography". Incl. 49 nudes of young woman in the Camargue region of France, which reminds one of the southwestern United States. 10,000 frames shot: Plus-X for daylight, Tri-X for indoors; Pentax Spotmatic 35mm SLR; 35, 50, 105mm lenses.

————. *Youpi & the Girls.* New York: Crown, 1969.

————. *Les Belles et la Bête.* Paris: Belfond, 1969.

————. *L'Amour.* Flensburg, Ger.: Stephenson, 1970.

————. *Love Story.* London: Skilton, 1973.

Vetter, Gerhard. (German 1918-) *Studien am Strand. Mit 104 Aufnahem des Verfassers.* Leipzig, Ger.: Fotokinoverlag, 1968.

Vignola, Amedée. *L'Etude Academique.* Paris: Librairie D'Art Technique, 1904.

Vila, Emili. (Spanish 1887-1967) Bauret, Gabriel. "Emili Vila," *Camera International* 22 (Autumn 1989):30-39. Includes primitive female nudes from 1920s [?] used as models for his painting & graphic works.

Vilatte, Philippe. Woman's torso frontal. *Photo* 280 (Jan 1991):66.

Vilander, Ica. *Akt Apart.* Bonn: Verlag der EBH, 1967.

————. *La Femme Vue par une Femme. Album de Modèles.* Paris: Éditions de la Table Ronde, 1967.

————. *La Donna Vista da una Donna.* Turin, Italy: Dellavalle, 1968.

————. *Akt Adonis.* Gütersloh, Ger.: Peter, 1969.

————. *Vive le Sex.* Güterloh, Ger.: Peter, 1970.

Villarrubia, Jose. (Spanish 1961-) Male nudes in HP.

Virt, Zdeněk. (Czech 1925-) Seated woman on rooftop. AA:117.

———. Seated woman on logs. AA:111.

———. Woman in fetal pose, nestled in depression of gravel pit. AA:112-13; JS:III.

———. High contrast graphics treatment of standing woman, 3/4 rear view. JS:VIII.

———. *Op-Art-Akte.* Hanau, Ger.: Müller und Kiepenheuer, 1970.

Vischi, Daniel. *Schönheit im Bild.* Thielle: Die Neue Zeit, 1967.

Vogel, Angelika. *Angelika Vogel. Photoedition 9.* Schaffhausen, Switzerland: Verlag Photographie, 1986.

Vogt, Christian. (Swiss 1946-) Color, 3/4 standing woman in room with window in background. Hasselblad, 40mm Distagon, available light. *Camera* 50 (Sep 1971):35.

———. Woman's face and chest portrait near window. *Camera* 53 (Sep 1974):31.

———. Studio nude, 1974. Hasselblad, 80mm, Broncolor flash. *Camera* 54 (Sep 1975):24.

———. Double exp. of room with two women standing on either side of door, 1975. Nikon F2, 28mm, HP4. *Camera* 54 (Dec 1975):36.

———. Color Polaroid of woman reclining on her side (back to camera) on a table, with picture frame between her and the camera. *Camera* 57 (May 1978):back cover.

———. "Sabine in Her Box," 1979. Studio shot, woman in stockings climbing head first into wooden box [upside-down posing block]. NN:178.

———. *Christian Vogt.* Geneva: RotoVision, 1980. Incl. 29 woman nudes in following series: "Romana," 1975-80, one woman in same pose taken over six year period; "Time-Space Sequences," 1970, several frames of woman in same room; "Kitchen Series," ca.1975, women's torsos w signs tied to them in kitchen setting; Frame Series," 1974-75, women and picture frames; "Red Series," 1976-77, women in red cloth; "Cloth and Sticks Series," 1978, women w white gauze & wooden poles; "Cloud Series," 1974, women & clouds.

———. "Kim," 1981. Studio shot of woman in white hose, on knees, seen from the back, propped up against a posing-block, her legs splayed. DP; BL:162.

———. "Emilietta," 1981. Studio shot of woman dancer seated atop pedestal in slightly contortionist pose. AVK:145.

———. *In Camera: Zweiundachtzig Fotografien mit Zweiundfunfzig Frauen.* Schaffhausen: Verlag Photographie, 1982. Women on seamless posed according to their interpretation of the word "sensual". Masterful portfolio. Models from diverse professional backgrounds and ages: half were between 20 & 30 years old, but a third were 30 to 40 years old. Five were under 20. An English translation of Vogt's thoughts on why he enjoys working w women: "I find they are less disrupted in relation to their bodies and less abstract about their own sensuality than most men in our society."

———. *Christian Vogt. Photoedition 5.* Schaffhausen, Switzerland: Verlag Photographie, 1982.

———. Ten works in NEW from his *In Camera*: standing woman in heels, scarf wrapped around head (176); woman in blazer, seated on posing block pinching her nipples (175); standing woman frontal on posing block pulling down the top of her black dress (178); standing woman frontal, black shimmering dress, slits exposing her nipples, her face covered w black fringe-like material (179); standing woman frontal in heels, arms raised, pulling her hair up (180); woman on all fours (181); woman doing hand stand (182); standing woman right profile, wearing plexiglass billboard (183); supine woman in

134

garters & hose visible from chest down, on edge of posing block, knees bent, feet together (184); woman climbing into posing block (185).

———. "Bathroom Fantasy," series on women in a tiled setting suggestive of a shower room. Highly erotic. MEP.

———. Work from the series "Das Erträgliche und das Unerträgliche," 1986-88. Woman's torso with left arm extended, finger pointing at something. SEM:195.

———. Studio shot of optically distorted woman, 1986. CP:1082.

———. "Sai Kijima," 1987. Studio shot of leaping man. BTM:42.

———. *Catshadowhare*. Basle: Wiese, 1989. Nudes and portraits.

———. "Nude in Red." Color, 3/4 woman frontal, wrapped from waist up in red fabric. NN:175.

Voland, Henri. (19th C France) "Nu à demi allongé," 1861. Woman reclining in studio setting. LN:10.

Volkman, Roy. Several vibrant studio shots of dancing women appear in *Exquisite Creatures*. *See* Clyne (ed.) above.

Von Bulow, Heinz. (German) Color, grainy, a bit fuzzy, two women on airport runway, one standing, one crouching, with Boeing 747 taking off in background. *Photo* 291 (Jan/Feb 1992):47.

Von Mentlen, Sepp. Color photo of reclining woman on red background, head and lower legs out of frame. From series first published in the Swiss *Portfolio Photographie*. See *Photographis 87* (New York: Graphis U.S., 1987):123.

Voogdt, Herman de. Color, standing woman 3/4 behind window blinds smiling. *Photo* 257 (Feb 1989):78.

Vo Van Tao, Albert. *Photo* 288 (Oct 1991):72. Incl. 2 woman nudes in *charme* style.

Vuillaume, Jean-Manuel. *Déshabillez-Vous*. Paris: J.M.V. Diffusion, 1984.

———. *Liberté de Jouir*. Paris: Éditions Rares, [ca.1990].

Vuilliet, Laurence. Color, woman's torso frontal. *Photo* 257 (Feb 1989):79.

Voyeux, Martine. (French, 1948-) "Nu au chat," 1984. LN:61.

Waagenar, Sam. *Frauen von Rom*. Text by Alberto Moravia. Vienna: Albert Müller, 1961.

Wagner, Paul. Three color shots of woman cavorting on a beach. *Photo* 208 (Jan 1985):14-16.

Wahlberg, Arne. (Swedish 1905-) "Rythm," 1930. Brown tinted print of seated woman, right profile. In *The Frozen Image: Scandinavian Photography*. New York: Abbeville Press, 1982.

Walker, Mike. (US 1951-) Supine woman in grassy area. Taken on a farm near Lexington, KY. Yashica 6x6, 75mm, Tri-X, 1/500, f/22. *Camera* 51 (Sep 1972):11.

———. Woman standing against bedstead in front of window. *Camera* 53 (Sep 1974):20.

Walker, Todd. (US 1917-) Solarized print of reclining plump woman, 1969. CS:109.

———. *Portfolio Three*. N.p.: Walker, 1969.

———. Semi-abstract technique applied to woman's torso, 1970. CP:1088.

———. Solarized print of plump reclining woman. BWC:57.

———. Following works in NIP: solarized standing woman frontal, wearing mask (181); chest of supine woman in tall grass (214-15).

———. *Twentyseven Photographs*. N.p.: Walker, 1974.

———. *A Few Notes*. N.p.: Walker, 1976.

———. *For Nothing Changes*. N.p.: Walker, 1976.

—————. *The Edge of the Shadow.* Tuscon, AZ: Thumprint Press, 1977.

—————. *Nude Forms.* Rochester, NY: Focal Point, 1978. 26 slides & guide.

—————. *See: Photographs and Words.* [Tuscon, AZ?], 1978.

—————. *Todd Walker.* Carmel, CA: Friends of Photography, 1985. Incl. "Jacque," 1968: gum dichromate of standing woman w arms raised; "Pearl," 1969: Sabattier effect on print of plump woman seated on floor resting on left arm; "Nancy," 1968: gum dichromate, double exp. of standing women.

Wallace, Don. Woman supine visible from waist to head, black b.g. BB:39.

—————. Standing woman against black b.g., harsh lighting. BB:60.

Wallis, Frank. (US 1957-) "Infrared Nude," 1992. Woman from waist up behind sheet-covered porch railing, wearing sunglasses, very dark sky background. *Photo* No. 298 (Jan./Feb. 1993): 51.

Walters, Margaret. *Der Männliche Akt. Ideal und Verdrängung in der Europäischen Kunstgeschichte.* Berlin: Medusa, 1979.

Walters, Thomas. *Nudes of the '20s and '30s.* London: Academy Editions, 1976.

Wangenheim, Chris von. (German 1942-81) "The Girl Behind the Fence," ca.1978. Frontal standing portrait of fashion model Gia. [See her bio. below]. He maintained that photographing the whole woman was more erotic than just concentrating on body fragments. On Gia: "...the best tits in the business." For this shot, Nikon, Plus-X, two Balcar strobes, D-76. FT:161, 154-55.

—————. "The Woman with the Horse." Studio shot of kneeling woman on seamless paper, w horse to right. FT:162.

—————. "Girl Standing on Her Head." The woman is decked out in heels, hose, & elbow gloves, all black. FT:166.

Wangenheim, Wolfgang von. *Schwarz.* Frankfurt, Ger.: D. Fricke, 1977.

Warstat, Willi. (b. 1884) *Der Schöne Akt.* Berlin: G. Hackebeil, 1929; 1932. ["How to" manual] Incl. Josef Schuwerak, Orplik, G. Krull, August Schwoerer, E. Quedenfeldt.

Waxman, Donald. (US 1947-) Blurred motion, prone woman on bed, seen from foot of bed. *Camera* 52 (Jly 1973):25.

Webb, Tracy. Woman's rear torso supine on floor, w unique viewing angle. BB:54.

—————. Three works in HS: supine woman's head & chest; seated woman on velvet covered posing block; supine woman on lakeside boulder.

Weber, Bruce. (US 1946-) "George, Liz and Eric, upper Saramac Lake, 1983" Two young men and a young woman up to the waist in water near a log. SEM:109.

—————. "Un jeune homme à la mode ou un classique retrouvé." *Photo* 186 (Mar 1983):58-65. Incl. "Nathalie dans la maison de bois," 1982, supine woman on porch.

—————. "Bruce Weber." *Photo* 200 (May 1984):202-209. Incl. 3 woman nudes in forest.

—————. Goldberg, Vicki. "Weber's Ideal Man in the Eighties..." *Vogue* (Oct 1988):281.

—————. *Bruce Weber.* New York: Knopf, 1989.

—————. *Bear Pond.* New York: Bulfinch Press, 1990.

—————. *Bruce Weber.* [Ex. cat.] Los Angeles, CA: Fahey-Klein, 1991. Several man nudes.

Weber, Hans Jürgen. (ed.) *Kunst und Fotografie.* Hannover, Ger.: Lehning, 1953-55.

Weber, Lynne. (US) Color, supine woman's mid-section seen from above near pool. *Photo* 184 (Jan 1983):75.

Webert, Francis. (French) Standing woman, visible from shoulders down, seen in a mirror, jeans pulled down to the knees, cat in background. *Photo* No. 291 (Jan./Feb. 1992):59.

Wedewardt, Heinz. (German 1928-) Woman side view, leaning out window, p. 16; woman standing next to open window, seen from head to upper highs, p. 31. *Camera* 50 (Sep 1971).

————. Breasts and crossed arms (12); seated woman among boulders and rocky cliff-face (38). *Camera* 53 (Sep 1974).

————. *Aktfotografie: Gestaltung, Technic, Spezialeffekte.* Neiderhausen, GEr.: Falken, 1984. ["How to" manual]

Wedge, James. *James Wedge.* London: Countdown Productions, 1972.

Weegee [Arthur Fellig]. (US 1899-1968) "Morning After," 1950. Distorted double image of crouching woman w/out head. DP.

————. Seated woman with veiled face, 1955. BL:136.

Weicherding, Alain. (French) Seated woman in opened shirt-dress, on beach. *Photo* No. 291 (Jan./Feb. 1992):58.

Weidemann, Magnus. *Kunstgabe 4.* Dresden, Ger.: Verlag d. Schönheit, 1921.

————. *Sonnenleben.* Kropp-Meilberg: O. Koepke, 1950.

————. Wulf, Jürgen. *Schönheit und Freude: Magnus Weidmann als Akt-photograph.* Kiel, Ger.: Schmidt und Klaunig, 1986. Diffuse woman nudes from 1920s, usually w a nature theme. Poorly produced, yet incl. many works inaccessible to non-German researchers.

Weiermair, Peter. (ed.) *Frauen sehen Männer: die Darstellung des männlichen Aktes durch zeitgenössiche Fotografinnen.* Shaffhausen: Verlag Photographie, 1988.

————. (ed.) Trans. Claus Nielander. *The Hidden Image: Photographs of the Male Nude in the Nineteenth and Twentieth Centuries.* Cambridge, MA: M.I.T. Press, 1988.

————. (ed.) *George Platt Lynes.* Berlin: Bruno Gmünder, 1989. Male nudes.

————. (ed.) *Die Sammlung E.J.* Aachen, Ger.: Rimbaud, 1990.

Weinberg, Carol. Standing man in dance studio photographing Weinberg, who is photographing the man. YK:100.

Weininger, Karl. *Spielarten des Weibes.* Leipzig, Ger.: Parthenon, 1928. 48 photos.

Weir, Thomas. Supine woman, spread-eagle on grass, circular frame, 1967. BWC:43.

Weiß, Walther. *Natur und Akt.* Dresden, Ger.: Verlag d. Schönheit, 1928. 60 woman nudes.

Weller, Freddy. *Anette.* Berlin: Druck, 1970.

Welpott, Jack. (US 1923-) Woman's arm and back behind insect screen. [hardly a nude] *Camera* 50 (Sep 1971):26.

————. "Sabine," 1973. Beautiful young woman in seated portrait. LN:46.

————. Four works in *Camera* 54 (May 1975):33, series on women in their rooms. Incl. seated black woman; topless woman sitting behind table and chairs in foreground; topless woman sitting near window; kneeling woman with long dark hair, on pillow in corner of room, in front of sheet draped windows. *See also* Dater, Judy and Welpott, Jack.

————. "65 Avenue de la Bourdonnais," 1983. Apartment w open bedroom door, exposing woman's butt. on bed. NN:159.

Wenner, Tom. (German 1951-) Standing woman against wall, viewed from shoulders down; electric fan in lower right corner. Pentax Spotmatic, Tri-X. *Camera* 60 (Sep 1981):26.

Wessel, Henry Jr. (US 1942-) "California," 1975. CS.

Weston, Edward. (US 1886-1958) "Nude," 1920. Frontal view of breast. DP.

———. "The Breast," 1921. LK image of woman's chest, w lined shadows cast upon it. *Photography in New York* 3 (Sep/Oct 1990).

———. "Nude in Old Adobe," 1937. Supine woman on blanket, adobe fireplace in b.g. amid outdoor setting. *Photography in New York* 5 (Sep/Oct 1992):n.p.

———. Series of 9 familiar classic Weston nudes. PL:72-85.

———. *Desnudos, 1920-1945.* Printed by Cole Weston. N.p., 1972. 11 plates.

———. Classic Weston nudes. NIP:19, 66-67, 70, 71.

———. *Edward Weston Nudes.* New York: Aperture, 1977.

———. Stebbins, Theodore E. (ed.) *Weston's Westons: Portraits and Nudes.* [Ex. cat.] Boston: Museum of Fine Arts, 1989.

White, Clarence H. (1871-1925) "Nude." IPM.

———. "Nude," 1907. Classically inspired diffuse image of standing woman w flower vase. NN:15.

———. Woman & her reflection in round mirror in floor, 1909. DP.

———. "Nude with Baby," 1912. Gum print. CS; LN:25.

White, Clarence H. and Stieglitz, Alfred. "Torso." (from *Camera Work* 26 [1909]). NN:67; *Photography in New York* 1 (May/Jun 1989):32.

———. Crouching woman seen from behind, ca.1900. CS:37.

———. Woman seated on edge of bed, 1907. CS:33.

———. Classically posed standing woman w small mirror in left hand, 1907. CS:39.

White, Jerry. *Beauty Photography.* New York: MACO, 1964. ["How to" manual]

White, Minor. (US 1908-1976) "Male Nude," 1940. Rear view of torso. CS:99.

———. "Nude Foot," 1987. Prone man's butt. & left foot. BTM:46.

———. Image from ser. "Temptation of St. Anthony," 1948. Frontal man's torso, w presumed center of attention on penis. CS:100.

———. Male nudes in HP.

———. *Be-ing Without Clothes.* [Catalog of exhibition sponsored by Massachusetts Institute of Technology, Nov. 1970. Also pub. as *Aperture* 15 (1970.] New York: Aperture, 1970. Incl. Stan Blanchard, Irene Strauss, E. Gowin, James Mozingo, Charles Renfrow, Goodwin Harding, Richard Wynn, Gary Cox, Barbara Morgan, John Brook, Jack Stuler, Barbara Crane, Judy Dater, Norman Lerner, James Powell, Wayne Soverns, Ralph Eugene Meatyard, Merg Ross, James Sahlstrand, Les Krims, Arthur Sawyers, Brian M. Katz, Thomas Weir, Joseph Jachna, Arthur Freed, James Marchael, Paul Wigger, Linda Connor, Sandy Hochhausen, Charles Swedlund, Herbert Hamilton, Todd Walker, Christine Enos, Richard Baldinger, A. Dutton, Edmund Teske, Arnold Doren. *See individual entries.*

Whiteman, Richard. "Nude." Seated woman, right arm raised; transluscent material f.g. *AAP* 56 (1942):89.

Wickrath, Claus. *Claus Wickrath: Flowerskin.* Köln, Ger.: Benedikt Taschen Verlag, 1992. Erotic shots with dried and fresh flowers. Unpaged.

Wiehr, Bruno. *Der Männliche Körper in Linien und Licht.* Düsseldorf, Ger.: Lichtkampf-Verlag, 1922. 30 nature nudes.

Wigger, Paul. Prone woman f.g., standing woman b.g. BWC:49

Wilbur, Lawrence. "Elation." Right profile of standing woman who seems to be caught in band of black cloth. *AAP* 52 (1938):130.

Wild, Victor. *How to Take & Sell Erotic Photographs: Secrets of the Masters.* Carpenteria, CA: Wildfire Publishing, 1981.

Wildbolz, Jost. (Austrian 1937-) Color, woman on all-fours placed on a mirror, 1979. A:265.

————. *Jost Wildbolz. Photoedition 1.* Schaffhausen, Switzerland: Verlag Photographie, 1979.

Wilding, Dorothy. (US) "Come Play With Me," 1928. Standing woman with white ball. BL:104.

————. "Silver Turban," 1928. Seated woman w silver turban. USII:99.

————. Seated woman wearing turban; retouched glamour shot, ca.1930. NE:99.

Wilke, Hermann. *Dein "Ja" zum Leibe.* Berlin: Dt. Leibeszucht, 1939; 1940.

Wilkemann, R.E. *Das System zu Zweien.* Braunschweig, Ger.: Westermann, 1926.

Williams, David Jordan. (US 1951-) Standing woman in grassy field, 1973. Minolta, 21mm, Tri-X (ASA 800). Infrared effect achieved with print bleaching. *Camera* 54 (Sep 1975):21.

Williams, Kathleen. (US 1947-) "Water Nude." Self portrait stretched out on rock amid rapids-type stream. Pentax, 28mm, Tri-X. *Camera* 51 (Sep 1972):8.

————. "Diffused Nude." Self portrait, face and torso (in apparent body stocking). Ibid (30).

Willinger, Lazlo. Three works in HS: slightly oiled seated woman w vacant stare; woman's torso similar in skin tone to previous image; supine woman, seen from waist up, positioned vertically in frame.

Wilman, G. Color, woman seated on bow of blue rowboat on beach. *Photo* 291 (Jan./Feb. 1992):50.

Wilms, Günter. (ed.) *Fotoaustellung Akt und Landschaft.* [Catalog for exhibition of the Klub der Künstler, Kulturbund der DDR, 2–31 May 1982] Potsdam, Ger., 1982.

Wilson, Robert. (US 1936-) Four studio shots of women. PL:206-210.

Wilson, Woodrow. "Burma Girl." Left profile of young woman's chest & face: she wears a Chinese straw hat. *AAP* 56 (1942):129.

Windmann Studios, New York. (ca.1930s) HK solarized print of kneeling woman. BB:8.

————. HK solarized print of standing woman on pedestal. BB:9.

————. Kneeling woman against black b.g., thighs & torso perpendicular to the floor, head back, long blond hair highlighted. BB:19.

Winquist, Rolf (Swedish 1930-) "Three." Sculptor, sculpture, model (woman standing rear view on posing block). *AAP* 62 (1948):126.

————. Studio shot, pensive woman seated on stick chair, head resting on left hand, left elbow resting on left knee. N.

————. Smiling supine woman, arms raised vertically. N.

————. Woman resting in sleeping pose on cloth-covered floor. N.

————. Pensive woman's profile, seated in studio. N.

Winther, Fritz. *Körperbildung als Kunst und Pflicht.* Munich: Delphinverlag, 1914; 1919.

Winther, Fritz and Winther Hanna. *Körperbildung als Kunst und Pflicht.* 1920; 1923. Incl. Hugo Erfurth, Hanns Hold, Franz Granier.

Wlassics, Olga. Seated woman w classic Hollywood makeup in tilted shot, 1945. BL:123.

Wobbe, Harve B. "The Goddess of the Flame." Kneeling woman in left profile proffers a bowl of flames. *AAP* 49 (1935):133.

Wog. [Adorian & Olga Wlassics] *Mappe 1. Der Akt. Eine Synfonie in Licht und Schatten.* Berlin: Arnold, 1941. *See also* Manassé.

Wohlauer, Ronald W. (US 1947-) White marble-toned woman reclining supine with knees bent, head out of frame. Cold-light print. *Camera* 54 (Sep 1975):9.

Wolff, Ilan. (Israeli 1955-) "New York Nude," 1987. Fuzzy pubic mound and belly with tenement tops in background. SEM:89.

———. Two outdoor reclining female nudes taken with pinhole camera. See *Mois de la Photo a Paris*. Paris: Audiovisuel, 1984:(166-67).

Wolman, Baron. *Profiles*. Mill Valley, CA: Squarebooks, 1974. 44 plates.

Wong, K.F. *Nus de Bornéo*. Paris: Éditions Prisma, 1966.

Woodman, Francesca. (US 1958-81) Valtorta, Roberta. "Francesca Woodman." *Progresso Fotografico* 77 (Oct 1979):46-50.

———. Haus, Mary Ellen. "Francesca Woodman." *Art News* 85 (Apr 1986):168.

———. Kenny, Lorraine. "Problem Sets: The Canonization of Francesca Woodman." *Afterimage* 14 (Nov 1986):4.

———. Antomarini, Brunella. "Francesca Woodman." *Parkett* 15 (Jan 1988):98-107.

———. *Francesca Woodman: Photographic Work.* Wellesley, MA: Wellesley College, 1989. Incl. nude self-portraits.

———. *Francesca Woodman.* Zürich: Shedhalle, 1992. Many nudes of herself incl. "Rome" series, 1977-78 (27, 57-59); "Eel Series," 1977-78 (89, 91); "On Being an Angel" series, 1977 (77, 79); "From Three Kinds of Melon in Four Kinds of Light," 1975-76 (88). Compare the last photograph w similar work by Kathleen King (1991) above.

Woolf, Paul J. Two works in HS: seated woman on studio floor; woman's torso frontal.

Woolley, A.E. *35mm Nudes*. New York: Amphoto, 1966.

Wortley, R. *Striptease: A Pictorial History of 100 Years of Undressing to Music*. London, 1976.

Wright, T.C. Woman reclining on sand dune. HS.

Wu, Francis and Wu, Daisy. *Chinese Beauties through the Camera Lens of Francis and Daisy Wu.* Hong Kong: M.S. Woo Service, 1970. 128 plates.

Wu, Sam. *Hollywood Figure Studies*. Greenwhich, CT: Whitestone, 1967.

Wyndham, Albert. Pearshaped standing woman with stockings, black hat and mask, ca.1900. BL:46.

Wynn, Richard. Multi-exp. of man & woman reaching out to each other over figure of supine woman, 1970. BWC:17.

Yagi, Yasuhiro. *Yojo Majo Bijo*. 1970.

Yasuzo, Nojima. (Japanese 1889-1964) Three woman nudes from 1931. *Photo* 278 (Oct 1990):100.

Yato, Tamotsu. *Otoko: Photo-studies of the Young Japanese Male*. Los Angeles: Rho-Delta Press, 1972.

Yeager, Bunny. (US 1929-) *The Art of Glamour Photography*. Philadelphia: Chilton, 1962.

———. *How to Take Figure Photos*. Louisville, KY: Whitestone, 1962. ["How to" manual]

———. *Photo Studies*. Louisville, KY: Whitestone, 1962.

———. *How I Photograph Nudes*. New York: Barnes, 1963. ["How to" manual] Incl. numerous female nudes, & at least three shots of Betty Page (see bio. below).

 On the question of which sex takes better nudes of women: "This battle between the sexes eludes me. The only thing a woman can take credit for doing better than a man is bearing children."(20) On the model: her waist should be at least ten inches smaller than either hips or bust; Yeager preferred models w breasts of C cup size and

no sags.(12) Unique observation: blondes find it more difficult to keep their eyes open in bright sunlight than do brunettes.(99) She favored 8x10 format for studio, Rolleiflex for location; favored Tri-X. (20, 103)

————. *ABC's of Figure Photography*. Edited by Adolphe Barreaux. Louisville, KY: Whitestone, 1964. ["How to" manual]

————. *How I Photograph Myself*. New York: A.S. Barnes, 1964.

————. *Drawing the Human Figure Using Photography*. New York: A.S. Barnes, 1965.

————. *100 Girls: New Concepts in Glamour Photography*. South Brunswick, NJ: A.S. Barnes, 1965.

————. *Camera in Mexico*. Greenwich, CT: Whitestone, 1967.

————. *Camera in Jamaica*. South Brunswick, NJ: A.S. Barnes, 1967.

————. Cohen, Barney. "Innocent Fascination." *American Photographer* 19 (Jul 1987):44. Focus on Yeager as "cheesecake" photographer of 1950s.

Yerbury, F.R. "Two Brothers at Play," 1918. Boy & young man in standing semi-wrestling pose. The latter's genitals have been retouched completely off. BTM:22.

Yokosuka, Noriaki. (Japanese 1937-) *Shafts*. N.p.: Chuo Koron-sha, 1972.

Yoshioka, Yasuhiro. *Yasuhiro Yoshioka Sakuhin Shu*. Tokyo, 1962. Series of very high contrast fragment nudes, featuring men & women models: an additional contrast is apparent between the smooth skin of the women and the hairy muscularity of the men.

Younger, Cheryl. "Summertime," 1989. HK shot of standing woman w horse; we see only the animal's legs & woman from shoulders down. NEW:197.

Zachmann, Patrick. (French 1955-) "Prostituées dans la banlieue de Naples, juin 1982" Four prostitutes topless at night; they might be transexuals. SEM:155.

Zadeh, D. Zaman. (ed.) *The Nude in Painting and Photography*. Montreal, Canada: Promotion Institute, 1989.

Zálesák, Zdenek. *See* Sirucek, Vladimir.

Zaloma, J.I. (Spanish) Flower between woman's breasts. *Photo* No. 291 (Jan./Feb. 1992):54.

Zambelli, R. Overhead shot of woman in white hose, reclining on white carpet, feet closest to camera, cat in f.g. *Photo* 268 (Jan 1990):117.

Zeemeijer, Peter. *Creative Nude Photography*. Watford, England: Fountain Press, 1979. ["How to" manual]

Zeidler, Hans. *Sommer mit Andrea*. Stuttgart, Ger.: Günther, 1967.

Zglinicki, Friedrich Pruss von. (German 1895-) *Sex im Bild. Intime Fotos Schöner Frauen*. Konstanz: Exakt-Verlag, 1967.

Zielke, Willy. (Polish 1902-) Supine woman on floor w cactus plant beside her casting a strong shadow on her chest from light source out of frame, at left. DP.

————. "The Cross" (From *La Beauté de la Femme* [1933]). 3/4 standing woman w window's lattice shadow forming a cross pattern upon her chest. NN:118.

————. "Forward." Pictorialist work of standing woman frontal w an Elk hound on either side. *AAP* 47 (1933):95.

Ziolkowski, Joe. *Walking the Line*. Berlin: Bruno Gmünder, 1992.

Zirah, Alain. (French) Color, woman's front torso with some sort of painting (or tattoo) on her left front. *Photo* 298 (Jan./Feb. 1993):52.

Ziuzic, Dusan. (Yugo.) Color, woman standing against tree. *Photo* 291 (Jan/Feb 1992):52.

Zora, Peter. (Czech 1923-) Woman's torso, LK b.g. AA:34.

II. THE PHOTOGRAPHER'S MODEL

Babitz, Eve. "I Was a Naked Pawn for Art." *Esquire* 116 (Sep 1991):164-68. Los Angeles art scene of the 1960s recounted by the author, who posed nude while playing chess with Marcel Duchamp.

Basinger, Kim. (US 1954-) *Playboy* (Feb 1983). Color series & bio. text on a rising film star.

Borges, Cibella. "Nude Model Gets Job Back with NYC Police." *Jet* 68 (April 1985):24. Report on Cibella Borges, who recently won the right to her old job (and $70,000 in back pay) after she was fired as a New York city police officer, because she had posed nude for a magazine, even though the photographs had been taken before she became an officer.

Carangi, Gia Marie. *See* Gia.

Dickinson, Janice. "Janice Dickinson. Vue par le Grands Photographes." *Photo* 189 (June 1983):48-71. Color shots of this very beautiful fashion model by Scavullo, Mike Reinhardt, Stan Malinowski, Art Kane, Pierre Houlès, J.–P. Goude, Mellon. *See also entry in section I.*

Gia. [Gia Marie Carangi] (US 1960-86) Fried, Stephen. *Thing of Beauty: the Tragedy of Supermodel Gia Carangi.* New York: Pocket Books, 1993.

Gracen, Elizabeth Ward. [*née* Elizabeth Ward] (US 1961-) Zeman, N. and Howard, L. "Strip Tease." *Newsweek* (6 April 1992):8. Report of former Miss America for 1982, Elizabeth Ward posing nude for the May issue of *Playboy*. Her possible relationship with presidential candidate Bill Clinton raised.

———. "There She Is." *Playboy* (May 1992):70. Article about her personal & professional development; incl. 12 color and B&W nudes.

Hemingway, Mariel. "Star 80." *Photo* 197 (Feb 1984):20-35. Outtakes from the movie of the same name, featuring actress Hemingway semi-nude.

Lords, Traci. (US 1969-) Svetkey, Benjamin. "Traci Goes Straight." *Rolling Stone* (16 June 1988):46. Ex-*Penthouse* centerfold model and then ex-porn star Traci Lords attempts a "legitimate" career in "Not of This Earth", a B film remake of another sci-fi/horror B film by Roger Corman (1957). A scandal surrounded Lords in 1986 when it became known that all of her approximately one hundred movies had been made when she was under 18. Lords has also appeared in the TV series "Wiseguys".

———. "Lord's Prayer." *Film Comment* 25 (Jul/Aug 1989):2. Recounts scandal story of Traci Lords and notes her recent role in John Waters's film "Cry Baby," a musical about the birth of rock and roll.

———. Jordan, Pat. "Traci Lords with Her Clothes On." *Gentlemen's Quarterly* 60 (April 1990):250. Comment on career of Traci Lords and her role in "Cry Baby."

Lyon, Lisa. *See* Mapplethorpe, Robert. *Lady Lisa Lyon.*

McCullough, Julie. Kaufman, D. *et al.* "'Growing Pains' Julie McCullough Tries to Bury Her Bare All Past." *People* (30 Nov 1988):57. Reports on the 24 year old actress who posed nude for *Playboy* in 1985.

Madonna [Madonna Ciccone] (US 1958-) "Madonna." *Newsweek* (22 July 1985):83. Reports publishing event of both *Playboy* and *Penthouse* magazines featuring Madonna in the nude in pictorials based on photographs made when she was a nude model in New York in the late 1970s (when she posed for Lee Friedlander & Martin Schreiber).

————. Phillips, Lynn. "Who's that Girl?" [Madonna] *American Film* 12 (July/August 1987):20-24.

————. Hoberman, J. "Believe it or Not." [Madonna] *Artforum* 26 (March 1988):16.

————. Brown, Jane D. and Schulze, Laurie. "The effects of race, gender, and fandom on audience interpretation of Madonna's music videos." *Journal of Communication* 40 (Spring 1990):88.

————. Johnson, Brian D. "Spanking new Madonna: a mega-star fights her way to the top." *Maclean's* 103 (18 June 1990):48.

————. Johnson, Bradley. "Madonna scores in L.A. bus shelters." (fans steal posters) *Advertising Age* 61 (18 June 1990):12.

————. Sante, Luc. "Unlike a virgin: Madonna, minx without a riddle." *The New Republic* (20 August 1990):25.

————. Schifrin, Matthew and Newcomb, Peter. "A brain for sin and a bod for business." *Forbes* 146 (1 Oct 1990):162.

————. "Madonna: image of the eighties. Herb Ritts and Paul Evans." *Rolling Stone* (15 Nov 1990):92.

————. Cocks, Jay. "Madonna draws a line: after MTV rejects her latest video, the Material Girl launches a program of self-defense and self-promotion." *Time* 136 (17 Dec 1990):74.

————. Evans, Greg. "Madonna video may 'Justify' controversy as selling Point." *Variety* (17 Dec 1990):57.

————. Miller, Jane. "Madonna." *Ploughshares* 17 (Winter 1991):221.

————. "A justified decision?" (MTV's refusal to air Madonna's video "Justify My Love") *The Advocate* (1 Jan 1991):72.

————. "Truth or Dare: In Bed with Madonna." *Variety* (6 May 1991):335.

————. Corliss, Richard. "Who does Madonna wanna be? In her new movie ["Truth or Dare"], the answer is superstar and den mother." *Time* 137 (6 May 1991):62.

————. Shewey, Don. "Madonna: the saint, the slut, the sensation...." *The Advocate* (7 May 1991):42.

————. Johnson, Brian D. "Madonna; the world's hottest star speaks her mind." ["Truth or Dare"] *Maclean's* 104 (13 May 1991):44.

————. Dayle, Kevin. "A sexy symbol talks back." [Madonna] *Maclean's* 104 (13 May 1991):2.

————. Magiera, Marcy. "Madonna bares all; but Miramax is modest about movie." [Truth or Dare] *Advertising Age* 62 (13 May 1991):4.

————. Arrington, Carl. "Madonna in bloom: Circe at her loom: roll over, Ulysses, she's at it again: winking, beckoning, scandalizing with her new film 'Truth or Dare,' and making one or two points on the way." *Time* 137 (20 May 1991):56.

————. Denby, David. "Madonna: Truth or Dare." *New York* 24 (20 May 1991):58.

————. Shewey, Don. "The Gospel According to St. Madonna." *The Advocate* (21 May 1991):40.

————. Kauffmann, Stanley."Truth or Dare." *New Republic* (10 June 1991):26.

————. Fisher, Carrie. "True confessions: the Rolling Stone interview with Madonna; part one." *Rolling Stone* (13 June 1991):35.

————. Fisher, Carrie. "True confessions: the Rolling Stone interview with Madonna; part two." *Rolling Stone* (27 June 1991):45.

————. Buck, Joan Juliet. "Truth or Dare." [Madonna] *Vogue* 181 (July 1991):73.

————. Talvacchia, Kathleen. "Truth or Dare." [Madonna] *Christianity and Crisis* 51 (15 July 1991):232.

————. Halasa, Malu. "Marketing Miss Thing: on the money behind Madonna's move from pop nymphet to gay diva." *New Statesman & Society* 4 (19 July 1991):30.

————. "Truth or Dare." [Madonna] *The Economist* (27 July 1991):82.

————. Franke, Lizzie. "In Bed with Madonna." *Sight and Sound* 1 (August 1991):43.

————. Simon, John. "Truth or Dare." *National Review* 43 (12 August 1991):34.

————. Sobran, Joseph. "Single sex and the girl: meet Madonna, scourge of the Pharisees, defender of artistic integrity, exposer of Christian uncharity." *National Review* 43 (12 August 1991):32.

————. Kalin, Tom. "Media kids." (pop singer Madonna and her sexually explicit videos) *Artforum* 30 (Sept 1991):19.

————. Andersen, Christopher. "Madonna rising: the wild and funky early years in New York." (excerpt from book *Madonna: Unauthorized*) *New York* 24 (24 Oct 1991):40.

————. Rothenberg, Robert S. "Madonna: Truth or Dare." *USA Today Magazine* (Nov 1991):97.

————. Schwichtenberg, Cathy. "Madonna's postmodern feminism: bringing the margins to the center." *Southern Communication Journal* 57 (Wntr 1992):120.

————. Harris, Daniel. "Blonde ambitions: the rise of Madonna studies." *Harper's Magazine* 285 (August 1992):30.

————. France, David. "Was it good for you, too?" [Madonna] *Esquire* 118 (Sept 1992):103.

————. Carpenter, Teresa. "Madonna's doctor of spin." (publicity manager Liz Rosenberg) *New York Times* (13 Sept 1992):H45.

————. Taylor, Sally and Baker, John F. "Madonna's 'Sex' too hot for Japanese publisher." (publisher Haruki Kadokawa has withdrawn from a contract with Warner Books to publish Madonna's book 'Sex' in Japan) *Publishers Weekly* (14 Sept 1992):12.

————. Tippens, Elizabeth. "Mastering Madonna." *Rolling Stone* (17 Sept 1992):89.

————. *Sex*. New York: Time-Warner, 1992. Biggest selling book on photography of the nude, features the pop singer in a series of nudes based on the theme of eroticism.

————. Handelman, David. "Madonna's head trip." *Vogue* 182 (Oct 1992):288.

————. Holden, Stephen. "Selling sex and (oh, yes) a record." [Madonna] *New York Times* (18 Oct 1992):H27.

————. Fein, Esther B. "On Madonna." [*Sex* review] *New York Times* (21 Oct 1992):C20.

————. Kakutani, Michiko. "Sex." *New York Times* (21 Oct 1992):B2; C21.

————. King, Chris Savage. "Sex." *New Statesman & Society* 5 (23 Oct 1992):33.

———. Kane, Pat. "Justify her love." [Madonna] *New Statesman & Society* 5 (23 Oct 1992):33.

———. Goldberg, Vicki. "Sex." *New York Times* (25 Oct 1992):H33.

———. James, Caryn. "Sex." *New York Times Book Review* (25 Oct 1992):7.

———. Max, D.T. "*Sex* is the latest lode in Madonna's gold mine." *Variety* (26 Oct 1992):84.

———. Tomkins, Calvin. "Sex." *The New Yorker* 68 (26 Oct 1992):38.

———. "Sex." *Time* 140 (2 Nov 1992):75.

———. Ansen, David. "Talking with Madonna: the unbridled truth." *Newsweek* 120 (Nov 1992):102.

———. Tsiantar, Dody and Hammer, Joshua. "Risque business at Time Warner." [Madonna] *Newsweek* 120 (2 Nov 1992):101.

———. Leland, John. "Sex." *Newsweek* 120 (2 Nov 1992):94.

———. Stevens, Mark. "After Sex: Madonna's next move." *The New Republic* 207 (9 Nov 1992):20.

———. Resnikova, Eva. "Sex." *National Review* 44 (30 Nov 1992):57.

———. Knoll, Erwin. "Sex for sale." (R.R. Donnelly and Sons Co. publishes Madonna but not gay-themed books) *The Progressive* 56 (Dec 1992):4.

———. Malanowski, Jamie. "Madonna: the next fifty years." *Esquire* 18 (Dec 1992):170.

———. "Sex." *Rolling Stone* (10 Dec 1992):87.

———. Wypijewski, JoAnn. "Sex." *The Nation* (14 Dec 1992):744.

———. Bergman-Carton, Janis. "Like an artist." (relationship of Madonna and artist Frida Kahlo) *Art in America* 81 (Jan 1993):35.

———. Hamill, Pete. "Mantrack." *Playboy* 40 (Apr 1993):32. Comment on her erotic adventures; one photo of Madonna hitching a ride in the nude.

Marshe, Surrey. (b. 1947) *The Girl in the Centerfold.* New York: Delacorte Press, 1969.

Page, Betty. (US 1923-) Nine nudes of this most popular pinup model of the 1950s, in Buck Henry, "The Betty Boom." *Playboy* (Dec 1992):122. Article traces her career.

Phillips, Michelle. "La Belle Michelle." *GQ* 61 (Nov 1991):? Former singer with the Mamas and Papas and now 47 year old actress on "Knots Landing" poses in a nude layout.

Rogers, Mimi. "Screaming Mimi." *Playboy* (Mar 1993):70. The successful actress posed for several color & B&W nudes, shot by Michel Comte.

Smith, Anna Nicole. [Vickie] (US 1967-) "Playmate of the Year." *Playboy* (Jun 1993):130. Model for national Guess Jeans ad campaign, & former centerfold model (May 1992); incl. several color nudes.

Stinger, Maria. *Guide for the Amateur Photographer's Model.* Philadelphia: Chilton, 1963.

Shirley, Isabel. *How to Pose for the Camera.* New York: APBPC, 1965.

Tula. [Barry Cossey] (UK) "The Transformation of Tula." *Playboy* (Sep 1991):102. Article on the transsexual fashion model; incl. 1 color nude, frontal 3/4.

Weigel, Terri. (US 1962-) "Albert's Bosom Buddy." *People* 36 (18 Nov 1991):151. Tabloid TV show "Hard Copy" paid former *Playboy* model Terri Weigel to tell about her relationship with Prince Albert of Monaco. Ms. Weigel now performs in adult videos, and has been formally cut off from any professional relationship with Playboy, Inc.

Williams, Vanessa. "Miss America Loses Title." *Newsweek* (30 July 1984):85. Reports the 21 year old Vanessa Williams, the first black pageant winner, is also the first to abdicate, due to the publication in *Penthouse* of nude photographs of her and another woman.

MISCELLANEOUS

Gardner, R. Jr. "Making Nudity Pay: Models Who Take it All Off." *Cosmopolitan* 200 (Dec 1990):212. Recounts the experiences of several women who posed nude for photographers.

Dougherty, Steve. "Women Peel for Quiet *Playboy* Photog David Chan..." *People* 29 (7 March 1988):121. Best known for his all-American coed pictorials for *Playboy*, the past twenty years of his on-going assignment has seen controversy. Some feminist groups protest that Chan exploits women.

Helgesen, Sally. "Why Would a Woman Peel Off Her Clothes and Pose Nude for Playboy? Three Women Tell Their Story." *Glamour* 85 (June 1987):218-19. Reactions of three college women who posed, one of whom would decline the offer if made again.

Meisler, Andy. "It's a Good Nudes, Bad Nudes Game." *TV Guide* 37 (26 Aug 1989):16-18. About actresses who pose for *Playboy*, hoping for a career boost, which many say has not happened.

III. RELATED ARTICLES

Adler, Warwick. "Photography and Eroticism." *Art and Australia* 30 (Spring 1992):96-07.

Bonfante, Larissa. "Nudity as a Costume in Classical Art." *American Journal of Archaeology* 93 (Oct 1989):543-70.

Crumley, B. "Eurocom Bares Logic Behind its Nude Ad." *Advertising Age* 82 (7 Jan 1991):38. Some think it too "racy" while others view it as humorous.

Davis, Douglas. "The Return of the Nude." *Newsweek* 108 (1 Sep 1986):78-79.

Decker-Heftler, Sylvaine de. "Étude: Le Nu en France au XIXe Siècle." *Photographies* 6 (1984):50. On the tension between art & eroticism in 19th century photography of the nude.

DeGrazia, Edward. "The Big Chill: Censorship and the Law." *Aperture* (Fall 1990):50.

Dyer, Richard. "The Right to Look." *New Statesman and Society* 2 (9 June 1989):31-34. Man nudes.

Fields, H. "Court to Rule on Early Enforcement of Child Obscenity Act." *Publishers Weekly* (12 May 1989):109. Update on Congressional hearings on federal law forcing all booksellers and publishers to keep records of the ages of anyone appearing nude in one of their publications. [Child Protection and Obscenity Enforcement Act of 1988]

Finch, Casey. "Two of a Kind." *Artforum* 30 (Feb 1992):91-95. Links Victorian porn and photography of the nude.

Fleig, A. "Le Nu dans les Années 30." *Contretype* (Brussels) 6 (1986):4. Contends a revolution in style took place in photography of the nude during the 1930s.

Foster, A. "The Male Nude in Photography." *The Photographic Collector* 3 (1985):331. Asserts that the male nude signifies weakness, and is thus unacceptable to men; the nude woman signifies vulnerability, a trait which women are trained to accept.

Goldin, N. "Body is a 4 Letter Word." *Art Journal* 50 (Winter 1991):8.

Heirogliphica, Monas. "L'Africa di ieri." *Progresso Fotografico* 9 (1980):62. Before 1918, bourgeois Europeans took pleasure in photographing the semi-nude women of Africa.

Julius, Muriel. "No Nudes is Good Nudes: A Retrospective View." *Contemporary Review* 255 (Sep 1989):158-60.

Kalmus, Yvonne. "Nude Between the Covers: a Survey of Recent Publications." *Popular Photography* 90 (Jun 1983):103.

Kardish, Laurence. "Afterimages." *The Georgia Review* 43 (Spring 1989):93-112. Photography of the nude.

La Balme, Corinne. "Liberté, Egalité, and Nudité." *American Photographer* 20 (May 1988):76. On French Socialist Party's billboard ad campaign featuring men, women, & children nude.

Laiken, Deidre S. "The Boys in the Buff." *Mademoiselle* 90 (Dec 1984):138-39. Advocates buying *Playgirl* so she can be the judge and not be judged.

Larsen, E. "Yes, We Have No Bananas." *Utne Reader* (Mar/Apr 1992):44. Criticism of society which permits depiction of womens' breasts in photography, but declines to show mens' penises.

Munsterberg, Marjorie. "Naked or Nude? A Battle Among French Critics of the Mid-Nineteenth Century." *Arts Magazine* 62 (Apr 1988):40-47. About paintings, but relevant to current debate on "correct" view of the nude in photography.

Muschamp, Herbert. "Don't Look Now." *Vogue* 181 (Feb 1991):318-23. Censorship.

Nead, Lynda. "The Female Nude: Pornography, Art, and Sexuality." *Signs* 15 (Winter 1990):325-35.

O'Brien, Glenn. "Like Art." *Artforum* 27 (Apr 1989):17-18. Perfume advertisements and photography of the nude.

Pelly, S. "Erotisme et Pictorialisme." *Zoom* 109 (1984):83. Autochrome nudes by P. Bergon, Charles Adrien, G. Balagny, Léon Gimpel.

Romer, G.B. "Die erotische Daguerreotypie." *Photo-Antiquaria* 1 (1989):19.

Samaras, Connie. "Look Who's Talking." *Artforum* 30 (Nov 1991):102-107. Censorship.

Schneeman, Carolee. "The Obscene Body/Politic." *Art Journal* 50 (Winter 1991):28-36.

Scully, Julia. "Seeing Pictures." *Modern Photography* 6 (1981):22. Review article on C. Sullivan's *Nude Photographs*.

Smith, Liz. "Naked Men." *McCall's* 109 (June 1992):98. Comment on why men do not appear nude in films.

Solomon-Godeau, Abigael. "Reconsidérer la photographie érotique." *La Recherche Photographique* 5 (1988):6. Urges consideration of erotic photos as cultural artifacts.

Stanley, L.A. "Art and 'Perversion'." *Art Journal* (Winter 1991):20. Discussion of children and photographic imagery of a controversial nature: cites cases of Sturges, Mapplethorpe, and Walter Chappell.

Steel, J. "The Stereoscope and Collecting Stereocards. Pt.3." *The Photographic Collector* 1 (1981):54. Stereo Nudes.

Steele, Valerie. "Erotic Allure." *Aperture* 122 (Winter 1991):81-101.

Wissembourg, Caroline. "La Collection Bourgeron." *Zoom* 152 (1989):86. Collection of naughty postcards.

Zeman, N. and Howard L. "Phone Book Sex." *Newsweek* (20 April 1992):14. Report of controversy in central Sweden over latest issue of the telephone book, whose cover bears a photo of a nude woman playing with a satyr. Religious leaders demanded withdrawal of the book.

―――. "Bun Alert." *Newsweek* (27 April 1992):4. Notes publication of Craig Hosoda's *The Bare Facts*, a video guide to every actor who has done a nude scene in a film.

IV. REFERENCE WORKS

American Book Publishing Record. Cummulative, 1876-1949. An American National Bibliography. 15 vols. New York: R.R. Bowker, 1980. This, and the 1978 volumes, record American book publication as cataloged by Library of Congress, *American Book Publishing Record,* and National Union Catalog. Difficult to use, primarily due to the maddening Dewey decimal classification system.

American Book Publishing Record. Cummulative, 1950-1977. An American National Bibliography. 15 vols. New York: R.R. Bowker, 1978.

American Book Publishing Record. New York: R.R. Bowker, 1969-. Cummulative annual series covering years since 1968. English language books published in the United States.

ARTbibliographies Modern: Abstracts of the Current Literature of Modern Art, Photography, and Design. Santa Barbara, CA: ABC-Clio, 1969-. Annual.

Bibliographic Guide to Art and Architecture. Boston: G.K. Hall, 1975-. Annual compilation which incl. section on photography, although needlessly complex in its headings and sub-headings.

Bibliographic Index. New York: H.W. Wilson, 1975-. Annual compilation with limited photography section.

Boni, Albert. (ed.) *Photographic Literature.* New York: Morgan & Morgan, 1962. An attempt at everything written about photography from 1727 to 1960. Virtually useless for nudes.

―――. *Photographic Literature, 1960-1970.* New York: Morgan & Morgan, 1972. Even less useful than the first volume.

Browne, Turner and Partnow, Elaine. (eds.) *Macmillan Biographical Encyclopedia of Photographic Artists and Innovators.* New York: Macmillan, 1983.

Catalog of the Library of the Museum of Modern Art. 14 vols. Boston: G.K. Hall, 1976. Vol. 11 covers photography. (98-241)

CATNYP. Online catalog of the New York Public Library. Accessioned books and serial publications from 1971 to present.

Cumulative Book Index: A World List of Books in the English Language. Multi-volume. New York: H.W. Wilson, 1928-. One may find books listed here and not listed in the Library of Congress Union Catalog.

DIALOG. Online computer search. Useful, and should not be ignored, but EPIC is better.

EPIC. OCLC. Online Union Catalog. Online computer search. A powerful bibliographic research tool without which this volume could not have been written.

Heidtmann, Frank. (ed.) *Bibliography of German Language Photographic Publications, 1839-1984.* 2 vols. 2nd rev. edn. K.G. Saur, 1989. Thorough and invaluable. Incl. section on photography of the nude, but arranged chronologically instead of alphabetically.

"History Of the Nude." *Photohistorica Newsletter* NB17 n.d. [ca.1988] Badly arranged 7 page bibliography. For more on *Photohistorica* see entry below.

Infotrac. CD-ROM computer data base on periodical literature since 1983.

Johnson, William S. (ed.) *An Index to Articles on Photography, 1977.* Rochester, NY: Visual Studies Workshop, 1978. Not of much use for the nude, unless one is searching for specific photographer(s).

————. *An Index to Articles on Photography, 1978.* Rochester, NY: Visual Studies Workshop, 1980.

————. *International Photography Index: 1979.* Boston: G.K. Hall, 1983. Periodical literature indexed from photography serial publications.

————. *Nineteenth Century Photography: An Annotated Bibliography.* Boston: G.K. Hall, 1990. 800 page tome which concentrates on the mid-nineteenth century.

Kuntz, Andreas. *Der blosse Leib: Bibliographie zu Nacktheit und Körperlichkeit.* Basel, Switzerland: Lang, 1985. A 90 page essay precedes a 170 page bibliography on the human body in culture, incl. topics such as pornography, photography, art, nudism, fashion, psychology, sociology. As a guide to photography of the nude it is not particularly useful.

Lambrechts, Eric and Salu, Luc. (eds.) *Photography and Literature: an International Bibliography of Monographs.* New York: Mansell, 1992. 296p., but sparse on the nude.

Library of Congress Catalog. Books: Subjects, 1950-54. 20 vols. Ann Arbor, MI: J.W. Edwards, 1955. Incl. photography section.

Library of Congress Catalog. Books: Subjects, 1955-59. 22 vols. Paterson, NJ: Pageant Books, 1960. Incl. photography section.

Library of Congress Catalog. Books: Subjects, 1960-64. 25 vols. Ann Arbor, MI: J.W. Edwards, 1965. Incl. photography section.

Library of Congress Catalog. Books: Subjects, 1965-69. 42 vols. Ann Arbor, MI: J.W. Edwards, 1970. Incl. photography section.

Library of Congress Catalog. Books: Subjects, 1970-74. 100 vols. Totowa, NJ: Rowman & Littlefield, 1976. Incl. photography section.

Moss, Martha. (ed.) *Photography Books Index.* Metuchen, NJ: Scarecrow Press, 1980. 2 pages of entries for individual works, culled from a handful of anthologies. Not adequate for the nude.

Naylor, Colin. (ed.) *Contemporary Photographers.* 2nd edn. Chicago: St. James's Press, 1988. Outstanding one volume biographical reference; incl. 700 entries w their publication history. Incl. several nudes as illustrations.

New York Public Library. *Photographica: a Subject Catalog of Books on Photography*. Boston: G.K. Hall, 1984. Incl. section on the nude.

ORBIS. Online catalog of the libraries of Yale University, New Haven, CT.

Parry, Pamela Jeffcoat. (ed.) *Photography Index: A Guide to Reproductions*. Westport, CT: Greenwood Press, 1979. 83 books served as the source for individually cited photographs making up the *Index*. A subject index lists some nudes, but even for 1979 it was sparse.

Photohistorica: Literature Index of the European Society for the History of Photography. (Antwerp, Belgium) 1978-. Annotated bibliographies of periodical literature, incl. some articles on the nude, usually w some relevance to history of photography. Has author/subject indexing.

"Propositions pour une bibliographie illustrée sur le corps regardé." *Les Cahiers de la Photographie* 4 (1981):58-59.

Roosens, Laurent and Salu, Luc. (eds.) *History of Photography: a Bibliography of Books*. New York: Mansell, 1989. 446p., but sparse on the nude.

Sennet, Robert S. *Photography and Photographers to Nineteen Hundred. An Annotated Bibliography*. Garland, 1985. 134 pages, 409 citations. Select bibliography of the most important books. Outclassed by the Johnson volume.

Wilsondisc. CD-ROM computer data base on periodical literature since 1983.

The Worldwide Bibliography of Art Exhibition Catalogues, 1963-1987. Ithaca, NY: Worldwide Books, 1992. Esp. vol. 2:(1669-1704) on photography.

GLOSSARY

6x6: refers to dimensions of film used in some medium format cameras; the frame of each shot measures 6x6cm, or close to 2¼x2¼ inches square.

6x7: refers to dimensions of film used in some medium format cameras; the frame of each shot measures 6x7cm, similar in proportion to an 8x10 inch photographic print.

35mm: refers to film size of small format cameras such as Nikon F. The most widely used film size. Each frame on a roll of 35mm film is rectangular, 24x36mm.

Albumin print: photographic paper coated with an emulsion whose binding agent is egg whites.

B&W: black and white.

Blurred motion: a photograph taken with a lens shutter speed too slow to "freeze" a moving object on film. Often this technique is chosen deliberately by the photographer to suggest movement.

Cibachrome: the highest quality color print paper, once made by Ciba-Geigy Corp. Prints are made from color slides, and have archival permanence.

D-76: B&W film developer patented by Kodak.

Daguerreotype: copper plate coated with silver iodide, invented in mid-19th century as a cheap way to make photographs.

Extachrome: color slide film made by Kodak, noted for sharpness, fine resolution, & accuracy of color rendition.

Gum bichromate print: paper sensitized with an emulsion of gum arabic, water, & potassium bichromate. Color may be introduced by adding watercolor to the emulsion, and after one layer of emulsion dries, another may be applied.

Hasselblad: Swedish medium format SLR camera w 6x6cm frame size, famous for durability and high quality of optics.

Infrared: a type of film especially sensitive to the infrared segment of the light spectrum. Depending upon the lens filtration, common objects take on an unreal appearance, e.g., green leaves are white in B&W prints made with B&W infrared film.

Kodachrome: the oldest color slide film, & perhaps the best, made by Kodak.

Large format: camera using single sheets of film larger than medium format, usually 4x5" and up. View cameras are large format.

Mamiya: Japanese medium format SLR camera, usually the RB-67 or RZ-67, with 6x7cm frame size.

Medium format: camera using 120 film, which is 6cm wide, and is in roll form.

Multiple exposure: when more than one shot has been taken on a single frame of film; when a single frame on a roll of film is exposed to light more than once. This results in overlapping images.

Nikon: Japanese 35mm camera renowned for high quality of optics, and ruggedness of construction.

Platinum print: photographic paper coated with platinum emulsion, noted for its long tonal scale and archival permanence. They are laborious to produce.

Polaroid: Polaroid instant print film, available in color or B&W, in sizes from 3x5" to 20x24". Once loaded and exposed, the film develops into a positive image, a print.

Rolleiflex: German medium format TLR camera known for high quality optics and simplicity of design.

Seamless: usually any seamless paper (or even canvas, muslin, etc.) used as a studio background. It is kept on rolls 3 to 4 meters wide and secured near the ceiling of the studio. When needed, the desired length is pulled down to the floor and towards the camera, creating a seamless background.

Sinar: large format camera.

SLR: single lens reflex, meaning the camera has one lens, which transmits the picture to the viewing screen by mirror.

SLR cameras permit the use of many different types of lenses on one camera.

Solarization/Solarized print: special film or print development technique in which the chosen media is exposed to light for a second about midway through the development process. The resulting print looks like a positive and a negative image combined, and the effect can range from subtle to bizarre.

Studio shot: photograph created in a photographer's studio, usually employing artificial light and the full panoply of exposure controls. Different from "location" shots, made either outdoors or in rooms which are not studios.

TLR: twin lens reflex, meaning the camera has two lenses: a focusing lens which transmits the picture to the viewing screen by mirror; and a taking lens which transmits the picture to the film.

Tri-X: versatile B&W film made by Kodak.

View camera: large format camera featuring lens, bellows, & viewing screen/film holder. A large and heavy camera, it requires a tripod. It makes up for lack of mobility & speed of use with its ability to control perspective, by means of tilting or swiveling either the lens or viewing screen, or both at once.

INDEXES

There are four indexes: I. Photographers in Anthologies, an index of photographers who have been included in anthologies on the nude, which gives some indication of their significance in the genre. II. Model, an index of men and women who have helped at least one of the photographers in this bibliography to create a nude by posing for them, or for themselves. Of course, the great majority of models are anonymous. III. Special Techniques, an index of photographers who made nudes with unconventional or experimental techniques. IV. Subject Areas, an index of significant categories.

I. PHOTOGRAPHERS in ANTHOLOGIES

154

II. MODEL

III. SPECIAL TECHNIQUES

Names will be found in either the bibliography or the Photographers in Anthologies index

Blurred Motion/Distortion

Bailey, David.
Benedict-Jones, Linda.
Benham, Sarah.
Blumenfeld, Erwin.
Carner, Bill.
Crane, Barbara.
Davenport, Alma.
Funke, Jaromir.
Gaillard, Didier.
Gaté, Jean-François.
Grey, David.
Groebli, René.
Jensen, Robert.
Kertész, André.
Krims, Leslie.
Leen, Sarah.
Le Mené, Marc.
Leroi, Philippe.
Loriente, Paulo.
Meatyard, Ralph Eugene.
Michals, Duane.
Mozingo, James.
Powell, James.
Stojko, Tone.
Székessy, Karin.
Tourdjman, Georges.
Vogt, Christian.
Waxman, Donald.
Weegee.

Infrared

Albright, Richard.
Bartoloni, Gary.
Cardish, Daniel.
Hunter, Debora.
Law, Craig.
Letbetter, Dennis.
Lindström, Tuija.
MacAdams, Cynthia.

Miller, Brigitte.
Moore, Susan J.
Morrison, Gavin.
Muehlen, Bernis von zur.
Ockenga, Starr.
O'Connor, David.
O'Dell, Dale.
Paduano, Joseph.
Roberts, Nancy P.
Schwartzman, Steven.
Székessy, Karin.
Thorne-Thomsen, Ruth.
Tolot, Alberto.
Wallis, Frank.

Multi-exposure

Bellmer, Hans.
Blumenfeld, Erwin.
Boháč, Vilém.
Borrero, Elsa.
Brehm, Heribert.
Bruguière, Francis.
Clotaire, Deheul.
Cornet, Jeanloup.
Davenport, Alma.
Dinther, Lenni van.
Eidenbenz, Willi.
Fitz, W. Grancel.
Fleischer, Alain.
Fonssagrives, Fernand.
Franchi de Alfaro, Luciano. III.
Friedman, Victor.
Gesinger, Michael.
Hajek-Halke, Heinz.
Hallgren, Christopher.
Haskins, Sam.
Heller, Amy.
Hunter, Debora.
Lategan, Barry.
Laughlin, Clarence John.
Lee & Burger.

Marchael, James.
Michals, Duane.
Paco. (Budapest)
Pétremand, Gérard.
Pruszkowski, Krysztof.
Rice, Pincus.
Roh, Franz.
Ruben, Ernestine.
Saudek, Jan.
Schäpfer, Hans R.
Šechtl, Josef.
Serbin, Vincent.
Seymour, Ronald.
Šmok, Jan.
Swedlund, Charles A.
Tabard, Maurice.
Tarsches, Abigail.
Teske, Edmund.
Ubac, Raoul.
Vávra, Jaroslav.
Vogt, Christian.
Walker, Todd.
Wynn, Richard.

Photomontage

Boucher, Pierre.
Butyrin, Vitaly.
Clergue, Lucien.
Dutton, Allen A.
Eluard, Nusch.
Hamilton, Herbert.
Hammit, Howard.
Haskins, Sam.
Heinecken, Robert.
Hockney, David.
Horvat, Frank.
Hugnet, Georges.
Karsten, Thomas.
Kovach, Peter.
Ommer, Uwe.
Sass, Alan.
Sirůček, Vladimir.
Spitzer, Neal.
Šplíchal, Jan.
Stenvert, Curt.
Ubac, Raoul.

Solarization

Blumenfeld, Erwin.
Bruguière, Francis.
Bullock, Wynn.
Deiss, Joseph L.
Ehm, Josef.
Fehr, Gertrude.
Hoepffner, Marta.
Kesting, Edmund.
Man Ray.
Marhoun, Bohdan.
Strebel, Lukas P.
Ubac, Raoul.
Walker, Todd.
Windmann Studios, New York.

IV. SUBJECT AREAS

Art

Most generally, everything in this volume. Art is defined here as "The conscious production or arrangement of...forms...in a manner that affects the sense of beauty."(American Heritage Dictionary [1970]).

Glamour/*Charme*

Adams, George.
Albee, Wayne.
Alterio, Dominik.
Andréani, Pierre.
Angelicas, Emmanuel.
Angelo (Paris).
Aslan.
Astore, Henri.
Audras, Eric.

Baege, Alexander.
Bailey, David.
Bali, Alain.
Banks, Iain.
Baranzelli, Dino.
Barbieri, Gianpaolo.
Barboza, Anthony.
Barreaux, Adolphe.
Barrett, Dean.
Barry, Peter.
Basch, Peter.
Bata, Vulovic.
Bauret, Gabriel.
Beauvais, Alain.
Beauvais, Robert.
Bellas, Bruce Harry.
Benanteur, Dahmane.
Berg, André.
Bergaud, Jacques.
Bernard, Bruno.
Berquet, Gilles.
Biancani, Laurent.
Bird, Walter.

Bisang, Bruno.
Blake, Rebecca.
Blok, Rimmy.
Blom, Geneviève.
Bohnhoff, Andreas.
Boisseau, Laure.
Bokelberg, Werner.
Bonnenblust, P.A.
Bordes, Patrick.
Botti, Giancarlo.
Bottius, Emmanuel.
Bourboulon, Jacques.
Bourdin, Guy.
Bourgeois, Jean-Pierre.
Brooks, David.
Brown, Tim.
Bruno of Hollywood.
Bull, Charles Sinclair.
Busselle, Michael.

Cass, Eli.
Chastin, Jean-Marc.
Clarke, Bob Carlos.
Claude, Bruno.
Clemmer, Jean.
Clovis, Elmont.
Cordon, Paul de.
Crichton, Bob.
Curto, Paulo.

Dau, Harro.
Dell'Orto, Alberto.
Demarchelier, Patrick.
Deratte, Antoine.
Dicker, Jean-Jacques.
Dickinson, Janice.
Diebold, Philippe.
Diénes, Andre de.
Domingue, Jean-Pierre.
Donovan, Terrence.
d'Ora, Madame.
D'Orazio, Sante.
Dunas, Jeff.

Eichler, Wolfgang.
Emili, Marco.
Everard, John.

Farber, Robert.
Farina, Ferruccio.
Fauchard, Stéphane.
Fegley, Richard.
Ferrier, Arthur.
Feurer, Hans.
Fierce, Brad.
Frankel, Haskel.
Frasnay, Arthur.
Fridel, Jacky.
Friedrich, Hans.

Gabor, Mark.
Gaillard, Didier.
Gainsbourg, Serge.
Gamer, Dieter.
Geordias, Dorothée.
Geradts, Evert.
Giacobetti, Francis.
Giller, Patrick.
Girard, Sylvie.
Glaviano, Marco.
Glover, Thomas.
Gordon, Larry Dale.
Gorman, Greg.
Goss, James M.
Gotlop, Philip.
Goude, Jean-Paul.
Gowland, Peter.
Granta, Roberto.
Gray, Orlande.
Guillou, Philippe.

Haak, Ken.
Haan, Karl de.
Haffner, Mary.
Haisch, Arthur G.
Halmi, Robert.
Hamilton, David.
Hammind, Paul.
Haskins, Sam.
Hedgecoe, John.
Hermans, Willem Frederick.
Hesselmann, Herbert W.
Hicks, Roger William.
Hooker, Dwight.
Hoppé, E.O.
Horst, H.P.
Horvat, Frank.

Howes, Geoff.
Humphreys, N. Thorp.

Inamura, Takamasa.
Ionesco, Irina.
Izon, Noel.

Jablonski, Chris.
Jesse, Nico.
Johnston, Alfred Cheney.
Jones, Terry.
Jonvelle, Jean-François.

Kane, Art.
Kelly, John.
Kelly, Tom.

Lari, Emilio.
Leatherdale, Marcus.
Lebeck, Robert.
Le Bihan, Theirry.
Leidmann, Cheyco.
Leven, Barbara E.
Litchfield, Patrick.
Lindbergh, Peter.
Lorieux, Jean-Daniel.
Louys, Pierre.
Love, Robin.
Lupino, Stephan.

Magaud, Patrick.
Malinowski, Stan.
Manassé
Marcus, Ken.
Marin, Corrado.
Meisnitzer, Fritz.
Meola, Eric.
Messens, Didier.
Michel, J.–L.
Mittledorf, Klaus.
Mohr, Ulrich.
Monthubert, Fabien.
Moore, James.
Moreau, Michel.
Moser, Christian.
Mure, Jean-Michel.

Newman, Byron.
Newton, Helmut.
Nikolson, Chris.
Nørgaard, Erik.

Ommer, Uwe.

Ornitz, Don.
Outerbridge, Paul.

Palais, Didier.
Park, Bertram and Gregory, Yvonne.
Parkinson, Norman.
Pawelec, Wladyslaw.
Perauer, Emil.
Peterson, C.A.
Posar, Pompeo.
Prévotel, Patrice.

Raffaelli, Ron.
Rancinan, Gérard.
Reinhardt, Mike.
Renard, Arlinda Mestre.
Rheinboldt, Frank.
Richard, Yva.
Rittlinger, Herbert.
Rougeron, Jean.
Rourke, Mickey.
Rouzer, Danny.
Roye.
Rutter, John.

Sachs, Günter.
Sahm, Anton.
San Martin, Mariola.
Scavullo, Francesco.
Schmitz, Dieter.
Schofield, Jack.
Schumacher, Jacques.
Schwartz, Robin.
Seufert, Reinhard.
Shearer, Graham.
Sieff, Jeanloup.
Smith, J. Frederick.
Sollers, Philippe.
Soulage, Christian.
Stark, Koo.
Stein, Ralph.
Stember, John.
Stern, Bert.
Suter, Jacques.
Swannell, John.

Téboul, Sabine.
Thomson, Chris.
Thornton, John.
Torlowia, Giovani.
Trillat, Elsa.
Tulchin, Lewis.

Véronèse, Marcel.
Von Bulow, Heinz.
Vo Van Tao, Albert.
Vuillaume, Jean-Manuel.

Wagner, Paul.
Wangenheim, Chris von.
Weicherding, Alain.
White, Jerry.
Wickrath, Klaus.
Wild, Victor.
Wildbolz, Jost.
Wilding, Dorothy.
Wlassics, Olga.
Wog.
Wu, Francis and Wu, Daisy.

Yeager, Bunny.

Man Nudes

Bettini, Richard.
Blue, Patt.
Burns, Marsha.

Campbell, Carolee.
Clark, Larry.
Clergue, Lucien.
Cloud, Greg.
Cohen, Sorel.
Cosindas, Marie.
Cunningham, Imogen.

Dater, Judy.
Davis, Lynn.
Durieu, Eugène

Flynt, Robert.
French, Jim.

Giard, Robert.
Gorman, Greg.

Hockney, David.
Holder, Geoffrey.
Horst, H.P.
Hujar, Peter.

Iverslien, Gry.

Koelbl, Herlinde.

Lebe, David.

Leen, Sarah.
Leonard, Joanne.
List, Herbert.
Lynes, George Platt.

Mandelbaum, Ann.
Mapplethorpe, Robert.
March, Charlotte.
Maricevic, Vivienne.
Mark, Mary Ellen.
Meatyard, Ralph Eugene.
Michals, Duane.
Moffett, Donald.
Muehlen, Bernis von zur.

Niccolini, Dianora.

Ockenga, Starr.

Rakoff, Penny.
Ritts, Herb.
Rivas, Humberto.

Samaras, Lucas.
Saudek, Jan.
Sieff, Jeanloup.
Simon, Peter.
Skrebneski, Victor.
Smith, Keith.
Sutlciffe, Frank Meadow.

Teske, Edmund.
Taylor, Robert.
Tress, Arthur.
Trichot, J-C.
Truitt, Warren.
Tweedy-Holmes, Karen.

Villarrubia, Jose.
Vogt, Christian.

Weber, Bruce.
White, Minor.
Weinberg, Carol.

Naturist/Nudist/FKK

Arbus, Diane.

Barsby, Jack.
Bayard, Emile.
Bernard, José.
Brauns, Walther.

Donger, Fernand.
Du Four, Gordon.

Erwitt, Elliot.

Grasselt, Karl Heinz.
Groot, Claus.

Herrlich, Lotte.

Janssen, Volker.

Koch, Adolf.

Lange, Ed.
Lange, June.
Loges, Werner.

Opalenik, Elizabeth.
Owen, Mike.

Peiser, Max.

Raba, Peter.
Reichert, Kurt.
Riebicke, Gerhard.
Rittlinger, Herbert.

Schertel, Ernst.
Schultz, Arthur.
Scott, Franz.
Simon, Peter.
Stoß, Hermann.
Strauss, Irene.
Suren, Hans.

Theewen, Gerhard.
Tregaskis, Richard.

Weidemann, Magnus.
Weihr, Bruno.